# Blender Foundations

# Blender Foundations
## The Essential Guide to Learning Blender 2.6

**Roland Hess**

AMSTERDAM • BOSTON • HEIDELBERG • LONDON
NEW YORK • OXFORD • PARIS • SAN DIEGO
SAN FRANCISCO • SINGAPORE • SYDNEY • TOKYO

Focal Press is an imprint of Elsevier

**ELSEVIER**

Focal Press is an imprint of Elsevier
30 Corporate Drive, Suite 400, Burlington, MA 01803, USA
The Boulevard, Langford Lane, Kidlington, Oxford, OX5 1GB, UK

**Notices**

Knowledge and best practice in this field are constantly changing. As new research and experience broaden our understanding, changes in research methods, professional practices, or medical treatment may become necessary.

Practitioners and researchers must always rely on their own experience and knowledge in evaluating and using any information, methods, compounds, or experiments described herein. In using such information or methods they should be mindful of their own safety and the safety of others, including parties for whom they have a professional responsibility.

To the fullest extent of the law, neither the Publisher nor the authors, contributors, or editors, assume any liability for any injury and/or damage to persons or property as a matter of products liability, negligence or otherwise, or from any use or operation of any methods, products, instructions, or ideas contained in the material herein.

**Library of Congress Cataloging-in-Publication Data**
Hess, D. Roland
Blender foundations : the essential guide to learning Blender 2.6 / Roland Hess.
   p. cm.
  ISBN 978-0-240-81430-8
  1. Computer animation.  2. Blender (Computer file)  3. Three-dimensional display systems.  4. Computer graphics.  I. Title.
TR897.7.H4865 2010
006.6′96—dc22                                                                                                2010011897

**British Library Cataloguing-in-Publication Data**
A catalogue record for this book is available from the British Library.

ISBN: 978-0-240-81430-8

For information on all Focal Press publications visit our website at www.elsevierdirect.com

10 11 12 13 14  5 4 3 2 1

Printed in the United States of America

# Contents

# Contents

# Contents

# Contents

# Preface

Howdy folks. This book is your guide to learning Blender 2.6. It assumes no previous knowledge of Blender, although old Blender users will find a lot to learn here too. Some beginner texts are dressed-up reference manuals, while some try to teach everything and end up teaching nothing. This book will teach you how to use Blender 2.6, and to actually use it well.

Being an artist consists of having a certain set of skills, having a point of view, and making choices. On the skill side, you must be familiar with your tools. And before that, you need to simply know what tools are available, and what they can do. On the other side, creating art with those tools is a series of choices, informed by observation and experience. You'll have to supply the observations—your unique viewpoint and way of processing the world—but hopefully this book will let you make use of some of my own experience to give your own a head start. Blender is a complex application with thousands of controls, properties, and ways of working. Not all of them are useful. In fact, when you are learning the basics of the medium, it turns out that trying to learn too much esoteric stuff can hurt you.

This isn't to say that what you can create with the basic tools can't be pleasing or even art. It can. Think of it this way. Ninety-five percent of the time in 3D, the set of tools you'll learn here will satisfy your needs. The other 5% of the time, well ... once you get good, the rest of the tools will actually be much easier to learn and apply because you have the fundamentals down. Build a strong foundation, and you will be ahead of the many others who started putting stakes in the ground wherever their fancy led them.

If you're new to computer graphics (CG) and 3D in general, Chapter 1 gives you a good overview of the whole process. If you're coming from another 3D application or even a previous version of Blender, Chapters 2 and 3 will help you to find your way through Blender's interface. In Chapter 4, we begin a project that lasts throughout the rest of the book. A room is modeled, lighted, and surfaced. A character is created and animated. Some special effects are added. Finally, the whole thing is rendered and built into

an animation file. With the techniques in this book, you will be able to fully build, light, surface, and animate a scene in Blender 2.6.

My hope is that you'll build the scene along with me as you work through the book. There's a lot more in there than just "click here" and "set this control to 0.5." It's important that you understand both sides of the artistic equation: *Here* are your tools, and *this* is how you decide when to use them. However, if there is a particular topic that you can't wait to touch, the Web Bucket (site) for this book contains versions of the project file at all stages of production. Even if you think you know it all though, you might want to at least read through those sections you think you can skip.

The website *http://www.blenderfoundations.com* contains not only these project files organized by chapter, but all of the screenshots from the examples, additional screenshots from complex tutorials, and all of the videos mentioned throughout the book. You will also find material and updates for information in the book that has been passed by because of Blender's amazing development speed.

Finally, a small note about Blender itself. *How can it be free?* I am often asked. My answer is always that it's free *to you*. Dozens of people have donated tens of thousands of hours to developing this fantastic software. An increasing number of people have had the opportunity to actually make a living working on it as well, due to the donations and support of an even greater pool of individuals from around the world. If you end up loving this software as much as I do, you could do worse than to head over to *http://www .blender.org* and see what they're working on. Buy something from the store. Make them happy.

As always, I love hearing from people who were helped by my books. If you've done something great (or even if it's just "better than you thought you could do"), and you think that the basics you picked up here helped you in some way, drop me a line at *animation@harkyman.com*. I'd love to hear from you.

# Chapter 1

## An Introduction to 3D: Recreating the World Inside Your Computer, or Not

You may be under the impression that working in 3D is an attempt to create the real world inside of your computer. It's a tempting and logical thought—the world itself is 3D. It consists of objects that have a certain form, the surfaces of which have properties that make them appear a certain way, and of light that allows us to see the whole thing. We can create form, surface, and light inside of a computer, so wouldn't the best approach just be to make everything inside the computer as close to the way it is in the real world and be done with it?

It turns out the answer is no—accurately simulating the world is not the best approach. That way madness lies.

We all live in the world. We know what it looks, smells, sounds, and feels like. More importantly though, we know what it looks like when carefully lit and shot through a lens by a skilled photographer. It is through two-dimensional (2D) images, either still or animated, that people will experience our 3D work, and this is the target we should be working toward. It turns out that this makes our job as a 3D artist both easier and harder than the job of someone who is mistakenly attempting to simulate the world. It's easier because, well, the world is stupifyingly large and deceptively complex. It's harder because there are considerations other than concrete sensory input (i.e., "A tree is shaped like *this,* feels *that,* and acts *thusly*"), and considerations like what is and is not seen in the final image, and at what level of detail: how it all goes together; how it demonstrates what you are trying to say; composition; art, even.

To be good at 3D creation, you will need to develop a facility for carefully observing the world around you, extracting those elements that will best contribute to your image and leaving the rest out. You will be creating a simulation of the real world that is specifically targeted at producing a final image—a unique virtual mini-world of which the sole purpose for existence is to create the illusion of reality in 2D that we experience when looking at a picture or watching a movie.

Let's take a look at the different elements of a real scene that we will need to analyze and rebuild in order to achieve this.

## Form

Everything that we see has a form—a physical structure. We know what these forms are: how a lion is shaped, what it looks like when pudding falls on the floor, the essence of a chair.

The essence of a chair?

Well, what is a chair, anyway? There are thousands of different kinds of chairs, but when we see one, we know it's a chair. That's because although the details differ, the form generally remains the same: a place to rest your back side, some means of support (usually legs, but it doesn't have to be), and a back. If there's no back, it's a stool. And so when we see an overstuffed recliner, a swivel chair attached to a table in a fast food place, or just a basic dining room Queen Anne–style chair, our brain identifies the form and tells us "chair."

It is form that lets us know what things are. In the real world, form is made from matter. Yes, that's "matter," as in solid/liquid/gas from science. I know that no one said there would be science here, but there is, as well as math—get used to it.

A lion's form is made up of organs, bone, muscle, skin, and fur. Pudding is made from milk, gelatin, and, hopefully, chocolate. A chair's form is constructed of any number of things, including wood, metal, and plastic. However, none of the insides really matter to our perception of the form. In general, we only see the outer surface, and that is enough for us to properly identify things.

This is the first place that we decide as 3D artists that we will not simulate the world as it is, but as we would see it through a lens. With a few exceptions, a camera only sees the outside surfaces of objects, so that is all that we need to worry about. If we want to create images of forms ("pictures of stuff" for the layman) we can temporarily forget about what things are made of and just focus on the shape of their surface.

In 3D, surfaces are built from *polygons*, specifically triangles and quadrangles in Blender's case (Figure 1.1). Usually, these polygons are built from vertices, edges, and faces (Figure 1.2).

These polygons are created and linked together in clever (or not-so-clever) ways until the whole surface of a form is constructed. This construction is called a *model*. When making models in 3D, it is important to keep in mind how their form will be shown in the final image. If the image of the object will be very small, perhaps because it is far in the distance or just a tiny detail like a flea or a grain of sugar, the model can be very simple (Figure 1.3). There would be no need to create a model of a building in exhaustive detail if it appeared only one-quarter inch high on a distant hillside in the final image.

We know what the form of such a building is in the real world. It has a roof, a chimney, windows with trim, maybe a spigot for a hose, and many other details. However, when we look at the 2D image with a critical eye, we can see that for our purposes, the building is little more than a box with a triangular

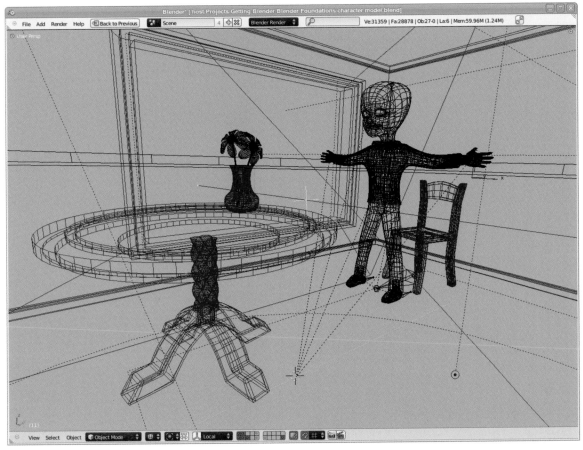

**Figure 1.1** *A scene created from polygons.*

top. If we were trying to reproduce this image in 3D, we would save ourselves a lot of trouble by modeling a simple box with a triangular top (Figure 1.4).

Obviously, if this same building were the main subject of the image, shown close up, its form in the image would be drastically different, and we would model it differently (Figure 1.5). In fact, depending on the image we are trying to achieve, we might only create a model of a portion of the building. If the image consisted of a close-up shot of the exterior of the building, we might choose to only model that part of the building that shows on camera.

In 3D, models that are made of polygons are our forms. They tell us what we are looking at. As a final example, take a look at the scene project for this book, without any texturing or lighting. It is only the forms, yet we know immediately what everything is. Clearly, though, none of this stuff is real, could be mistaken for real, or is even believable. That's because believability comes not from form, but from surfacing and lighting.

**Figure 1.2** *Vertex, edge, and face.*

## Surfacing

*Surfacing* refers to the way that surfaces look. Once again, we can examine the real world to learn a few things. We know what wood looks like. However, it looks different when it's part of a tree, freshly cut, or stained and finished in a piece of furniture. Each of these surfaces have different visual properties. A tree is rough—the bark is generally a brownish gray, rough, occasionally covered with moss or lichen. Cut wood is often light (excepting things like walnut, of course) with a pattern of concentric circles. It is generally smooth, although if you look closely you can see a pattern of grain. Finished wood that is part of a piece of furniture can be many colors; for example, it can be extremely smooth and highly reflective, in the case of a grand piano.

So, while *models* tell us what forms we are looking at, *surfacing* gives us the additional clues we need to understand what the forms are made of (Figure 1.6).

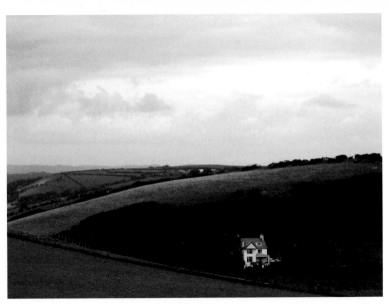

**Figure 1.3** *A landscape with a building in the distance. (Photograph by alexanderwar12/Al, Creative Commons Attribution-Share Alike 2.0 Generic.)*

**Figure 1.4** *A basic model of a building for use in the distance.*

Once surfacing has been added, the image becomes much more believable. In fact, surfacing gives us so much information that if we mix it up, the scene remains believable in a general sense, but becomes strange. It plays with our expectations of what we should be seeing.

In Blender, an object's surfacing is described by two sets of properties: materials and textures. Materials involve the basic visual properties of the surface, without texturing (Figure 1.7). How does light react when it strikes the surface? Does the surface emit its own light? Is it rough or smooth? Is it reflective? Is it transparent? Does it act like milk or skin, taking a little bit of light inside itself, scattering it around, then letting it back out?

With the basic materials in place, the objects in the scene take on a certain aspect of believability. Even though they don't look real, they at least look like physical objects.

Material properties deal with a number of areas:

- *Color:* The basic, overall color of the surface in white light.
- *Shading:* The way that light affects a surface. How much light does a surface absorb or reflect? How do the angle of the incoming light and the viewing angle affect what it looks like? Different shading models are available to give you a better chance at mimicking certain effects seen in the real world.
- *Transparency:* Whether or not an object's surfaces are transparent.

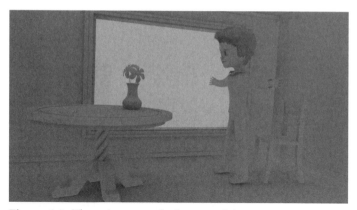

**Figure 1.5** *The project scene—the forms are obvious.*

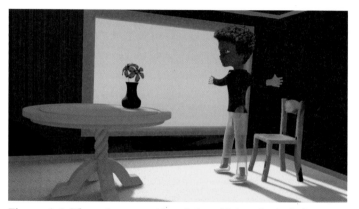

**Figure 1.6** *The project scene with surfacing added, and mixed about.*

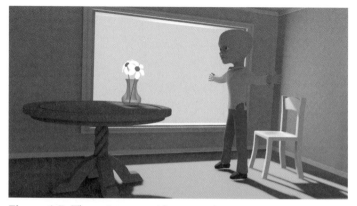

**Figure 1.7** *The project scene with no texturing.*

Simple transparency, based on something called Alpha (Z-transparency in Blender) is quick to render. Another method of calculating transparency, called ray tracing, takes longer to render but is more realistic and able to simulate effects like refraction.

- *Reflection:* Is the surface mirrorlike?
- *Subsurface scattering:* Certain real-world materials like skin, jade, or the flesh of a potato exhibit this property, often abbreviated as SSS. Light enters the material, scatters around, possibly changes color a bit, then exits. When you hold a flashlight against your fingers in the dark, you see subsurface scattering.

While these material properties affect an object's overall reaction to light, textures help to define the way that those properties vary across the surface. Textures can be photo mapped onto a surface, generate bumps on a surface, or cause transparency to fade in and out, among other things. A careful observation of objects in the real world will help you to determine which combinations of material settings and textures will produce the most believable results.

## Light

The final ingredient in your still images is light. In the real world, light appears to be easy. You have the sun and the sky. If you need more light than that, you flip a switch. That's it!

Of course, good photographers know that it's not that simple. Even if they are shooting outside, they carefully monitor light sources, highlights, and shadows. They might use a reflector to bounce some natural light into an area that is too deeply in shadow. Indoors, things get even trickier. The great indoor photography you are used to seeing in magazines (not to mention television and movies) is usually the result of careful planning and expensive equipment.

It should be no surprise then that lighting in 3D isn't easy. In the real world a lot of lighting, even in complex commercial situations, is accomplished by the simple fact that light bounces off anything it hits, and scatters in the air. Shine a focused bright light into a completely dark room and you will be able to see quite a bit. You will see that objects that aren't even near the beam of light are illuminated, either

from the beam bouncing off the opposite wall or simple atmospheric scattering. In 3D though, putting a spotlight into a dark room gets you next to nothing (Figure 1.8).

Some 3D systems allow you to define lights in a fairly natural way: add a sun, add a lamp, done. Blender, however, does not work this way. If you want light to "bounce" off a far wall, you will have to add another light source on the wall, shining in the direction of the bounce. It can become complicated.

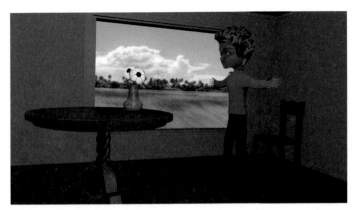

**Figure 1.8** *The project scene with a simple spotlight.*

In 3D, there are a number of different light styles, each with their own set of properties and effects. Blender's Spot Lamp, for example, can cast the kind of "light cone" that many people expect to see in concert or film noir situations. While real-world shadows are simply a consequence of the physics of light, 3D shadows can be turned on or off and have several calculation methods, each of which is appropriate to a different situation.

More than any other aspect of the 3D creation process, effective lighting will require that you carefully consider the 2D images you want to generate. Beyond just showing the forms in a picture and their surfacing, lighting sets a mood, directs the eye, becomes a part of the composition, and will either make or break your final image.

## Motion

In the real world, things move. We're accustomed to the way that things move, and when we see unnatural motion we know it right away. It looks bad. As 3D artists we are not trying to recreate the world. What artistry or skill would there be in a painstakingly exact reproduction of real motion, other than technical curiosity? What purpose would it serve?

Fortunately, this is ground on which lies a well-worn path. Since its beginning in the 1920s, artists and entertainers have a developed a well-known language for animation. Things that would look bizarre in the real world—bulging eyes, rubbery arms, and the ability to hover for a moment before falling off a cliff—are perfectly acceptable and actually expected by the viewer in the realm of animation.

Whether for film, television, or even content produced exclusively for viewing on the Internet, animation works the same way. It is a series of still images shown rapidly one after the other, producing the illusion of actual motion. In traditional (hand-drawn) animation, each of those frames must be drawn individually. At 30 frames per second (the frame rate of North American television), that's 900 images for just 30 seconds of animation. In other words, it is a lot of drawing.

Computer animation, which is what we're about, is in some ways easier. If you were to follow the traditional model of animation, you would create the entire scene 900 times, each with a slight variation. Obviously, that's silly. Within your single scene you have the ability to record and change objects' positions (e.g., on the floor, in the air), states (e.g., lights on, lights off), and poses (e.g., reaching for a towel, pulling on a shoe) along a timeline, and have the software calculate all of the positions, states, and poses in between. The process of saving this information in time is called *keyframing* ("key" information is saved on certain "frames" in the timeline; Figure 1.9).

In Blender, keyframes are created for entire objects by transforming them in space and recording their status. When you add several keyframes, Blender interpolates the difference between them along smooth curves. Character models are not animated directly. Instead, they are attached to control rigs called armatures. These rigs act like a skeleton and control panel that can be posed and keyframed to produce beautiful character animation.

## Rendering

Even after you have created your forms, carefully surfaced and lit them, and animated your scene, there is more to do. Just as there are many variations in cameras in the real world (Film or digital? Color or black and white? 35 mm lens or 50 mm?), there are an almost infinite number of ways that you can capture your scene into a 2D image.

In 3D art, the process of actually creating this image is called *rendering*. The renderer analyzes the forms in your scene, and decides which ones are visible and which are not and how they appear in perspective from the camera's viewpoint (Figure 1.10). There are different kinds of renderers, and depending on their type, they proceed differently from here. In our case, Blender's renderer begins to go through each pixel of the final image, calculating which form is visible there, and how it will look based on the surfacing properties and lamp and shadow settings that have been chosen. It proceeds through every pixel until the

**Figure 1.9** *A bouncing ball's keyframes.*

Figure 1.9, cont'd

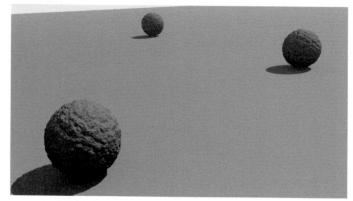

Figure 1.10 *The raw output from the renderer.*

image is complete. If the scene contains simple forms, basic surfacing, and only a few lamps, this can be accomplished in as little as a few seconds. More complexity costs more time. Scenes that contain large numbers of polygons, math-intensive surfacing like true refraction, and certain kinds of diffuse shadows can take hours to render.

This raw render output can be put through Blender's compositor. Even if you are not a photo editing professional,

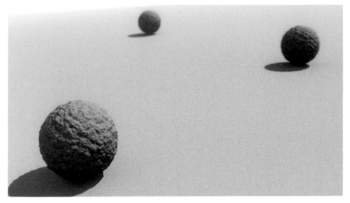

**Figure 1.11** *The same scene after visiting the compositor.*

you have almost certainly put your home photography through some kind of management or enhancement software like Adobe's Photoshop Elements or Google's Picasa. These programs allow you to enhance your raw photography: fixing exposure problems, clearing red eye, or adding special effects like a soft glow, directional blurring, or sepia toning. Blender's compositor is a kind of integrated after-processor for your rendered images.

As you can see from Figure 1.11, the compositing process can add a great degree of believability to an otherwise pedestrian render.

And so, after creating your scene, then rendering and processing it, you arrive at a final 2D image that hopefully expresses what you had been thinking in the first place.

But, how do you get to this final image? Anyone firing up Blender for the first time will find a confusing array of buttons, screens, and controls. Before we get into actually doing anything, it pays to spend a few minutes to familiarize yourself with Blender's interface, both the widgets that make up the control system and the thinking behind it. In Chapter 2, we'll look at how to find your way around in this innovative interface.

## Next Up ...

In Chapter 2, we actually dig into Blender's interface, going over the different widgets, screen elements, and the thinking behind the whole thing.

# Chapter 2
## Understanding Blender's Interface

## A Little Bit of History

I'm not going to bore you with the entire history of Blender, the free and open-source software movement, or a dissertation on the various theories of human interface design. A bit of knowledge, however, can give you some perspective on the thinking behind Blender's interface.

Some programs don't have any thinking behind their interfaces. This is obvious. The programmers write the functionality, which is operated from a command line, and realize at some point that the general public has no way of using their wonder-program without a graphical interface. So, they learn to create a data entry form, slap it on top of their program, and away they go. And it stinks.

A lot of people think that Blender was created in a similar fashion, and in the very recent past, this was true. Until version 2.5, a lot of new features were added without any kind of real review of how their functionality fit in with the rest of the program, and how their interface elements should organically merge with the existing ones. As someone who has added a few features to Blender myself, I experienced this firsthand. Functionality came first, and then I searched for anywhere into which I could reasonably shoehorn a few new buttons or steal a keyboard shortcut.

Blender's origins, however, were much more noble.

NeoGeo, a Dutch game and animation studio, wanted a better tool than they could afford, so they decided to develop their own. Blender was the result. From the beginning it was designed to be a streamlined, production-oriented animation program. The emphasis was on keeping all tasks within a single application, unlike other 3D tools of the time. Lightwave, 3D Studio, and Hash Animation Master all had separate applications for modeling and animation. Blender had everything in one package, including video editing and an interactive real-time engine. It exhibited a heavy reliance on keyboard shortcuts. For people trying to learn the software from scratch, this made it extremely difficult. For experienced users, though, it was ridiculously efficient.

Over time, and especially since Blender became open-source software in 2003, a lot of cruft has built up. Tools have been added with little thought to how they ought to be organized. The old "buttons window" for mesh modeling was a nightmare. But the solid, efficient core remained. In the first part of 2008 a project began to take Blender back to its roots.

It wasn't a stripping of functionality; it was a restatement of first principles. The entire bag of features, both old and new, were reconsidered, reshuffled, and finally given the thought they had deserved all along but rarely received. The result is Blender 2.6.

If you have prior Blender experience, some of the higher-level stuff will stay, but prepare to blow it up and learn it again. The good news is that you've already been exposed to the way that Blender thinks. The new interface is like the old one, but more consistent, more logical, and more … Blenderish—which is fantastic.

## Spend the Time

Too many people have downloaded Blender because, you know, it's free and what the heck, eh? They play with it for 15 minutes and never touch it again, figuring they should have been able to make *Finding Nemo* with little effort, and finding themselves sorely disappointed. The truth is that 3D and animation are not simple, not easy, and no one is going to become an expert without some kind of training, talent, and dedication. It is both a craft and an art form, and like any such endeavor—metal working, carpentry, oil painting, sculpting—you must become proficient with the tools before you can have any expectation of producing examples that are worth showing to people who don't already dearly love you. As the Blender Foundation's benevolent dictator for life, Ton Roosendal, has said, "You can't get a piano and expect to be a big composer. You need to be a pianist first."

Patiently working through this chapter and Chapter 3 (object manipulation and basic animation) will pay dividends for the rest of the time that you spend with Blender. While Blender makes heavy use of hotkeys, they are not essential for getting around. Any functions can be achieved in a number of ways that we will detail later. However, the more hotkeys you commit to your fingers' memory, the more efficient you will become. The more efficient you are, the less time you will spend fooling with the tools themselves, and the more time you can devote to the artistic aspects of your work.

To help you make the most of your training, this book will always provide hotkeys for newly presented tools in **boldface**. If it is a common hotkey that is frequently used, the book will specifically recommend that you try to memorize it. Committing a hotkey to memory is a simple procedure.

The first time you encounter a tool in the text (or, say, an online tutorial), make sure to use the hotkey that is printed with it. The next time you need to use the tool, try to remember. If you can't, that's okay. Find the tool through another method (look it up in the book or find it through the menus, toolboxes, or search function that we'll learn about in a bit), but don't actually use that other method. Anywhere you find a tool in Blender (menu, button, etc.), simply hovering the mouse over it for a second will display the tool's full name and any hotkeys that are associated with it. Force yourself to leave the toolbar, menu, or search bar and just use the hotkey. Resolve that, for certain very important functions, you will never

use anything to activate it other than the hotkey, even if you have to go searching for what that hotkey is a dozen times.

Even if you're not the best with memorization, you will eventually become tired of poring through the menu structure or slogging through the search bar to find it. You'll learn it by force of your own sheer laziness, which is kind of ironically awesome.

## Getting and Installing Blender

Before we actually start to look at the interface, make sure you have Blender 2.6 installed. *Wait*, I say, raising a hand to forestall your objections. There is a chance that you might not have Blender 2.6 installed. Slim, yes, but the chance exists. This book provides equal service to all.

Blender 2.6 is available from a number of locations online, and if you're looking for the absolute latest version, get it from the official website: *www.blender.org*. There's a big Download Now button on the first page. There will be versions for your flavor of computer: Windows, Mac, or Linux. If you are already running something from the Blender 2.5 or 2.6 series, you don't need to redownload. However, if this book is your first point of contact with this great software, be sure to get Blender 2.6. That is the version that the tutorials in this book are designed to work with. Later versions might have small (or even large) variances, and if you're just starting out, you'll want to keep things as straightforward as possible.

The best way to guarantee that you are using the proper version of the software for these tutorials is to download Blender 2.6 from the Web Bucket for this book, which can be found at *http://www.blenderfoundations.com*. The first page of that site contains direct links to the official downloads on *www.blender.org* of the exact version of the software. Windows users get a standard Windows installer. Mac and Linux users get a compressed archive that contains the application. No need to even "install" it—just decompress and go.

## The Parts of the Interface

Run Blender. Take a look. Let's dig in and dissect the first thing you see, as shown in Figure 2.1. (*Note:* The colors in our screenshots have been adjusted for contrast, and do not reflect Blender's default theme.)

Obviously there's a lot going on in Figure 2.1. Before we begin talking about any specifics regarding the controls you see, you need to learn how this screen is constructed.

Blender's entire interface scheme is based on **nonoverlapping windows**. If you've worked with Photoshop (or its open-source cousin, GIMP) or basically any other graphics program, you're probably used to having palettes flying here and there, trying to manage them so the right ones are showing and they're not covering up any relevant portion of your artwork. Blender avoids this problem altogether by not allowing that kind of overlap. Blender's entire display area can be split into as many subdivisions as you like, but not one of them will ever overlap another.

### Changing Window Sizes

Within Blender, each of these subdivisions is called a **view** or **window**. The borders between the different windows can be moved by hovering the mouse over that border. When you do this, the cursor changes

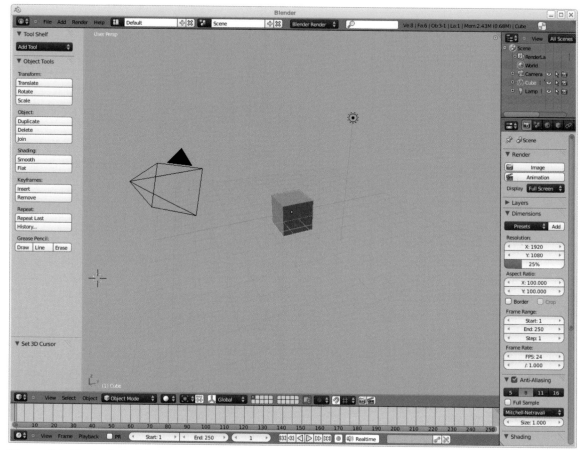

**Figure 2.1** *Blender 2.6's default startup screen.*

to a double-headed arrow. Left mouse button (LMB) clicking and dragging on that border resizes the windows on either side of it. Just by dragging the boundaries around, you can arrive at an interface that looks strikingly different from the default, shown in Figure 2.2.

It barely seems like the same thing, does it? And yet, it is. It is probably not as useful as the original, but the reconfigurability is the point. If you ever need a little more screen real estate for a set of buttons or a particular view, you can grant it immediately and quite reversibly by dragging view boundaries.

### *Headers*

Each window is eligible for a **header**. Headers contain controls and menus specific to the contents of the window. In Figure 2.1 the headers are the dark gray horizontal bands. Header controls generally pertain to how the information in the accompanying window is displayed, although they sometimes have buttons

**Figure 2.2** *The default screen with boundaries moved about.*

for frequently used tools that would otherwise be difficult to access. We said that windows are *eligible* for headers, not that they *had to* have them. And, in fact, they do not. In order to maximize your screen's usable real estate, you may choose to hide the headers on any particular window. To do this, hover your mouse over the boundary between the header and the rest of the window. When it changes to a double-headed arrow, just drag it downward until it disappears. Note the little + symbol that appears on the right of the window in the area the header used to occupy. To get the header back, LMB click the symbol.

On the leftmost end of each header is an icon that shows the current window type. This is where Blender's configurability becomes really cool. LMB click on the icon, and a menu pops up, like the one in Figure 2.3. This menu shows all of the different types of windows that Blender has available. There are 16 in version 2.6. The great thing is that any of the windows on the current screen can be set to display any of these window types at any time. Blender, for its part, is completely view agnostic. It doesn't care how you set it up. Sure, some configurations are going to be more useful than others, but in the end you can

mold the application to show the information that you find most useful, and to provide the tools that you need in the way that you like to see them.

### Merging and Splitting Windows

But so what if you can slide windows around, making them bigger and smaller and changing their type? That doesn't provide ultimate configurability. Below and to the left of each window-type icon on the window headers is a little bit of diagonal hashing. This has been highlighted in Figure 2.4. Hovering the mouse over this small region changes the cursor into a crosshairs. LMB dragging on this region allows you to split and merge windows.

Dragging with the crosshairs into an adjoining window expands the original window to also fill up the space of the target. The effect is as though the original window "took over" the other. This works nicely for windows below or to the left of the window you're expanding. For windows above or to the right, there is another hashed region in the upper right of each window. Drag from this into an adjoining window for the same effect.

To create a new window, you split an existing one into two. This is even easier than joining window spaces. You use the same control—an LMB drag on the hashed control region—but in this case you drag it within the same window. This creates a duplicate of the original window, the new one sharing space with the old one. From there, you can set either of those windows in the split area to a different window type.

Figure 2.5 shows a before and after of this process, splitting the 3D view into two identical windows, then changing one to a properties window.

Let's look at two more configuration tricks before we start working with the different window types and what they do.

### Window Swap

Let's say that you have two windows and you would simply like to swap their contents. You could change each window's type, then try to configure them from their defaults to match what had been in the other view. Or, you can use the hashed corner region. Holding down the **Alt** key while dragging the hash mark

**Figure 2.3** *The Window Type menu.*

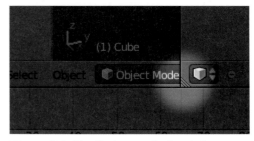

**Figure 2.4** *The "action zone" of a window.*

into another region and releasing the mouse button swaps the window contents. You probably won't use this all that often, but it's a nice trick to mention at parties to break the ice.

## Creating a New Application Window

If you have two monitors, it can be efficient to put controls, settings, or reference material on one monitor while devoting your main display to, say, an entire 3D workspace. While your computer's video card may be able to tile Blender across both windows, there can be problems with this scheme. A single instance of Blender can run in more than one application window at a time. In this case, application window doesn't refer to the working, subdivided windows that make up Blender's interface, but the overall window that your operating system uses to display Blender.

To split off a completely separate application window that can be moved to the second monitor and dealt with individually, hold down the **Shift** key as you LMB drag on the hashed corner of a window.

## Using Different Screens

All of this configuration we've been talking about so far takes place in one screen. One of the great things about Blender is its ability to have any number of screens available that you can switch among almost instantly. Blender comes with eight screens in its default configuration: one each for modeling, compositing, scripting, properties editing, animation, UV/image editing, game logic, and video editing.

**Figure 2.5** *Splitting and reconfiguring the interface.*

These different screens can be accessed from the **Screens** browser, located immediately to the right of the **Help** menu item on the Info header at the very top of the display. Figure 2.6 shows this browser in action. Each of these screens is a good general beginning for working on that aspect of a project, and you are advised to give each one a try. There is no need, however, to stick with what's been given just because it's "official." If you don't like something, change it. Also, don't feel that you can't, for example, assign materials in the animation screen. You can. You can do any-

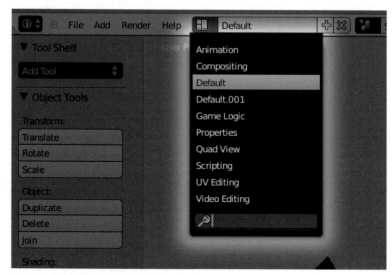

Figure 2.6 *The Screens browser.*

thing from anywhere in Blender. The screen names are just configurations that others have found useful and are provided for your convenience as a starting point.

Here's the first occasion where I'm going to recommend that you memorize a hotkey. The fastest way to switch between screens is to use **Ctrl-Left Arrow**, which changes to the previous screen on the list, and **Ctrl-Right Arrow**, which changes to the next screen. The change is rapid, even with more complex scenes and datasets. Usually, it is instant.

As you work, you may find that there are certain screens you never use. Removing them is simple. LMB click the "**X**" button on the Screens browser on the header. It's gone, never to bother you again.

Adding a new screen is just as easy. The **+** symbol on the same control duplicates the current screen, adding it as a new line item to the browser. This new screen can be changed in any way you like.

If you find yourself constantly reconfiguring a single working screen in Blender, even for minor things, you're doing it wrong. Let's say that you're playing with some objects, changing their properties in the appropriate window, and you want to examine their animation data. You change the properties window to an animation window with the Window Type menu. Then, you change it back to continue tweaking properties. You do this several times. Instead of constantly switching window types, why not duplicate the entire screen itself? On the one version of the screen, set the window to animation data. On the other, set it to properties. When you want to switch, use the appropriate hotkey (Ctrl-Left or Ctrl-Right Arrow) to instantly switch screens. It is much more efficient.

### Maximizing a View

The last way of changing the size and configuration of your screen is the Maximize command. With the mouse hovering over any window in the screen, pressing **Ctrl-Space** causes that window to temporarily

fill the screen. This is great when you are working on a model, and a lot of screen space is devoted to controls and properties—you like your configuration but would prefer to have more space in which to work. Use Ctrl-Space to fill the entire screen with the modeling window, then switch back with Ctrl-Space again to access the original screen configuration. Remembering to use this maximization feature, along with quick screen switching, will make your work in Blender so much easier.

### A Tour of the Common Window Types

While we won't be looking at every single window type (some we'll deal with much later and some not at all), let's take a look at the most common ones.

### 3D View

The dominant window when you start Blender is obviously the 3D view. It's the large workspace where you see your 3D models. This is where you will spend most of your time in Blender. In the default configuration, you are presented with a cube, a grid, and a few other objects (see Figure 2.1).

In addition to the main workspace of the 3D view, there are two additional pop-up elements to help you keep things organized and useful. Figure 2.7 shows a 3D window with panels of controls on both the left and right. The left panel is called the **tool shelf**. It contains commonly used tools that change depending on what is selected in the 3D window. If you are mesh modeling, one set of tools will be present. If you have a lamp selected, a different set of tools that are more appropriate will be presented.

The tool shelf can be shown and hidden with the **T** key. You will use this toggle *all the time*, so commit it to memory. You *can* hide the tool shelf by hovering the mouse over the border between the shelf and the 3D workspace, then LMB dragging it the whole way to the left. Clicking on the + symbol that hiding the shelf creates in the upper left corner of the view brings it back. But you're never going to use that method. You're going to use the T key.

At the top of the tool shelf is a control labeled **Add Tool**. This button brings up a search bar for finding new tools. We'll discuss this browser later in the chapter, but for now, suffice it to say that when you are a more experienced user, you can use this portion of the tool shelf to add custom one-button tools for easy access.

If you end up with too many tools in the shelf and things extend off the bottom of the available area, you can scroll the shelf by dragging inside it with the middle mouse button (MMB). You can also scroll the contents by hovering the mouse over the panel and operating the MMB scroll wheel, or by dragging the scroll bar on the right side of the panel.

*Fundamental:* Almost any non-3D window or panel in Blender can be panned and scrolled by dragging inside it with the MMB.

The bottom of the tool shelf houses the **Tweak panel**. As you use tools in Blender and perform procedures in the 3D view, the results of those actions will be displayed in the Tweak panel. Sometimes the panel will show options that can be applied to the action you've just taken. For example, upon adding a

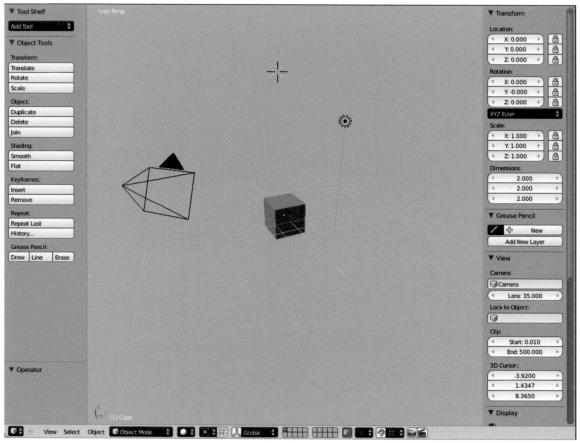

**Figure 2.7** *The tool shelf and Properties panels.*

mesh circle to a scene, you can change the number of vertices that make up the circle, as well as its radius, by using the controls that appear in the panel.

On the right of the 3D view is the **Properties panel**. It is toggled with the **N** key, which you should also memorize. This panel displays transform information (rotation, position, scaling) for selected objects, as well as options for the Grease Pencil (a note-taking tool) and certain items specific to what is drawn in the view itself. This Properties panel is also found in other workspace-oriented window types like the Graph Editor, and is a way to quickly view data about selected objects throughout Blender.

## Outliner

In the upper right corner of the default screen is an Outliner view, which has been expanded in Figure 2.8. The Outliner is an all-in-one representation of the structure of your scene. All of your objects, materials, animation data, and scene settings can be browsed here. This information can be sorted and filtered in

a number of ways. In a complex scene with many layered objects, it can often be easier to find and select an object by name in the Outliner than to try to sort through a tangled mass of lines and vertices in the 3D view.

## Timeline

Animation is most generically defined as a "change in state over time." Obviously then, you're going to need to be able to manipulate time within your scene in order to animate. The most convenient way to deal with this is through a Timeline window. In the default scene, a Timeline window occupies most of the lower edge of the screen. By LMB clicking in the timeline itself, you set Blender's internal "clock" to that point in time. We'll deal with the timeline more extensively when we get into animation in Chapter 3.

## Graph Editor

The Graph Editor, which is not a part of the opening screen, shows animation curves. Shown in Figure 2.9, the Graph Editor allows you to fine tune

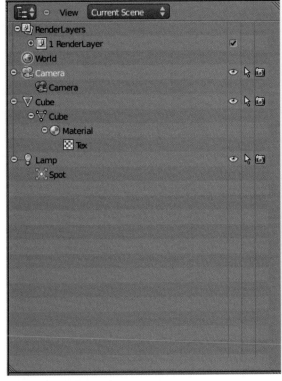

**Figure 2.8** *The Outliner view.*

the timing of specific portions of your animation work. Like the 3D view, the Graph Editor has an N-key properties panel that explains more information about your selections in the main part of the view.

## Dope Sheet

The Dope Sheet is another animation-related scene. It gives a higher-level overview of animation data for many objects at a time. With it, you can easily synchronize different events, adjust timing, and keep track of what is going on in your scene and when it is happening. We'll go in-depth with it when we tackle character animation.

## Properties

A Properties window is different from the N-key properties panel. The Properties window occupies its own window space and has half a dozen different groups of properties that you can set. Some pertain to the scene as a whole, like render and world settings, while others are dependent on the selected object in the 3D view, like materials, modifiers, or constraints. Almost all of the control widgets that you'll find in Blender are located here, so let's break them down one by one.

**Data Block browser** (Figure 2.10) lets you select from a menu of available options. These might be different materials, animation blocks, world settings, or anything else depending on where it is used.

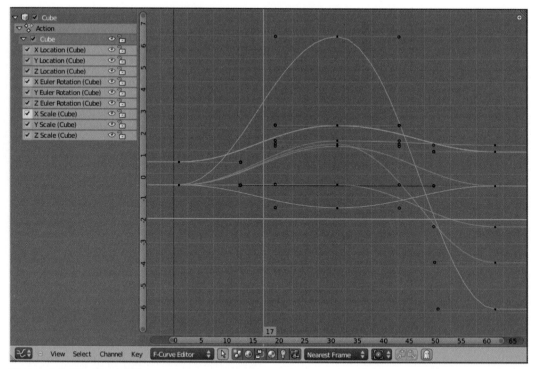

**Figure 2.9** *The Graph Editor.*

The browser has five components. The leftmost is an icon that shows what kind of data the browser represents. Next is the name of the current data block that is selected in the browser. LMB clicking on the name allows you to change it by typing. Beside the name block is the Add New button, which looks like a plus (+) symbol. As mentioned previously, clicking this button adds a new data block, duplicating the current

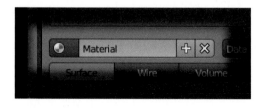

**Figure 2.10** *A data block browser.*

one. The next control is the X, which removes the data block (i.e., clicking the "X" on a material will detach that material from the object). The leftmost control is the browser itself, which is accessed by LMB clicking on the icon portion of the button. This pop-up menu presents all available data blocks of the type that works with the control (i.e., a pop-up menu on the materials panel will only show materials). If there are too many to fit within the space of the browser, you can just begin typing to filter the results. When you see the one you want, LMB click it to select or highlight the bottom entry in the list and use the mouse wheel to scroll through them.

**Pop-up menus** (Figure 2.11) are just like pop-up menus in every other program you've ever used. Click one to open the menu, then click on the element you want to select.

**Text box** (Figure 2.12) usually represents a name value. Click inside the box to change the text.

**Panels** (Figure 2.13) are found throughout the interface. They act as containers for other sets of controls. A panel can be collapsed and expanded by clicking the triangle to the left of the name. By clicking and dragging on the title area, panels can be dragged to new locations within their own window, causing other panels to shuffle out of the way and rearrange.

**Toggles** (Figure 2.14) are visualized as checkboxes in Blender. They are either "on" or "off." Checkbox toggles are always independent of one another. Even if you see them in clusters, they will not act like radio buttons. You can enable and disable them individually.

**Buttons groups** (Figure 2.15) are groups of mutually exclusive buttons. Only one of them can be active at a time. In the default theme, the active option of the group is colored blue.

**Figure 2.11** *Pop-up menu.*

**Figure 2.12** *Text box.*

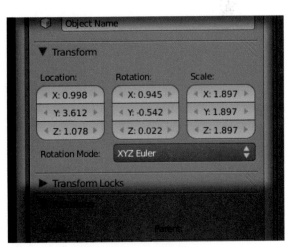

**Figure 2.13** *The "Transform" panel.*

**Figure 2.14** *Toggles.*

**Figure 2.15** *Buttons group.*

**Number buttons** (Figure 2.16) come in two slightly differ-
ent flavors. Each allows you to enter number values in
two ways. By simply clicking directly on the number
value itself, the value is highlighted and you can enter
an exact number with the keyboard. By LMB dragging
anywhere on the control, you can increase (right) or
decrease (left) the value. Holding down the Ctrl key
while dragging changes the way that the number incre-
ments. For example, it might cause the button to go up
or down in even steps of 10, 0.1, or whatever is most
appropriate for the control's range. One type of number
button has arrowheads near the ends. LMB clicking on

**Figure 2.16** *Number buttons.*

the arrowheads changes the value by one unit, either up or down. With these types of number buttons,
you can click on the value itself and enter a number by hand, even if it's out of the slider's default range.

The other type of number
button displays a small graph
behind the value that fills up
as the value increases. This is
most often seen in buttons that
deal with a percentage (0–
100%) or have a clearly defined
numeric range.

**Action buttons** (Figure 2.17) are
any button that activates a
tool or initiates some kind
of process. The buttons on
the tool shelf are all action

**Figure 2.17** *Action buttons.*

buttons. The Render and Animate buttons in the Properties window are also action buttons. They
can contain icons in addition to labeling text.

**File selectors** (Figure 2.18) are a special case of text box. While you could just type right into them if
you somehow knew the exact path and file name you wanted to use, you can also LMB click on the

File/Folder icon to the right to open the File
Browser window. Any time you need to locate
or select a file—for textures, when saving
renders, etc.—this control type will be used.

As Blender does not use the normal system file
browser on your computer (the one you usually
encounter when you choose Open or Save As in
other applications), opting for its own special brew,
we'll take a closer look at it.

**Figure 2.18** *File selectors.*

### File Browser

Most of the controls in Blender's version of the file browser (what many people call an Open/Save dialog) are the same as those in other systems. They just look a bit different. The main goal of the File Browser view is to locate either files or folders. For navigating the directory structure of your hard drive, there are the navigation buttons (labeled A in Figure 2.19) that allow you to move up a directory level, refresh the current directory, or move back and forward in your browsing history. Anyone familiar with a modern file browser will be familiar with this.

Down the left side of the view are groups of shortcuts to various locations on your hard drive. Some common system directory locations are found in the **System** section, followed by bookmarks that you can add and remove yourself, and a small selection of recently browsed folders. LMB clicking on any of these items will immediately take the file browser to that directory. You will never have to double click in Blender.

The main workspace on the right contains the file listing for the current directory. To select a file, LMB click on it. To enter a folder (directory) in the listing, once again, just LMB click on it once. If you need more information about a file before you choose it, the small cluster of buttons labeled B in Figure 2.19 change the display from a long list to a list with file details such as creation date and size, and a thumbnail view that can display image previews.

**Figure 2.19** *Blender's File Browser window.*

The buttons in the group labeled C sort the available files in different ways. Group D buttons hide (or "filter") certain kinds of files when the **Filter Files** toggle is checked.

Finally, when you have the file that you want selected, LMB click on the **File Browse** button or press the **Enter** key to confirm it and return to working.

If you decide that you're done with the file browser and don't want to select anything, pressing the **Esc** key or LMB clicking **Cancel** cancels the browser and returns to work without making a selection.

## How to Find the Tools You Need

It's no secret that Blender, or any 3D application for that matter, has a lot of tools and a ridiculous amount of functionality packed into a small space. Once you actually start working with the application, there will be things you want to do that you don't know how to do. You'll think "Surely Blender must be able to do *x*." And you're probably right. Additionally, there might be a tool that you used once, either in this book, an online tutorial, or that you stumbled across on your own, and you just can't remember where it is. The following is an overview of where things live inside Blender.

**Are you looking for a tool—something that performs an action?** Items like this, if they are common and popular, will be found on the tool shelves of the 3D view, Graph Editor, Dope Sheet, or NLA Editor. If they are not there, *all* tools are available from the header menu system. Header menus are generally organized with overall actions being in the top level of the menu, while actions specific to something selected will be buried a bit deeper. For example, you can find the Merge Vertices tool (which has both a keyboard shortcut and tool shelf entry) by navigating through the **Mesh** menu on the 3D view header, to the **Vertices** submenu. If all of this fails, you can use the tool browser.

By pressing **Space** almost anywhere in Blender, you summon the mighty **Tool Browser** (Figure 2.20). This is an interactive search function for finding tools. It searches as you type. So, if you really need to loop cut and just can't figure out where to go for it, hit Space, and start typing "loop." Instantly the list is narrowed down to only a few items, one of which is Loop Cut! Better yet, it lists the keyboard command right beside it. At this point, you can either LMB click on the listing in the tool browser or use RMB to escape from it, then use the keyboard command.

**Do you want to change some aspect of a selected object or overall setting?** The most popular and useful settings can often be found in a workspace's N-key properties panel. Other than that, you'll be looking in a full Properties window.

**Figure 2.20** *The tool browser.*

There are a number of contexts for these windows, and as you learn them throughout this book, you'll begin to know where to look. As a last resort, you can create an Outliner view and set the pop-up browser on its header to **Data Block** view. This shows a treelike hierarchy of every single aspect of the current scene, down to the tiniest nuts and bolts. Figure 2.21 shows the Outliner in Data Block mode, with a texture expanded. As you can see, there is a ton of information there. However, if you need to change a property or setting for something in Blender and absolutely can't find it anywhere else, you will find it here. If it exists, it's in the Data Block Outliner view.

## Next Up ...

In Chapter 3, we discuss how to find your way around in the 3D view, adding and working with objects, and basic object-level animation.

**Figure 2.21** *The final word on properties and settings.*

# Chapter 3

## Object and Animation Basics

## Finding Your Way in 3D

This chapter is here to get you familiar with the very basics of working in Blender. Now that you're familiar with the different types of on-screen controls and the way that Blender organizes and works with windows, panels, and screens, we can actually start to do things in 3D. We'll begin by just navigating around in 3D space and changing the way that the view is displayed. After that, we'll add some objects, move them around, and animate them. Finally, we'll discuss some of the ways that objects can relate to one another, and how that affects them.

Begin a new Blender session with **Ctrl-N**. You will see the default cube, a lamp, and a camera object. A grid floats in space, passing through the center of the cube.

3D space in Blender is measured along three axes: The $x$ axis represents left and right, the $y$ axis represents forward and backward, and the $z$ axis is up and down. These axes are also consistently color coded, as you can see in Figure 3.1: $x$ (left/right) is red, $y$ (forward/back) is green, and $z$ (up/down) is blue. While you may run into the axis in the figure in other places in Blender, you can always find it in the lower left corner of the 3D view, oriented appropriately, so you never lose your bearings.

There are three ways to change the orientation of the 3D view, all based around the middle mouse button (MMB). Right now, click and drag in the 3D view with the MMB. It spins! MMB rotates the 3D view. Holding down the **Shift** key, click and drag with the MMB again. This time, the view pans—it slides along with the motion of the mouse. Finally, roll the mouse wheel forward and back. The view zooms in and out. Simple, and intuitive.

You can control the entire view with the MMB and Shift key. I actually don't even need to tell you to commit these three controls to memory. You will use them all the time. If you end up somehow *not* committing them to memory, then it is quite possible that 3D isn't for you. Crayola makes some nice Model Magic stuff that is really cool to work with.

Fundamental:

- **3D view rotation: MMB**
- **3D view pan: Shift–MMB**
- **3D view zoom: mouse wheel**

> **Note**
>
> If you're familiar with another 3D application and are used to the way the view controls work there, you can change between free rotation and turntable, and how the zoom is targeted in the user preferences under the view.

In many cases, you're going to want an exact front, top, or side view. Manipulating the viewport into those exact orientations would be tedious if not nearly impossible. Fortunately, there are shortcuts for this. The number pad on the right side of your keyboard (or embedded within your normal keyboard and accessed by some kind of function key on your laptop) can be used to access these views. Figure 3.2 shows a sphere with the number pad superimposed on it. **Numpad-1** shows a front view, **Numpad-3** shows a side view, and **Numpad-7** shows a view from the top. Just visualize the sphere with **Numpad-1** at the center, and the rest is easy. To invert those commands (back, left side, and bottom view), use those same keys, but hold down **Ctrl** while you do it.

I'm going to throw a couple more shortcuts at you for view manipulation that will make your life easier in the coming days:

**Home:** Your keyboard's Home key will zoom and pan to fit everything that's alive in the 3D space into view. If you completely lose your bearings, go **Home**, just like your mom told you to do when you were a kid.

**Numpad-period:** This is another super-saver. Sometimes when you've been working for a while, you might go to rotate the view and it just doesn't work right. It'll be rotating around some weird point in space that isn't what you want. Use the **period** key on the number pad. This key centers and zooms the view on whatever object (or objects) is currently selected. Afterward, view rotation starts to act like expected. (Look, I realize that we haven't talked about

**Figure 3.1** *Blender's axes.*

selections yet, but, come on! You should have expected that somehow you'd be selecting objects for some reason or another.)

## Perspective and Orthographic View

The world around you is in a perspective mode. The world inside certain games is orthographic, lacking perspective. Figures 3.3 and 3.4 show the obvious difference.

Almost always, your final renders will be in **Perspective** mode, because that's how we perceive things, and that's what makes the most believable images. All renders in Blender are made from a camera object, and you have to go out of your way to force a camera not to draw things with perspective.

**Figure 3.2** *A visualization of the view shortcuts.*

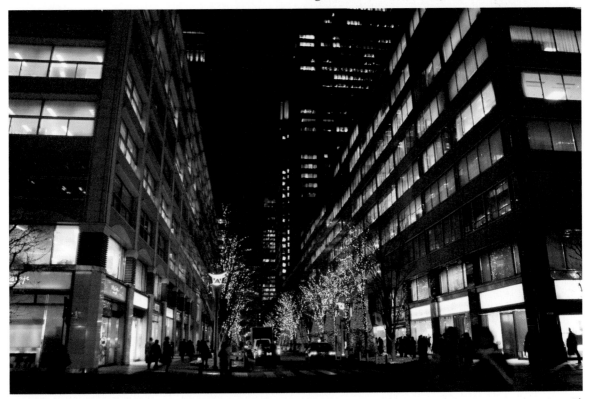

**Figure 3.3** *A city street with converging buildings shows the main feature of perspective: objects decrease in apparent size with distance. (Photo by OiMax, Creative Commons Attribution 2.0 Generic.)*

**Figure 3.4** *In orthographic drawing, objects have the same apparent size, regardless of how far away they are from the viewer. (Courtesy of Unknown Horizons, www.unknown-horizons.org.)*

**Orthographic** mode, on the other hand, is often good while modeling and animating. Why? In Perspective mode, lines that we know to be parallel, like the ground and the top of a building, appear to converge or to be at angles with each other. While this is how things look in the real world, it makes modeling and animation difficult. When you model or animate, it is helpful to know precisely where things are. Is this ball higher or lower than the cube? In Perspective mode, the answer is not as obvious as you think. Take a look at Figure 3.5. Is the sphere larger than the cube? Which is in front of the other? You can guess, but you can't be sure. When working on something that might take you hours (or days!) to finish, it's best to be sure. The orthographic view shows the relationship of the objects quite clearly.

You can toggle between Perspective and Orthographic modes in the 3D view using **Numpad-5**. In general, you will model and animate in Orthographic mode, although many animators prefer to refine their animation in either Perspective mode or directly from the Camera view in order to get the most believable performance possible. It's important that, for example, a ball bounces exactly off the surface of

a road when animated—something easily done in an Orthographic view—while character motion is most often seen on film or TV through a camera lens—perfect for perspective work.

## Display Modes

There are a number of ways that Blender can draw the objects in the 3D view. The default, and the only one you've encountered so far, is **Solid** mode. In Solid mode, things look … solid. Of course, that doesn't mean much without something to compare. I mean, how else would things look? Unsolid?

The answer is actually **Wireframe**. Recall in Chapter 1 that the models and objects you deal with are made of triangles and quadrangles. Wireframe mode shows these substructures. Figure 3.6 demonstrates the difference.

In case you're not aware of it, that monkey head in Figure 3.6 is Suzanne,

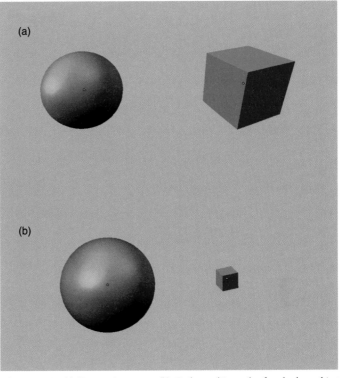

**Figure 3.5** *(a) Perspective versus (b) Orthographic modes for absolute object location.*

Blender's mascot. Many 3D software packages use built-in models of teapots for testing materials, lighting, animation, etc. But really, a teapot? I know it's traditional and everything for 3D, but teapot = not fun. A monkey head, on the other hand? Instant 3D party time! And it's built in, as you'll see in the Section 3.4.

The other thing you'll notice in Figure 3.6 is the pop-up menu on the 3D header. It contains a listing of the different draw modes that are available. Until we start modeling, we won't be using the Wireframe view. However, in addition to the view manipulation controls (MMB, Shift-MMB, mouse wheel) and the perspective/orthographic toggle (Numpad-5), the switch between Solid and Wireframe mode will be one of your most frequently used operations. You *could* use the header menu, but you *will* use the shortcut key: **Z**. I usually try to think of some clever way to tie a shortcut to what it does, but in this case there isn't anything good. It's just Z. Sorry.

The other useful view mode is **Textured**, toggled with **Alt-Z**. Textured mode uses GLSL, an on-screen shading language, to attempt to give you a decent approximation of your scene without actually rendering. Not everything is supported (certain textures, special kinds of shadows and lighting effects), but it does a decent job. It's great for positioning lamps and adjusting certain kinds of textures. To make sure that your

**Figure 3.6** *A monkey's head in Solid and Wireframe modes.*

system is using GLSL for Textured mode, press the N key in the 3D view and set the **Shading** control in the **Display** panel at the bottom to **GLSL**.

> **Note**
> Blender tries to group different options for the same type of function on the same hotkey. A good example is the drawing mode switching discussed here. The Z key toggles between Solid and Wireframe views. Augmenting the command with the Alt key gets you to Textured mode.

## Working with Objects

The default scene starts off with three objects (Figure 3.7): a cube, a lamp, and a camera. This is not a coincidence, as these are the three things you need in order to actually produce a render—that is, something to see (the cube), some way to see it (the lamp), and somewhere to see it from (the camera).

**Select/Deselect All (A key).** You're going to learn how to add all of this stuff for yourself, so let's clear the slate. The command in Blender to Select and Deselect everything at once is the **A** key. As we mentioned in the previous chapter, you can find any command using either the menu system or the tool browser. Just for practice, head down to the **Select** menu on the 3D view header, and find Select/Deselect All. It is like we promised, and the hotkey is right beside it in the menu entry. RMB click to get out of that menu, then use the **spacebar** anywhere in the 3D view. Begin to type "select all." The more you type, the more the list of available tools narrows. Eventually you'll see just a few tools left, including "deselect all."

However, don't use the menu or the spacebar. Just hit the **A** key. When you do, the default cube is deselected. Press the **A** key one more time, and the cube, camera, and lamp are all selected. That is the cycle of Select/Deselect All. Pressing the A key once deselects everything, and pressing it a second time selects everything available in the workspace. Get used to this functionality, because you will use it constantly during your work.

**Delete/Remove (X key, Delete key).** Kill off those lame default objects by pressing either

**Figure 3.7** *The default scene.*

the X key or the number pad Delete key. I prefer to use the X key, just because my left hand is usually over that part of the keyboard while I work, and I don't have to reposition to reach it. When you use either delete hotkey, a pop-up menu appears under the mouse's current location, asking to confirm the deletion. Simply LMB click to confirm, or, if you've changed your mind, RMB click to cancel. In case you haven't noticed, this is another one of Blender's interface conventions:

- **LMB = Accept/Confirm**
- **RMB = Cancel/No!/Yikes!** What did I almost do?

So, if you've done a proper Select All and Delete, the workspace is completely clear. Let's add something more interesting: a monkey.

**Add Objects (Shift-A).** There's a nice little **Add** menu on the main information bar at the top of the screen, but we both know it's for suckers, right? I mean, who would want to move their mouse the whole way up there, click a few times, then have to move it the whole way back down to the workspace? Not me, that's for sure. When you need to add a new object in the 3D view, use **Shift-A** to pop up that same menu right under your mouse. Make it come to you. Figure 3.8 shows the menu. As you can see, there are a number of top-level options, but we're only going to be concerned with one of them

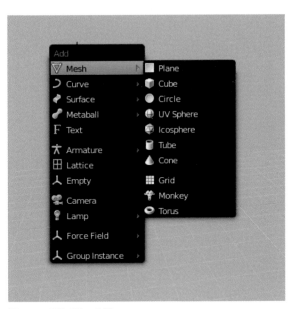

**Figure 3.8** *The Add menu.*

right now: mesh. Enter the Menu submenu, and find **Monkey** at the very bottom. LMB click it. A monkey! In the 3D view! Isn't that significantly better than a teapot?

## Transformation Basics

We've seen how to move the view. Let's learn how to move objects.

**Figure 3.9** *Transform information shown on the 3D view header.*

**Move/Translate/Grab (G key).** Press the **G** key. You can now move the monkey around with the mouse. This is called either Translate or Grab mode. To be honest, we just call it Grab mode so that it matches the keyboard command. This is how you change an object's location in 3D space. Figure 3.9 shows a portion of the 3D view header during a grab transformation. Notice how there are four numbers: $Dx$, $Dy$, $Dz$, and a number in parentheses. The $D$ values show how far the object has moved along that particular axis, while the number in parentheses shows the current distance away from the original location. If you use the N key to show the Properties panel, you can also see the actual $x$, $y$, and $z$ locations of the object as you move it.

Stay in Grab mode and press the X key. Regardless of where the monkey was at the time, it instantly snaps back onto the red line in the display that represents the $x$ axis. That line is now highlighted, and no matter how you move the mouse, the monkey only moves along that axis. This is called a **transformation constraint**. Press the Y key and the monkey is released from the $x$ axis and constrained to only move along the $y$ axis. It works the same with the Z key and $z$ axis. If you're a big fan of the mouse, you can also invoke these types of constraints by tapping the MMB while you're moving an object. Blender takes a look at the predominant axis that you're moving along and constrains to it. The result is sometimes a surprise, and for that reason I generally rely on pressing the X, Y, or Z key.

So, you can force an object to move, for example, only up or down by pressing the Z key. But what if you want to move it any way other than up or down? What if it's just as high (or low) as you please, and you want to be able to move it freely within that $z$ level? In Grab mode, hold down the **Shift** key and press the appropriate axis key. So, to be able to move in $x$ and $y$ freely, but not move up or down, you enter Grab mode with the G key, then press Shift-Z. The same trick works with the X or Y keys, but I find that I mostly use this with the $z$ axis.

Now that we've added a bit of precision into a simple object translation, let's add a bit more. Anytime you're transforming something in Blender, you can start typing numbers and it will override the current location and mouse movement. You can try it by entering Grab mode (G key), pressing the Z key to constrain to up/down motion, then typing a number (7.221, for example). The object moves upward 7.221 units. You can invert that by typing the minus symbol. Figure 3.10 shows the feedback you get for this on the 3D view header. The current transform is displayed there as you type it.

The last way to directly change an object's location in 3D space builds off this last method. Bring up the N-key properties region. Note the **Transform** panel at the top, with three number buttons for **Location**. You can directly enter a new location for the object right here (or use the left/right arrowheads) and the

change will be reflected immediately in the 3D view.

**Rotate (R key).** Take all of the things that just applied to translation, and apply them to rotation. Object rotation is triggered with the **R** key, which is easier to remember than G key = move, so you've got that going for you. All of Blender's transform tools (even the ones in the 2D workspaces later in the book!) are built around the same core, and the same rules apply across the board. You can constrain a rotation by hitting any of the axis keys (*x*, *y*, or *z*), directly enter rotation values, or simply set a new rotation in the N-key properties region.

**Figure 3.10** *The 3D view header when directly entering transform values.*

**Scaling (S key).** Once again the same rules apply, but this time to scaling. In case you're in need of some very, very remedial help, let's spell it out: Scaling means making things larger and smaller.

Let's add another new trick: stepping. By holding down the **Ctrl** key while transforming, whether in a constrained mode or not, you cause the object to transform using stepped values. When moving, this means the object moves in steps of whole units (1.00, 2.00, etc.). During a rotation transform, it uses rotation values in steps of five degrees (5.00, 10.00, 15.00, etc.). Holding down the **Shift** key during a transform steps in partial units (0.1, 0.2, etc.).

We'll use all of these transformation tools in the animation part this chapter, Section 3.10, so you'll get plenty of practice.

## Selection Basics

You've already used the **A** key to select everything in a scene. It's good to know that this selection command, just like the transform tools, applies throughout Blender. Whether you're working with an object, animation curves, or compositing nodes, the A key selects everything.

**Select an individual item (right mouse button).** This is the convention in Blender that generally gives users the most trouble, especially those that are familiar with other 3D applications. Yes, there is a user preference (**Ctrl-Alt-U**) to swap the functionality of the left and right buttons, but I implore you not to use it. Stick with **RMB** select for a couple of days. The main reason to do so is that if you don't, every tutorial or book ever written for Blender will have to be adjusted by you on-the-fly when you use them.

Use **Shift-A** to add another monkey to your scene, and use one of the transform methods to move it away from the original monkey. Note that when you add the new monkey and move it, it looks slightly different from the first one. As you can see in Figure 3.11, the new monkey has a thin orange outline, while the original monkey does not. This outline indicates that the one monkey is **selected**.

When an object is selected, it means that things will happen to it. What kinds of things? Things like transformations and tools. Use any of Blender's object tools, and it will affect the selected objects, leaving unselected objects alone. This is the basis for how you get things done in 3D. A selection is made, settings are adjusted, and tools are applied. A different selection is made. Repeat. That's how you make a movie like *Toy Story*, in a nutshell.

**Figure 3.11** *Two monkeys. One is selected, the other is not. Poor monkey. Won't you select her so she is not lonely?*

If you **RMB** select the other monkey in the scene, you'll see that the orange outline disappears from the one and appears on the now-selected monkey. Making a new selection generally clears the old selection. However, if you would like both the old object and the new one to be selected, hold down the **Shift** key while RMB selecting. Using the Shift key builds a selection—each new object that is Shift-RMB selected adds to the current batch of objects that are selected.

Build a selection by first RMB selecting one monkey, then Shift-RMB selecting the other. There's one more thing to observe. The most recently selected monkey has a brighter orange outline than the other. In fact, the most recently selected object in the 3D view is kind of "superselected." There might be three hundred selected objects, but only one, the last selected, can have this superstate. It is referred to as the **active** object. There are a number of operations in Blender that you will learn later (constraints, linking, copying) that make use of multiple-object selections and an active object.

But how do you deselect an object? There are a few ways. If you want to clear all selections, you already know the answer: press the A key. If you intend to select something else, just select it. Recall that making a new selection without holding down the Shift key clears the previous selection. Finally, if you have several objects selected and you would like to remove one of them from the selection but retain the others, it is a two-step process. First, Shift-RMB click the object so that it becomes the active object. Then, Shift-RMB click on it again. Executing a Shift-RMB click on the active object deselects it.

Before we move on, we'll check out a few more selection methods. Often, you will have a whole cluster of objects you would like to select at once. Finding and selecting each one using Shift-RMB would be tedious at best.

**Border/Area Select (B key).** Pressing the B key turns the mouse pointer into a crosshairs. By LMB dragging in the 3D view, you draw a rectangle. Upon releasing the LMB, any object that falls within that rectangle is added to the selection. Note that this selection method does not affect the active object. Whatever was active before remains active afterward. If there was no active object, border select will not designate one. Last trick: Using the B key and MMB dragging (instead of LMB) removes anything within the rectangle from selection.

**Lasso Select (Ctrl-LMB).** Holding down the Ctrl key while LMB dragging in the 3D view draws a line wherever the mouse goes. If you use that line to encircle several objects, then release the LMB, the objects within the lassoed area are selected.

**Paint Select (C key).** Pressing the C key changes the cursor into a resizable selection brush. With the cursor in this mode, objects are selected by LMB clicking directly on them or by LMB dragging across them. The mouse wheel grows and shrinks the brush indicator. The RMB returns the cursor to its normal state.

As we proceed through the tutorials in the rest of the book, we'll mention which selection method is most appropriate for the task at hand, but you are always free to use any way that suits you.

---

### Menu Selection

The **Select** menu on the 3D header has a few selection methods that, while you won't use them all the time, can really come in handy on special occasions. **Select by Layer** selects all of the objects on the designated layer. Later on, you'll learn how to organize a project into layers, and this is perfect for dealing with things a layer at a time. Also available is **Select by Type**, which pops up a menu for all of the different object types (mesh, camera, lamp, etc.).

---

## Transformation Manipulator

If you're coming from another 3D application, you might be thinking, "These keyboard commands are nice for engineers, but I'm an artist. I want my transformation manipulator!" Figure 3.12 shows the header of the 3D view with a section of controls isolated. These enable and configure the transformation manipulator.

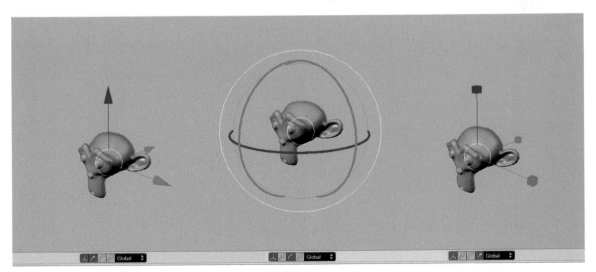

**Figure 3.12** *The transformation manipulator buttons and their 3D view representations.*

If you have not worked with one before, the transformation manipulator is an on-screen tool for transforming objects with the mouse. When enabled with the translate controls, as seen in Figure 3.12, a three-colored figure appears, centered on the selected object. By LMB dragging on any of the arrowheads, the object is translated along that axis. Note that the colors of the axes on the widget correspond to the general axis colors used in Blender ($x$ = red, $y$ = green, $z$ = blue). In Figure 3.12, translate is on the left, rotate is in the center, and scale is on the right. Keeping with the standards of selection in Blender, you can actually Shift select the widget buttons on the header to enable more than one transformation mode at a time.

While it is usually more efficient to just use the keyboard commands (G/S/R) for transforming, there are some times when the manipulator can make your life easier. To see how, take a look at the last control on the right in Figure 3.12. Until now, we have been doing these transformations in Global mode. In Global mode, $x$ is always left to right, $y$ is front to back, etc. Pretend for a second that you've rotated an object in several ways. If we were to make the object's axes "sticky," rotating along with it, the global $x$ would then be different than the object's "sticky" $x$. Figure 3.13 shows such a setup. Notice how the axis situated on the monkey has a different orientation than the main global axis beside it. This "sticky" axis is called **Local** space, an axis system defined locally by an object.

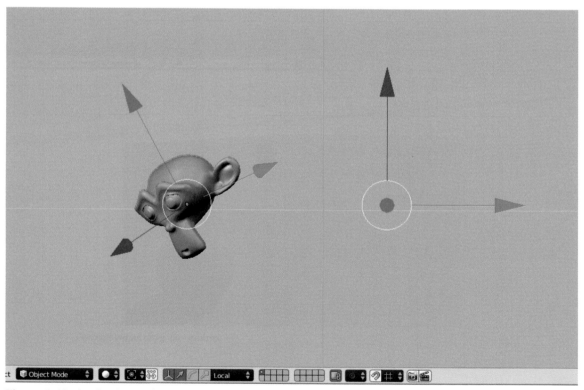

**Figure 3.13** *An object's axis showing local space.*

You can use the control on the 3D view header to tell the manipulator which space to use. How is this useful? Well, let's say that you have a model of a car and are using the manipulator to animate it. The car slides around a turn, then takes off in a new direction. You would like to use the manipulator, but the car isn't going to be moving along any of the global axes (*x* or *y*). It just needs to move straight ahead, relative to the car. Setting the widget to Local mode then displays it so that the *y* axis always points forward. No matter how the car is oriented, you know that LMB dragging on the widget's *y* axis will move the car in the direction it is facing. There are other instances in which this becomes useful, and we'll discuss them as we encounter them throughout the book.

## 3D Cursor

When you're working in a word processor, you have a nice, blinky cursor that tells you where new letters will appear when you type them. Blender's 3D cursor is a cursor—in 3D! You can see what it looks like in Figure 3.14. When you add new objects, they appear at this location.

The 3D cursor is positioned in 3D space by clicking with the LMB. One click positions it relative to your view. In other words, if you are in a front view and click the LMB to set the cursor location, it will change the cursor's *x* and *z* values. Its *y* value, which in a front view is "into" and "out of" the screen, remains the same. To change its *y* value, you have to go into a side view. So, a precise positioning of the 3D cursor requires two LMB clicks, one each in a different view.

**Figure 3.14** *The 3D cursor.*

While it's nice to know where new objects will sprout in your scene, the cursor has a more important use. It can act as a pivot point for scaling and rotation transformations. Examine Figure 3.15, a simian orrery. To achieve this positioning, you could of course use the G key and simply move the orbiting monkey. If you wanted precision, though, it would be nice to be able to use the rotate command, but with something other than the monkey's center point as the pivot. Enter: the 3D cursor.

Notice the pop-up menu that's expanded on the 3D view header in Figure 3.15. It allows you to use different ways of determining the scale and rotation pivot point. The two most commonly used are **Bounding Box** (the default, comma key) and **3D cursor** (period key). When the 3D cursor is set as the pivot point, any rotations that are done (R key, transformation widget) use it's location as the center of rotation. Likewise, scaling will be done toward or away from the cursor, depending on how you move the mouse while transforming. The hotkeys for switching the pivot point are useful, but I wouldn't call them essential for memorization. If you're eating this up, go ahead and add them to the list of things to try to remember.

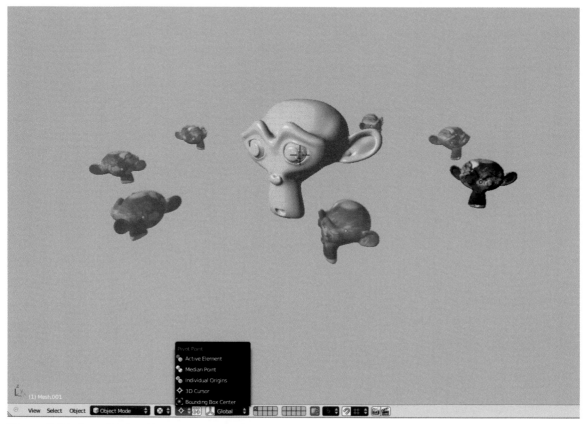

**Figure 3.15** *A monkey in orbit.*

If you're feeling overwhelmed, don't worry about it. We'll revisit the pivot point and its shortcuts as we use it throughout the coming chapters.

Finally, the 3D cursor can be used to set the locations of objects that already exist in a scene. By using the Snap menu, which is accessed with **Shift-S**, you can move the 3D cursor to match the location of an object, or to make an object match the location of the cursor.

## Moving in Time

Now that you can move things around, let's animate. In its most basic form, animation is a change over time. That change is often a transformation of some type. Time in animation is divided into units called **frames**. As a default, Blender uses 24 frames for every second of time. Depending on what your final target is for your animation (TV, the Web, film, your own enjoyment), this might be different, but for a beginner 24 fps (frames per second) will be fine.

**Figure 3.16** *The Timeline window.*

Figure 3.16 shows Blender's Timeline window, which you've already seen in Chapter 2. Depending on the resolution of your display, Blender shows a frame range of 0 to around 250, a little more than ten seconds of time. If you'd like to see the timeline displayed in seconds, you can hover the mouse over that region and press **Ctrl-T**. When you do, you see a different notation for time than you are probably used to seeing. Along the bottom of the timeline, the numbers read 0+12, 1+00, 1+12, 2+00, 2+12, etc. The number before the plus sign represents seconds. The digits after are the number of frames at that point in time. It's a kind of funky decimal notation, except it uses a "+" instead of a ".", and counts from 0 through 23 instead of 0 through 9 like regular numbers.

Your scene can appear in different states at different points along the timeline. When you render an image for each frame, then play them back in real time, you have animation.

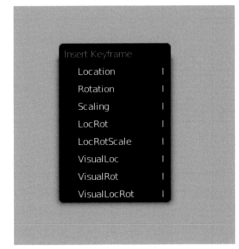

**Figure 3.17** *The object keying menu.*

## Basic Keyframe Animation

Start a clean Blender scene with **Ctrl-N**. Use **Shift-A** to add a monkey. Jump to a top view with **Numpad-7**. You'll be in Perspective mode, but we're going to do this in Orthographic mode, so change that view setting with **Numpad-5**. This is easy stuff you've already done.

Using the **G** key, move Suzanne (the monkey) to the upper left area of the screen. The exact location isn't important. With the mouse still over the 3D view, press the **I** key. A little menu appears, like the one in Figure 3.17. The I key and this menu let you set **keyframes**. Keyframes, often referred to simply as "keys," are Blender's way of storing the object's transformation at a certain point in time. Examining Figure 3.17, it's kind of obvious what kinds of keyframes you can set: location, rotation, and scale. There are some other options in there like LocRot and LocRotScale, which are just convenient ways of setting location, rotation, and scaling keys with one command. Ignore the ones tagged with "Visual" for now. They don't become important until much later.

From this menu, select **LocRot**. We're going to move Suzanne and rotate her as well, and we want both kinds of transformations to be recorded. A key for her current location and rotation has just been recorded on frame 1. The current frame is indicated, as you know, by the location of the vertical green bar on the

timeline, but also in parentheses in the lower left corner of the 3D view. Let's advance the timeline a bit, change Suzanne's location and rotation, and add a new key.

You could LMB click somewhere in the timeline to change the current frame, but you should learn a few more hotkeys for efficient navigation. When animating, you change the current frame *all the time*, and if you're always heading back to the timeline, you're going to become sadly inefficient. Your keyboard's arrow keys control time.

**Figure 3.18** *The arrows keys are the masters of time itself.*

Figure 3.18 is a diagram of the arrow keys and how they affect the current frame. Right and left arrow move the frame count by one. Up and down move it by ten.

With that in mind, let's jump ahead 20 frames. Tap the ↑ key twice. You'll notice the frame counter on the timeline pop ahead each time. You're now on frame 21.

Use the G key to move Suzanne more or less straight down on the screen. Then, rotate her 90 degrees clockwise so that her head is facing to the right. Use the **I** key and set another **LocRot** key.

Go another 20 frames forward (↑ twice), move Suzanne to the right, and rotate her again so her head is facing upward. Set another LocRot keyframe with the I key.

Finally, do the same thing again (advance 20 frames), move her up, set a final key.

When you've done this, the indicator should be on frame 61, and you should see three yellow lines in the timeline, one each on frames 1, 21, and 41. These yellow lines indicate that there are keys on those frames.

Ostensibly, you've just done your first animation. Let's set things up so you can play it back.

In the Timeline view, note the **Start** and **End** controls. These indicate the frame range that Blender will use when playing back (or rendering) animation. Leave the **Start** value at **1**, and change the **End** value to **61**. This encompasses the entire range of work you've just done.

Hover the mouse over the 3D view and activate animation playback with **Alt-A**. You can also use the "Play" button (the forward-facing arrow) in the Timeline view header.

The Web Bucket for this chapter contains an animation file of this exercise (*first_animation.mpeg*). Compare it to your own.

A couple of notes on animation playback in the 3D view are necessary. Blender's animation playback is independent of most other functions. You can start animation playback with Alt-A, then fiddle with

settings, rotate the view, change the frame range, etc. The animation will loop and loop in the 3D view until you press the Esc key or Alt-A again to stop it.

Let your own animation cycle several times, or watch the one from the Web Bucket if you're not actually working in Blender at the moment. Analyze what's happening. As Suzanne descends in the first 20 frames, she's rotating the whole time. This may not be what you would have expected. (If you did expect it, good for you!) Ideally, we'd like to have Suzanne descend, then turn at the bottom and set off in a new direction. Obviously that's not what is happening.

How would you go about something like this? First, you need to understand that the reason Suzanne rotates while descending is because that is exactly what we told her to do. Animation isn't intelligent. Just like any other aspect of computers, it will only do exactly what you ask of it. In this case, you told it to use a certain rotation on frame 1, then another on frame 21, and to blend between those values in the interim. Okay, you don't realize that you asked her to do that last bit, but you did. If a frame contains a key, the value at the frame is obvious. However, between keyframes, Blender (and all other animation systems) interpolates a value, based on the relative location between the keyframes and a number of other factors.

Let's examine this interpolation in a very visual way. In Chapter 2 we talked about using different screens for different types of work. Use the hotkey **Ctrl-→** or **Ctrl-←** to switch to our next screen: Animation. This screen, shown in Figure 3.19, is mostly split between a 3D view on the right and a different screen, called the **Graph Editor**, on the left. The curves on the left are a graphical representation of the way that Blender interpolates between keyframes.

Tour time. Check Figure 3.20 for an expanded view of the Graph Editor. Each of the six curves in the Graph Editor represents one of the axes and types of transformation of Suzanne. You can see the names of these in the panel to the left of the curves: X Location, Y Location, Z Location, X Euler Rotation, Y Euler Rotation, and Z Euler Rotation. If you had also keyframed Suzanne's scale, you would have three more curves to deal with. Curves can be hidden and shown to clean up the view by enabling and disabling the checkbox beside the curve's name. All of these animation channels can be collapsed on the left by clicking the triangle icon to the left of the object's name. In Figure 3.20, Suzanne's object name is "Mesh."

The workspace of the Graph Editor is its own timeline. LMB drag in it, and you will see Suzanne go back and forth throughout the steps you've animated. To get the hang of looking at a curve and actually understanding what you see, examine Figure 3.21. It shows an **F-curve** for an object that is animated along the x axis—that is, moving left to right.

You read an F-curve from left to right, like a Western language, as it represents time. A flat portion of an F-curve (B) means that the value is not changing over time. In this case, it means that between frames 30 and 50, the object is not moving along the x axis. A portion of the curve that slopes upward (C) means that the value is increasing. An increase of the x axis value indicates motion toward the right. A downward slope (A) indicates a decrease, or leftward motion along the x axis. The steeper the slope, the faster the change. Curves (D) mean gentle transitions in motion, like a leaf soaring gently on the wind. Points (E) mean abrupt changes, like running into a brick wall.

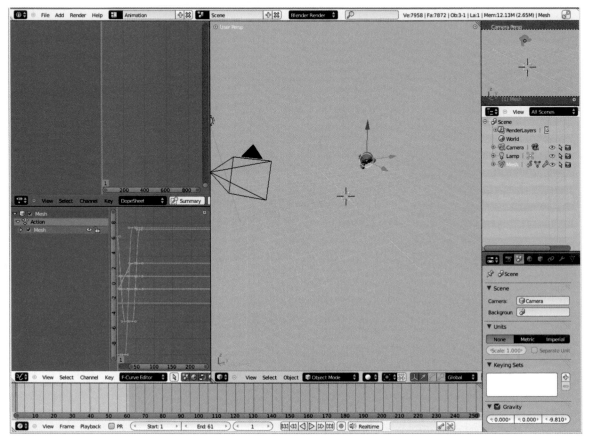

**Figure 3.19** *The Animation screen.*

Going back to the actual animation you've just done, you want Suzanne *not* to rotate until around frame 21, then to rotate quickly and hold that rotation. That's going to look more like the rotation F-curve in Figure 3.22. Notice how the curve for rotation around the *z* axis is flat, then bumps upward a little around frame 21, runs flat, and bumps again at frame 42? In terms of visuals, that would translate to no change, then an abrupt rotation, followed by no change, and then another abrupt, short rotation.

But how do we get from Figure 3.20 to Figure 3.21? I'm not going to lie. Just like math class, we're going to do this the hard way first. If you understand what goes on under the hood, you'll not only get the higher-order stuff better, but you'll be able to dig in and get your hands dirty if you really need to. Ninety-five percent of the time, you won't need to edit an F-curve directly, but don't skip this. It's important.

Disable all of the F-curves in the Graph Editor until only **Z Euler Rotation** and **Y Location** are showing. To the right of the **Y Location** control are an eye and a lock. Toggling the eye off would cause that

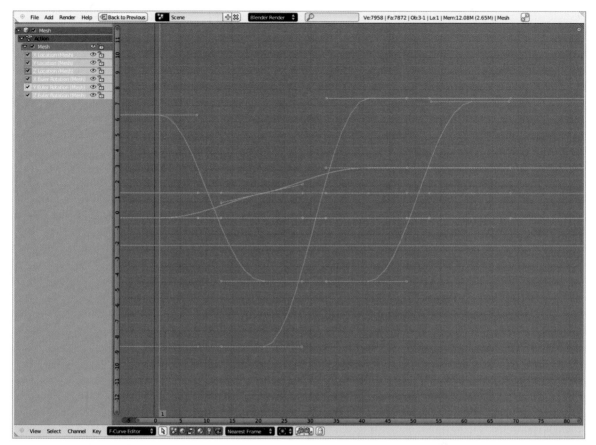

**Figure 3.20** *The Graph Editor.*

F-curve not to affect the object. Toggling the lock will prevent you from messing with it. Toggle the lock only. You'll see that the curve itself is now presented with a dash pattern. It also becomes nonselectable.

There is a simple command for adding points in Blender. Those points might be on an F-curve, a Bezier object, or a vertex in a mesh. Whatever the situation, the command is the same: **Ctrl-LMB**. Our goal is to reshape the Z Rotation curve from Figure 3.20 to look like the one in Figure 3.22. To do that, we will need to add a couple of points.

The original curve has three points on it, one for each time a rotation key was set. Before you try to add a point, make sure we're working on the correct curve by LMB clicking on the name "Z Euler Rotation" on the panel on the left. Then, using **Ctrl-LMB**, click about midway between the first two points on the highlighted curve.

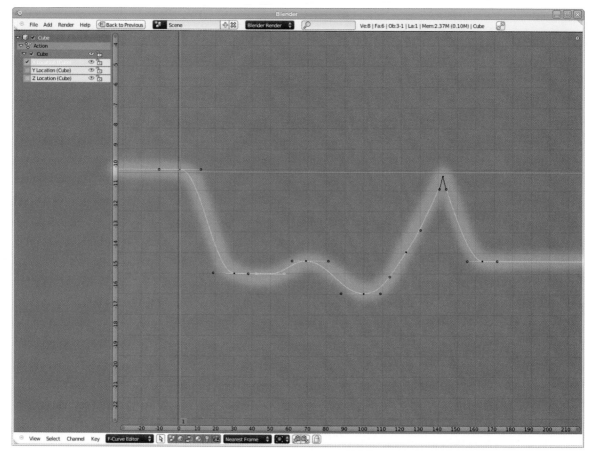

**Figure 3.21** *A single F-curve.*

A new point is added. RMB select this point, causing it to be highlighted in orange while the other points go dark. Press the G key to move it. Your goal is to bring it down to the same horizontal line as the first point on the curve (we want no rotation at first, which means we need it to be flat) and then push it as close to the middle point from left to right as possible.

**Figure 3.22** *A good guess as to what we're looking for.*

That will give us the lack of change we require, followed by a short rotation to the new position on frame

21. You can see the result of this in Figure 3.23.

To handle the second rotation, Ctrl-LMB click between the last two points on the curve. RMB select the new point and use the G key to move it … where? Think about it for a second. We want no change in rotation, again, followed by an abrupt change before the final key.

If you thought to put it on the same horizontal line as the middle key, moving

**Figure 3.23** *A new point added to an F-curve and moved.*

it as close to the last key from left to right as possible, then you've got it. The only way this edited curve differs from our target in Figure 3.22 is in the point handles. You've no doubt noticed that each of the vertices in the editor have two handles growing away from them. RMB selecting these handles and moving them with the G key leaves the point itself in place, but changes the way the curve flows into and out of it. A little bit of playing with the handles on the moved points will bring the example right into line with the reference.

Use Alt-A to play the animation now. Hopefully it actually does what you intended. This concept of visualizing motion as a series of curves on a graph can be a bit much at first. If you still don't get it, you can watch the short video in the Web Bucket (*f-curve-basics.mpeg*) in which I demonstrate and explain this in a little more detail.

So, you've done this the "hard" way. Let's do it the sort of easier way. I say "sort of," because while this way doesn't require as much handwork and conceptual shenanigans, it does require some forethought. That's all right, though. Animation itself requires forethought. To animate well, you'll need to really think about how things move, when they stop, when they start, what isn't changing about them, and a host of other things. You'll need to become an active, careful observer of motion.

In the panel of the Graph Editor, use Shift-LMB to highlight all of the curve names (X Location through Z Euler Rotation). Hit the X key to delete them. Boom. Animation gone. Using either the arrow keys or the timeline in the Graph Editor, return the frame counter to 1. We're going to do this animation over, and build the motion we want directly into it.

Return Suzanne to the upper left corner of the 3D view. Set a **LocRot** key (I key). On the Timeline view header, find the little red dot button, the one that usually stands for "record" on physical playback devices. LMB click to enable it. This button activates **automatic keyframing**. Once you've set an initial keyframe, any changes you make to an object's transformations are recorded and keyed automatically. When you're animating, this is an immense timesaver. You don't have to constantly hit the I key and choose a key type. With that in mind, advance 20 frames (↑ twice). Move Suzanne down. Normally, you'd hit the I key here, but autokeying takes care of setting a new transformation key for you on this new frame. Advance 3 or 4 frames. Rotate Suzanne 90 degrees clockwise. Advance 20 frames; you should now be at

or around frame 43. Move Suzanne across the view to the right. Go forward a couple more frames. Rotate her 90 degrees counterclockwise. Forward 20 frames. Move her up. Autokeying is great, eh?

That's the last time we'll go step-by-step for animation. As you can see, it's a bit tedious. Plus, nobody likes to be told what to do all the time.

Play your animation with Alt-A. Suzanne should descend, turn, cross the screen, turn again, then move upward. If the animation resets to the beginning before she completes the motion, recall that this animation is a few frames longer than the original. If you're working on the same file as before, your animation playback range on the Timeline view is probably still set to 1–61. Figure out where the animation should really end by looking at the yellow key lines in the timeline. Change the animation **End** value to match this new number (probably 66 or 67).

The F-curve for $z$ axis rotation now looks like Figure 3.22. It's pretty much exactly what we wanted it to look like earlier when we redrew the existing curve. The lesson from this is that you can always come back later, bust your butt, and fix something that didn't work out like you thought it would. However, it's significantly better to just think about it for an extra couple of seconds, then do it right the first time.

We'll revisit these mechanics in Chapter 11, Character Animation, but be aware that these are only just that: mechanics. There is a lot of art to animation. It's a curious combination of technical skill, observation, acting, and puppetry. Don't think that knowing how to set a keyframe will make you an animator.

## Object Relationships and Management

Shifting gears a bit from basic animation, there are a few fundamentals of working with objects left to introduce. The first two can assist you with project organization. Depending on what you're doing, your scene might contain hundreds (or thousands) of objects. Some objects might even have several versions— high resolution for close-ups, low resolution for distant shots—and you will need some way to manage all of this.

### Layers

If you are familiar with layers from many graphics production applications (Photoshop, Illustrator, page layout applications), leave that knowledge at the door. In Blender, layers are simply a tool for organizing objects. Think of layers as the King Kong of grouping functionality. Really, they should be called something like Master Groups, which would much better define what they do. However, we're stuck with the terminology in the application, so we'll muddle through.

For example, let's say that you're blocking in a big outdoor animation. You don't have final models yet— just fooling around. There is a terrain, a cabin, a stand-in character, and several hundred trees. Figure 3.24 shows what this could look like. You want to work on character positioning and keyframe the low-resolution person moving across the terrain. Those trees keep getting in the way, though. If only there were some way to turn them off and on at will.

The cluster of 20 buttons on the 3D view header is the layer controller. Objects can be assigned to any layer (or even to several layers at once) and can be shown and hidden with a click. The buttons on the

**Figure 3.24** *A low-resolution terrain with proxy trees and a character.*

header control which layers are displayed. In Figure 3.25, the layer buttons are numbered. The scheme is simple: the top row represents layers 1–10; the bottom, 11–20. LMB clicking on a layer button works just like all other button sets in Blender: it clears the current "selection" and replaces it with the one clicked. To display the contents of several layers at once, you build a selection with Shift-LMB.

In the case of our example, the trees have been assigned to layer 2. Note on

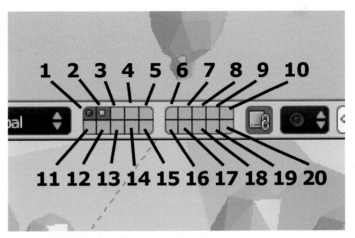

**Figure 3.25** *The layer buttons, numbered.*

the header how the buttons for both layers 1 and 2 are enabled. To hide the trees, just Shift-LMB click on the layer 2 button, deselecting it.

In order to set an object's layer, first RMB select it in the 3D view. The **M** key brings up a tool that allows you to change the object's layer by clicking on a button cluster that is identical to the one on the 3D view header. The feedback is immediate, so you will see objects pop into and out of visibility as you change the settings. When you have the layers set as you please, move the mouse outside of the tool to accept the change. Note that the tool works on the entire selection, not just the active object, so you can move a number of objects to different layers at once.

The layering system is also great when you have enough complex or high-resolution objects that they slow down the 3D display. Place the high-resolution objects on a separate layer, while adding simple cubes of roughly the same size and location to a different layer. While you are working on other things, hide the high-resolution layer and show the low-resolution one. When it's time to render, show the high-resolution layer and hide the low–resolution one.

## Parenting

In real life, objects can be linked to one another. When you set a book on a desk, pushing the desk across the room moves the book too. Tie a string to a weight, hold the string in your hand, and start to spin. The weight flies in a circle around you.

These kinds of relationships (but not the physics themselves) are defined in Blender by **parenting**. Parenting lets you define an object as a parent (the desk), and an object as a child (the book). You can move the child object independently, but any transformations you perform to the parent object are also performed on the child. These automatic transformations use the parent object for their pivot point.

To create a parent–child relationship between objects, first RMB select the child, then Shift-RMB select the parent, making it the active object. Create the relationship with **Ctrl-P**. When you do, a dashed line appears, joining the objects.

Take a look at Figure 3.26, Suzanne with three of her children beside her. The child immediately to her right has been set as her child with Ctrl-P. The next little monkey over has been set as the child of the first little monkey, using the same process:

- RMB select Beatrice, then Shift-RMB select Alexander.
- Press Ctrl-P to create the relationship.

**Figure 3.26** *Suzanne and her kids.*

Finally, Cornelius has been set as Beatrice's child in the same way.

What you end up with is a chain of parent–child objects. Transforming Suzanne moves the rest of her brood. Moving Alexander transforms all of his siblings, but does not affect Suzanne. Transforming Beatrice moves only herself and Cornelius. Directly moving Cornelius does not affect anything else. Rotating Suzanne rotates the whole chain of child objects around her, as though they were attached to a string.

A parent–child relationship can be broken by selecting the child and pressing **Alt-P**.

You can check the Web Bucket for a video of these monkeys, animated (*suzanne_and_kids.mpeg*).

One last note on parents and children. Often in tutorials and other books you will see the creation of parent–child structures simply referred to as "parenting." The way it is said is usually "Parent Cornelius to Suzanne." Although it's not actually accurate, this means that the tutorial wants you to make Cornelius the *child* of Suzanne.

## Empties

While you're working in 3D, organizing your scenes and animating, you might find that you need an object for purposes of parenting, marking a location or something else, but you don't need it to actually render. For example, you might have a car that drives around and around in a circle. You could keyframe the car around a circular path, but much easier is to make it the child of a central object and animate that object's rotation. The car will move in a perfect circle. Blender provides a kind of dummy object for these constructive purposes that never renders and takes up almost no processing time or memory: the **Empty**.

Empties are added through the Shift-A menu, at the top level. By default, Empties look like a three-arrowed axis, which lets you determine their orientation at a glance. On the Object Data context of the Properties window though, you can change the visualization depending on your needs. Figure 3.27 shows several Empties, with different visualizations.

### Instancing and Duplicating

The last general object task we need to cover is duplication. The trees back in Figure 3.24 were not each created individually. I made one, then duplicated it to make the rest.

Selected objects are duplicated with **Shift-D**. Newly duplicated objects are born in Grab trans-formation mode, allowing you to

**Figure 3.27** *A cavalcade of Empties.*

move them away from the original object immediately. It's actually easy to make a duplicate, then cancel the transformation, giving you two identical objects sitting on top of one another. You won't be able to see it in the 3D view, but rendering will produce a pattern of interfering faces, like the one in Figure 3.28. If you see this, a frustrating problem many beginners run into, the odds are that you have two copies of an object on top of each other.

These duplicated objects are somewhat dependent on one another. Both the new and original objects share a material. Any changes you make to one's material will affect the other as well. Animation is also duplicated, but the objects don't share animation data. This means that if you change the animation of one of the objects, that change will not be reflected in the other object. Likewise, editing the mesh of the new object will not affect the original.

**Figure 3.28** *Two identical Suzannes, at the same point in space.*

But what if you wanted all your duplicates to stay linked together? For example, you might be constructing a space battle. There are dozens of little ships zipping around, all of the same type. Halfway through the project, you decide that you want to add an additional engine to that type of ship. You could go in and add that engine to each and every copy you had made, or you could have thought ahead and used **instancing**. Instancing is the practice of making live, linked copies of a single object.

To instance, instead of duplicate, use **Alt-D**. Notice how a lot of Blender's hotkeys use the Alt or Ctrl modifier to slightly change their behavior.

Instanced copies of an object all share the same mesh structure. Make a change to one, and it happens to all instances simultaneously. You can still assign different materials and animation to them, which you'll understand in a moment, but the mesh is shared.

This is an ideal moment to bring up data blocks.

## Data Blocks

We're about to get really technical for the first time. Everything in Blender's insides is arranged around something called a **data block**. A mesh is a data block. Each F-curve that represents animation is a data block. A material is a data block. An object is a data block that is made up of some special properties, including links to mesh, material, and effects data blocks. Even the 3D view itself is a kind of data block, which includes links to a particular scene, which in turn includes links to all of the object data blocks that comprise that scene. Fortunately, you don't have to mess with this system directly very often, but knowing about its existence can really help you to understand some of Blender's more powerful features.

Figure 3.29 shows the Data Block view of an Outliner window. From this, you can browse every data block and every aspect of Blender, seeing how they relate to one another and their basic properties.

With that in mind, let's rephrase what you just learned about creating duplicates and instances. When you duplicate an object with Shift-D, you create a new object data block and new mesh data block, which are copied from the originals. The material data block of the new object just points back to the same material data block as the original. This is why changing the material on a duplicated object affects the first one as well: They are actually the same material data block.

On the other hand, creating an instance with Alt-D generates a new object data block with links to all of the various data blocks that make up the original. Everything is linked, so any edits show up on every single object that is similarly linked to those data blocks.

## Summary

It wouldn't be a bad idea to stick a bookmark in this page for reference during the work in the next few chapters. This is bedrock material, so hopefully it will become ingrained in your fingers and mind before too long.

- New blend file: Ctrl-N
- View manipulation with the mouse:
  - Pan: Shift-MMB
  - Zoom: mouse wheel
  - Rotate: MMB

**Figure 3.29** *Data Block view in the Outliner.*

- View manipulation with the keyboard:
  - Front view: Numpad-1
  - Side view: Numpad-3
  - Top view: Numpad-7
- Orthographic/Perspective view toggle: Numpad-5
- Solid/Wireframe view toggle: Z key
- Textured view: Alt-Z
- Select all/deselect all: A key
- Border select: B key, then LMB drag
- Border deselect: B key, then MMB drag
- Delete selected object: X key (or the Delete key)
- Accept a procedure/result: LMB
- Reject/cancel an operation: RMB
- Add objects: Shift-A
- Transformation controls:
  - Move (grab): G key
  - Rotate: R key
  - Scale: S key
- Transformation constraints:
  - X, Y, or Z during transformations to move along only that axis
  - Shift-X, -Y, or -Z to lock that axis
- Transform by keyboard:
  - G, S, or R, followed by an axis (X, Y, Z) and numbers
- Time control:
  - Forward 1 frame: →
  - Forward 10 frames: ↑
  - Backward 1 frame: ←
  - Backward 10 frames: ↓
- Play animation: Alt-A
- Create parent–child relationship: Ctrl-P
- Remove parent–child relationship: Alt-P
- Set keyframe: I key
- Duplicate object: Shift-D
- Instance object: Alt-D

## What We Missed

If we had unlimited time and space in this book, we'd cover every single aspect of Blender from these basics up through the most advanced material and out the other side to stuff that is of dubious value at best. But we don't, so we can't. From here on out, we'll give a mention at the end of each of chapter of what we skipped, but what you should look up on your own as you take some steps on your stubby little 3D toddler legs.

- **Custom view orientations:** Define and use your own view orientations, alongside Global, Normal, and Local modes.
- **Markers:** The Timeline window can hold markers that let you mark and name specific points in time for animation reference

## Next Up ...

In Chapter 4, we learn how to create your own objects with mesh modeling.

# Chapter 4
## Modeling: A Million to One

So far, you've become familiar with Blender's interface, and moved and animated some simple objects. If you want to create your own scenes—which, let's face it, reading this book if you weren't interested in that would be silly—you'll need to learn to create custom objects. While there are some specialty object types, by far the most commonly used is the mesh model. In this chapter, we'll look at several approaches to mesh modeling: polygon by polygon, tools based, box, and with modifiers. Before we actually model anything, let's learn the terminology and basics.

## The Building Blocks of Mesh Modeling

When Blender renders your final image, it breaks up every surface into triangles. A triangle is the simplest object that can have a visible surface, and it is also the shape toward which decades of computer scientists have dedicated their efforts in order to quickly transform and draw. If you're a computer, triangles are where it's at. It should come as no surprise then that triangles will be the building blocks of your mesh model.

Figure 4.1 shows several objects in the 3D view, with their mesh structure visible. The object on the left is a simple triangle. The edges of the triangle are called, officially, Edges. The points that you can see where the edges meet are called Vertices. If you have only one, it is a Vertex. The triangular surface that those vertices and edges make up is called a Face. Vertices and edges will never show up in a render, only faces will. But in order to have faces, you need to have accompanying edges and vertices.

If you've ever seen a finished model like the one on the right in Figure 4.1, you might be thinking, "That must have taken forever!" I guarantee you that the artist did not do it by placing each and every vertex, edge, and face by hand. Blender has tools that allow the mass manipulation of these structures to simplify your life as a modeler.

Take a look now at the object on the right of Figure 4.1. It has the same shape as the one in the center, but it appears to be made up of squarish objects instead of triangles. If you were a geometry whiz in high school, you're probably thinking, "Moron—quadrangles are just two triangles that share an edge," and you'd be correct. Generically, quadrangles and triangles together are referred to as polygons. Many modelers find it more convenient to work with quadrangles, using triangles only when necessary.

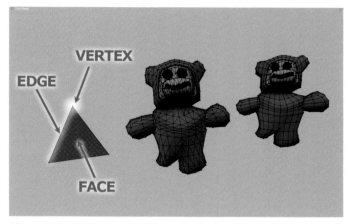

Figure 4.1 *Mesh objects in Edit mode: Vertices, Edges, Faces.*

The hardest part about modeling, though, is not whether to use quadrangles or triangles. The real trick is in thinking about the object you are trying to create and deciding from the different methods. Really, there are millions of ways to model an object, beyond the initial aesthetic considerations such as how stylized it should be or how much detail to give it. Your first job as a modeler is to decide which approach you will take, and that approach will have a major effect on the amount of effort you have to put into the model.

Unfortunately, until you're more familiar with the tools and approaches, you won't be able to make an informed decision on how to go about things. So, let's jump in with the most "nuts and bolts" method: free modeling, or building an object polygon by polygon.

## Free Modeling: Polygon by Polygon

Figure 4.2 shows a flower, modeled with a variety of techniques, but started with polygon-by-polygon modeling. Also in the figure is a good configuration for mesh modeling in Blender on a widescreen monitor or laptop. Along the right of the screen is a Properties window, which will be useful for some more advanced techniques when we directly access object data and modifiers that are discussed in later sections and chapters. The rest of the screen is dedicated to a large 3D view that provides you with maximum screen real estate for modeling. The T key toggles the tool shelf, which will appear on the left. The tool shelf gives you quick access to the various mesh modeling tools that are available, lets you search for and add new tools that might not be a part of the default configuration, and lets you tweak previous modeling actions that you've performed. The N key toggles a Properties panel (no, not the Properties window—I guess we still don't have our act completely together in Amsterdam) that gives access to transform information. The nice thing about both the tool shelf and Properties panel are that they quickly pop into and out of existence as you need them with the appropriate toggle key, letting you grant the largest possible area to your modeling activity.

In this modeling view, note how the 3D cursor lies at the origin (0,0,0) in 3D space. When you create a new object, it appears at the location of the 3D cursor, just like new words appear at the location of the cursor in a word processor. The flower in Figure 4.2 is what we are shooting for in this exercise.

**Figure 4.2** *A model of a flower, begun with the polygon-by-polygon method.*

To begin a new mesh object, hover the mouse inside the 3D view and press Shift-A. Once again, you see the familiar menu. Select the uppermost entry: Mesh, and then Plane. This menu hierarchy is shown in Figure 4.3.

Doing so creates a new mesh object, a plane, at the location of the 3D cursor. At the moment, it's just a generic object like the ones you worked with in Chapter 3. In order to change the mesh structure itself, you need to enter Edit mode by pressing the Tab key.

> **Fundamental**
> The **Tab** key enters Edit mode for many selectable objects in Blender. If you need to change points or individual elements of a larger object, try the Tab key.

Once the object is in Edit mode, you will see its vertices, edges, and single face (Figure 4.4). As we're building a flower, we don't need any of these default elements. When entering Edit mode on a newly created mesh object, all of its vertices are selected by default. This is perfect, because right now, you want to delete all of those vertices for a clean slate. Use the X key and choose Vertices from the menu that pops up to remove them.

At this point, your object is in an odd state. It's actually an object, but it's essentially empty—it has no vertices, edges, or faces. If you were to press the Tab key again—Don't do it!—you would leave Edit mode and it would only be selectable and noticeable by the little object center indicator.

So, before something weird like that happens, add a new vertex. Hold down the Ctrl key and LMB click in the 3D view. It creates a vertex. Continuing down the screen, Ctrl-LMB several more times until you've made an arc like the one in Figure 4.5. As you Ctrl-click, you'll find that each new vertex is linked to the previous one with an edge. For the start of the flower petal in the sample files, I've used six vertices. Don't use too many, or things will be harder to manipulate later on. If this is your first try at placing vertices, the positioning and spacing may not be to your liking.

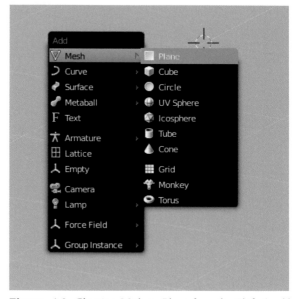

**Figure 4.3** *Choosing Mesh > Plane from the Shift-A add toolbox.*

The nice thing about the vertex/edge/face structures in Blender is that the same rules apply to them that apply to the objects you worked with in Chapter 3. If a vertex is not in a place that you like, RMB select it, just like a whole object. The G key enters Transform mode so that you can move it. LMB drops it when you have it positioned to your liking, while RMB clicking cancels the transform. Using the Transform tools, try to get your arc to resemble the one in Figure 4.5.

If you're following the illustration exactly, you'll have an arc that consists of six vertices and five edges. There are not, however, any faces. Let's add one.

RMB select the vertex at the top of the arc. It will be highlighted white to indicate its selection state, and the edge leading away from it toward the next lower vertex has a gradation from orange

**Figure 4.4** *The default plane in Edit mode.*

**Figure 4.5** *The first arc.*

to black. When you are working with more complex meshes, this gradation will help you to identify adjacent vertices that might not be necessarily obvious.

With this vertex selected, Ctrl-LMB to the right of it, then down a bit, so it looks like Figure 4.6. You now have almost a quadrangle at the top of the form. To make a face out of it, use Shift-RMB to select all four of the vertices. Press the F key, and the vertices turn into a face. Something you can actually render!

Using this same technique (RMB select a vertex, Ctrl-LMB below it, select all four, and use the F key) add two more faces, as in Figure 4.7.

You could go on like this all day, creating the entire flower polygon by polygon. There are, however, more efficient ways of doing these sorts of things. For the most part, you won't be modeling objects in this fashion, but every now and then the fancy tools won't be up to the task, and you'll need to know how to get down and dirty.

To try one of these other techniques, RMB select the lowest right vertex. Ctrl-LMB to create a vertex straight down from it, but parallel to the lowermost vertex, essentially skipping the next one down. Select these two lowest vertices and press the F key, creating the result in Figure 4.8. This time, a face is not created, which is important to remember. The F key only creates a face when three (a triangle) or four (a quadrangle) vertices are selected. When two vertices are selected, the F key joins them with an edge.

**Figure 4.6** *Getting ready to create a face.*

If only there were some way to add a new vertex in the middle of that long edge, you could connect it to the vertex directly across to the left, then use the F key to create faces.

Before you learn how to do that, let's try another way of working with mesh structures. In the little bit of work you've done so far, you've only been working directly with vertices. You can also work directly with edges or faces. If you were to try to RMB select one of the edges right now, Blender would probably select one of the vertices attached to it. In order to be able to select that edge with a single click, you need to change to Edge select mode. This can be done either from the 3D view header with the Edge select mode button, highlighted in Figure 4.8, or by pressing Ctrl-Tab to bring up the selection mode menu. From this menu, choose Edge. When you do this, the little dots that represent vertices in the 3D view disappear.

RMB select that long vertical edge. Notice how it actually selects the edge directly now. Since vertices aren't showing, you can't even select them. If you had been in Face select mode, you would only be able

**Figure 4.7** *Three faces created, with two more edges below.*

to select faces. At the moment, that might seem like a questionable benefit, but later on when mesh models become increasingly complex, it often makes sense to work at this level.

Anyway, with this edge selected, use the Subdivide tool, either from the T-key tool shelf on the left or by pressing the W key to bring up the Specials pop-up menu in the 3D view. Subdivide splits the selected geometry into two equal parts, and in this case creates a new vertex in the middle of the edge. Switching back to Vertex select mode, either from the 3D header button or by pressing Ctrl-Tab, shows this new vertex.

Want to see something cool? Bring up the tool shelf with the T key if it isn't already visible. At the bottom of the shelf, you'll notice the Tweak Panel for the last operation. In this case, that's Subdivide.

**Figure 4.8** *Choosing Edge select mode.*

The Tweak Panel is shown in Figure 4.9. Adjusting the Number of Cuts control changes the way that the Subdivide tool you just used affects the edge. If you wanted, you could add an enormous amount of vertices very easily by raising that value in the Tweak Panel.

The two other controls on the Tweak Panel—Fractal and Smoothness—also affect the result of the tool. Play around with them if you like, but neither is particularly useful to us right now. When you're done experimenting, set Fractal and Smoothness back to 0.0, and Number of Cuts back to 1.

> **Note**
> You can tweak the results of tools and operations in the Tweak Panel at the bottom of the T-key tool shelf. Each tool has its own set of tweakable parameters.

Let's fill in the the remaining two faces using two new selection methods. Go back into Edge select mode, and, using RMB and Shift-RMB, select two opposing edges, one on the left and one on the right. Press

**Figure 4.9** *The Tweak Panel of the tool shelf.*

the F key. A face is created. When working in Edge select mode, you only need to select two opposing edges in order for Blender to understand how to create the face. If you were to select two edges that shared a vertex, pressing the F key would create a triangular face, bridging the two loose vertices.

To create the last face before we move on to some more efficient techniques, we'll use the C-key selection brush. Press the C key and the cursor turns into a circle. This circle is the selection brush, and it can be grown or shrunk by spinning the mouse wheel. You "paint" a selection with it by holding down the LMB while dragging across your mesh. You "erase" from the selection by dragging with the MMB. A common technique when building faces is to use the C key, then adjust the size of the brush so that it covers all four vertices of the face you want to create. Give a single LMB click to select all four at once, then an RMB click to leave brush selection mode. Press the F key and create the face, bringing you to the final state of our little polygon-by-polygon experiment, as shown in Figure 4.10.

Things get faster and easier from here. We'd like to make a whole additional column of faces extending to the right of the ones we just created, but it would be nice to avoid adding vertices and creating faces by hand this time. The simplest way to do this is with the Extrude tool.

Extrude can be found in the Modeling section of the tool shelf, but since it is perhaps the most commonly used model-ing tool, it has its own top-level shortcut: the **E** key. Extrude takes whatever is a part of your current selection (vertices, edges, and faces), creates new attached copies of those elements, and lets you move them around. It's easier to see it in motion than to read about it.

Make sure you're in Vertex select mode and select the rightmost column of ver-tices. Press the E key and see what happens. Those vertices and edges are duplicated, and the duplicates remain connected to the originals, forming 11 new edges, 6 new vertices, and 5 new faces. The new elements are automati-cally put into the equivalent of the G-key translation mode so that you can position them as you like. Pull the new geometry to the right a bit, creating something like Figure 4.11. Using RMB selection and the G key, try to make the resulting petal roughly symmetrical.

Much simpler, no? Usually, you will be able to get away with creating just the beginning of your model "by hand."

**Figure 4.10** *The final result of polygon-by-polygon modeling.*

From there, you can usually extrude your way into anything that you need. Of course, there will be times when you need to bridge a gap in the mesh, connecting two different sections or some other specialty. On those occasions, you will need to know how to add individual vertices, connect them with edges, and use them to create faces from scratch.

So now, we have this petal- or leaf-shaped item, but it's flat. If you rotate the 3D view around, it's obvious that this shape is seriously lacking a third dimension. Sometimes it is helpful to see a 3D object from several directions at once. You could split the work space into several 3D views and set each one to a useful perspective. Blender includes a shortcut for this setup, though: Quad view, toggled on and off with Ctrl-Alt-Q and also accessible from the view menu. It divides the current 3D view into four separate views: front, side, top, and camera. Go into Quad view now.

It's even more obvious from here that our petal needs some help in order to be considered 3D. There are a number of ways to go about this, but we're going to use something called Proportional Edit Falloff (PEF) to pull this off. The Proportional Edit Falloff tool allows you to

**Figure 4.11** *After a successful extrusion.*

select and transform a handful of elements (vertices, edges, and faces) and have that transformation proportionally affect the elements around it. Without PEF, grabbing a vertex in the middle of a model and moving it only moves the vertex. With PEF, moving this same vertex also moves the ones around it, with the effect fading the further you go from the original selection. This creates a smoother effect than trying to move each element individually.

To enable PEF transformation, either use the control on the 3D view header (highlighted in Figure 4.12) or the O-key shortcut. This is one you'll most likely use all the time, so it will pay to learn the shortcut. PEF doesn't look any different at the moment—it takes effect once you begin a transform.

Select the top center vertex of the petal. From the side view then, press the G key to move the selected vertex. As soon as you do, you'll notice something different. There is now a circle in the 3D view, much like the C-key selection brush. And just like that tool, spinning the mouse wheel causes this circle to grow and shrink. This circle indicates how far away from the selected elements the influence of the transformation will extend. Moving the mouse now should pull not only the selected vertex but several of those around it. Roll the mouse wheel to see the effect of a larger or smaller radius of influence.

There are different styles of PEF that are appropriate for different modeling situations. In this case, we are trying to get a nice curve to our petal, like the one in Figure 4.12. Leave Blender in PEF Transform mode (i.e., don't use either LMB or RMB to accept or cancel the transformation) and try repeatedly pressing

(a)

**Figure 4.12** *The petal curved using (a) PEF,*

(b)

**Figure 4.12, cont'd** *then (b) finished.*

Shift-O. This shortcut cycles through the different falloff modes: Smooth, Sphere, Root, Sharp, Linear, and Constant. You don't need to memorize these, and in fact I often don't pay attention to which is which. I just cycle through them until I get the falloff shape I need. The shape in Figure 4.12 can be achieved by setting the PEF circle to reach just to the bottom of the petal, using the Sharp falloff style. See if you can adjust your controls to get the same effect.

> **Web**
> You can see images of each of the different PEF falloff modes in the Web Bucket for this chapter at *http://www.blenderfoundations.com.*

PEF works not only with a single element selected, but you can have an entire line of vertices selected, or some vertices and edges. You can use it with rotation, scaling, and even some of the more advanced transform modes like Shrink/Fatten that we haven't learned yet.

To finish the petal and give a little more dimension, let's select the column of vertices down the center and offset them slightly in side view. You'll probably have better luck selecting them in the front view. You won't need to move it much, but the result should look like Figure 4.12(b). When you have it, either use the view menu or Ctrl-Alt-Q to toggle back out of Quad view.

Okay. The petal's done, and it felt like a lot of work. Don't worry though—we're learning concepts as we do the grunt work. Once the basics are down, this will get a lot faster.

Move back to a top view of the petal (Numpad-7) if you're not already there. Recall from Chapter 3 how the 3D cursor can be used as a visual reference of a pivot point for transformations? Let's use it to help efficiently duplicate our petal around a central point. Using the LMB, click just slightly below the bottom of the petal. Position your view (zoom and pan) so that the 3D cursor appears in about the middle of the 3D view, with the petal taking up the upper portion. You're going to create a number of duplicates of the petal, rotating each around the 3D cursor. Before you begin though, use the O key to disable PEF mode. Leaving it on while trying to move a duplicate item will result in pulling the original right along with it.

Use the A key to select all of the vertices in the petal. As a default, Blender rotates items around their center point. However, we want to rotate around the 3D cursor. If you remember from Chapter 3, the pivot point can be changed either on the 3D view header (the Rotation/Scaling Pivot icon menu) or by pressing the keyboard period key. When free modeling, you will probably change between 3D cursor pivot (period key) and center point pivot (comma key) with some frequency, so this is another shortcut that's great to commit to reflex. No matter how you decide to do it, set the pivot point to be the 3D cursor.

The Duplicate Object command from Chapter 3 was Shift-D. It's the same here. Press Shift-D to duplicate the selected mesh of the petal, then press the R key. Once again, this changes the Transform mode on-the-fly from translation to rotation. As you move the mouse, you'll see that the newly created petal is rotating around the 3D cursor. When you have it rotated to your liking, LMB click to drop it in place. Do this several more times until you have a nice flowery cluster. My result, which you don't have to replicate exactly, is seen in Figure 4.13.

Let's add a simple center to the flower. Ideally, we'd like a squashed dome. One of the things to consider when modeling is: What can save me time and effort? In this case, that timesaver is going to be the UV Sphere

primitive. As noted in Chapter 3 there are a number of primitives to choose from, and the more you are familiar with them, the better you will be able to take advantage of them while modeling. Coincidentally, slicing the rear half off a UV Sphere primitive will give us a very squashable dome. The Web Bucket for Chapter 4 contains images of each of the different mesh primitives.

Use the Shift-A menu to add a Mesh > UV Sphere to the scene. Adding objects with the Shift-A menu in Chapter 3 created independent elements that were individually animatable. When adding mesh primitives while already in Edit mode on a mesh, though, their structure is added directly into the existing mesh framework. It's all part of the same object.

What we would like to do now is to select the vertices that make up the lower half of the UV Sphere. This presents a

**Figure 4.13** *Several petals, duplicated from the first and rotated around the 3D cursor, which is found in the center.*

problem, though, as the sphere seems to be intersecting the flower petals. A little while ago, you pressed the C key to access the selection brush. You could do that again, but there's an even easier way this time. When making fairly boxy regional selections, you can press the B key to enter Border Select mode. Border Select mode turns the cursor into a crosshairs that spans the entire 3D view. LMB click and drag to define a region. When you let go, mesh elements within that region are selected.

If you were to try to make this selection from the top view, you'd be in trouble. The 3D cursor is in the middle of the flower, so that's where the UV Sphere came into being. Trying to select its lower half would result in also selecting some of the vertices of the petals. One of the big challenges in modeling is in the management of selections, and sometimes in just being able to select one element without accidentally grabbing another along with it. There are a couple of ways to get around this.

First, you could just switch into side view and see if you have a clear shot at it. Depending on where the 3D cursor was, you may or may not be able to B-key border select the lower half of the sphere this way.

Second, you could Undo (or just delete the selected UV Sphere), reposition the 3D cursor away from the existing portion of the model, and re-add the sphere.

Third, you could move the existing sphere clear of the rest of the model. If you've tried to select it already and messed up the selection state, there is a simple way to select the entire UV Sphere at once. The L key selects mesh islands. An island is a distinct, separate part of a mesh. Try it now by clearing any

selections with the A-key dance. Then, hovering the mouse over the sphere, press the L key. It should select the UV Sphere. Now, you can use the G key to move it away from the rest of the model and border select the lower half.

There is a fourth, more clever, way though. Use this same L-key technique to select the entire UV Sphere if it isn't already selected. Then, press the B key to enter Border Select mode. At this point, either a front or side view is fine. Instead of LMB dragging to select a region, MMB drag to define a region around the top of the sphere. This will deselect the vertices within the space, just like MMB painting with the selection brush removes selection. This is a nice way to do it, because it doesn't matter what is behind the sphere or how cluttered the display might be.

At this point, the complexity of choice involved in modeling might be dawning on you. There are a million ways to model a particular object. The way that you choose to approach a modeling task will be determined by how well you know the available tools and personal preference. The more you know about the tools, the more efficient you will be, and the better your end result will be.

Before we get too far ahead, remove the selected lower vertices with the X key. We're trying to make a dome (half-sphere), no?

To move it into proper place and orientation now shouldn't be too difficult. It only uses skills you've already learned. I'll make it brief, since you're no dummy:

- Reselect the half-sphere (L key).
- Rotate it in a side view so that it is facing outward from the center of the flower.
- Scale it so that its outer edges nicely cover the inner tips of the petals.
- In a side view, scale it once more but use the transform constraints you learned in Chapter 3 to scale it only along the $z$ axis (S key for scale, followed by the Z key). You might have to reposition it above the petals after this last scaling.

When you've done these things, you should have something like Figure 4.14. Rotate the view with the MMB to see your modeling work in all of its beginner's beauty.

---

**Web**

Step-by-step images are available for this sequence in the Web Bucket for Chapter 4.

---

Let's finish this little monster. Once again, we won't do anything we haven't already learned. It's seeing where you need to go and figuring out how to apply the tools that is the trick. Right now we need a circular stem that extends downward from the center of the flower and possibly has a slight bend to it. One thing you might have noticed is that from a global perspective, the flower is facing upward. We'd actually like for it to face forward so it looks nice in a vase. Select all the vertices you've modeled so far with the A key, then rotate them 90 degrees around the $x$ axis by pressing the R key, pressing the X key (to signal the $x$ axis), typing "90," and pressing Enter. Now the flower is oriented properly for later.

In a top view (Numpad-7), make sure that the 3D cursor is about dead center in the flower. Use Shift-A > Circle. A circle springs into life, selected. Use the S key to scale it down to an appropriate size for the cross section of a stem. Jump to a side view (Numpad-3). Extrude that circle downward several times with the E key. Depending on where you LMB drop the transform after each extrusion, you might end up with something like Figure 4.15.

Before we move on, let's put a few finishing touches in place. If you haven't been working in Solid view mode, switch to it now. Use the Tab key to leave Edit mode, allowing you to get a look at what the surfaces of your model look like. You will notice that all of its elements appear faceted, not smooth like the one in Figure 4.15. If we were to render this now, this is how it would look—not good. Over on the tool shelf in the Shading section are two tools: Smooth and Flat. You can guess what they're for. With the flower model selected, use the Smooth tool. The shading method changes, and the flower now appears nicely smoothed.

You won't always want to smooth an entire model at once, so these same tools are available on the shelf in Edit mode, too. To make certain sets of faces smooth (or flat), you only need to select them and use the appropriate tool. There are other ways to do this, but we'll stick with this for now.

Finally, we'll introduce a new concept: modifiers. Modifiers are tools that you can attach to a model that alter the

**Figure 4.14** *The flower with petals and a center piece.*

**Figure 4.15** *The completely modeled flower.*

configuration of the mesh in some way. However, unlike the tools we've used so far (extrude, duplicate, transform, etc.), their effects are "live." Think of it this way: When you add vertices, edges, and faces to a model, they are actually there. They can be selected, duplicated, and deleted. Modifiers, however, create virtual geometry according to a set of rules and controls. As you manipulate the "real" portions of the mesh (vertices, edges, and faces), the virtual geometry adjusts itself, usually in real time.

In the Properties window, choose the wrench icon from the header. This brings up the object's modifiers context. Right now, there aren't any modifiers. Take a good look at your model in the 3D view. Notice the chunky, angular edges on the petals and possibly the stem. Now, click the Add Modifier button in the Properties window and choose Subdivision Surface from the very long list of available modifiers (lower left, under Generate). Examine your model. Instant smoothness and roundification!

Subdivision Surface takes your normal mesh model, divides its triangles and quadrangles into smaller tessellations of themselves, and smoothes them. Since it's a modifier, this is done on-the-fly, leaving your original mesh structure intact. The modifier just affects how the rest of Blender, including the view, interprets that mesh data. There are a number of options for subsurfacing, but we'll get into those in Section 4.3. For now, take a look at your first finished model in Blender 2.6.

It's quite simple, but that's okay. The flower will only be a minor part of our overall scene, so it doesn't deserve the hero treatment. In fact, for all of the time it took to work through this tutorial, this flower can be modeled by an experienced user with these exact techniques in a little over 30 seconds.

---

**Web**

You can watch a brief video of this flower being quickly modeled in the Web Bucket for Chapter 4.

---

Once again, the skill is not so much involved in clicking this button or memorizing hotkeys (although that helps); it lies in understanding your tools enough to know how to get from a blank slate to a finished model.

Before moving on, save your file. Give it a name you can come back to later, like "demo scene." We'll be working on this one scene for the length of the book.

## Tools

The flower needs a vase. It doesn't need to be fancy; we'll give it a nice material later on that will give it some detail. In the vein of Section 4.2, let's consider for a moment the structure of your typical vase. Generally, a vase is some kind of variation on a tube. This suggests that one approach to modeling a vase would be to begin with the tube mesh primitive. There's a better way to do it, but let's take a quick look at that method. Using your mad skills from the previous section, you should be able to follow this.

---

**Warning**

Make sure you leave Edit mode on the flower before you begin a new model. Otherwise, your new mesh model will be added in to the flower model, making it much harder to surface your scene later. There are ways to remedy this problem (L-key select the separate parts and break them into individual objects with the P key), but it's best not to have it happen in the first place.

---

**Figure 4.16** *Several vases quickly created from a cylinder primitive.*

- Add a mesh tube, and go into Edit mode (Tab key).
- Select and delete the vertex in the center of each end, making the cylinder into a hollow tube. You could also disable Cap Ends in the Tweak Panel after adding the tube.
- Switch to Edge select mode (no vertices!) and B-key border select across the tube to grab the vertical edges. Make sure not to select the edges that run along the top and bottom.
- Use the Subdivide tool from the tool shelf or W-key Specials menu.
- Use the Tweak Panel to change the number of cuts to ten.

You'll end up with a subdivided tube like the one in Figure 4.16. From here, you can use B-key border select to select a whole horizontal row of vertices at a time, then scale them with Proportional Edit Falloff until you are happy with the final shape. Figure 4.16 also shows several outcomes for this process.

---

**Web**
Each step of this exercise can be seen in Chapter 4's Web Bucket.

---

You'd probably want to use the Smooth shading tool and a Subdivision Surface modifier, as with the flower, to complete it. If you were just knocking out a generic vase, this process would be fine. However, if you were trying to create a specific vase with a specific profile, or just to have more exacting control over the outcome, there is another way.

The Spin tool—found in the Modeling section of the tool shelf or Alt-R in the 3D view—takes a flat mesh profile and extrudes and rotates it around a central point. It lets you easily turn the edge-and-vertex profile on the left of Figure 4.17 into the surfaced object on the right. This process is sometimes referred to as *lathing*.

Begin by opening the file that has your flower and adding a mesh plane primitive (Shift-A > Mesh > Plane). Make sure that you're not in Edit mode on the flower and that the 3D cursor is somewhere away from it, so new work won't overlap. Use the Tab key to enter Edit mode and delete (X key) all four vertices. Get used to doing this when modeling, as it is the standard way to begin a model "from scratch."

Use Numpad-1 to go into a front view. Then, use Ctrl-LMB to draw the profile of the vase, just like we did with the petal in the previous section.

Let's take a look at exactly what the Spin tool does. As we said before, it extrudes a mesh profile around a central point. That point happens to be the 3D cursor. But how does it know which way to rotate? It is view dependent. Spin basically draws a circle on the screen around the 3D cursor. Figure 4.18 shows how this works.

The first thing this means is that you need to create the mesh profile on the correct side of the 3D cursor. If you are drawing the left profile of the vase, it should be to the left of the cursor. Put the profile close to the cursor and the vase will be very narrow. Create it far away, and the result will be wide.

**Figure 4.17** *A vase's profile, before and after using the Spin tool.*

**Web**
You can see the same profile spun narrow, wide, and from the wrong side in the Web Bucket for this chapter.

Let's go with what you have, though. Change to a top view (Numpad-7) and activate the Spin tool. You only get a quarter of a vase. Take a look at Spin's Tweak Panel on the tool shelf, or by pressing F6. Among the number of settings and options there are Steps and Degrees. The first setting to tweak is Degrees. Change it from 90 to 360, which, if you know even the slightest thing about geometry, changes things from a quarter to a full circle. The result is kind of blocky, though. That's because only nine "steps" were used to spin the profile. Raising the number of steps gives you a correspondingly more rounded result. You don't have to get it perfectly smooth, though, as you'll probably be using a Subdivision Surface modifier on it later. You can try dropping steps to 4 or even 3. The result looks like a kind of paper lantern, which suggests that you can use Spin not just for rounded objects but for general modeling of objects with a consistent contour. Once again, it boils down to knowing where you are trying to get to, and knowing which tools are at your disposal.

Now that you see how Spin works, and before we finish the model, it should be easy for you to go back and add some thickness to the vase. A real vase does not have infinitely thin walls with a razor's edge on the

top, but our spun model does. Use Undo (Ctrl-Z) to remove the Spin operation, leaving only the original mesh profile. Back in the original front view, select the top vertex of the profile and use Ctrl-LMB to draw a top lip and interior wall for the vase. Leave the "bottom" open, as in Figure 4.19.

Head back to the top view and use Spin again. Tweak the tool to 360 degrees, and somewhere around 24 steps. This time the result has thickness, with separate interior and exterior surfaces. It's still open on the bottom, though. Before we close it in, let's fix one little bad point on the geometry. When you spin a mesh 360 degrees, the first and last instances of the profile land exactly on top of each other. They don't join up automatically, leading to a loose edge. To join them, we'll use the Remove Doubles tool. Use the A key to select everything in the mesh, then choose Remove Doubles from the W-key Specials pop-up menu. Remove Doubles merges any vertices that are in the same location. In the vase, this means that the top vertex of the first instance of the profile and the same one from the last are merged, with corresponding sets on down merging with their counterparts. You may have to adjust the value on the Tweak Panel for Remove Doubles to get it to work properly: 0.01 is the highest you should need to go. If you don't do this step, your vase will have a nasty seam running down one side.

With that taken care of, let's close up both the inside and outside walls. Make sure that you are in Wireframe view mode and zoom in on the bottom portion

**Figure 4.18** *Spinning a profile in top view.*

**Figure 4.19** *Ready to spin a vase with thickness.*

of the spun model. By rotating the view a bit with the MMB, you should be able to tell which ring of vertices belongs to the inside of the vase. Instead of trying to individually select these vertices or use either the B-key or C-key methods, let's do something else. Hold down the Alt key while you RMB select any edge along that lower circle. It should select the entire loop of edges. This method is called Edge Loop selection, and will be very useful in Section 4.4.

**Figure 4.20** *The inside of the vase's lower edge ring, selected.*

If instead of selecting the bottom ring, the selection that appeared for you runs up the inside of the vase and down the outside, simply position the mouse more closely to the middle of one of the ring edges and try it again. In fact, by playing around with this selection style on the vase model, you should quickly get a feel for how it works. Figure 4.20 shows the bottommost inner ring of edges selected.

Once you have the bottom loop of the inside of the vase selected, closing it up is relatively easy. You need to create some new geometry (we need faces to fill the gap, no?) based on a current selection, so the Extrude tool is the way to go. Pressing the E key puts an extruded version of the ring into Transform mode. Unlike the time we used extrusion on the petal, we don't want to really "move" this anywhere. Instead, we would like to pull it all toward a central point. With the newly extruded geometry still in Transform mode (i.e., you haven't pressed LMB or RMB yet), press the S key to switch to scaling. Scale it inward a bit, just enough so that it is not laying on top of the original loop of vertices, and LMB to accept this state.

So, with this new loop created and scaled inward, visit the Modeling section of the tool shelf again. In the Remove section is Merge. Choose it, and then choose At Center from the menu that pops up. The vertices that were a part of the selection all converge on their center point and merge into one. Instant bottom surface! Merge is another one of those tools that modelers use constantly, so it will pay to memorize Alt-M as its shortcut.

Perform the same procedure on the outside of the vase (select bottom loop, extrude/scale inward, and merge). This process is the most common one for closing off circular holes in geometry and will probably become an almost single reflex action once you've been modeling for long enough. Figure 4.21 shows the final result, after closing the bottoms and applying smooth shading and a Subdivision Surface modifier.

## Box Modeling

Box modeling requires a different approach than what we've done so far. It's not so much that you use different tools as that the philosophy is different. In box modeling, you begin with a closed mesh primitive (like … a box!) and throughout the process you never "break" the box. You can add geometry to it through subdivision, loop cuts, and

**Figure 4.21** *The completed vase model.*

extrusion, but you will never delete a face, edge, or vertex in a way that leaves a hole. Why would you want to work this way? Well, it's appropriate for certain types of objects, like the chair in Figure 4.22.

Make sure you're out of Edit mode on the vase model and save your file, if you haven't already. Position the 3D cursor somewhere away from both the flower and vase. Using the Shift-A menu, add a mesh cube.

---

**Web**
Some key figures are shown in the text, but you can check the Web Bucket for this chapter to see each and every step of this instructional.

---

We've been adding Subdivision Surface modifiers at the end of the modeling process up until now. In this case, it will help us to add it at the beginning. From the Modifiers context of the Properties window, add a Subdivision Surface modifier. Doing so on a simple cube turns it into a kind of blocky ball. On the modifier panel, raise the preview level to 2 in order to smooth things out a bit better.

Tab into Edit mode. The effect is interesting. You see the normal mesh cage like you are used to, but you also see the blocky representation of the subdivision surface beneath it. This is nice, because it lets you model on the mesh itself, while seeing the resulting subdivided surface in real time.

The logical place to begin the construction of a chair is with the seat. It's like a squashed box. So, select all eight vertices of the box and scale it vertically (S key, Z key) until it looks to be about the same

**Figure 4.22** *A modeled chair.*

proportions as the finished chair in Figure 4.22. One nice thing about box modeling is that you can often easily do it in an off-axis view, or even in Perspective view. The workflow isn't so dependent on adding geometry that is floating in space and needs a straight-on view in order to position properly. To create this chair, I worked in an off-axis view exclusively.

In the previous exercise, you selected a loop of vertices on the bottom of the vase with Alt-RMB. But what if had wanted to select not a connected loop of edges, but the disconnected loop of parallel edges above it? Figure 4.23 shows such a selection. Why would this even

**Figure 4.23** *An edge ring selection and a loop cut.*

be useful? Well, the selection of an edge ring allows you to create a loop cut. A loop cut is a new edge that runs through a series of edges like the one selected in Figure 4.23. This is one of the major ways that detail is added when box modeling. Let's examine how.

It would be great to have slightly rounded edges on the chair, and to have the center of the seat sink down a bit. You could just subdivide the entire cube a number of times, but this would lead to a lot of useless extra geometry. Loop cutting adds the ability to etch detail exactly and only where we need it.

**Figure 4.24** *A simple (subsurfaced) cube with one edge loop cut and moved.*

Before making this loop cut, switch to Edge select mode (header button or Ctrl-Tab). Hover the mouse over one of the long top edges of the squashed cube. Press Ctrl-R to ask for a loop cut. A purple line springs into life and jumps around the cube as you move the mouse. This line is a preview of the cut that you would make if you LMB clicked now. For our purposes, it doesn't matter which way the cut runs. Choose one and LMB. The cut is made, and if you move your mouse, you'll find that it slides back and forth along the cut edges. This allows you to precisely make and place loop cuts with ease. To set it back to the exact center where it began, type 0 (zero) on your keyboard and press Enter. In the future, if you want to make a loop cut in the dead center of an edge ring, always LMB once to execute the cut, then LMB right away again to accept it in the center point without sliding.

For now though, let's slide that cut very near to one of the existing sides of the cube. As you do this, you'll notice that the very curved surface of the subdivision "ball" begins to flatten in that direction. This is one of the foundations of modeling objects with subdivision surfaces—controlling the "roundness" of corners by cutting and sliding edge loops.

The result of doing this is shown in Figure 4.24.

It should be fairly obvious how we'll proceed. Make another edge loop cut down the middle of the cube, more or less in the same place as the original, and push it in the other direction, giving you a subsurfaced object with two relatively flat ends. If you would like to adjust the sharpness or roundness of the object at any time, all you need to do is Edge Loop select (Alt-RMB) one of the loops and use the Edge Slide command to move it closer to or farther from the outside edge. Edge Slide is the standalone version of the last step of the Loop Cut tool. It can be accessed by selecting an edge loop and pressing the E key to pop up the Edge Specials menu in the 3D view.

Add two more loop cuts, this time perpendicular to the originals, sliding each to opposite ends of the seat. You'll see that the Loop Cut tool has no problem cutting across the extra geometry, and Edge Slide works just as well too. When you have these two new cuts made and positioned, you should have something that looks similar to Figure 4.25. If you want to get fancy with this step, you can try making two loop

cuts at once, then sliding them individually. To do this, use Ctrl-R to ask for a loop cut, and before you LMB to accept, roll the scroll wheel. This changes the number of cuts interactively. Pressing LMB now makes all of those cuts at once!

When you are box modeling, it pays to think ahead. It would be nice to press the center of the seat downward right now so whoever is going to sit in the chair can enjoy a bit more comfort than, say, sitting on a perfectly flat concrete floor would provide. There are a number

**Figure 4.25** *Four loop cuts made and positioned.*

of ways to do this, but as I said, let's think ahead. We know that our chair is going to need both a back and four legs. Since we are box modeling, that new geometry will need to be extruded from the seat itself. Take a look back at Figure 4.22. We are going to need available faces on the top and bottom of the seat of the appropriate size and location to do our eventual extrusion. Since we know we're going to need them anyway, let's make the cuts that provide the proper geometry to do this right now.

The process is actually a repeat of what you've just done. Two more loop cuts in each direction, slid toward the edges. The goal is to get four nice little "launching pads" for the extrusion that we'll be doing to make the chair legs. And if it turns out that we've made them too large or too small? No problem. Sliding a few edges will nondestructively fix the problem. Figure 4.26 shows the model with these four

new edge loops cut and positioned. The new edge loops are selected, and the squares that will be used for later extrusion are highlighted.

With those cuts made, let's pull the center of the seat down. Switch to Face select mode (Ctrl-Tab or header button). This is the first time we've used this mode, and you'll see that each face has a nice little dot in its center. You can select a whole face in this mode by just RMB clicking anywhere in the face. When using either the Selection brush (C key) or Border Select (B key), however, the center point of a face must be within the defined area in order to be selected.

**Figure 4.26** *Four new cuts added for later.*

Select the large central face on the top side of the seat. Extrude the face with the E key, and immediately switch to scaling mode with the S key. Make it a bit smaller, then accept the transform with the LMB. The new face is surrounded by four new faces that look like a type of picture frame. This technique is great for adding windows and doorways to walls or any time you need to punch a hole through a quadrangular face without adding a bunch of extra geometry.

Use the G key (along with the Z key to constrain the motion) to pull that new central face down a bit. Toggle out of Edit mode for a moment to see what the new surface looks like without the mesh cage surrounding it.

Let's add the legs. Use your MMB to rotate the view so the underside of the seat is showing. Make sure that you are now working in Solid view mode, and that the Occlude Background Geometry button on the 3D view header is enabled. It is located immediately to the right of the Vertex/Edge/Face selection controls. When enabled, it prevents you from seeing through your model while you work and further prevents you from accidentally selecting elements on the opposite side.

In Face select mode, select the four quadrangles that we designated in Figure 4.26. You'll grow the chair's legs from them. Press the E key to extrude, followed by the Z key twice to make sure the new geometry moves straight down. Once you've confirmed the extrusion and placement with the LMB, a problem arises. The legs look … bad. They are fat and rounded at the tops and have tiny points that don't even reach the whole way to the end of the mesh cage on the bottom. The solution? Loop cuts.

Using the same technique as you did when working with the seat, add three loop cuts to each leg:

- Don't forget to start in Edge select mode.
- Place a triple loop cut around the center of a leg.
- Alt-RMB select the top cut.
- Invoke Edge Slide from the Ctrl-E Edge Specials menu.
- This time, though, don't slide the edge with the mouse. From the keyboard, just enter ".9" (as in: point nine) and press the Enter key. This will slide the edge 90% of the way upward. We'll want to keep all of the legs the same, so it makes sense to do this procedure in an exactly repeatable fashion. If you had used the mouse, you would probably be close, but you would still just be eyeballing it.
- Alt-RMB select the lower cut. Invoke Edge Slide, but this time type "−.9" (minus point nine) and press Enter. This moves the lower cut almost next to the floor, giving this chair leg a much more pleasing form.

Do this same procedure for the other three legs. You can see a close-up of a finished leg in Figure 4.27. At this point, you can add some form and interest to the model by playing with the legs. Carefully observe a real example of the style of chair we're building. The legs usually splay out a bit at the bottom, covering slightly more space than the area of the seat.

Here's a cool trick for moving them all outward at once. You would think that the scale tool would be able to accomplish this, and it can. However, if you just select the bottom faces of the legs and hit the S key, they will move apart as you scale them up, but they will also grow in size. We'll try a new pivot style to solve the problem.

Beside the pivot style menu on the 3D view header is a button called Manipulate Object Centers Only. This magical button causes transformations to only affect object centers, not their component structures. The effect works both in Object mode and Edit mode. In this case, selecting the four faces on the bottoms of the legs and enabling Manipulate Object Centers Only will move the faces away from one another when scaling without actually changing their size. This is exactly what we want.

Make sure to also enable Proportional Editing Falloff (O key), or only the selected faces will move. With PEF turned on, it will pull the rest of the leg along with it. Do this now to move the bottoms of the legs away from the center. With the bottoms of the legs splayed a bit,

**Figure 4.27** *A cut and sharpened leg.*

let's reduce the size of those bottom faces (and everything else attached to them with PEF) so that the legs appear to taper as well. Turn off Manipulate Object Centers Only—this time we actually want to scale the structure itself, not just move it around. Change the pivot style to Individual Origins; this setting will scale (or rotate) the selected element as though it were the only one in the selection. In this example, it means that each of the four bottom faces will shrink in place, without the normal kind of contracting motion that a midpoint style pivot would bring.

Figure 4.28 shows the result of these last few scaling procedures.

The last thing to add is a back. You should know what to do now:

- Select and extrude upward two of the little "launch-pad" quadrangles we created earlier.
- Give each extruded piece of the backframe two loop cuts and slide them toward the tops and bottoms.

We now have two pieces of backframe sticking up, but nothing to join them. Add a double loop cut that runs along the inside and outside edges of these upper pieces. It will also run around the bottom of the chair and two of the legs. Then, make a single loop cut a little over halfway up on each of the risers. The result is shown in Figure 4.29. Select the upper interior face that is highlighted in the figure on each riser, then press Ctrl-Alt-F to execute the Bridge Faces command (also available from the Mesh > Faces menu). Blender builds geometry that connects the two faces, leaving them intact and selected. Use the X key to remove them, choosing Only Faces from the Delete menu when it pops up. Two loop cuts on this chair back, slid to the sides, finishes the basic form.

Select the upper interior face that is highlighted in Figure 4.29. Extrude it almost halfway toward the center of the space. Do the same with the opposing face on the other riser. Select and remove the two tall, inner-most faces so that the two sides of the chair back are open to one another. Finally, using vertex selection, select pairs of opposing vertices and Merge (Alt-M) them At Center, joining the separate pieces into a single chair back. Please check the Web Bucket for step-by-step illustrations of this process.

To get to the chair in the original illustration (Figure 4.22), you'll need to add a bit more detail. Do some loop cuts and scaling on the legs, and push some vertices around to shape the seat. Artistic decisions. But that's it.

In Section 4.5, we'll tackle using modifiers as a general modeling tool and assistant as we build the table to go along with this chair.

## Modeling with Modifiers

The table in Figure 4.30 appears to be fairly complex. Yet, it is made only with the techniques you've learned so far and a few more modifiers. We'll be building this in three sections as separate objects that will all be merged together in the end.

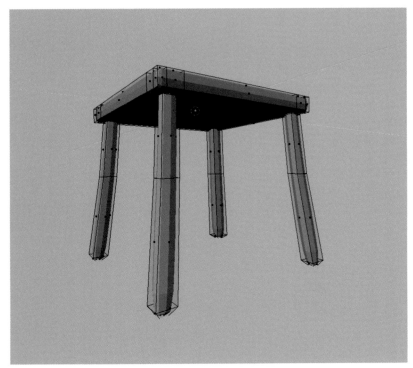

**Figure 4.28** *The chair with legs.*

**Figure 4.29** *Preparing to bridge the risers.*

Let's tackle the spiral center column first. Set the 3D cursor away from the objects you've already created so you have a relatively clear workspace. Begin in a top view and add a mesh circle. Drop its Vertices property in the Tweak Panel down to 16. You could keep the default value of 32, but there's no reason for that amount of resolution. It adds extra geometry without necessity.

Over in the Properties window, go to the Modifiers context and add a Mirror modifier from the Generate column. The Mirror modifier reflects a mesh around its center point. Enable the little triangle mesh button (labeled "F" in Figure 4.31). You can see the effect immediately by selecting all the vertices of the circle, and

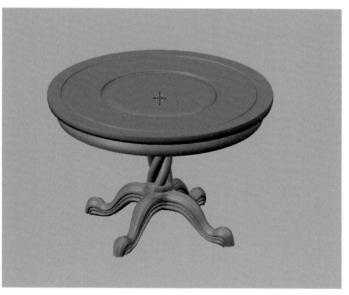

**Figure 4.30** *A table.*

G-key moving them either to the left or right. There are now two versions of the circle in opposing motion. The one that follows your mouse movements is the original; the one that moves against the motion is the live copy generated by the modifier.

---

**Note**

You can find out which context is which in the Properties windows by hovering your mouse over the icons in the window header. In the case of the Modifiers context, hovering over the little wrench icon the header shows the title "Modifiers."

---

Figure 4.31 shows the Mirror modifier panel. Let's examine the controls on the modifier's header, which are common to almost all modifiers. From left to right, the controls are:

- Collapse/Expand: The little triangle allows the modifier to be collapsed into just a title bar. This is useful when you have an entire stack of modifiers. It can get ugly.
- A—Icon: Represents the type of modifier.
- B—Name: You can give modifiers names. This is useful if you are writing scripts or browsing for information through an Outliner window.
- C—Render: Determines whether this modifier is considered when rendering.
- D—View: Whether or not the modifier is displayed in the 3D view. For certain modifiers that generate a lot of geometry, you may not want them cluttering your view and slowing down your display after you have it set up correctly. Disabling this button skips the modifier in the 3D view.
- E—Edit: Displays the results of the modifier while in Edit mode. Without this enabled, you wouldn't be able to see the mirrored circle while you are moving it.

- F—Direct Edit: This option has slightly different effects depending on which modifier you're using. Generally, it lets you treat any geometry generated by the modifier as though it were real, live geometry in Edit mode. For example, enabling Direct Edit on the current example will let you select vertices in either the "original" circle or in the "copy."
- G—Up/Down: Raises or lowers the modifier, if there are more than one. Modifiers are calculated and applied from the top down, and the results aren't always the same if you change the order.
- H—Delete.

In addition to those controls, each modifier has it's own set of buttons. In the case of the Mirror modifier, we are concerned with the axes buttons along the left. As a default, *x* is checked, which means that the mesh will mirror along the object's local *x* axis.

**Figure 4.31** *The Mirror modifier panel.*

LMB click the *y* axis button. You now have four versions of the circle, mirrored along two different axes. Moving the original around in Edit mode becomes kind of funkadelic.

So what good is this? Well, we're trying to make a shape like the one in Figure 4.32. Just four circles slightly intertwined. Sure, you could have created several duplicates of the circle and positioned them this way, but using the modifier and positioning all four intertwined like this is much more intuitive and faster.

Select and delete the vertices within the areas of intersection—you won't need them. We're going to extrude this whole form downward. Making sure that all the vertices are selected, switch to a side or front view and use the E key to extrude (constrain for downward motion with the Z key).

**Figure 4.32** *Four circles joined, extruded, and loop cut.*

You're going for something with about the same proportions as the column in Figure 4.32. Once you've accepted the extrusion with the LMB, try an experiment. Use the A key twice to select all and move the mesh around. You'll notice that the Mirror modifier is still active, and affects the newly extruded portions of the mesh as well as the original. This is what we meant earlier when we said that modifier effects were "live." They persist in their influence on a mesh, unlike a one-time use tool. Use the RMB to cancel any transformation you introduced while moving this column.

We would like to twist this object to look like the introductory figure, but to do that we'll need more geometry. It would be great to put a bunch of slices horizontally through the model, and you already know the tool that will do it. Use Ctrl-R and the mouse wheel to cut ten loops through the middle of the column. That should provide enough geometry for what we're about to do.

In the Properties window, add a new modifier from the Deform section: Simple Deform. Simple Deform lets you perform a number of interactive effects to your meshes: stretch, taper, bend, and twist. We are interested in the twist right now, but you can see the effects of the other Simple Deform methods in the Web Bucket for this chapter. While we're working with this modifier, jump out of Edit mode so the mesh structure doesn't obscure the effect of the modifier.

Right away, you can see the result of the modifier. The model twists a bit. Raise the Factor value until you like the effect. I've used 5 in my sample. Note that if you raise the factor too high, the level of geometry in the mesh won't be able to take the stress and things will begin to look ugly. The Limit controls act as percentage values between which the twist takes place. It defaults from 0.00 to 1.00 (0% to 100%), which means that the modifier affects the entire height of the model. For fun, try two experiments:

- Uncheck *x* and *y* on the Mirror modifier. The effects are still live, and the Simple Deform modifier below it still works on the unmirrored mesh. Reenable *x* and *y* on the Mirror modifier.

- Use the Up/Down control on the Simple Deform modifier to move it up one slot, placing it above the Mirror modifier. This is a prime example of how modifier order matters. With the Simple Deform modifier first, followed by the Mirror modifier, the results are quite different. Figure 4.33

**Figure 4.33** *Using modifiers in different orders can create different results.*

shows the difference. Once you're happy with the look of your twisting center column, use the Apply buttons on the modifiers. Start with the topmost modifier so that everything works properly. In fact, if you try to apply a modifier that isn't at the top of the stack, Blender will warn you that you might have some unexpected results.

The Apply button does just what you would think—bakes the effects of the modifier into the mesh. The generated (or changed) mesh effect is no longer "live." It is just a plain old mesh.

Make sure that you're not in Edit mode and add a new mesh plane to the scene. Move this object a bit below the column you just created. Rotate the plane in Edit mode so that it is facing directly forward. You can do this entirely from the keyboard by pressing the R key, X key, 90, and then Enter. Scale it so that its size relative to the column is close to the highlighted portion of Figure 4.34. Then, in Edge select mode select and delete the top edge of the plane (choose Edges from the Delete menu), leaving four vertices and three edges. Back in Vertex select mode, select one of those top remaining vertices.

**Figure 4.34** *A profile for extruding the table legs.*

Figure 4.34 shows one possible way to redraw the top of the plane. The exact configuration doesn't matter. The goal is just to make it a bit interesting. Use Ctrl-LMB to add vertices, creating a new top for the plane. To close the outline, select your last drawn vertex, Shift-RMB select the other top vertex of the plane, and use the F key to bridge the gap.

Switch to a side view, select that profile, and begin the following process:

1. Extrude (E key).
2. Move a bit.
3. Rotate (R key) and Scale (S key).
4. Repeat.

**Figure 4.35** *A single table leg.*

The sequence is shown in Figure 4.35 for using this process to create a nicely detailed table leg. By carefully (or even uncarefully) creating a base object and extruding and rotating it several times, you can create some fairly detailed objects.

Let's use a new modifier to create rotated copies of the leg around the base. For this kind of operation, placement is critical. You may or may not have positioned the leg you created below the column perfectly in line with the column's center. For the next thing we do, we need to be sure it is centered. To position the leg, we'll use Blender's Copy Location tool. First, select the leg, then Shift-RMB select the column so that both are selected, but the column is active.

Unlike Copy and Paste in other programs, there is no Paste step in Blender. You simply select your objects, make the "master" or "source" object active, and copy. The Paste step is automatically applied to all selected objects. In this case, we just want to get the leg squarely centered on the column, so bring up the N-key properties panel in the 3D view and RMB click over any of the Location values of the column. A menu pops up with lots of options. Choose Copy to Selected. The table leg should jump to the top of the column so that their object centers are in the same location.

While you're there, use the Snap menu (Shift-S) to bring the 3D cursor to the same location. We'll need it in a bit. Choose either Cursor to Active or Cursor to Selected from the menu that pops up.

Reselect the leg (just RMB on it so the selection of the column is cleared) and G-key move it orthogonally (either left/right or up/down) into a position like the one shown in Figure 4.36.

In the Properties window, add an Array modifier. The Array modifier is complex and powerful. Its general purpose is to create offset duplicates of an object. Those duplicates can be independent of each other, connected into a single large object, spread out, overlapped, rotated, or scaled. All of these properties can be animated, which gives Array some fantastic capabilities. In fact, check the Web Bucket for the animation called *array_craziness* to see what the effect of just Array modifiers and two animated Empties can do.

As it is a powerful modeling tool, we'll spend a bit of time looking at it. The default Array modifier is shown in Figure 4.37.

**Figure 4.36** *One table leg positioned to the bottom.*

When it is added, the Array modifier has Constant Offset enabled. This setting tells the modifier to create copies of the object in question at a constant distance from one another. Obviously, the Count property indicates exactly how many object copies to create. Adjusting the $x$, $y$, and $z$ values under Constant Offset changes the distance. This is appropriate for creating, for example, the rungs of a ladder, which are a constant, measurable distance apart.

What if you want the copies to be set end-to-end, though, without gaps? You could determine the exact size of the object in the N-key properties panel and use that value in the Constant Offset section. Or, you could disable Constant, and turn on Relative Offset. The $x$, $y$, and $z$ values in Relative Offset refer not to any specific measurement but to the dimensions of the object itself. Thus, a Relative Offset of $x = 1$ would place each copy exactly one full "object" to the right of the original. Depending on the shape of the model itself, this might create a continuous surface. Relative Offset is perfect for creating repeating patterns with meshes. Two Array modifiers on top of one another, one set to Relative X and one set to Relative Y offset, quickly creates a parquet-style floor from a single tile model, as shown in Figure 4.38. The great thing about modeling with Relative Offset is that you don't have to worry about the exact dimensions of your arrayed model. As you change the shape and size, the Array modifier adjusts to accommodate.

The last way of creating offset is the most flexible: Add Offset Object. When this is enabled and a valid object is entered in the data field, array becomes a bit mind-boggling. Offset Object uses the difference in

**Figure 4.37** *Default Array modifier.*

**Figure 4.38** *A parquet floor with a ladder, done with the Array modifier.*

transformation between the main model and the offset object. For example, an Empty that is 1 unit to the right of the object's center would be the same as a Constant Offset value of $x = 1$, stepping each copy one unit to the right. The cool thing about Offset Object is that you don't have to stick to just translation. Rotation and scaling are fair game. So, by putting the Empty 1 unit to the right, rotating it a bit, and scaling it slightly down, you create a curving array of smaller and smaller objects. If you want to animate the Empty ... well, that's what was done to make the video in the Web Bucket.

We're going to use this technique to create four versions of the table leg, arrayed around the bottom of the column. If you just thought to yourself "I could just use the spin tool to do this," then good for you. And please be quiet. We're learning the array modifier right now. You already have the 3D cursor centered on the column (You are truly smart!), so add an Empty to the scene right there. Select the table leg, turn off Constant Offset on its Array modifier, and enable Add Offset Object. Enter "Empty" into the data field below it or select it from the list. Set the Count value to 4. Not quite what we expected. The table legs array way up into the air. Reselect the Empty and, in a top view, rotate it 90 degrees around the $z$ axis. Figure 4.39

shows what it looks like after first adding the offset object. At this point, you can fix the positioning problem by simply moving the Empty around a bit, but there is a better, more exact way to do it, as follows.

RMB select the table leg and change its Object Center to the location of the cursor. As you learned in Chapter 3, object centers often act as a pivot or reference point for an object, and are usually found "inside" of the surfaces of a mesh. They do not have to be. Recall that the Array modifier's Offset Object works relative to the Object Center. Changing the location of the Object Center changes that relationship.

So, using Set Center (Shift-Ctrl-Alt-C) and selecting Origin to 3D cursor from the menu that pops up immediately sets things right. Remember though, that as long as the modifier is live (not applied) you will need to move both the leg and Empty together if you need to reposition the whole structure, as the array values are built between the difference in location of the leg and Empty. And, since

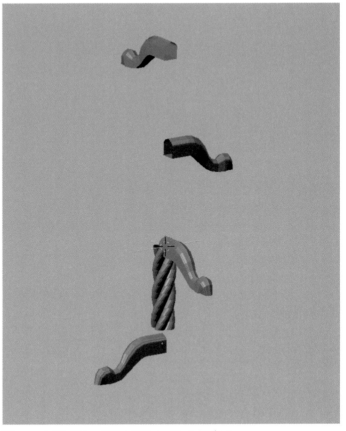

**Figure 4.39** *Using Offset Object with the table leg.*

the Array modifier works on the existing mesh data, you can still change the leg model itself—enhancing it possibly—and have those changes reflected in all four copies in real time. For the final model in the example scene, a little more geometry has been added to fill out this part of the base. It's actually kind of fun to model on an arrayed object and watch your actions take place across the entire array.

There are two more modifiers and one more tool to learn, on one more section of the table: the top. Go into a top view and add a mesh tube as a new object. Scale it overall so that the boundaries of the cylinder extend just past the limits of the table legs. Then, scale it down in the *z* direction (S key, Z key) so that it looks to be a reasonable thickness for a tabletop. It will look like Figure 4.40 when in Edit mode.

The first thing we're going to do is add a little detail to the upper surface. If you try to loop cut on the tabletop, you'll see that it doesn't work. That's because the way the triangular faces are arranged in "pie" format doesn't actually qualify as a loop. We need another way to cut into a mesh.

Hold down the K key and drag across the model (anywhere) with the LMB. It traces a little line. When you release the mouse button, any selected parts of the mesh are sliced wherever you crossed them. This is the Knife tool. In its default mode, Knife will cut any selected edge that it crosses at the first point of crossing.

That is, if you drag the Knife tool across an edge once, then switch back and cross it again, only the first crossing is used for the cut. This is great if you need to cut a specific shape or line into a mesh. For our purposes, it's kind of useless. We want a nice, round cut through the edges without having to painstakingly draw it. Undo that test cut. Holding down the K key, drag the knife in a circle around the tabletop.

Knife has another mode called Midpoint. Simply change the Type setting in the Tweak Panel to Midpoint, and the cut now resembles the one in Figure 4.41. Regardless of where the edge is actually crossed with the knife, the cut is made on the edge's midpoint. In this case, the knife tool is just a general indicator of which edges you would like to have cut, not where you would like them to be cut.

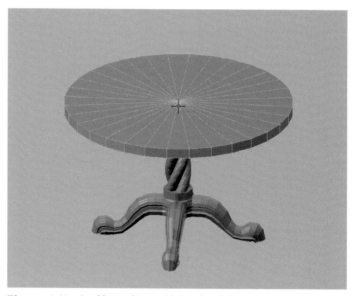

Figure 4.40 *A tabletop object, added and scaled.*

Between this new ring of edges and the outer edge of the cylinder use the Loop Cut tool (Ctrl-R) to add another circle. This time it works, as we're adding a loop to a true ring of faces. It was the central, shared point of the pie formation that was messing things up. Use Edge Slide (Ctrl-E) to move this fairly close to the first cut. In Face select mode, use Alt-RMB to select the thin ring of faces you've just created. Use the E key to extrude them downward (constrain with the Z key), making a little indentation in the table.

If you like you can make two more loop cuts near the edge of the table and use

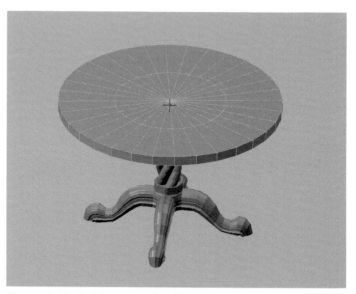

Figure 4.41 *A circle cut into the tabletop.*

the same procedure to add a little more visual interest to the model. You can see that this is what was done to the example file back in Figure 4.30.

Finally, go to the Properties window and add a new modifier: Bevel. Bevel places a nice, well-beveled edge on your models. Beveling is very useful when it comes time to render objects. Almost nothing in

the real world has a perfectly turned corner or edge. Glass can. Finely honed, hard metals, possibly. Everything else exhibits a slight rounding on what we would normally consider a sharp edge. In the real world, this grants a certain high-lighting style to most things we see. Our brains don't perceive that tiny surface as there, but we sure miss it when it isn't. Beveling objects in your scene that have "sharp" edges but that aren't made from very hard materials will increase the believability of your renders. You don't need to go crazy with it, but a little can

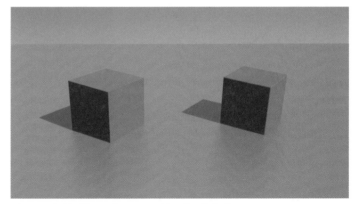

**Figure 4.42** *Two cubes, one with a beveled edge.*

make a big difference. Figure 4.42 shows two simple cubes, one beveled, one not. Believe it or not, that subtle bit of shading along the edge of the beveled cube on the left can make a huge difference in the eventual quality of your renders.

In its default state the Bevel modifier will put a bevel on every edge in the entire object, even ones that lie along a flat surface. This is a waste. Ideally, we'd like to just bevel the more pronounced edges of the object. Switching the Limit Method of the modifier to Angle allows you to do this. Simply choose the minimum angle for a bevel in the Angle property, and you're set.

## Putting the Table Together

So you now have three different sections of a table: the top, the legs, and a center column. Before you join them, select each one individually and apply any modifiers that remain in effect. Remember to apply them from top to bottom to maintain the proper order of effects. When all of the modifiers for all three objects have been applied, it's time to put them together.

RMB select one of the objects, then Shift-RMB select the other two so that all three are a part of the selection. Ctrl-J, the Join operation, merges the objects into a single mesh. Depending on your smoothing settings, you may or may not see a difference in appearance when you join the objects. They will all take on the smoothing and shading attributes of whichever object was active in the selection.

To even out the appearance, let's use that last modifier we mentioned earlier. In Object mode, use the Smooth tool from the Shading section of the tool shelf. Most likely, this will make your model look a bit odd. Even very sharp edges are shaded "smooth," which doesn't look right. In the Properties window, give this table object an Edge Split modifier.

Edge Split does the hard work of breaking up the shading surfaces of your model. With an entire model set to Smooth shading, Edge Split allows you to set an angle at which smooth shading breaks. In the case of our table, the default works fine. Surfaces that should be smoothed appear to be so, while edges appear as actual edges. If you run into complex cases where you want to define nonsmoothing edges more exactly,

you can select edges in Edit mode and mark them by hand as Sharp through the Ctrl-E Edge Specials menu. As a final step, we've added a Subdivision Surface modifier above Edge Split, to round out the pointy edges on the top and legs. Putting the Edge Split modifier below the Subdivision Surface will cause something entirely different (Try it!), which shows how important it is to have your modifier stack in the proper order.

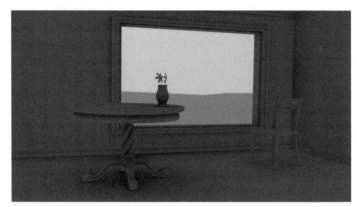

**Figure 4.43** *The finished models.*

## Assembling the Room

This shouldn't be too hard. Using the G, R, and S keys, assemble the different objects you've modeled (Yeah you!) into a pleasing configuration. My suggestion is that you mimic the example scene, although you don't have to. I'm not going to show up at your house to check. We'll tackle adding a character in Chapter 5.

Oh, before we move on, add a cube to your scene and kill off one of the upper vertices to make it a three-faced hemi-cube. In Face mode, select one of the vertical "walls," extrude and scale it smaller, like you did with the seat of the chair. Delete this new face, creating a window. You can choose to leave the room itself in this simple state. For the example scene, we use the edges around the window, floor, and ceiling to extrude some trim. Figure 4.43 shows all of the models in the room, including some simple trim that I added, with basic shading and nondirectional illumination.

Now, we're ready to continue.

## What We Missed

Models aren't restricted to meshes. Blender allows the use of different kinds of renderable objects such as Bezier and NURBS curves and surfaces, meatballs, and text. Obviously, the Modifiers panel contains a great number of options we didn't explore. A lot of useful selection methods can be found and tested in the Select header menu. An entire Snapping system is available through the magnet icon and accompanying pop-up menu on the header that lets you do things like interactively snap transforming vertices to surfaces, points, and other targets. You know enough to do some experimentation on your own now and to actually get something out of it. Go for it.

## Next Up ...

In Chapter 5, we learn how to add lamps to produce lighting schemes for indoor and outdoor situations.

# Chapter 5

## Lighting: The Easiest Thing That's Tough

Blender's lighting tools are simple and fall into two categories: directional lighting, which is created by lamp objects, and nondirectional lighting, which is generated with a technique called ambient occlusion. It's "simple" in that the tools have only a few settings, and all work in the same basic way. In other words, it is not difficult to use them.

The downside of it is that effective, quality lighting is difficult. It's hard enough to properly and nicely light a scene in real life where the universe itself takes care of a bunch of the things we take for granted: atmospheric scattering, diffuse reflection, filtering, etc. In the land of numbers, triangles, and tricks that is 3D, it becomes even more difficult. Figure 5.1 shows what happens when we place a simple light source outside of a window in a room scene. Notice how it doesn't look anything remotely like what would happen in the real world. No air or dust scatters the light as it enters the window. The light that hits the far wall is not bounced and rebounced around the room, leaving anything not directly in its path completely black. Objects that *are* directly in its path cast no shadows. We have to take on all of these kinds of things on our own.

Before we get into learning to play with Blender's lighting tools, let's take a moment to understand the importance of lighting in a scene. It's simple, really. The wrong lighting will ruin a shot, regardless of how fantastic your modeling and surfacing. The right lighting won't turn bad modeling and surfacing into something that goes into a museum, but it might get you halfway there. Lighting sets the mood. It gives us more environmental clues that can make or break the illusion of believability than any other aspect of a scene. It quite literally determines what parts of your work are seen, and what parts are not.

You might be wondering why we are lighting a scene with only bare objects. We've not done any surfacing—materials and texturing—and have not really finished modeling yet. There are two reasons for this. First, if you can light a scene effectively without any custom surfacing, you know you have done it right. If you can convey the mood and setting of the scene properly through the lighting alone, then your job

is almost done. Second, materials will appear differently under different lighting conditions. Few things in 3D are worse than spending hours surfacing your models under a studio-style lighting setup, only to learn that everything looks wrong under the final light structure of your scene.

Do your lighting first, and make it good.

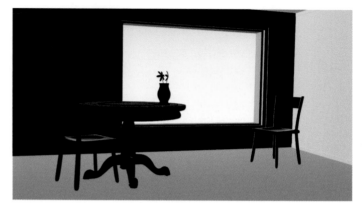

**Figure 5.1** *The limits of working in 3D.*

## The Tools: Directional Lighting

You get out of bed in the middle of the night. It's dark. You can't see. You turn on a lamp. That's about as simple as it gets in real life, but it's not quite so easy in 3D. Light isn't real there. It doesn't have physical properties. In the end, it's just the processor figuring out which triangles are where, whether they can see any lights from their point of view, and how they are oriented. Different aspects of lighting that we take for granted, such as shadows or the way that a large light source makes things look differently than a small one, can cost the computer lots of time and cycles to calculate. In order to keep those calculations to a minimum, 3D applications give you a choice of a number of different kinds of lights. Each are optimized for certain tasks. Let's take a look.

### Point Lamp

The point lamp is the simplest kind of light source available in Blender. You can see both the lamp's 3D representation and its control panel from the Properties window in Figure 5.2.

Lamps are added to your scene just like any other object: **Shift-A**. They appear at the 3D cursor, as you would expect. There are a number of organizational and workflow controls on the panel. The top row of buttons allow you to switch an object from one lamp type to another, should you change your mind after adding the lamp to the scene. The checkboxes labeled "Negative," "This Layer Only," "Specular," and "Diffuse" will all be discussed later. For now, the three most important controls are **Color, Energy,** and **Distance**. These are common to all of the lamp types.

### Color

LMB clicking on the color swatch brings up Blender's color picker. It is similar to color pickers from just about every application you've ever used, from Word to Photoshop. Set your Color values by LMB dragging inside the color wheel and adjusting the vertical value slider, or by setting the RGB values below it. The default color for all lamps is white, represented in RGB as (1,1,1). Almost no light you will ever encounter in real life is purely white. Don't let it happen in your scene. Take a hard look at the color of the light source's real-life equivalent (unless it's the sun!) and the apparent color of the light that it casts. Set your 3D light accordingly.

Resist the temptation to overdo it. You might set the color swatch appropriately, then see it in your scene and think "You can't even tell it's not white!" and want to really crank up the color. Ironically, not being able to notice it probably means that you've done it properly, as under most circumstances our eyes correct for nonwhite lighting in the real world.

### Energy

From 0.0 to 10.0, the Energy value is how much actual light the lamp flings off. The default is 1.0. Too much energy will create "blow-outs," regions in an image where the lighting is so intense that everything within it becomes white and all detail is lost. Figure 5.3 shows this effect. This happens in real life, too, and you will sometimes see it in styled photography. However, we're not recreating real life, remember? While you *sometimes* see this in professional imaging, it's rare, and you should avoid it.

Here's where it gets complicated. While the Energy value certainly has an effect on how things are lit, it works in conjunction with the next control, Falloff Distance, and the actual distance between the lamp and the objects in your scene. The relationship between these three factors can be tricky to manage, and

**Figure 5.2** *A point lamp and its controls.*

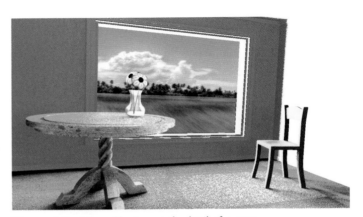

**Figure 5.3** *A lamp blowing out the detail of a scene.*

doing so correctly will go a long way toward believability. We'll talk about this little love triangle after we finish with the tools rundown.

### Distance

This is a value in Blender units that indicates the Falloff Distance of the light. At the value of the Distance control, the energy from the lamp will be exactly half of its normal energy setting. An object that is 10.0 units away from a lamp of which the Energy value is 4.0 and the Distance value is 10.0, would actually receive light energy of 2.0. Increasing or decreasing this value will drastically affect the way that your lamp behaves and the look of your scene.

Note the illustrated arrows in Figure 5.2, all pointing away from the lamp in the 3D view. Point lamps shine their light in all directions, emanating from the center of the object itself.

The next panel down in Figure 5.2 is titled **Shadow**. Unlike the real world, shadows are an option in 3D. There are two main ways to compute shadows, techniques called **ray tracing** and **buffering**. Ray tracing generally takes longer, and produces perfectly sharp shadows that are unlike almost anything in nature. Buffering, though usually faster, has a number of technical drawbacks that make it only appropriate for one type of lamp: the spot. We'll save the buffering options until we work with spots.

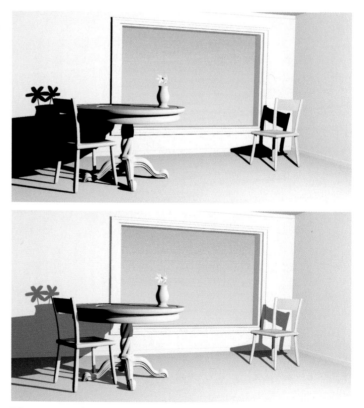

In order to turn on ray-traced shadows for a point lamp, you just LMB click the **Ray Shadow** button. There aren't that many options that we'll use at this stage. The only one you might need to know is to control **shadow color**. LMB clicking the shadow color swatch allows you to change the base color of the shadows cast by your lamp. Figure 5.4 shows the same scene, one with normal black shadows (RGB, 0,0,0) and one with the shadows made less "intense" with a bluish gray (RGB, 0.3, 0.3, 1). That's a pretty neat feature, don't you think? Who would have come up with such a cool thing? Why, that was me, thank you very much.

Unless you have a specific reason to do so, you probably will not be using ray-traced shadows on a point lamp.

**Figure 5.4** *Changing the apparent "density" of a shadow with shadow color.*

Point lamps are good for subtly brightening areas that do not receive enough light due to shadows and lamp distance. Remember that areas that fall within shadows will not be receiving bounced light from other sources.

### Sun Lamp

Figure 5.5 shows the control panel for working with sun lamps, beside its representation in the 3D view. Unlike a point lamp, the actual location of the sun lamp in a scene doesn't matter, only the orientation. The sun lamp has a dashed line extending below it. This line indicates the direction in which the "sun" is pointing. You change the orientation of this line with the R key, as a standard object rotation.

**Figure 5.5** *The sun lamp control panel.*

When a sun lamp is added to a scene, it provides uniform illumination in a single direction. With the Ray Shadow option enabled, this is easy to see, as all of the shadows in the scene are parallel. Shadows from lamps that are location-dependent always diverge. You can see the difference in Figure 5.6.

Because the location of the sun lamp is not taken into account, there is no Distance control.

Sun lamps are good for outdoor lighting, to mimic the very distant sun.

### Hemi Lamp

Figure 5.7 shows the hemi lamp in the 3D view, with its accompanying control panel. Like the sun lamp, they are not location-dependent. Only their orientation matters. Hemi lamps come with only two controls: Energy and Color.

The purpose of a hemi lamp is to provide a controllable, directable level of overall lighting. There will be many situations in which, due to shadowing, there are areas of your scene that don't receive direct light. One of the ways to prevent those areas from appearing completely black is to use one or more hemi lamps.

Here's how they work: Hemi lamps provide illumination on each object in a scene as though they were individually surrounded by a large glowing hemisphere (like the sky), with its open end facing in the direction of the lamp. While it would be great to just assign a light-blue hemi lamp pointing straight down

and have it light things up like the real sky, there is a drawback. Hemi lamps do not cast shadows. So, an outdoor scene lit with only a hemi lamp appears flat and completely unrealistic, like Figure 5.8. For that reason, hemi lamps are inadequate for the main lighting in a scene.

However, this does not mean that hemi lamps are useless. For example, in an outdoor scene with a strong sun lamp, extra illumination can be added by using a downward-facing light-blue hemi lamp and an upward-facing green hemi lamp. The blue is for the sky, while the green gives objects a downward tint as though light were reflecting off the green grass. When using hemi lamps like this, start your Energy settings very low: in the 0.1–0.3 range.

Hemi lamps are good for providing a baseline, directional illumination to scenes.

### Area Lamp

Figure 5.9 shows an area lamp and its controls. Clearly, there is a little more

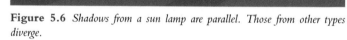

**Figure 5.6** *Shadows from a sun lamp are parallel. Those from other types diverge.*

going on here. Area lamps have a Distance control, which means that their location affects the scene (unlike hemi or sun lamps). Unlike the point lamp, the direction that an area lamp is pointing is important. They only cast light in the way they are oriented.

Area lamps have two controls on the **Area Shape** panel, one a toggle between square and rectangular, the other a size control. Unlike every other lamp type, area lamps have a physical size. This is because they are used to represent light that emanates from an entire area, like a window or a large ceiling fixture.

You can see the visualization of the area lamp's size in the 3D view portion of Figure 5.9. When set to **Square**, a single value controls its size. Used as a **Rectangle**, you can adjust height and width independently. Feedback in the 3D view is immediate, so you really don't need to worry which of the rectangle's axes is which when your lamp is rotated at an odd angle. It will be obvious as you adjust the controls.

Area lamps with Ray Shadow enabled can provide some of the most realistic shadowing effects available within Blender's renderer. While the standard ray shadows that are available to the other lamps produce hard-edged shadows, altering the **Samples** value in the Shadow panel for area lamps can produce excel-

lent, albeit somewhat slow, results. Figure 5.10 demonstrates the shadowing produced with this technique. Note that the higher you set the Samples value, the smoother and less grainy your shadows will appear, but they will take appreciably longer to render.

In animation work, area lamps without shadows are good for simulating direct lighting from open windows, light from large signs, and light reflected from flat surfaces like walls or floor. In nonanimation (still) work, where render time is less of a factor, area lamps with shadows and high sample levels are excel-

**Figure 5.7** *A hemi lamp and controls.*

lent for realistic lighting, especially when mimicking studio lighting rigs and professional photographic settings.

## Spot Lamp

Figure 5.11 shows the workhorse of Blender lighting: the spot lamp. Spot lamps have the unique capability to cast **buffered shadows**. Unlike ray-traced shadows, buffered shadows can be nicely softened to get closer to real-world shadowing. However, they are not as precise and sometimes require careful tuning to get good results.

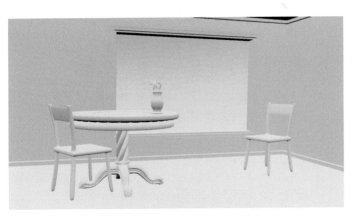

**Figure 5.8** *A single hemi lamp provides crummy lighting.*

The first thing you notice about a spot lamp is the large cone descending from it. This cone is a representation of the boundaries of the lamp. If an object falls outside of the cone, it will receive no light. This holds true for the end of the cone, as well. While the Distance value on other lamps describes the distance at which light energy is halved, in a spot lamp, it indicates the end of illumination.

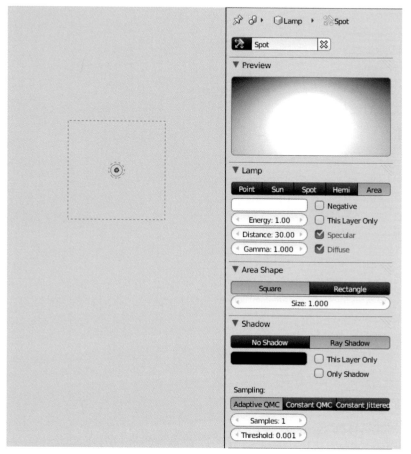

**Figure 5.9** *An area lamp and its controls.*

The cone can be made larger or smaller by adjusting the **Size** control on the **Spot Shape** panel. Spot lamps default to a 45-degree coverage, but can range anywhere from 1 to 180 degrees. Note that in the upper ranges (above 130 degrees), the quality of shadows drops off noticeably. The outer edge of the light cast by a spot lamp can be either hard or soft, as seen in Figure 5.12. This property is controlled by the **Blend** control on the Spot Shape panel. A blend value of 0.0 puts a hard edge on the light, while a value of 1.0 blends smoothly from the outer edge the whole way to the center.

That brings us to buffered shadows, which have a metric ton of options. Yes, you can use ray shadows with spot lamps, but the options for that are the same as those for every other lamp. As for the four different **Buffer Types** present in the **Shadow** panel, we're only going to concern ourselves with two of them: classic-halfway and deep. Their controls are mostly the same, though, so really we're only learning one thing. Regarding the two other buffer types, classic has really been supplanted by classic-halfway and

is only there for backwards compatibility, and irregular is for special-use cases that you won't run into for years, if ever.

So that you can understand the settings involved, here is a brief explanation of how shadow buffering works. For each shadow-buffered lamp in the scene, a mini render is done from its perspective showing which objects it can see, and how far away they are. This is saved as a type of image called a **shadow map**. When the final render for the scene occurs, the renderer checks every surface to see where it falls in that shadow map, and how far away it is from the lamp in relation to the object saved in the map. If it's farther away from the lamp than the map object, it's considered in shadow.

All of the settings in the buffering section of the Shadow panel deal with the creation and application of this shadow image map. These controls have to be set up just right to give good results. You can look at Figure 5.11 for the default values. They aren't terrible, but I have my own set of defaults when working with buffered shadows, shown in Figure 5.13. Here's an analysis of these controls, and why I start where I do.

### Size

This is the actual size in pixels of the shadow map. Obviously, the higher this number, the more detail the map can contain, just like a high-resolution image of a forest has a better chance of showing

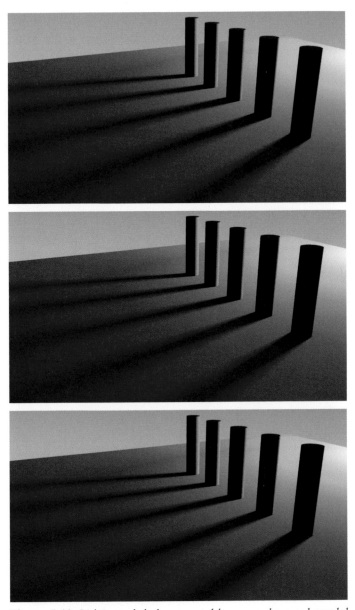

**Figure 5.10** *Lighting and shadow generated by an area lamp and sampled shadowing.*

the individual leaves than a low-resolution copy. If you will be heavily blurring the shadows or have no detailed elements in your scene, you can afford to go lower. However, if you have a lot of fine detail that must show in the shape of a cast shadow, you will want to go higher. Some of the shadow lamps in previous Foundation productions used maps of up to 8,000 pixels across. When building your

**Figure 5.11** *The spot lamp.*

own, start with 2048. If you're missing detail, make it bigger, but the odds are that things will be fine at this level.

### Samples

When the shadow map is generated, there will be times when more than one object's surface comes together on a single pixel of the shadow map. Which one surface should it choose? The answer is that it doesn't. Blender would prefer to take samples of different surfaces and try to give you a blended result. If you have a sample value higher than 1, it will make that number of tests and average the results. I never

use a shadow lamp with a sample value below 8, and often push it up to the maximum value, 16, for final renders. If you begin to notice banding in your shadows, raising the sample value can help to fix it.

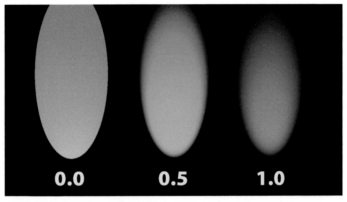

**Figure 5.12** *Different blend values.*

### Soft

This controls the fuzziness of the cast shadow. Technically, soft represents the sampling area during map creation, but the end result is that low values (1.0) produce fairly sharp-edged shadows, while higher values (8 and up) make softer edges. When choosing a Softness value, consider how the shadow would look if cast in the real world. Few shadows, even those from direct sunlight on a clear day, are perfectly sharp. Several factors control real-world shadow sharpness, including the size of the apparent light source (remember that only the area lamp has a "size" in Blender) and the distance from the shadow-casting object to the receiver. A larger light source and a larger distance both lead to softer shadows. Note that a high Softness value with a low Samples value will produce bad results.

### Bias

Many rendering computations have a fudge factor thrown in, in case things just aren't working properly. In the case of buffered shadows, this is called **Bias**. Basically, you should try to keep the Bias value as low as possible, beginning around 0.2. Make it smaller, if you can get away with it. How will you know when it's too low? You'll begin to see tight concentric circles in the surfaces of your render, like the ones in Figure 5.14. If that happens, raise your Bias value. If the Bias value gets too high, cast shadows will appear not to touch their casting objects, which is fine if the object is flying, but bad if it's sitting on a surface.

**Figure 5.13** *My default shadow buffer settings.*

### Clipping

When a shadow map is being created, it has a limited range of values that it can use to represent distance. It doesn't use the actual distances, it just puts things into a set of distance categories. If you have a lamp

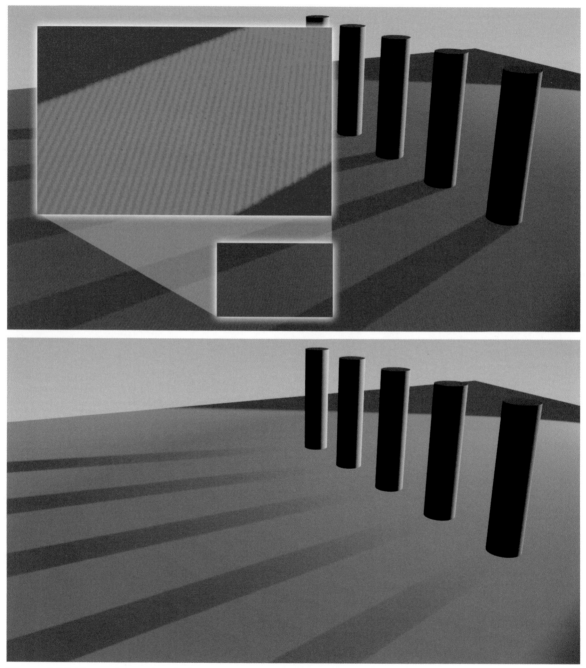

**Figure 5.14** *Bias too low, and too high.*

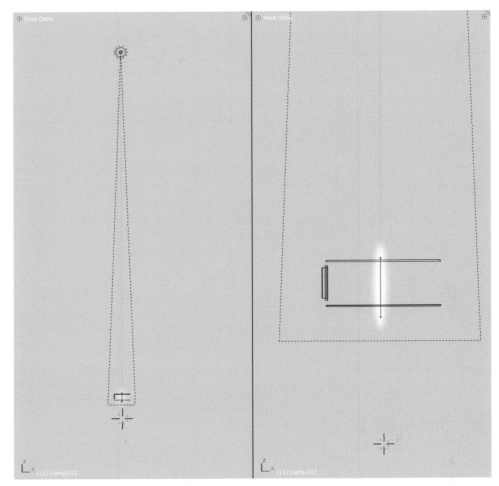

**Figure 5.15** *Clip values for a spot lamp.*

with a long reach, say across 300 units in your scene, it is probably going to end up grouping many of those things together into the same distance categories. That would lead to imprecise results. It would be nice to be able to tell the lamp to ignore anything outside of a certain range, and to use all of its distance categories for, say, just stuff inside this one room. The **Clip Start** and **Clip End** values do this very thing. Figure 5.15 shows a spot lamp very far away from a room. Note the small line down the center of the spot cone that begins and ends right outside of the room. This is the indicator for the clip area.

Any objects that the lamp encounters before the start value or after the end value are ignored for the purpose of shadow creation. The entire range of distances is allocated to the small area between the two, giving you much better shadow creation accuracy. The panel has "autoclip" buttons, but I don't recom-

mend that you use them. Set your start and end clips manually by adjusting the appropriate controls. The goal when doing this is to get the clip area as small as possible while still encompassing everything in your scene that needs to cast and receive shadows.

### Filter Type

I prefer to use the Gaussian filter type, which produces rounded smooth shadows. Both the tent and box filters tend to produce more angular results, with obvious beveling in the shadows at the corners.

### Deep Shadow Maps

I had mentioned that the other type of shadow map you might use is the deep shadow. Regular shadow maps have problems with transparent objects. All they know is that they've encountered a surface, so they mark it and move on. In real life, light shines through transparent objects, which can cast partial or even colored shadows. This is one of the problems that deep shadow maps strive to alleviate. If you need shadows to be cast by transparent objects, try switching to deep. Deep shadow maps also give significantly better results for elements like hair and fur, which we'll learn about in Chapter 6.

This map generation style uses significantly more memory and processing time than a standard map, but if you need those features, well, you need those features. When using a deep shadow map, reduce your size requirements. A standard map that looked acceptable at a buffer size of 2048 pixels will look nice as a deep map at only 512. Keeping standard sizing for deep maps will eat your RAM so quickly there'll be a sonic boom.

Those are the mechanics and controls for the directional lighting tools. We'll use them to light our room scene after we learn about the nondirectional tools.

## Nondirectional Lighting

Nondirectional lighting does not come from lamps. It is calculated as an overall solution for a scene. Some renderers include global illumination, which takes the actual effects of light transport into account. Blender is not one of these. To achieve a similar though inferior effect, Blender uses a technique called **Ambient Occlusion** (AO). A scene "lit" with AO looks as though it were outside on a thoroughly cloudy day. Figure 5.16 shows our scene lit with nothing but the **Environment Lighting** portion of AO.

As you can see, it's not bad. It provides overall illumination, while darkening creases and the places where objects contact one another. Although it isn't sufficient for any kind of believable work, it makes a great basis for an overall lighting solution. Environment Lighting settings are found in the **World** context

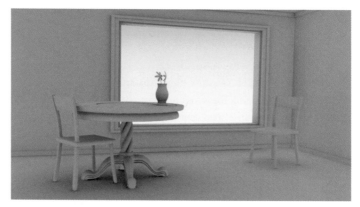

**Figure 5.16** *Environment Lighting with Ambient Occlusion.*

of the Properties window. It is enabled by checking the box next to the panel's title: Environment Lighting. Blender uses two different methods of calculating this lighting: ray tracing and approximate. The selector for which type to use is found on the **Gather** panel. "Gather" is a term taken from the backend processes of global illumination and environment lighting.

### Ray-Based Gathering

Ray-traced environment lighting can be pretty much fire and forget. You turn it on, the defaults are decent, and your render looks ten times better. In Figure 5.17, ray-traced environment lighting has been selected. The three main controls you should be concerned with are **Distance, Samples** (found on the Gather panel), and **Energy** (found on the Environment Lighting panel).

The Distance value tells the renderer how far away from a surface it should look for another surface before giving up. If it runs into nothing at all, then that point on the surface is considered fully illuminated. If it *does* run into something, though, how close it is determines how much illumination is taken away. So, by setting the Distance value, you determine how much light is put into tight spaces.

The best way to decide how to use this is to ask yourself, "In my scene, which two objects are the farthest apart, yet should still affect each other?" If we were to take the sample scene outdoors (i.e., removing the room), we would want the chair and the table to still affect each other. A quick measurement in the 3D view (by grabbing the table, moving

**Figure 5.17** *Ray-traced environment lighting controls.*

it on top of the chair, and noting the total distance moved on the header) shows that they are about 3.1 units apart. So, a Distance value of 3.1 is in order.

**Samples** controls the amount of graininess. If you do a render with Samples at 1, the result will be noisy, as you can see on the top portion of Figure 5.18. Samples cranked up to 32 (the maximum) creates a nicely smoothed result. The difference in render times is significant, though. Using ray-traced environment lighting at high sample levels will drastically increase your render times. If you're just using it to provide some underlying shading in a scene though, you can get away with lower values. The best general method of sampling is **Adaptive QMC** (Quasi-Monte Carlo sampling).

**Energy** controls the overall level of the effect. Higher values (over 2.0) will quickly blow every detail out of a scene. When working with environment lighting as a basis for an overall lighting scheme,

you will most likely keep this value below 0.75.

*Note:* Several times in this chapter, as well as the rest of this book, there will be cases (like Adaptive QMC in AO) where you are told to ignore several options. It is not that these options are completely useless. It's just that the differences are sometimes esoteric, and the use cases for these other controls and methods are rather small. If we had infinite time, this book could be an absolute reference for every single setting and control in Blender. As it is, we have to be satisfied with the knowledge that the things we're skipping are more advanced material, and that you have more important things to worry about at the moment.

### Approximate Environment Lighting

While Blender's ray tracer is certainly faster than it used to be, trying to implement ray-traced environment lighting in

**Figure 5.18** *Maximum and minimum sampling values for ray-traced environment lighting.*

an animation is probably going to take forever. The benefits of environment lighting though are so great that you might be loathe to surrender it. The approximate option can sometimes solve this dilemma. It's not as accurate as ray tracing, but for many cases, the results are quite acceptable and the speed increases are significant. Figure 5.16 shows the room scene using approximate environment lighting, and Figure 5.19 shows the settings I usually begin with.

As with ray-traced gathering, approximate also uses the same energy in the Environment Lighting panel value to set its overall level of effect. There may be some unique situations that need different settings, but the control panel in Figure 5.19 shows the starting point I've found works well in a great number of situations.

**Sampling Error** is the main value that balances quality with speed. Very low error values will cause render times to be on par with ray-traced gathering. In my own tests, I am often able to set this value as high as 0.50 and still achieve good results.

**Pixel Cache** should be enabled. Under most circumstances it will speed things up with no ill effects.

**Correction** takes care of one of the downsides of approximate gathering. The calculation is much less "intelligent" than ray tracing, and areas that have layers of faces can accidentally reinforce the shading

effect. When this happens, the correction value will help to fix it. When using environment lighting as a basis, starting with this value set to 1.0 (the maximum) will be fine.

**Color:** The system generally just adds "white" light to your scene. You can, however, use the sky color for a little more realism. By setting the Color control to Sky Color or Sky Texture, Blender will use the appropriate colors, as though the sky were truly illuminating the objects in the scene. In Figure 5.20, you can see the effects of using a sky with a blue zenith and green horizon. There are no other textures, colors, or lights in the scene. The colorization on the objects is entirely due to the environment lighting. Note that the Sky Texture option does not work with approximate gathering.

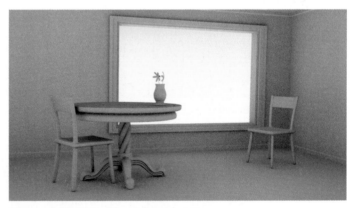

**Figure 5.19** *Approximate gathering controls.*

As you've looked at these panels, you've no doubt noticed the Ambient Occlusion and Indirect Lighting options. Ambient Occlusion is useful for adding the same type of inside angle shading you see with Environment Lighting, but without adding any additional light. If you are lighting your scene completely with traditional lamps, but would like the nice contact shading effect, use Ambient Occlusion. Indirect Lighting can actually simulate light bouncing, but is still under heavy development in Blender and not really ready for inclusion in your scenes at this point. Check the Web Bucket video *global_illumination_developments.mpeg* for the latest on developments in this area.

**Figure 5.20** *Using Sky Color with AO.*

## An Effective General Outdoor Lighting Setup

Let's move our scene outdoors for a moment. You can do this by selecting the room object and sending it to another layer with the M key. If you like, add a sphere (Shift-A), smooth it, scale it way up (S key), squash it in the *z* direction (S key, Z key), and move it down (G key, Z key) until it makes a nice ground for the table and chair to rest on.

For your reference throughout this section, Figure 5.21 shows the setup we'll be building in the 3D view. If you would like to see individual renders for each stage, you can grab them from the Web Bucket for this chapter.

In the world panel, enable Environment Lighting and set it to Approximate. Use the defaults from the last section: error at 0.5, Pixel Cache enabled, correction at 1.0, and Color set to Sky Color. Reduce Energy to 0.5. Why not use it at full strength (Energy at 1.0)? We will be using a sun lamp for the direct illumination, so the environment lighting will only fill in the places that the sun don't shine. Ahem. How bright should an area be that is in shadow, but fairly out in the open (i.e., the ground under the table)? 0.5 is a good starting point.

Before we even render this, let's set up the sky so that the Sky Color option makes a difference. Above the Ambient Occlusion panel on the World Properties is the main World panel. Color pickers allow you to set both the horizon and zenith (top of the sky) colors. For this test, I've chosen a light blue and a

**Figure 5.21** *The 3D structure of this setup.*

**Figure 5.21, cont'd**

dark blue, respectively. Also, **Blend Sky** and **Real Sky** have been enabled. Blend Sky causes the sky to blend between the horizon and zenith colors. Without this option, only the horizon color is used for the entire sky. Real Sky causes the horizon to correspond to the actual horizon in the 3D world (i.e., $z = 0$). Otherwise, the blend between the colors occurs simply from the bottom of the screen to the top, regardless of how the camera is oriented. Figure 5.22 shows the whole setup of the Environment Lighting panel we've just described.

Let's add the sun—Shift-A, and throw a sun into the sky. Actually, if you remember, it doesn't really matter where you put it, as long as you orient it properly. Let's pretend it's several hours before sunset, because midday lighting is generally boring. The sun should sit at about a 30-degree angle from the horizontal. Okay, I know that the positioning of the lamp doesn't matter to the final result, but it's the sun. I find it easier to set its orientation if I put it up in the sky. So, move it up, then position it somewhere nice in a top view. I've put mine off to the left of the scene. Now, use the R key in front, side, and top views to orient the sun lamp so it appears to be pointing toward the scene objects, like the sun in Figure 5.23.

Consider the settings for the sun lamp. Sunlight has a yellow cast, which is generally offset visually by the blue cast of the illumination from the rest of the sky. Use the color picker in the lamp's controls to set it to a mild yellow (R, 1.0; G, 0.9; B, 0.6). We'll already be getting a certain amount of light from the environment, so we should reduce the sun's energy value a little. Since we're getting 0.5 energy from the environment itself, let's just cut the sun's energy to the same level so that for things in direct sunlight, they end up with a 1.0 on light energy (0.5 from AO plus 0.5 from the sun).

At this point you could just turn on the Ray Shadow button for the sun lamp and call it finished. If you have a complex scene though, say characters with hair or fur, or grass or trees with actual leaves, render times with ray tracing can head through the roof. Also, you probably don't want to have the completely sharp shadows that ray tracing produces.

Here's a different technique for using buffered shadows, which are much more controllable, in conjunction with a sun lamp. RMB select the sun and duplicate it with Shift-D. Move the new copy of the sun lamp a little so you can select it easily without getting confused with the original. Take a look at Figure 5.24, which shows the controls for this duplicate lamp. In the **Lamp** panel, change it from **Sun** to **Spot**, so that we can use buffered shadows. Then, adjust

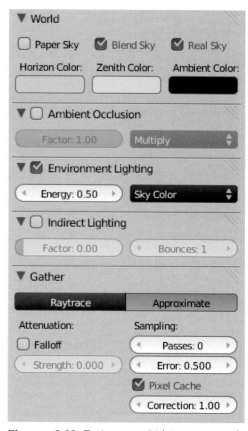

**Figure 5.22** *Environment Lighting settings for outdoor lighting baseline.*

the **Size**, **Clip Start**, and **Clip End** values so that the objects just fit inside the cone and clip indicator, like the demonstration in Figure 5.20. Set the buffer controls to the defaults given earlier in the chapter: **Softness: 3**; **Bias: 0.2**; **Size: 2048**; **Samples: 8**. You may need to move the lamp in order to get the cone and clip area to intersect with the objects in the scene. This is fine, but be sure not to rotate the lamp. This is because we are trying to match the shadows cast by this lamp with the illumination of the sun. The angle must be the same as the sun lamp's, but, since the sun lamp isn't location dependent, any location of a spot lamp will work. If you were to render now, you'd get double illumination—once from the sun, once from this spot lamp—and only a single shadow.

The key is to disable illumination on the spot lamp, but leave the shadow. On the **Shadow** panel, enable **Only Shadow**. This will cause the lamp to cast a shadow without generating any light. Not "real world" by any stretch of the imagination, but it's an extremely flexible production technique. Rendering now will most likely produce an image with no cast shadows. Why not? The spot lamp is possibly far enough away that its energy (which in this case is shadow energy) isn't strong enough to cast a visible shadow. The sun

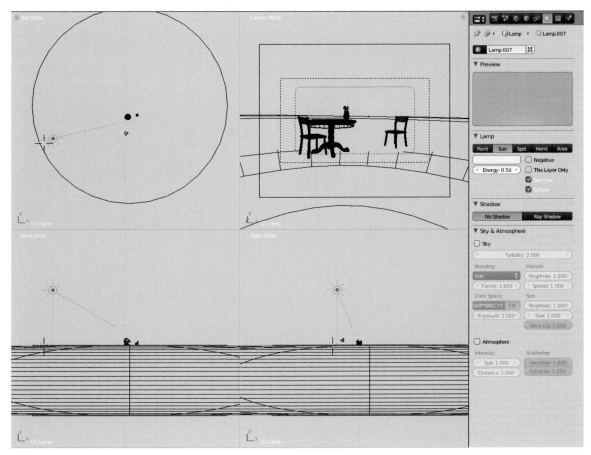

**Figure 5.23** *The sun in the sky.*

lamp does not have a Distance value, because its energy does not dissipate. The spot lamp does, though. You *could* move the lamp closer or extend the distance. There's an easier way, though.

Above the Distance value on the Lamp panel is a menu labeled **Falloff**. This determines the way in which energy dissipates over distance. Set Falloff to **Constant**. Constant means that the energy does not dissipate. It remains in full force, no matter how far away the object of illumination, just like the sun lamp. Now, a render produces the result in Figure 5.25, a decent and fast rendering approximation of outdoor illumination on a sunny day.

The direct sunlight looks a little weak, so tweak the sun lamp's energy up to 0.75. At this point, it boils down to adjusting things to taste. This setup works very well for outdoor lighting in a general sense too. If your actual scene is larger or has clusters of objects, you can add as many shadow-only spots as you need to in order to cast shadows for everything. As long as the spot lamps are all at the same rotation and

their areas of influence don't cross, it will work. For an additional enhancement, you can add an upward-pointing, low-energy green hemi lamp to suggest light reflected from a grassy field.

### An Effective General Indoor Lighting Setup

Indoor lighting is much more difficult. In fact, the indoor lighting problem falls into two distinct categories, due to their very different natures. The first is lighting an indoor space that has no access to outside (natural) light. This might be a room without windows, or one with windows but at night. The other case is when there is access to natural light, through a window, doorway, etc. Let's tackle the completely artificially lit space first.

The BLEND file provided with the Web Bucket for this chapter contains the default objects that were created in Chapter 4, plus three different lighting schemes. The scheme on layer 2 (simply Shift-LMB on layer 2 to enable it) is the outdoor setup from the previous section. Layer 3 is my general solution for completely artificial indoor lighting without using ray tracing. Once again, ray-traced environment lighting can really add some punch to your indoor scenes, and, if you're only creating still images, feel free to use it. For animation, however, you still need to deal with alternatives. Figure 5.26 shows the scene with a simple, windowless box around the objects to stand in for an enclosed room. In order to provide a reasonable source of illumination, the flower has been swapped out for a lamp shade, a matter of adding a tube mesh and scaling the upper ring of vertices toward the center.

The really hard thing about interior lighting is the way that light bounces around in the confined spaces and manages to permeate every nook, while giving soft reflected light to everything in the room.

Before we turn on the table lamp, let's get the baseline illumination for the room setup. A tiny bit of environment lighting is in order, but for speed we use approximate instead of ray traced. If all of the lights are off in the room, we don't want much in the way of ambient light, so environmental energy should be very low: around 0.05. This will provide just enough to give a little bit of detail and contact shadows in areas where no other light reaches. Make sure to use the White Color setting, as we don't want the sky to influence anything here.

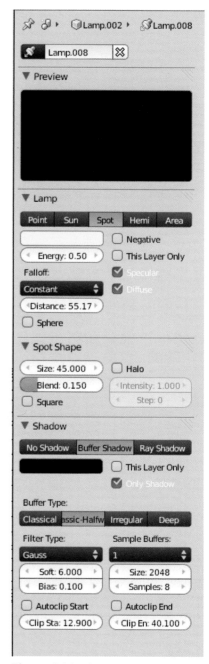

**Figure 5.24** *The spot lamp settings.*

For the rest of the ambient lighting, we're going to build a rig of six shadow buffered spot lamps. The goal is to make lamps that have low levels of illumination, with very soft shadow settings, to simulate the way that light bounces off of all the walls, the floor, and the ceiling in an enclosed space. Figure 5.27 shows the settings for one of these spot lamps. Energy is low: 0.05. The lamp itself is set far away from the room, just like the shadow-generating lamp in the outdoor example. The cone, Clip Start, and Clip End are kept as small as possible, while still including the contents of the room. The special trick here is to set the **Clip Start** just inside the nearest wall. If you are working on the spot lamp that shines from above, you want the Clip Start indicator just *below* the ceiling. What this does is cause the lamp and shadow to actually shine "through" the ceiling.

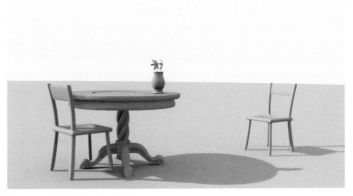

**Figure 5.25** *Outdoor lighting.*

Other settings of importance are **Falloff: Constant**, just like the outdoor example. Crank **Softness** up to something like 20.0. We don't want distinct shadows, just suggestions to give some volume to the room. In our example, we've also used the shadow color feature to set shadows to a medium gray, instead of completely black.

If your room is relatively square, you can make a single lamp for one of the walls,

**Figure 5.26** *A standard indoor lighting setup, appropriate to animation.*

then use Alt-D to create instances of it, one for each wall. Arrange them all pointing inward, like Figure 5.26. Choose one of the horizontal-facing lamps, use Shift-D to duplicate it, and move it below the room, rotating it to face upward. You may have to adjust the Clip Start and Clip End values now to take the height of the room into account. Once again, the Clip Start should begin just *above* the level of the floor. As a reminder, you use Shift-D to create this duplicate instead of Alt-D, so that when you adjust clip values the other lamps aren't affected. All four of the lamps for the walls are instances, which means that you can easily adjust the overall "reflected" lighting in the room by changing the values of just one of them.

Later on, when we begin to assign different surface properties to objects, including the walls, floor, etc., we can set these lamps to mimic the colors that would be subtly reflected. For example, a red carpet would mean that the lamp shining upward should receive a reddish cast. As before, it should not be overwhelming, and resist the urge to make it "show off." Subtlety is the rule of the day.

Let's turn on the table lamp. This is done with a placement of three different Blender lamps. Two shadow buffered spot lamps provide most of the lighting, one facing up, one facing down. Figure 5.28 shows the exact configuration, including the lamps' properties panel. You don't have to make the lamp cones line up exactly with the lamp shade—you're just going for an approximation of the effect of the shaded lamp. The buffered shadows, the settings of which you can see in the figure, do most of the work here. The final touch is to add a dim point lamp where the table lamp's lightbulb would be, without using shadows. It provides some overall illumination to fill

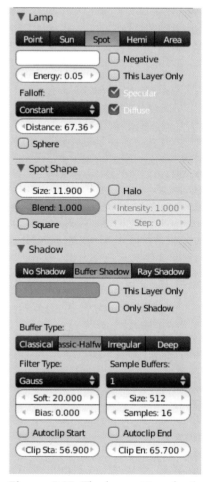

**Figure 5.27** *The lamp settings for the "ambient" lights.*

in areas that are completely in shadow. Don't forget to set lamps like this to mimic the color of the real-life light source.

Take a final look at the interior lighting generated by this whole setup, in Figure 5.29. It's certainly not fancy, but realize that we haven't even begun to apply surfaces to our objects. The right "feel" is there, so we can proceed to other steps in scene production with confidence.

But what if there is a window (or windows) with natural light? Let's return to the scene and change that lamp shade back out for the flower. By using perpendicular double loop cuts, edge slides, and removing a single face, we create a window. Figure 5.30 shows the windowed room, along with the lighting.

Once again, we create a base of illumination with approximate environment lighting, this time bumping the energy up to around 0.2. Remember that we're only using environment lighting to brighten the

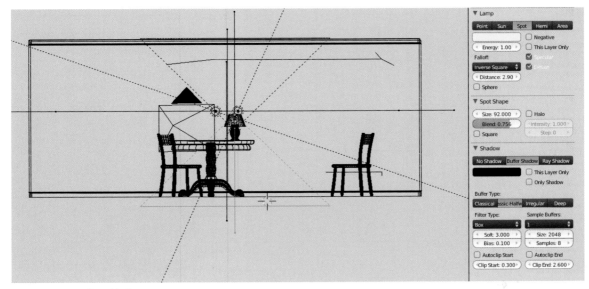

**Figure 5.28** *The table lamp's settings.*

"darkest" regions of the scene, so we keep it under wraps. When using other light sources, environment lighting will tend to flatten things out, reducing the impact of directional lighting if you turn it up too high.

Also shared with the previous interior setup are the overhead and underfloor buffered shadow spot lamps. They provide a nice, subtle shadowing on the floor that can be seen under the table and chair, and provide some variation to ceiling illumination if it's visible. The

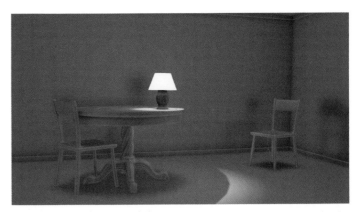

**Figure 5.29** *The interior lighting setup.*

settings before were fine, and there is no need to change them.

The direct sunlight streaming in the window is accomplished by a spot lamp with a buffered shadow. Figure 5.31 shows its lamp settings. As we're mimicking the sun again, Falloff has been set to **Constant**. (The sun is millions of miles away. While its energy certainly falls off, the length of a room after millions of miles of space is infinitesimally small, and the falloff across that distance is negligible.) Note, too, how tightly controlled the cone and Clip Start/Clip End values are. Energy is a product of experimentation and what looks good. I had started around 1.0, but found that I wasn't able to get the impact and contrast that I wanted for the direct lighting until it was up to 3.0.

**Figure 5.30** *A window cut into the wall allows exterior lighting.*

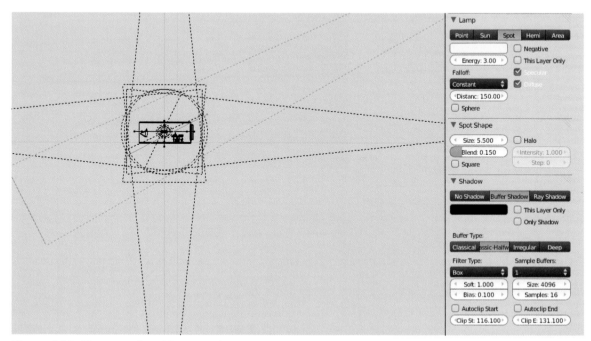

**Figure 5.31** *The settings for a fake sun to shine into our lives and make us happy.*

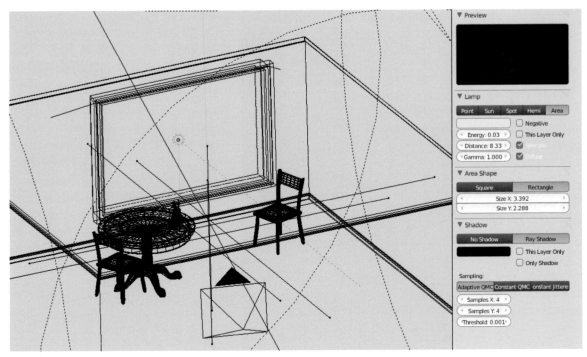

**Figure 5.32** *An area lamp outside the window.*

Windows provide more illumination than just the direct lighting from the sun. The sky outside turns the window itself into a kind of diffuse lighting panel. An area lamp is perfect for this. In Figure 5.32, an area lamp is positioned and sized (rectangular) to match the window opening. The Falloff Distance is set visually so that it reaches the other side of the room. Energy has to be very low, as area lamps will quickly blow out a scene. You can see that I've set it to 0.03. The goal for this lamp is to provide some fairly diffuse directional light, without showing an overpowering amount of contrast between its light and shadow.

At this point I'm going to recommend something a little out of character. Enable the ray-traced shadows on the area lamp, and set the Samples to a fairly low value. I've used 4. The shadows can be a bit grainy. With this setup, especially while keeping the Energy value low, it won't be noticeable. What happens, though, is that the lamp produces a subtle illumination from the entire area of the window, giving some credence to the whole thing.

The final touch is to create a bounce of the direct sunlight. You don't have to do it exactly, but perform a test render and observe the general outline of the patch of light the sun makes on the floor. Add another area lamp, and size it to approximate this patch. Face it upward, and set its Energy values close to those of the window lamp (0.05 in my case). A brighter or duller sun would require an appropriate adjustment. If the floor is colored, set the area lamp to match this color. You can enable shadows on this reflection lamp, but to me, they don't add a whole lot. If you disable shadows, you can even sit the lamp just a tiny

bit under the level of the floor so that you don't get an illumination line along the bottom of any of your objects.

Figure 5.33 shows a final render of this lighting structure. The objects, even without surfacing, have already begun to look physical. This is exactly what you're going for.

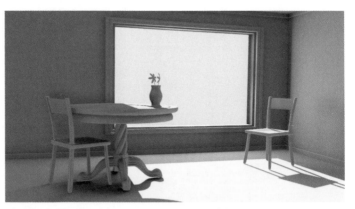

**Figure 5.33** *Illuminating a room with natural light.*

## Generalizing

These techniques are referred to as "lighting rigs." You can feel free to use them again and again. Once you've found a solution that works, it's not cheating to keep using it. Of course, you can always add to it, and tweak and refine it to make it better, but there's no need to reinvent the wheel every time you start a new project. Lighting isn't easy. However, you now know how to do a number of things—create direct outdoor sunlight and shadows, put a lamp in a room, fill a room with sunlight from a window, etc.—that can be duplicated or combined to mimic just about any real-world lighting situation you will need to use.

## Next Up ...

In Chapter 6, work through creating a character model that will be appropriate for animation, including clothes and hair.

# Chapter 6

## Character Creation

Sometimes you'll run across an animation that is just a fly-through of a landscape or a building. While these can be nice, even breathtaking if done well, they generally lack something. The heart of animation is character work. The character can be as simple as a ball or a leaf, or as complex as the N'avi in *Avatar*.

For our scene, we'll be adding a fairly simple character: a boy, wearing a collared shirt, pants, and shoes. In later chapters, we'll rig him for animation. He is not going to be photorealistic, but hopefully the modeling, surfacing, and animation will make him believable. The overall goal of adding a character to your work is simply to add *character* to your work. Personality. Something memorable.

## An Overview of Character Creation

The actual creation of a character is a multistep process. First, a character sketch is done, or reference photographs are obtained if you are modeling toward a specific person. The character sketches (front and side views) are loaded into Blender's 3D view to provide a modeling template.

Second, the head actually is modeled. If you're a glutton for punishment or supremely talented, you can model each and every head you ever need from scratch. If you like to have free time and are a particularly clever person (which I know you are!), you can use a base head model and alter it to fit your character needs. You then refine the base head, adding detail depending on the needs of the final character's look. At this point, attention is paid to getting the look in 3D that you had visualized in 2D, and to providing the proper mesh structure for facial animation.

Next, clothes are created. Some people feel the need to model a completely accurate structural person with musculature, etc., but if your character is clothed (and most are) you don't need to do this.

Finally, hands and other exposed portions of the character's body are modeled.

In the end, this multistep process creates a multipart character, with each part a separate object—head, hands, and clothes—that actually forms the "body."

## Starting from a Base Head

As there are a number of "modeling a head from scratch" tutorials available on the Internet, I'm not going to go into that here. You've already done a modeling tutorial, so if you want to do it from the ground up, you'll be able to find and successfully follow one at this point. There is a lot of trial and error involved in the process though, and in order to facilitate actually getting on with things, I've provided you with the base head model that I've been using for years now. It can be found in the Web Bucket for this chapter under the name *base_head.blend*.

There are two ways to begin working with this model. The first is to simply make a duplicate of the file; call the new one something like *my_character.blend* and open it. This ensures you can begin to work on the model without messing up the original. The other way is to Append the head model from the file into your current Blender session.

To Append, use either the **Shift-F1** key combination (it's like a modified open command) or select **Append** from the **File** menu. The File Browser window (see Chapter 2) appears and lets you locate a file. Locate the *base_head.blend* file and LMB click on it. Notice that in the Append view, the browser shows BLEND files as though they were folders, not files. That is because in a way, they are. Each BLEND file on your hard drive is really a browsable library of everything that is in that file. When you click on the file, you go "into" it and see a number of folders like Animation, Group, Material, Object, and Scene. We're looking for an object, so LMB click on **Object**. The only object available in that file is called *base_head*. LMB click on it to select it.

On the left of the file browser, you will see a small options panel like the one in Figure 6.1. There are two ways to bring an asset into your Blender sessions: linking and appending. Linking maintains a link to the original asset in the original file and limits what you can do with it. Appending just makes a new copy of the asset in your current session. This is what we want, so make sure that **Link** is disabled (unchecked).

LMB click the **Link/Append from Library** button in the upper right to add the head model to your scene. The base head is shown in Figure 6.2. One of the reasons that modeling a head from scratch is difficult is that there are certain requirements for nice facial animation. The way the quads line up needs to match the alignment of facial muscles in a real face, or it will deform unconvincingly. If you enter Edit mode on the provided base head and begin issuing the Loop Cut command (Ctrl-R), you will find a number of conspicuously located loops—around the eyes, from the nose to the chin, and around the mouth—all of which are highlighted in Figure 6.2.

Using this as a starting point, it is easy to fit it to your sketch or reference pictures.

**Figure 6.1** *The Link/Append panel in the file browser.*

Divide your main modeling area into two distinct windows by dragging from either of the action zones as you learned to do in Chapter 2. Set one to front view (**Numpad-1**) and one to side view (**Numpad-3**). Hover the mouse over one of them and press the **N** key to bring up the view options. Scrolling down to the bottom of the panel, you will find a section called **Background Image**, which is shown in Figure 6.3. Enable the panel by checking the box next to the label, then LMB click the **Add Image** button. Expand the controls by clicking the triangle to the left of the Not Set notifier. LMB click the **Image Open** button and browse to your front view reference in the file browser. After selecting an image, you will see it in the 3D view. Use the **Scale** and **Offset** controls to interactively adjust the image so that it lines up closely with the model of the head.

**Figure 6.2** *The base head model, with crucial loops highlighted.*

Use the **N** key again to hide the View/ Properties panel. Repeat the process in the other 3D view, this time choosing your other sketch or reference image. The goal is to have two 3D views, one for adjusting from the front, and one for adjusting from the side.

Now, it is a matter of using the modeling tools to make the rough structure of the base head fit the contours of the reference pictures.

The best way to proceed is to begin in the front view. Switch to Edit mode (**Tab** key) and show wireframes (**Z** key, as opposed to solid view). Use the **O** key to enable **Proportional Edit Falloff** (PEF). With those things in order, select the outer vertices and try to make the front view contour match the one in your reference. You'll notice as you work on the base head that it is in fact a

**Figure 6.3** *The Background Image controls.*

model with a Mirror modifier. Adjustments only need to be made to one half, and the other half follows along.

To match the eyes to the reference, begin by Alt-RMB clicking the ring of edges that describe the eye. You can move it all at once, pulling neighboring vertices around with PEF, and slightly rotate and scale it along the *x* and *z* axes to get it close. Follow up by moving the individual vertices to create the proper shape.

Match the mouth in the same fashion as the eyes.

As you work on this from the front view, it is useful to toggle back and forth between solid and wireframe modes. Solid gives you a nice idea of how things are coming along, while wireframe lets you see the reference image and actually work.

When you have the front view taken care of (overall contour, eyes, mouth), move over to your side view. Here, you use the same technique (single vertex selection with PEF) to create the proper profile. At this point, you may find that adjusting something in the side view might throw things off a bit in the front view. Here's where the translation to 3D takes precedence over your references. Unless your side and front reference pictures are mathematically accurate, there will probably be some differences. Maybe your sketches aren't perfect (duh). Maybe your reference photos were taken with slightly different expressions or a bit off angle. Whatever the case, you must decide on a happy medium when the two don't exactly line up. The final rule is to find what looks best in 3D.

In addition to the contour of the profile, the side view will also help you match the contour of the cheeks and cheekbones, and the eyebrows and orbital ridge.

Once again, switching between solid and wireframe views will help you to see the actual results of your work. At this stage, it can also be beneficial to make another 3D view, set to solid and perspective for a more "true to production" look at what you're doing.

The Web Bucket for this chapter has a small video, *face_matching.mpeg*, that shows this process in motion. I have found that the base head provided with this book can be easily and quickly adapted to a large variety of situations, from realistic to cartoonish, both male and female. Figure 6.4 shows the base head adapted to my sketches for the example character. The sketches are also available in the Web Bucket in case you want to follow this tutorial exactly instead of creating your own character.

## Refining Facial Features

Simply forcing the base head to match the contours of reference images will not produce a satisfactory result. Due to the very low-resolution nature of the base model, there might be places where you simply can't get it to conform very well to your sketches. Figure 6.5 shows a few of these areas highlighted on the example character.

Before you begin adding detail, add a Subdivision Surface (Subsurf) modifier to the head. This will give you a better idea of what things will look like when it is finished and help you to decide where you need to add geometry.

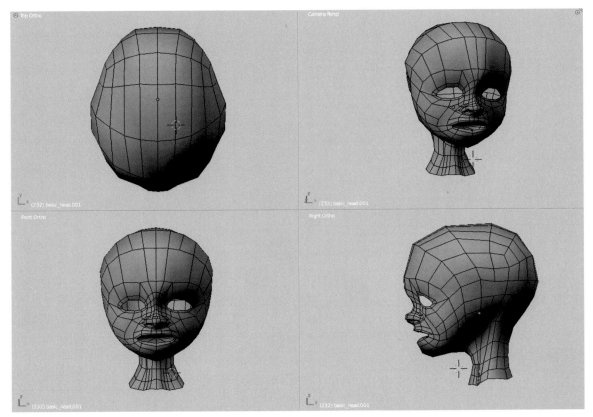

**Figure 6.4** *The base head roughly adapted to the example character.*

## Cheeks

Let's fix the blocky look of the cheeks. In Edit mode, use Ctrl-R to cut a loop that runs around the entire head. When adding geometry to a head model, you will almost always use the Loop Cut tool, as it maintains the crucial loop structure that you will need later for animation. With this new loop in place, adjusting the curvature of the cheek to better match the reference is easy. Just grab the appropriate vertex, make sure that PEF (O key) is enabled, and pull it out. Figure 6.6 shows a before and after of the whole process.

In this same way, you can add additional definition to your model. For example, the sketch of my character shows a nice crease that runs from the outer edges of the nostrils around the mouth and down. This is the typical smile crease that humans exhibit. Note how easy it is to enhance this feature on the model by adding a loop cut like the one in Figure 6.7. Once that cut is made, the upper vertices that were created can be selected and moved slightly "inside" the head to produce a natural-looking indentation. Figure 6.7 shows the procedure and the result.

This also allows you to adjust the curve of the cheek above the crease more easily, without disturbing the geometry surrounding the mouth.

## Lips

The same technique is used to add some definition to the lips. A single loop cut is made around the mouth, between the loop of edges that make up the lips and the next one out. With that new loop selected, activate Edge Slide (**Ctrl-E**) and move that loop toward the lips. As you get closer, you will be able to see a nicely defined, though still smooth, edge appear in the subsurfaced mesh.

This demonstrates a general rule for working with meshes that will use a Subdivision Surface modifier: To "harden" an edge and add definition, add a loop cut and edge slide it toward one of the existing loops. Figure 6.8 shows a before and after of the technique.

## Eyes and Eyelids

In order to create eyelids and to get the correct shape for the geometry surrounding the eyes, you need to actually add eyes. For almost all natural characters, eyes are spheres. For test purposes, you can simply

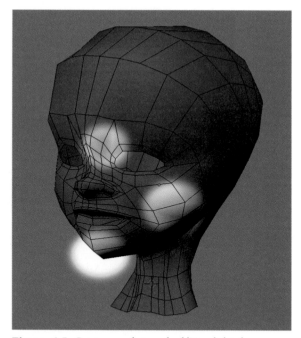

**Figure 6.5** *Some areas that need additional detail.*

add a UV Sphere to the scene, scale it appropriately, and move it into position. If you like, you can Append a finished eye object from the Web Bucket file *eyeball.blend*. This object includes all the surfacing needed for a good eye. When you place the eyeball within the head, you will probably find that the mesh surrounding the eye is not a good fit. Remember that you must make the head conform to the eye, not the other way around. Nonspherical eyes will not rotate properly. Whether you choose a placeholder sphere or the appended eye object, the new goal is the same: fit the geometry of the head to the eyeball.

Figure 6.9 shows the rough head with eyes in place. Notice how the inner portion of the opening for the eye leaves a large gap, and the outside edge disappears into the eye. Some PEF modeling and fine tweaking will remedy this into the "after" shot of the figure. Keep in mind that this may change the look of the character. So what does this mean? First, it means that your

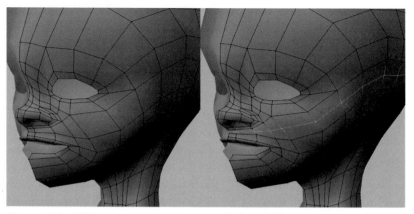

**Figure 6.6** *Adding geometry via a loop cut and adjusting the contour.*

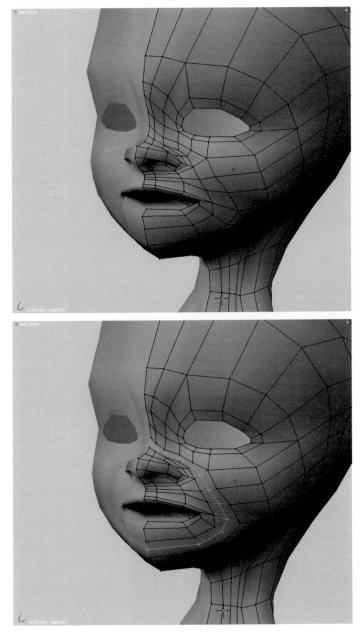

**Figure 6.7** *Adding a crease with a loop cut.*

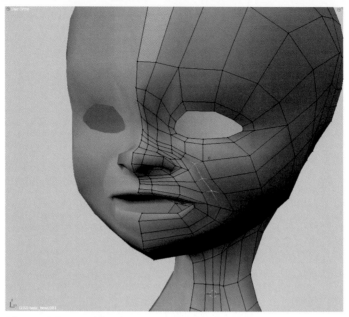

**Figure 6.7, cont'd**

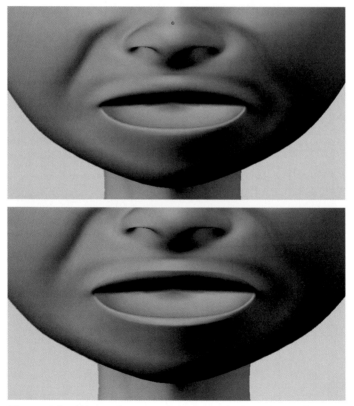

**Figure 6.8** *Adding a loop around the lips and edge sliding it for greater definition.*

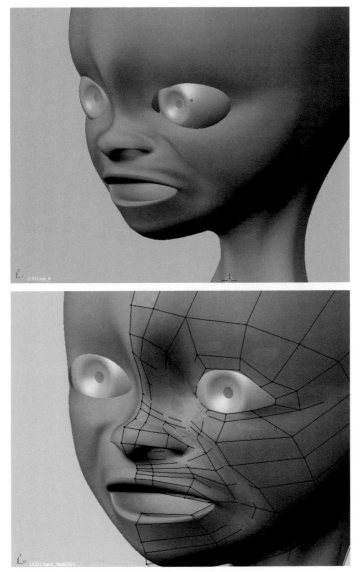

**Figure 6.9** *Fixing the opening to fit a spherical eye.*

original reference wasn't realistic enough. It's hard to take truly spherical eyeballs into account when you're drawing. Second, it means that you're going to have to break with your reference and decide what practically looks best in 3D.

Once you have the eye opening adjusted to fit, it's time to add eyelids. The easiest way to do this is by Alt-RMB selecting the innermost ring of edges on the eye opening and extruding. Do this from a side

view, and pull the extruded edges away from the face. Scale them vertically (S key, Z key) until the top and bottom edges are fairly close together, as shown in Figure 6.10. Pull this line of edges back toward the eyeball, until it is just a hair in front of it. The flat surfaces of the eyelid will disappear into the eye.

To fix this, we need to refine the geometry. Remember how to refine? Loop cut. When you cut a new loop around the eyelid (you may need to enter Wireframe mode to see it), there's a simple way to bring it out: a new modeling tool, **Shrink/Fatten**, which is triggered with **Alt-S**. In some ways, it is akin to scaling, but instead of applying a uniform growth factor, it moves vertices "in" and "out" on a mesh, depending on how the surfaces are facing. In this case, using Alt-S with the new loop still selected will "balloon" it out, which is exactly what we want. The effect is shown in Figure 6.11. You will probably have to adjust these vertices individually to get them just right.

To finish the hard work on the eyelid, we'll use another new modeling tool: **Tear**. The upper and lower eyelids need to be separate. Tearing the mesh on the side is the solution. Select the first and second vertices inside the corner of the

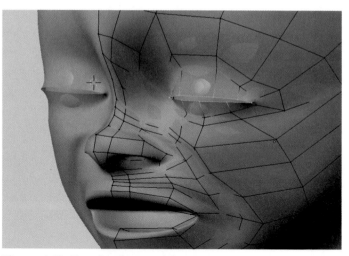

**Figure 6.10** *Extruding for an eyelid.*

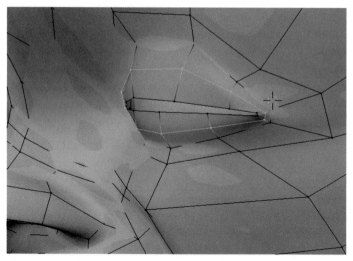

**Figure 6.11** *Using Alt-S Shrink/Fatten to adjust the eyelid.*

eye, as shown in Figure 6.12. Then, press the **V** key to tear the mesh. The V represents a mesh line that was torn at the top, opening up into a V. Clever! When you do this, those vertices are duplicated, but remain attached at the base. You can move the new duplicates a little bit away from the originals, and voila—you have sliced the eyelid in half. Do the same thing on the outer edge so you end up with complete upper and lower eyelids.

Now you can use PEF modeling to further adjust the shape of the eyelids. Don't worry that the eyelids are closed. This is how you have to model them. We'll open them in a later chapter. Until then, you'll

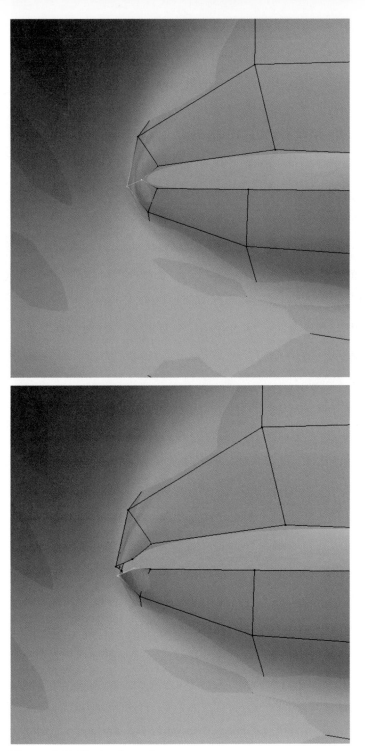

**Figure 6.12** *Tearing the mesh.*

just have to live with a zombie sleep-walking character "staring" you in the face.

On a real face, the eyelids rest on the eyeball itself, suspended by a thin layer of fluid. We're not going to do that here, but we do need to make sure that the eyelid mesh meets the eye sphere. You could use a Shrink Wrap modifier that affects only a vertex group that contains the inner edge of the eyelid, but there is an easier way. Select the inner edge of each of the eyelids and extrude them backwards along the *y* axis, into the head. You only have to go a part of the way into the eye, actually, but the result when seen with a Subsurf modifier is that the inner surface of the eyelid seems to meet the eye.

Before moving on, let's add a little crease around the eyes themselves, just to give them some more definition. Once again, the Loop Cut tool is your best friend. Add a new loop around the eye and edge slide it inward. Add a second loop outside of it and slide it inward too. Use Alt-RMB to select that first loop, which is now sandwiched between two nearby loops (Figure 6.13). Deselect the couple of vertices nearest the corners of the eyes. Then, use Alt-S to shrink the remaining selected vertices a very short way into the head. This creates a crease along the top and bottom of the eyelids.

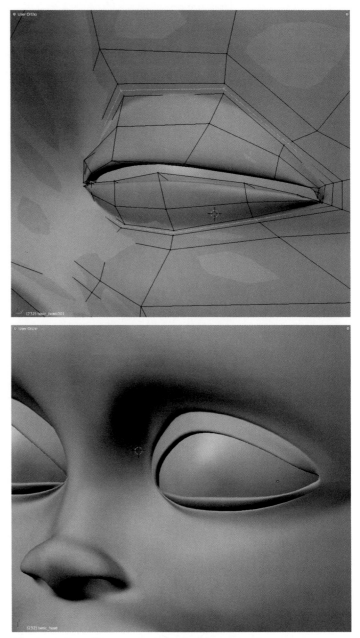

**Figure 6.13** *Adding a crease to the eyelids.*

## Asymmetry

As was mentioned earlier, the base head model is provided with a Mirror modifier to make initial work easier. Not all of your character designs will be symmetrical, and, if you're using reference photos, you may have just learned how asymmetrical your subject's face really is. During the initial phase, it makes sense to

use a mirrored mesh, as large-scale adjustments to match the references are much easier to accomplish. At some point, though, you need to apply the Mirror modifier.

If your model looks good to you with a Subdivision Surface modifier enabled, in solid view and perspective mode, then it's time to ditch the mirroring and turn that into live geometry. Click the **Apply** button on the Mirror modifier, and there you go. Now, you can edit the sides individually to generate the proper asymmetry that your character requires.

> **Note**
> The terms "Subdivision Surface" and "Subsurf" modifier are used interchangeably throughout this text, and in tutorials and other books. They mean the same thing. Don't let it throw you.

## Modeling Joints

The human body has two sets of major single-axis joints: elbows and knees. Other animals may have more or less. When creating joints like this, there is a specific way to model them that produces the best results

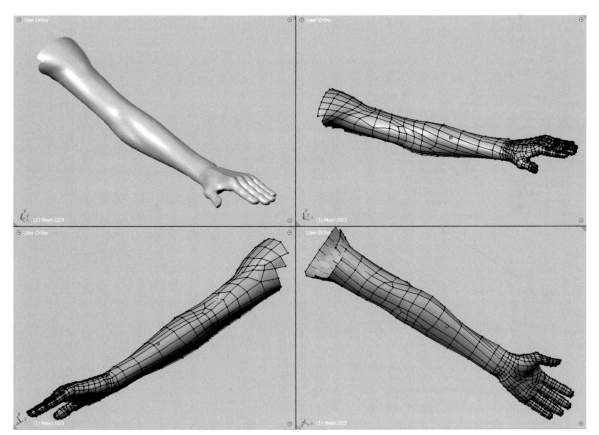

**Figure 6.14** *An elbow from the MakeHuman project.*

when animated and bent. Figure 6.14 shows several views of a model of an elbow joint. By now, you should be able to see that it is mostly a series of loop cuts around the circumference of the arm. Notice how loops are also in place that describe the area around the elbow and biceps. This is the main reason that I recommend using a stock model for the human figure unless you are specifically attempting to model a person as an educational exercise: The levels of detail, proportion, and mesh control that go into a successful model are a complete topic and art unto themselves.

When modeling clothing though, you don't need to have this complex loop structure to get a realistic deformation. As we'll see in Section 6.7 on adding clothes, cloth is more akin to a grid in 3D than anything else. The only thing to really avoid is putting too little geometry into a joint like this—the outside edge, like the elbow, will get "mushy" and flatten out when animated.

## Hands and Other Exposed Parts

I'm about to give you the greatest advice you can receive in CG: cheat. Cheating is good. In fact, CG itself is little more than a series of cheats. There's no real light. None of the objects we make have volume—they're just empty shells. Shading and surfacing are a compilation of dodges and approximations. Did you know that in *The Incredibles* every single nonhero character (i.e., the cast of thousands of extras) in the movie is a variation on the same base model? I say this so that when I make my statement you'll remember that the character was modeled once, then used over and over again by the best people in the business (and possibly the history of the business).

Here it is: Use someone else's hands. Sure, you can learn to make your own, but even if you do that, you'll probably end up using that same hand over and over again. If you really want to see how to create a hand from scratch, there's a video in the Web Bucket (*let_me_hand_it_to_you.mpeg*) of me doing that very thing. I've included a low-resolution version of that hand in the file *helping_hand.blend*. You either duplicate the file, open and start working with it, or Append it to your file like we did with the head. The object's name within the file is "hand."

While we're on the topic of using premade structures, let's take a look at two free programs that are a source for human figures with great anatomy, MakeHuman and DAZ Studio. Both programs allow you to adjust a basic body directly within their interface, then export the results as an OBJ file that Blender will happily import. Personally, I don't feel like learning a whole new interface and find that Blender's mesh editing tools are more than sufficient to the task, so I just export the OBJ straight away from both programs. Then, I bring it into Blender and start editing.

Figure 6.15 shows MakeHuman, an open-source application available for Windows, Mac, and Linux at *http://www.makehuman.org*. It's interface changes drastically with each Alpha release, so I'm loathe to give step-by-step instructions on anything but a basic export.

The other free application that can generate people is DAZ Studio. It's not open source, but is extremely popular. In fact, the DAZ community has a bunch of relatively inexpensive premodeled resources if you should ever need such a thing. DAZ Studio can be slow, and its interface obtuse and frustrating, but if you select the default human object and choose **File > Export** you can make an OBJ for Blender to

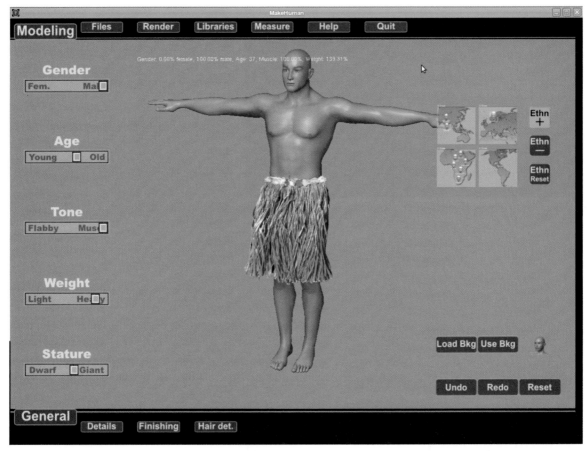

**Figure 6.15** *MakeHuman in action. I added the hula skirt.*

work with. Figure 6.16 shows DAZ Studio running with the default character. If you'd like to use DAZ to pose the figure (No!), it includes a decent QuickStart tabbed tutorial on the right side of the screen.

To bring these models into Blender, use the **Import > Wavefront (.obj)** command on the **File** menu. Sometimes, OBJ files show up in Blender in odd locations or with strange scaling values. If it seems that nothing appears when you import, check the N-key panel for the location of the currently selected object. The newly imported objects should begin their lives selected in Blender, and simply setting the Location values on the panel to zeros (or using Alt-G to clear any translation) will bring them to the center of the 3D space. Also, check the Dimension section of the N-key panel, as the object might be so large or small that you can't see it.

Often, OBJ files that are imported might have lots of extra vertices that need to be removed before any serious work can begin. Simply jump into edit mode, select all the vertices (A key), and use the **Remove Doubles** tool, either from the W-key specials menu, the toolbar, or the spacebar pop-up menu. Remove

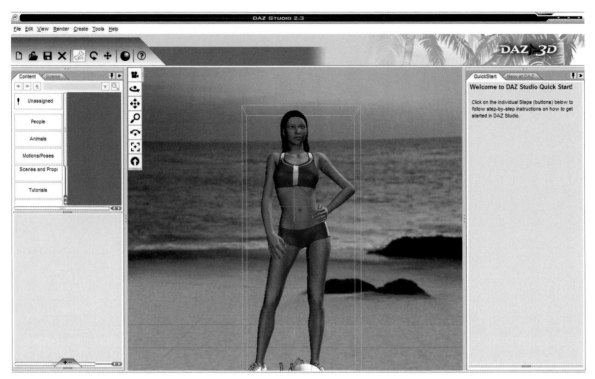

**Figure 6.16** *DAZ Studio.*

Doubles merges any vertices that are on top of each other, effectively fixing the duplicate surfaces that plague many import files.

If you need realistic feet, hands, arms, or even an entire body, remember that yes, you can model them yourself if you want to. However, not only do you not *have* to do this, there are strong incentives against it. At some point, you're going to want to whet your modeling chops and tackle something as difficult as the human form. Until then, well, you probably have better ways to spend your time.

Keep in mind, though, that you should adapt the models you import to your own needs, and to the look of your scene. You don't want the people to have a different level of detail or believability than the other portions of your work.

So, for the character in this scene, we'll be adding my standard hand model. Just like bringing the head into the scene file, we'll use the File > Append command, followed by browsing to the *helping_hand.blend* file from the Web Bucket, digging into its Object folder, and locating the object called "hand." It looks a bit mannish, and this is a kid, so some editing is in order.

Figure 6.17 shows the base hand model. It's about as low resolution as can be. You'll note that it has more apparent detail than the base head. This is because of the creases in the fingers and palm, and the knuckles, and the simple fact that there are five fingers. I suppose if the head had five noses, it too would sport some more detail.

A quick check of either Google image search (*http://images.google.com*) or Flickr (*http://www.flickr.com*) shows the way in which children's hands differ from those of adults. The fingers are a bit shorter, the overall hand narrower, and, most significantly, softer. The knuckles are less pronounced, as is any creasing. A trip into Edit mode on the imported hand model will fix these problems.

In order to make the hand more childlike, the following procedures have been done:

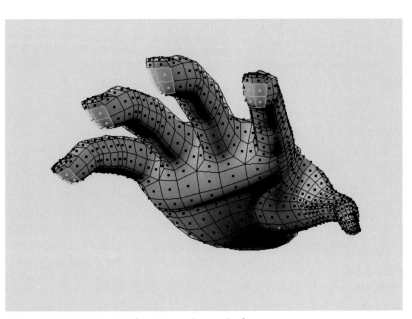

**Figure 6.17** *The default hand object beside a younger version.*

1. The entire mesh for the hand is selected, then scaled slightly along the *x* axis to make it more narrow.
2. With the whole mesh still selected, use the **Smooth** command several times. This will smooth the creases and deemphasize the knuckles. It will also tend to round the fingertips a bit, which, looking at the reference images, isn't a bad thing.
3. Figure 6.18 shows the model in Face Select mode, with the four faces on the tips of the fingers selected. Going into PEF mode and carefully adjusting the falloff circle to end just at the base of the fingers, the fingers are shortened by G-key moving the selected tips slightly toward the finger bases in a side view.

The resulting hand looks much more childlike than the original, as shown in Figure 6.17. In fact, these techniques—scaling, smoothing, and PEF movement and rotation—are the primary tools you will use to alter imported character meshes.

## Techniques for Adding Clothes

One of the big mistakes that people beginning in 3D make with character work is to model an entire human form, then put clothes on top of it. Unless you're using a cloth

**Figure 6.18** *Selecting the fingertips to shorten the fingers.*

simulation that needs an underlying structure in order to deform, there is no need for that body. The clothes themselves become the body.

Some people will spend days or even weeks trying to model the perfect head or human figure, but spend only the barest amount of time on clothing that character. This is obviously a mistake (and yet it happens), as for the most part, the clothes are what will be seen. Carefully constructed and animated clothes *imply* the correct body structure underneath—they make its existence assumed and believable even though there is nothing there. Fortunately, the structure of clothing is simpler than heads and hands.

In real life clothing is made by starting with flat pieces of fabric that are cut apart in patterns, then fastened together (usually stitched) so that they drape properly on the body. The great news for 3D artists is that this means you don't have to worry about funky loop structures. Fabric is basically a grid, and this lets you work with fairly uniform grid-type primitives when making clothing. For our character, let's construct a simple long-sleeved shirt with a v-neck and collar.

### *Shirt*

**Observation**

Depending on your skill level with artistic observation, you may or may not be able to sit down and draw a collared Oxford shirt without using a reference. If you find that you can't, it's almost certain that although you "know" what one looks like, you've never really observed one in enough detail to reproduce it. Search for some reference images (or pull one from a closet in your home) and take a look. A standard Oxford is made from seven different sections, pieced together. While you don't need to replicate this method of manufacture, a subdivided cylinder with appropriate extrusions and cutouts will suffice. A careful observation will go a long way to informing your result in 3D.

To begin the shirt add a tube (Shift-A), and in the Tweak panel uncheck **Cap Ends**. Use the Loop Cut tool (Ctrl-R, mouse wheel) to add something like nine cuts around the circumference of the tube. This will make a nice, even grid structure, shown in Figure 6.19. Also highlighted in the figure are several sets of vertices along the top edge of the tube. By selecting these vertices in sets of four—two from the front and two from the back—and

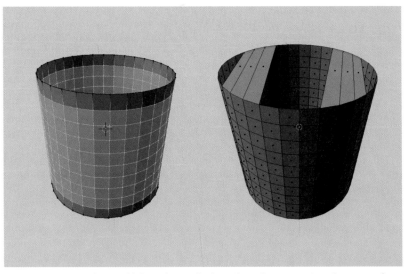

**Figure 6.19** *A tube is added, and several edges along the top are joined to create faces.*

using the F key to create a face, you can end up with the structure on the right side of the figure. Note that these faces do not go the whole way to the side or the center, leaving some room for arms and a head to poke through.

What you're creating is the main body of the shirt. The joined faces will form the part that goes over the shoulders. Use the Loop Cut tool on each shoulder region, dividing it with an odd number of cuts (five will be fine). Figure 6.20 shows this division.

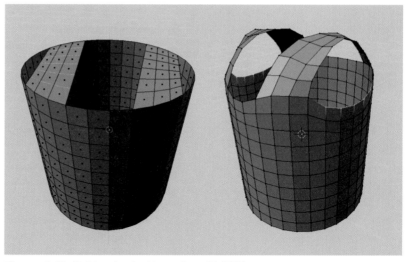

**Figure 6.20** *Raising the shoulder section with PEF.*

Then, select the central row of each of these new cuts and use PEF to pull them up into a curve. The result is shown in the second half of Figure 6.20, after a little more PEF tweaking.

Now, select the remaining vertices on the bottom of this opening (the ones selected in the right half of Figure 6.20) on both sides of the shirt and delete them. This makes the arm holes a little larger. At this point, you could pull things around by hand and round the openings and the shoulder curve nicely. You could, but that would be doing it the hard way. When you just want to round out stuff, what you really want to do is smooth the mesh. A simple way to do this is to select everything (A key), then use the **Smooth** command from the **W**-key Specials Menu. Note that this is *not* the Smooth command from the Shading section of the toolbar. This command actually changes the shape of the mesh. The Smooth command works incrementally, and you will have to apply it several times to get to a decently finished shape, like the one in Figure 6.21. A slightly more complicated, but more intuitive and visual way to accomplish this is with the Smooth modifier.

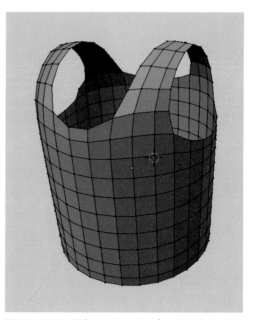

**Figure 6.21** *What you're going for with a basic shirt.*

To do this, leave Edit mode for a moment and add a Smooth modifier to the mesh, which is under the Deform heading in the modifier's pop-up menu. Set the **Factor** to 1.0, then start upping the **Repeat**

value until you have something that resembles Figure 6.21. The feedback is immediate, and you can adjust it back and forth without having to use Undo if you go too far. When you have it nicely smoothed (perhaps around Repeat: 8), hit the Apply button on the modifier to make the results real. Jump back into Edit mode, and hooray for using modifiers as modeling tools!

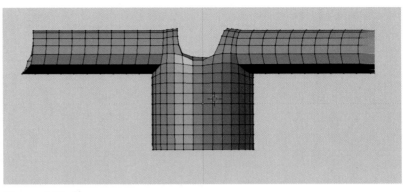

**Figure 6.22** *Sleeves.*

Alt-RMB clicking (loop select) grabs the entire ring of vertices around the arm opening at once. An Extrude command (E key) creates a long, narrow sleeve. A multiple loop cut later and the sleeves are ready for shaping. Figure 6.22 shows the sleeves extruded and gently sliced. The sleeve on the left slopes outward toward its bottom, while the one on the right seems to line up properly. To accomplish this, use Alt-RMB again on the end of the sleeve to select the vertices around its circumference. In a front view, press the S key, followed by the X key to constrain along that axis. Then, type 0 (the number zero), and the edge of the sleeve will line up perfectly. If you like, you can do this to every loop along the length of the sleeve.

We still need to add a collar, optional details like buttons/pockets/etc., and push it into a form that more closely resembles a shirt. The pushing needs to happen first, though, as the other steps involve overlapping geometry. Collars, certain kinds of cuffs, hems, and other details all involve geometry that overlaps the base fabric of the shirt, and trying to prevent all of that from self-intersecting while changing the overall shape can be a nightmare.

Figure 6.23 shows a 3D view set to display two reference sketches of the example character's whole body. By using the same techniques that you learned when matching the base head model to sketches, you match the rough clothing to the finished shape in the sketch. Mostly, you'll be grabbing single vertices with Proportional Editing Falloff enabled and pulling them into position. The Web Bucket has a video of this very thing called *matching_a_shirt.mpeg*. Both the rough starting shirt and the sketch reference are available too, in case you want to practice this step.

If you're not very good at drawing clothes (and unless you're a careful observer you probably won't be), an easy reference can be obtained by having someone stand in the character's pose and taking a digital picture of them. It really couldn't be easier.

*Note:* A character's initial pose. When creating a character, you should begin with a neutral pose. The most common is the one seen in this chapter: legs apart, arms outstretched, elbows and knees slightly bent,

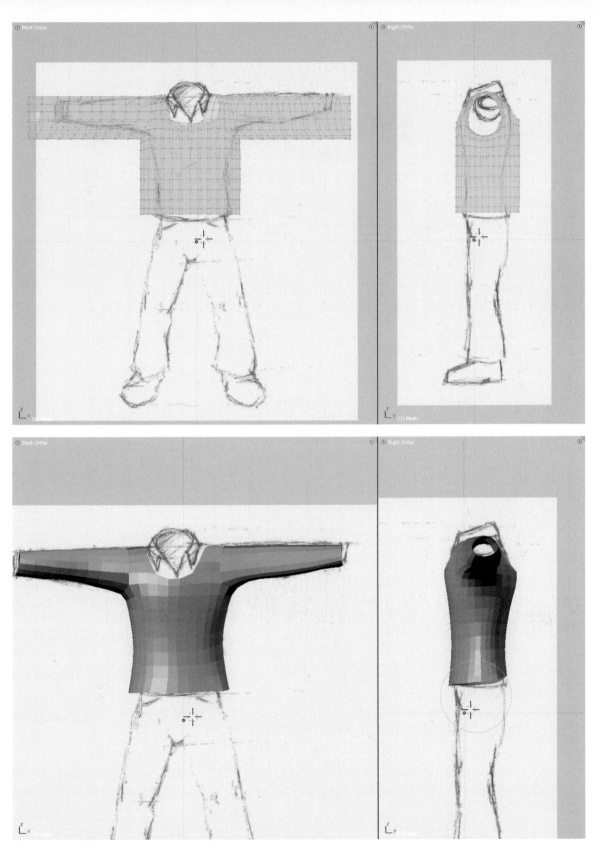

**Figure 6.23** *Whole-body references.*

*Continued*

**Figure 6.23, cont'd**

palms down. This pose makes it much easier to bind your character model to a control structure later on for animation.

Once the shirt (or pants or coat) that you've made conforms to the outlines of reference, you can begin to add details. Some, like the actual texture of the fabric, will be added later when surfacing. Others though, like buttons, collars, pockets, and cuffs, should probably be modeled. Remember to add extra edge loops at boundaries like cuffs and seams. When a Subdivision Surface modifier is added later, these edges will help to maintain the definition of these parts of the model. Figure 6.24 shows cuffs and a shoulder seam with two extra loops added at each, and the central loop inset a bit.

Details that are fabric like a shirt pocket and that will bend along with the rest of the cloth when your character moves should be included as part of the main shirt model. Rigid items, like buttons, require a different method if they are not to "bend" when the cloth does. To demonstrate, we'll add a name tag to the model.

Use the Tab key to leave Edit mode on the shirt. Add a cube (Shift-A) and scale it down along the different axes until it looks about the relative size and shape of a name tag. Move it into place just in front

**Figure 6.24** *Using edge loops to add definition when subsurfacing.*

**Figure 6.25** *A scaled cube stands in for a name tag for now.*

of the shirt, where you'd pin such a thing. When positioning objects close to one another, it can be helpful to use Solid mode (Z key) to find out just where the pieces intersect. Figure 6.25 shows the result.

Here's the trick. Make sure that the **name tag** object is selected, and in Object mode (not Edit mode). Hold down Shift and RMB select the **shirt** object. Both will be selected, with the shirt being active. Press the Tab key. This puts the shirt into Edit mode, but note that the name tag is still selected. In Edit mode then, RMB select the three vertices that are nearest to the center of the name tag—essentially where it would be pinned in real life. Now, press Ctrl-P. That's right, the Parenting command from Chapter 3. This makes those three vertices the parent of the name tag. Now when the shirt moves as it will when animated, the tag will move along with it, changing its position and rotation as though it were pinned there, but not actually deforming. This process, called **Vertex Parenting**, works with either one or three vertices.

A collar can be created by using Alt-RMB to select the ring of vertices around the neck. Extrude followed by a scale pulls the new vertices in toward the center a bit. If you're just creating a crew-neck shirt, you can stop there. However, creating a full collar is not much more trouble. Figure 6.26 shows several steps of collar creation, each made by extruding, scaling, and moving the new vertices constrained along the *z* axis. The endpoint of this step is sufficient for a priest- or turtleneck-type collar. To finish it though,

**Figure 6.26** *Creating a collar.*

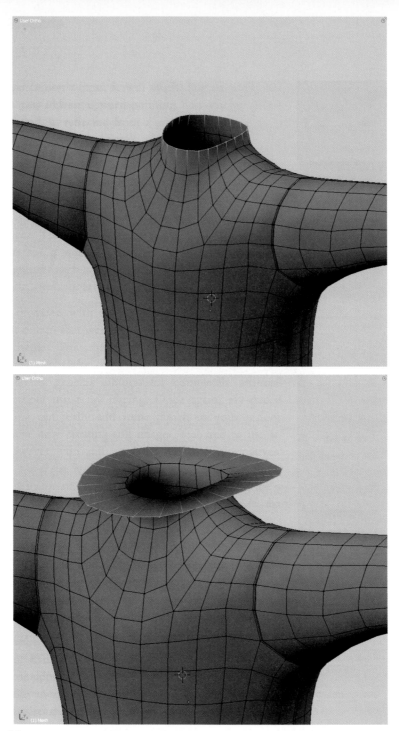

Figure 6.26, cont'd

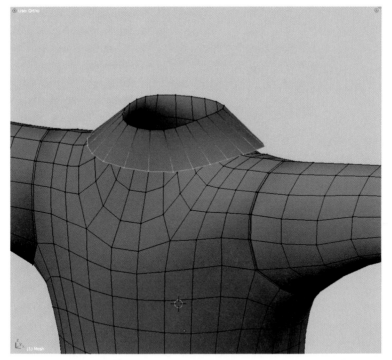

**Figure 6.26, cont'd**

extrude one more time, this time scaling larger to push the ring of vertices away from the center. Move this new ring down, and you have something that looks not entirely unlike a Victorian ruffle collar.

Do you remember the **Tear** command from the eyelid creation exercise (V key)? It's time to use it again. If you were creating a jacket instead of a shirt, you would select an entire column of vertices the whole way down the front of the shirt. Tearing that opens the entire front. To create a collar that is open, say, to the first button, you would select the top several vertices of the shirt, up through the collar as shown in Figure 6.27, then tear it with the V key. The mesh separates, leaving you with the proper effect. Now, that's a shirt in Figure 6.28.

### *Pants*

Pants are just a reiteration of what you've done with the shirt. Figure 6.29 shows a very simple beginning to a mesh for pants.

The keys to creating this basic shape are the loop cuts running down the outside and front edges of the pant legs. Making these cuts allows you to select the long vertical edges on all four corners of the original cube and pull them into a more rounded situation with Shrink/Fatten (Alt-S). It's simple box modeling like the chair in Chapter 4, with a Mirror modifier thrown in so you only have to work on one side at a time.

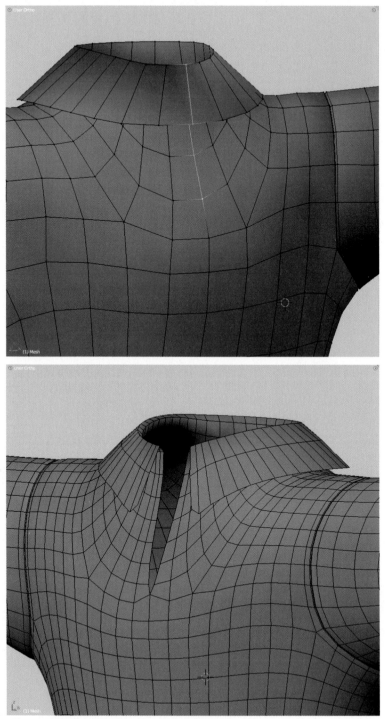

**Figure 6.27** *Tearing the front of the mesh.*

**Figure 6.28** *The shirt.*

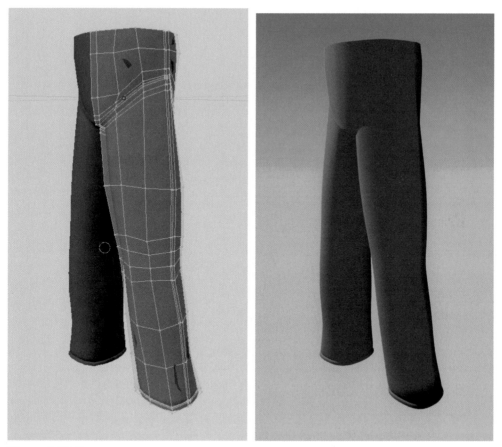

**Figure 6.29** *Pants.*

## Shoes and Feet

You know what I'm going to say about feet, don't you? That's right. Get a foot from somewhere else, and if your character is going to wear shoes of some kind, just forget about the feet altogether.

Figure 6.30 shows the basic, unmodified structure of a shoe. Nothing more than a cube, some scaling and loop cuts. After that structure is pushed around, a Subsurf modifier is applied. You then add a few more loop cuts for definition, and you get the finished shoe. Once again, your best friend will be a simple structure like the one shown here, along with a top and side reference image. A front image can also be helpful for shoes in order to get the proper insole and outer edge curvature, but it's not necessary.

Remember that we're building our forms first, and that not every detail has to be modeled. The purpose of modeling is to show the forms when lit. The surfacing that we'll do in Chapter 7 will hopefully add the level of believability we're going for.

If you've been following along, you should have a little bald fellow

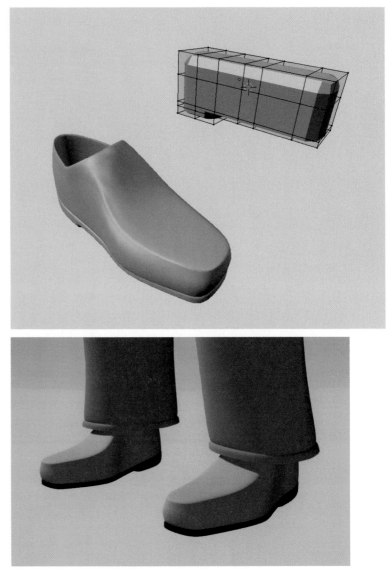

**Figure 6.30** *A basic shoe structure.*

who is made up of seven objects: a head, two eyes, a shirt, pants, and two shoes. Let's end this young man's embarrassment and give him some hair. Figure 6.31 shows where we are with the character. Admittedly it's a little creepy. Once he has hair and proper surfacing though, he'll start to look better.

# Adding Hair

To add hair, we're going to deal with three new concepts: **vertex groups, weight painting,** and **particles.** Before working, let's clean up the 3D view a bit. We'll only be dealing with the head, so let's

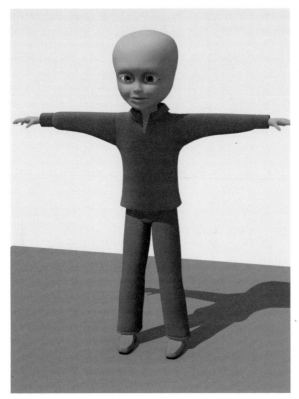

**Figure 6.31** *The character thus far.*

isolate it. RMB select the head, then press the forward slash on the number pad (**Numpad-/**). Everything else disappears, leaving the head by itself. This is called **Local** mode and is convenient when you have a full scene and need to concentrate and do detail work on a single element. Any objects that are selected when pressing Numpad-/ follow along into Local view. Pressing Numpad-/ again leaves this mode, returning your previous layer and visibility settings.

In Local mode then, make sure the head is selected and find the Particle Context of the Properties window. The four little sparkles are shown in Figure 6.32. There's not much going on in this panel to begin with. Hair (and fur and other things) in Blender is created by a **particle system**. Particle

**Figure 6.32** *The Particle panel. Clicking the + symbol adds a new particle system.*

systems have a ton of uses in Blender, and we have a whole section on them coming up later. For now, though, we'll show you the basics of this specific application.

The interface element at the top of the panel is a new one. It is used whenever a property (like particles, materials, or texturing) can have multiple entries that apply to a single object. This little window shows all of the property sets that are attached to the object. LMB clicking on them sets the Properties window to display the value for that particular entry. In this case, we only need one particle system attached to the head. LMB click the plus sign (+) to add a new particle system. When you do, the window will be populated with all of the controls you see in Figure 6.32, at their default settings.

The only things we need to change at first are the **Type** in the topmost panel and **Amount** in the **Emission** panel. Set **Type** to **Hair,** because, well, we're making hair. As soon as you do that, your head turns into a spiny atrocity. Reduce the value of **Amount** from 1,000 to 500. This is the number of spines on the head that will someday soon be the guidelines for hair. Not that there's anything wrong with 1,000, we're just trying to follow the 3D principle called "get away with using as little of everything as you possibly can."

Finally, adjust the **Normal** value in the **Emitter Geometry** section of the **Velocity** panel. That controls how long these initial hairs are. I'm not going to give an exact value here, as the scale of your own project may differ from the ongoing example. Use the real-time feedback to make it look like the hairs are growing away from the head only 4 or 5 inches. Figure 6.33 shows what this looks like.

Obviously, this is unacceptable. People don't have long hair coming out of every inch of their skin. At least they shouldn't. Way down at the bottom of the particle settings is a panel called **Vertex Groups**. If you expand it, you'll see a bunch of oddly named fields. The top one, **Density**, allows you to specify the density of hair growth on the model. Some places, like the face, should have zero hair growth. Others, like the top of the head, should have a lot of growth. We're going to use this panel, in conjunction with the Vertex Groups panel, to restrict the hair growth to the normal places it would be on a person.

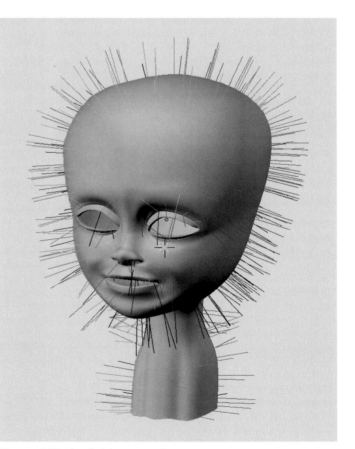

**Figure 6.33** *Attacked by a porcupine.*

Tab into Edit mode on the head, causing the hair to temporarily disappear, as particles are only visible in Object mode. In the Properties window, switch contexts from Particles to Object Data properties (the little mesh triangle icon). You'll note that one of the panels there is called **Vertex Groups** and sports the same multisetting interface you just encountered with particles. Click + to add a new vertex group. Figure 6.34 shows the panel.

Vertex groups are named collections of vertices. You can think of it as a way of "saving" mesh selections. For example, let's say that you keep tweaking the mesh of your table model. You're just not happy with it and always going back to shrink or grow the central column. Of course, every time you do it, you need to reselect the column. It would nice if there were a way to store that selection, and in fact there is.

LMB the vertex group in the panel that you just created, called "Group" by default. Change its name to something descriptive like "hair density" in the name field. Now, in the 3D view use the selection tools to select the faces from which you would like hair to grow. Figure 6.35 shows just such a selection.

**Figure 6.34** *The Vertex Group controls.*

When you're done, LMB click the **Assign** button on the Vertex Groups panel. This "saves" your current selection into the vertex group named "hair density." Want to test it? Deselect the mesh with a tap of the A key, then click the **Select** button on the panel. The selection returns! Magic (that is, for certain values of magic)!

Of course, you can do more than that with the Vertex Groups panel, and you probably will. For example, if you add a vertex that you don't want in the selection anymore, you can select it (by itself!) in the 3D view, then click **Remove**. That says, "Take whatever the current selection is and subtract it from the current vertex group." Your meshes can have many vertex groups, as many Blender features use them for different things. To manage them, just remember to first LMB click on the vertex group name in the chooser, then make your adjustments. You can also access a number of vertex group–based operations from the 3D view by pressing **Ctrl-G** while in Edit mode.

Jumping back to the particle controls, you can now click on the field beside **Density** in the **Vertex Groups** panel and select the group called "hair density" (or whatever you named it). Tab out of Edit mode and … magic again! The hair growth is now restricted to the faces you selected and saved as a vertex group.

Vertex groups do not need to be an either/or proposition, especially when used for something like hair density. You might want to have different portions of your mesh have a hair density somewhere between "none" and "all." You accomplish this with the **Weight Painting** mode.

161

Weight Painting allows you to adjust vertex groups visually and interactively. Enter Weight Painting mode either by using the keyboard shortcut (not one you should memorize necessarily) **Ctrl-Tab** or changing the mode selector on the 3D view header from Object mode to Weight Painting. When you enter Weight Painting mode, your model turns blue and red. Blue represents "not in the group" and red stands for "completely in the group." You don't see it yet, but the colors gradate from blue through green, yellow and orange, then red. If you don't currently have the tool shelf on screen, press the T key to show it. The display should resemble Figure 6.36. The painting tools are in the tool shelf on the left. The 3D view shows the colorized mesh, which represents the state of the currently active group from the Vertex Groups panel. If you had more than one vertex group, LMB clicking on the different ones would instantly change the

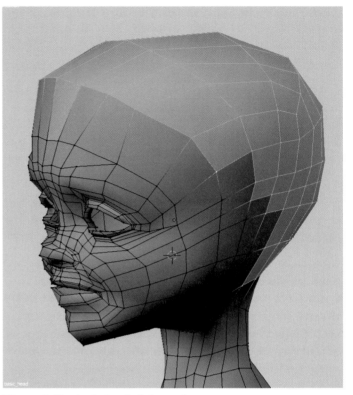

**Figure 6.35** *A selection for hair growth.*

colorized mesh display, allowing you to work on the selected group.

Looking at the paint controls in the tool shelf, the important ones to adjust right away are **Jitter** in the **Brush** section and **All Face** in the **Options** section. Make sure Jitter is at 0, and that All Faces is disabled. Jitter applies a random motion while you paint that might be nice for some things, but is awful for precision paint work. Once you begin painting though, your main controls are **Weight**, followed by brush **Size** and **Strength**. Weight controls what "color" you paint with. The highest (1.0) is red; the lowest (0.0) is dark blue. If you want to add an area to the vertex group, paint with red (1.0). If you want to take away, paint with blue (0.0). Hovering your mouse in the 3D view, you'll notice that the cursor has been replaced with a circular paintbrush. You control the size of the brush either with the Size slider on the tool shelf, or by pressing the **F** key in the 3D view, adjusting the size interactively with mouse motion, and clicking LMB to accept the change. Likewise, brush strength is adjusted with **Shift-F** and the same procedure. Note that a high brush strength is denoted in the 3D view by a very small circle. Think of it as brush "concentration."

At this point, painting is as simple as LMB dragging on the mesh in the 3D view and watching the hairs reapportion themselves every time you paint a stroke. Using this method, it is easy to restrict hair growth anywhere on your model. If you find that the edges and vertices don't quite line up where you would

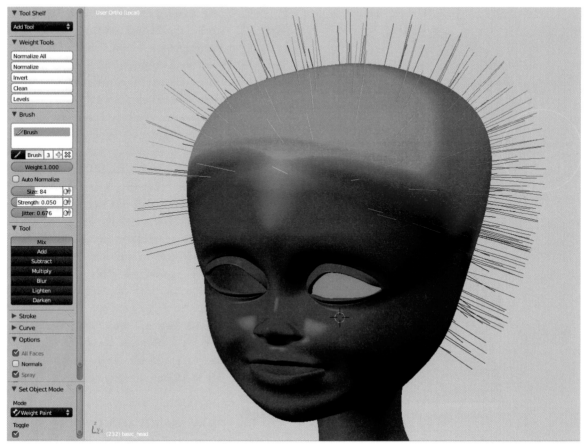

**Figure 6.36** *Ready to paint.*

like hairlines to be, you can always go into Edit mode and add an edge loop or two to provide the extra geometry that you need. If painting seems sluggish on your system, try disabling the Subsurf modifier on the head. It can really slow down the paint tools.

## Hair Styling and Digital Rogaine

Let's take a look at another 3D view mode that uses the same brush-type interface as Weight Painting. On the 3D view header, switch from Weight Painting mode to **Particle** mode, which uses a little comb as its icon. The tool shelf changes to the particle tools, as shown in Figure 6.37. It's time to think of yourself as a digital hair stylist. All of the provided styling tools work with the same Size and Strength controls as painting, and function by LMB dragging on the hair in the 3D view.

- **Comb:** This pulls the hair around. By keeping **Root** and **Length** enabled in the Options section, it works as you would expect. Disabling Root causes the tools to move the entire hair, including where is it "anchored" to the mesh. Disabling Length causes the comb tool to stretch the hair.

- **Smooth:** Hair can get kinked. This smoothes it.
- **Length:** This can be set to make hair Grow or Shrink.
- **Puff:** This causes the base of hairs to tend to stand straight out from the mesh.
- **Cut:** This simply cuts hairs wherever the brush goes, like a laser beam.

Styling is really one of those things you have to see in motion (or just do) to get. The Web Bucket has a video of a simple style job on this kid character called *make_me_look_good.mpeg*. The best workflow I've encountered with hair and fur is to use the comb on maximum strength to just lay the hair flat against the head in the appropriate direction, then make use of the Puff tool to selectively raise it back up. Waves, peaks, and additional styling are then fairly easy to execute with the Comb tool. Cut is used to eliminate stragglers and to help sculpt the final shape. If at any point you really hate the hair style you've created, you can wipe it back to the default by clicking the **Free Edit** button in the particle controls. Once again, disabling the head's Subsurf modifier will speed up your system's response.

Figure 6.38 shows a simple upswept hair style that is created with just this technique: laying the hair down on the head, and using Puff.

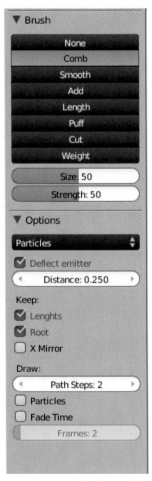

**Figure 6.37** *The hair styling brush tool.*

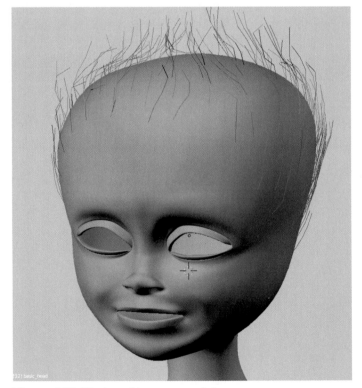

**Figure 6.38** *The boy with some sparse hair.*

The strands we've been playing with are just guides for the real hair, which is about to materialize. Set the head back to Object mode. Find the **Children** panel in the particle properties and change it from None to **Faces**. A bunch of new controls show up. The ones under the **Effects** heading all deal with the different ways that child hairs can clump around the parent strands, roughen themselves, and even kink and curl. For now, all you need to do is set the **Display** value to around **5** and **Render** to around **25**. This means that for each guide hair you styled, Blender will generate 5 additional hairs in the display, and 25 additional hairs at render time. The extras, called "child" particles, decide how to style themselves based on the original guide hairs that you already worked with. A quick bit of math shows you that Blender will render over 12,000 hairs at these settings (500 originals × 25 child hairs per guide). This is quite a few, but it can easily go higher.

Figure 6.39 shows the head with these child strands enabled. Note that this is only one-fifth of the amount that we'll render. We're not going to bother rendering the hair right now, as strand appearance is highly dependent on materials, which we'll tackle in Chapter 7.

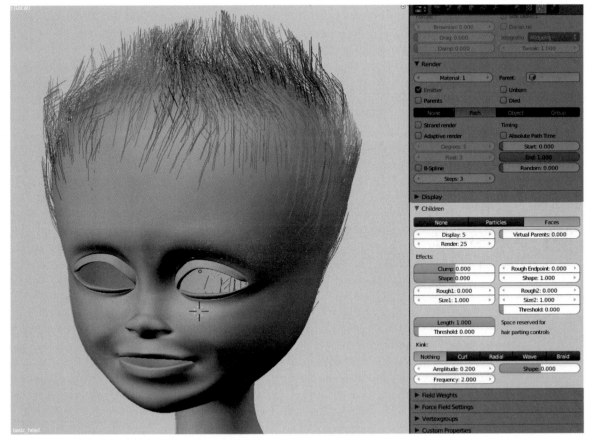

**Figure 6.39** *The head with child strands enabled.*

## What We Missed

Character design and modeling is another one of those huge topics. This chapter has equipped you to strike out on your own. Do some anatomy study. If you can't draw figures, get yourself one of the many great "learn to draw figures" books that are available. You can literally spend all of your available time working on character development and modeling. Like so many other artistic endeavors though, at some point you just have to call it quits. Hopefully the techniques and suggestions in this chapter will allow you to develop an acceptable character within your time constraints.

## Next Up ...

We've modeled and lit our scene, and created a character. In Chapter 7 we learn how to apply believable surfacing to everything we've built.

# Chapter 7

## Targets for Building Believable Materials

Every surface in Blender requires a material. Materials define the way that light interacts with that surface. Blender's material system allows a gigantic variety of settings. Too many, actually. Most of the ways that you can set the properties will result in materials that couldn't exist in the physical universe, and if you use them they will bring down your artwork. In this chapter, we're going to learn how to use Blender's surfacing tools with an eye toward keeping it real.

A few very nontechnical rules will keep you well within where you should be:

1. Subtlety. In the real world, things rarely stand out because of their surfaces. Keep everything two notches below what you think they should be.
2. Not everything that's there needs to be used. Blender has a seemingly limitless set of texturing and material options, and not all of them will help you.
3. Observation. Look around you, carefully. Find references that match the things you are creating in 3D. Don't take it for granted that you know what a surface really looks like from memory.

And a few technical ones:

1. Surfaces don't give off more light than they receive.
2. Most objects in real life have surprisingly low glossiness and color saturation.

## Basic Material and Texture Settings: Walls and Floor

Let's dig right into learning the material system by surfacing the walls and floor of our example room. Figure 7.1 shows the Materials context of the Properties window. The top panel is the familiar interface from working with multiple property sets, like the Vertex Group and Particle system panels from Chapter 6. This indicates right away that objects can have multiple materials. When you work with a new object

167

that has no materials assigned to it, the selector window will be blank, and a large button that reads **New** is displayed. LMB click it to add a new material to the object.

LMB clicking on the Material icon (the checkered ball) to the left of the material's name—"walls" in our example—allows you to choose any material in the current file. In case you want to remove a material (unlink it from the selected object), just click the "X" icon to the right of the name.

Below that management panel is the **Preview** panel. Blender's material preview renders live as you make adjustments to your settings. It uses Blender's actual internal renderer—no tricks—so you can be sure that what you're doing in the panel is what you will get in your scene. By clicking on the icons to the right of the preview, it can be set to show a plane, a sphere, a cube, a monkey, hair strands, or a larger-scale sphere with a sky background. In general, you'll choose the preview object that is closest to the actual one you are surfacing in your scene. In the case of the example, we are working on walls and a floor, so the cube (or the plane) is an appropriate choice.

Continuing down the line, we come to the **Diffuse** panel. Diffuse refers to the general shading properties of the surface—that is, the actual way that incoming illumination is dealt with. There are a number of ways of making these calculations in 3D, and Blender allows you to select from several options. Each is appropriate for different circumstances.

- **Oren-Nayer** is the best for most nonglossy surfaces.
- **Lambert** is appropriate for shiny metals and plastics.
- **Minnaert** is good for lush fabrics.
- **Toon** and **Fresnel** are special-purpose shaders that won't play a role in the vast majority of projects you do.

The Web Bucket has examples of each of these. The differences are sometimes subtle, but it is inaccuracy in the subtleties that can ruin your scene.

Here's the first place where you'll have to exercise some discipline. Most of the work you do will almost certainly require Oren-Nayer and Lambert shading. Don't use the other ones "just because they're there" or because you suspect they might be lonely.

**Figure 7.1** *The Materials context.*

Observing any number of interior walls, you'll find that unless they are painted with a flat finish, they do exhibit a certain amount of gloss. While the Oren-Nayer model would be okay, we'll go with Lambert (the default) because of the slight glossiness.

In that same panel is the **Intensity** control. This slider controls how much of the incoming light is reflected. In the real world, nothing reflects 100% of the light that hits it. Manufactured white items like plaster and paint will have the highest reflectance, getting as high as 0.9 (i.e., 90%). The Web Bucket contains a text file (*common reflectance.txt*) with reflectance ranges for some common classes of materials. In general, the rougher the surface, the lower this value is going to be. The roughness in question isn't the large-scale roughness of the bark of a maple tree, but on a smaller scale, like the finely pitted surface of sidewalk concrete. We'll revisit this value as we work through the different objects in the scene.

In addition to Intensity, this panel also has a **Color** swatch control, just like the lamp controls discussed in Chapter 5. Once again, almost nothing is perfectly white. Even a painted white wall or paper will have a slight color cast to it. LMB clicking on the color swatch brings up the color picker, which is highlighted in Figure 7.2. The black/white slider on the right selects for overall brightness, while the hue and saturation can be selected within the color circle

**Figure 7.2** *The color picker.*

itself. Of course, you can set colors using the RGB sliders at the bottom, but I don't recommend it. In fact, I generally change from RGB (red, green, blue) to HSV (hue, saturation, value) controls. Why? I find that it's fairly easy to obtain the general color you need by using the visual controls (black/white + color wheel). Then, I use the HSV controls, mostly the S (saturation), to make the color more realistic. This is a place where careful observation will pay off. Yes, that vase in your scene might be red, but how red is it really? Do not oversaturate your colors. Real life is, for the most part, lacking in saturation. Pull that S slider to the left, just a little bit past where you think it ought to be.

At this point, it doesn't matter if your object has a complex color scheme. The color you pick here serves as a base for everything else that you do, so choose a color that represents what you think the object would look like if it were evenly lit and heavily blurred. It also sets the color of the object when drawn in Solid mode in the 3D view. In our example scene, the walls are set to a dull, light mustard color, because white walls are boring (R = 0.70, G = 0.62, B = 0.28).

The next panel is titled **Specular**. Specular is a trick that 3D renderers use to represent the real-world phenomenon of being able to see an often diffused reflection of a light source on a surface. Changing the Specular Intensity between 0.0 and 1.0 will show you the effect immediately in a spherical material preview. The abuse of specular highlighting is one of those things that instantly identifies an amateur image. It's there, and the default Intensity is 0.5, so people figure "That must be good, right?" Well, it isn't. Start by just turning it off completely—Intensity to 0.0.

Now, we only bring it back up for things that really require it. What kind of stuff requires a specular highlight? Things with gloss and shine: lacquered wood, glass, polished metal, many plastics, wet pavement. Remember when we mentioned that a material shouldn't reflect more light than it receives? Well, that comes into play right now. Our walls are a bit glossy as we noted when we selected the Lambert base shader. So, it would make sense that they exhibit some specular highlighting as well. The Diffuse Intensity is set at 0.9, meaning that the surface is already reflecting 90% of the light it receives. Using our previous rule, the Specular Intensity shouldn't be higher than 0.1 (0.9 + 0.1 = 1.00). It might even be lower.

At this point you might be looking at a material preview with these settings and thinking that it doesn't show much at all. You would be correct. Crank the values up until it's obvious and you lose your (1) subtlety and (2) believability.

In addition to **Intensity**, there are three other options with specularity. The first is **Color**. Unless you're dealing with a colored metallic substance, leave it pure white. Specular highlights should show the color of the light source without alteration. When dealing with a metallic surface though, the specular should be adjusted to match the diffuse color. That's just the way that colored metals do it.

The next option is the **Specular Shader**. Just like with Diffuse, there are a number of choices, some more useful than others. The one that fits the most real-life cases is the **Blinn** shader, which we've chosen for our walls. Chose Blinn as your default. However, if you're working with a high-gloss material, choose either **Phong** or **CookTorr** (it's nearly impossible to tell the difference between the two, so flip a coin).

Finally, each of these specular shading models has a way of controlling the size of the highlighted area. The **Hardness** value runs from "extremely diffuse highlight" at 0 through "tight and highly focused" at 511. Higher values mean smaller, more intense highlights. For most surfaces, start testing this value around 25. Materials with a high gloss should have this set over 128 to produce the proper highlighting. For everything else, though, you'll either have specularity turned off completely or set to very low intensity levels. Be careful dropping this value below 10, as it is so diffuse that the highlighted area actually becomes most of the portion of the object facing the lamp. In the example scene, the hardness of the walls is set to 11—a very diffused highlight that is close to covering too much area.

Let's move one more panel downward before we move on to texturing. (Move on, you say!? But what about all of those other buttons? We'll either deal with them later in more advanced examples, or their use is so specialized that they don't have a place in a beginner's book.) The **Shading** panel controls options that apply to the way Blender handles shading (brilliant!), regardless of the individual shader choices you've made in the other panels. For now, the only one we are concerned about is **Cubic Interpolation**. Really, this should be enabled as a default for every material you create. It provides a more natural transition from the lit portion of an object to the unlit portion.

### *Varying Material Properties with Textures*

So far, it seems that the main properties of a material are the diffuse color and intensity and the specular color and intensity. But nothing in the real world has a perfectly uniform color. To vary these properties (and others you haven't used yet) across the surface, we use **Textures**. Textures can be of two types: image

and procedural. Image textures use image files to create their variation. Figure 7.3 shows a digital photo of a section of carpet. A little later, we'll use that image to vary the material properties of the floor so that our 3D surface looks like carpet. The other type of texturing, procedural, is generated on-the-fly from mathematical models within the renderer. Blender has a decent number of procedural texturing styles (wood, marble, clouds, and noise are a few) that more or less don't look like what you'd hope.

I'm going to catch some grief for this, but I find procedural textures of limited value. Not necessarily zero value, but there you have it. It is so simple now to just grab your digital camera and start snapping, or to browse *www.flickr.com* for

Figure 7.3 *This is carpet.*

Creative Commons material for use as textures in your scenes, that the difficulty involved in creating a good procedural is just not worth it.

With that said though, let's start by using a procedural texture to roughen the walls and learn the ropes.

Every surface you can observe around you shows variation in at least three properties: color, shine, and roughness. Even a white painted gypsum wall varies, although that variation is extremely subtle. The color of a wall will probably vary near the floor, in corners, and near any openings, where dirt will tend to accumulate. The shine will vary in a similar way, as dirt reduces the sheen of the paint, but it might also increase in certain places if people have leaned against it, leaving a slight oily handprint or shoulder print. The roughness on such a wall shows up as micropits, or in the case of a highly textured drywall job, as peaks and valleys of drywall compound.

If at this point you're thinking, "Gee, I have to think about this kind of stuff for every object in my scene?" rest assured. The truth is that you don't have to think about it that hard, *if* you want your work to be lame. However, if your goal is to make your scenes feel like real places, even if they are stylized and nonphotorealistic, you have to give the viewer the subtle clues that they need in order to believe. So yes, you have to think like this for your "hero" objects. Stuff that's way in the background or that flies on and off camera in the blink of an eye can do with a little less attention, as we'll see later. But for the main things, don't compromise.

And with that note about details being important, we're going to skip the dirt and handprints for now, as they require skills that you don't have yet. Let's examine Figure 7.4, which shows the Texture context of a Properties window.

A texture requires three groups of properties: The first is the actual texture itself, whether it be an imported image, a marble simulation, or just noise; the second is the way that the texture is mapped onto geometry; the third defines which properties of the material the texture affects.

The topmost panel of the Texture button is the familiar multiproperty selector. Blender allows as many as 18 different textures layered onto a single material. The texture in the example scene is called "walls," and you can add a new texture to your own scene by first making sure that the wall object is selected and that the proper material appears in the material buttons, then clicking the **New** button below the selector.

**Figure 7.5** *Blender's texturing styles. Not all styles are created equal.*

> ### Note
> When you create a new texture in this panel, name it right away by clicking on the default name (something like "Texture.001") and changing it to something descriptive. When you're ten hours into creating surfaces for your scene, you don't want to have to browse through a bunch of textures with names like "Texture.007" and "Texture.009," blindly flailing for the exact one you need to apply to your material.

Figure 7.5 shows all of the different texturing styles available. The textures with checkerboard icons are procedural (computer-generated), while the ones with the image file icon are image types. For the walls, we've chosen **stucci**, one of the useful procedurals. The stucci texture is perfect for anything that might be created by troweling a compound over a surface (Stucco! Drywall!).

**Figure 7.4** *A basic procedural texture.*

The Preview panel can show you either a flat representation of your texture, which is useful when starting out, a preview of the whole

material with the texture incorporated, or both side by side. As I usually use a materials window to the left of my texturing window, I can already see the material preview there. These different preview styles are selected with the buttons below the preview.

Below the Preview panel is a panel named with the texture type. In the case of this example, it is called "stucci." This panel holds the controls that are specific to that texture type. Getting just the right settings in this panel is a combination of knowing what you are shooting for, and trial and error. The different button options present for the texture types (Plastic/Wall In/Wall Out and Soft/Hard for stucci) obey one rule: If it looks like what you want, it's what you want. There are no hard-and-fast guides about what option you should use where or when. It's completely subjective, and one artist might be able to use Wall In/Hard to get a believable wall texture, while another will use Wall Out/Soft and achieve an equally believable one.

Below the style-specific options is often a **Noise Basis** selector. Blender has ten different kinds of "noise," which just refers to different mathematical models for generating semi-random patterning. The default is always Blender Original, but it's worth paging through each of them until you get a feel for what they look like.

**Blender Original** and the two **Perlin** variations create similar globby noises that when set to "hard" noise almost look like the cross section of an ant hill. The **Voronoi** textures take a seemingly cellular approach, creating everything from haphazard honeycombs to patterns that resemble a cracked desert floor. **Cell Noise** creates a grid, and is superb for adding visual interest to mechanical and manufactured surfaces. Check the Web Bucket (*noise_texture_types.mpeg*) for a run through of all the different texture types, regardless of their actual usefulness.

The last two common controls for procedural textures are **Size** and **Turbulence**. The Size property brings us to one of the most important aspects of achieving believability in your scenes: scale. As long as your models are fairly accurate, the only thing you need to worry about is texture scaling. Consider Figure 7.6. It shows a chair sitting on

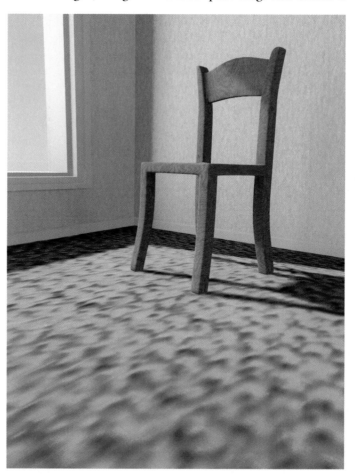

**Figure 7.6** *An oddly carpeted floor.*

173

a carpeted floor. Unfortunately, the carpet texture is applied at an unrealistic scale, ruining the illusion of reality. It's not horribly wrong, but wrong enough. As you choose and generate your textures, make sure that they are in the correct scale. The best way to do this is to observe reference images (or the real world, if you have it handy) and compare them to your own test renders, paying specific attention to texture scale.

**Turbulence** "messes up" the texture. The more you add, the more random it becomes. How much turbulence do you need? Once again, you should know where you're headed. Set it 0.0 and observe. Then max it out (1000.00 in most cases) and see where that gets you. Your solution will obviously fall somewhere between the two, and the near-real-time preview will help you to find it.

The last panel that directly affects the image is **Colors**. You can see the familiar RGB controls here, but they only work with texture types that have color information to begin with. Only Image,

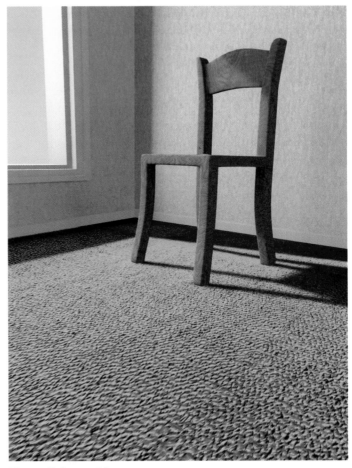

Figure 7.6, cont'd

Magic, and Clouds make use of them. Even then, the set of RGB sliders is the crudest of tools, suitable to a last-minute push toward a certain color cast. If you really want to colorize something or otherwise adjust it, you're better off doing it another way. The **Brightness** and **Contrast** controls, however, work with all of the texture types. Increasing brightness pushes the entire texture toward white, while decreasing it pushes toward black. Decreasing contrast tends the texture toward neutral gray. Raising contrast makes the differences between dark and light portions of the texture more stark. These controls should also be used with care, as they can result in texture values outside of the normal range (think of a perfectly white texture with a raised brightness) that can in turn produce unexpected "burned out" spots in your resulting material. My advice is to use the RGB, Brightness, and Contrast controls sparingly.

## Color Ramps

Enabling the little checkbox at the top of the Colors panel brings up the **Color Ramp** interface. Color ramps are Blender's name for what are sometimes called gradients or blends in other software. Basically, a ramp is a band that varies in color and possibly in Alpha across its width. Figure 7.7 shows a typical color ramp. Each of the vertical bars within the band represent a set RGB and Alpha point. The ramp interprets the colors between them, then uses that result for the texture, instead of simple black to white. Note the vertical bar in the center of the figure; it is dashed while the others are solid lines. This dashing indicates selection. To select a bar, LMB click on it. When you do, its color and Alpha values are displayed below the band, in the color swatch and the **A** slider. To change those values, just operate the controls as you would elsewhere in Blender. You can change the position of the selected bar by LMB dragging it to its new location along the band. Adding new bars (for increased color detail) is accomplished by Ctrl-LMB clicking within the band, just like adding vertices to a mesh. Selected bars are removed by LMB clicking the **Delete** button above the band.

We'll revisit color and Alpha ramps when we deal with hair texturing later in this chapter.

**Figure 7.7** *Blender's Color Ramp controls.*

Once you have an actual texture, whether it be generated by Blender (procedurals) or brought in from a camera or paint program (images), you need to decide how it will be applied to your geometry. This is another area where the wrong choice can ruin your work. While there are 11 mapping possibilities in Blender, each with a number of attendant options, only 2 of them are really necessary for general work: **Generated** and **UV**. Some of the others are useful for special purposes (Strand, Reflection) that we'll get to later. The question you need to answer about your object in relation to mapping is: Does the texture that I have apply to the surface only (like a tattoo, a coat of paint, or a wood veneer) or does it go the whole way through (rings in a piece of wood or veins in marble)? If the texture in the real-world version of the object is "discovered" because of the pattern formed by carving a solid object, then you will use **Generated** mapping (the texture mapping is *generated* from the relative locations of the surface and the center of the object). However, if the texture is the result of some kind of surface application, **UV** is the way to go.

We'll deal with UV mapping in a later section, so let's take a look at Generated mapping now. First, Generated mapping is mostly going to occur with procedural textures. Think about it for a second. Image-based textures are going to take a flat picture and apply it somehow to your 3D model. It's quite possible that it will be a picture of that kind of surface from the real world. As you're using an image of a *surface*, it will probably be applied to the *surface*, which according to our previous test indicates it will be UV

mapped. That leaves Generated mapping as the almost exclusive province of procedural textures.

So, if your object is "solid," and you're planning to use a procedural texture to simulate it, choose **Generated** from the **Coordinates** control on the **Mapping** panel. For now, you can ignore both the Projection and $x$, $y$, and $z$ controls.

The **Offset** and **Size** controls, however, determine the scale and location of your object's texture space, and are very important. Figure 7.8 shows a single channel of a procedural texture that uses the **Wood** style. As a default, textures are centered, meaning that the center of the concentric rings will be in the center of your object. What if you want a different "slice" of the texture? The Offset values move the object's texture space, changing the portion of the texture that you see. By adjusting the offset $x$, $y$, and $z$ values, you can cause your wooden cube to use only the portion indicated in the figure.

The Size controls will seem backwards at first. Raise the size values over 1.0, and the texture will appear to shrink on your object. Lower the value between and 1.0 and 0.0, and the texture will appear larger. Negative values will mirror the texture along that axis (e.g., size $y = -1$ will flip the texture along the $y$ axis). The reason for the apparent opposition to reality is that the Size controls affect not the texture, but the object's **texture space**. The texture space is the "size" that Blender considers an object for texturing purposes. So, if you have a cube

**Figure 7.8** *Finding the right part of a texture with Offset.*

that is 1 × 1 × 1 units, but has size values of 20 × 20 × 20, Blender textures it as though it were 20 times its original size. What does this result in? A 1 × 1 × 1 cube with 20 times as much texturing stuffed onto its surface, or very tiny textures.

With that in mind, you might be wondering how best to scale your textures: Use the Size slider on the individual texture style's panel (stucci, wood, etc.) or the texture mapping Size x, y, and z controls on the Mapping panel? Generally, I try to keep the Size control on the style panel to such a level that I can see what's going on with the texture in the Preview panel. Make it too small and it will just look like grain; too large, and you won't get a representative sample. So, use the style Size control to get yourself a good preview. Then use the mapping Size controls to set the proper scale for your scene.

For the walls in the example scene, a series of test renders indicate that a Size setting of around 50.0 for x, y, and z gives the proper look, without any weird artifacts.

One final note on texture sizes. When creating objects with fine detail, like these walls, it's important not to make your textures too small. At some point every texture will appear like little more than noise if it is reduced too much. When this happens, it will ruin animation rendering. Blender's renderer does its best, but as too much texture detail is packed into a single pixel on each frame, the resulting colors are essentially random, which causes the texture to appear to "crawl." Check out *crawling_walls.mpeg* in the Web Bucket for an example of the effect. When you see this in your own animations, the cause is always the same: Your texture is too small. There are two solutions. The first is to increase the apparent size of the texture, rendering two consecutive frames to see if the crawling effect disappears. The other is to enable **Full Oversampling** in the **Options** panel on the material (not the texture). This causes the renderer to use a much more exacting method of determining texture colors. It takes a lot longer to render, but if your scale is truly set and you're unwilling to change it, this is the only way forward.

So far in our wall example, we have selected a procedural texture (stucci) and set its properties, selected a mapping (Generated), and adjusted the size of the texture space (to 50.0). Now, we have to decide what aspects of the material the texture is going to affect.

If you'll recall from earlier in the chapter, we said that surfaces usually vary in three ways: color, shine, and roughness. Let's take a look in the **Influence** panel of the texture. In all, there are 14 different material properties to which we could apply this texture. Most of them (like mirror, emit, etc.) are inappropriate in this case. The three "must-haves," though, are **Diffuse Color**, **Specular Intensity,** and **Geometry Normal**. These account for color, shine, and roughness. Unless there is a compelling reason to do otherwise, you should always have some sort of texturing applied to each of these channels. The rest are bonuses, and somewhat unnecessary excepting special situations. Failure to texture on these three channels, though, will result in images that lack believability.

To make the texture affect the Diffuse Color, enable the checkbox beside Color in the Diffuse section of the panel (it should actually already be enabled as the default). The control doubles as a slider, allowing you to select the amount of the texture's color that affects the main material color. In these sliders 1.0 is the same as 100%, so leaving it at 1.0 (the default) results in the texture's color completely replacing that of the main material. If you were applying wallpaper or some such, this is exactly what you would want.

In this case, careful observation will show that gypsum (or plaster) walls don't show a lot of variation in color. They are generally painted white. So, we'll let the texture affect the diffuse color only slightly, say, 0.200.

If you're creating the example for yourself as you follow along with the book, you may have noticed something odd when you enabled the Color control. The material preview turned a nasty magenta color. This is because the stucci texture (as well as most of the other procedurals) does not generate color information by default. You can *force* it to generate color by use of the Ramp option as discussed earlier, but for now it is only a gray value. When the Influence panel receives noncolor information for a channel that requires color, it has to generate one. The color picker swatch at the bottom of the panel lets you set this color. For the wall example, I've set mine to a yellow gold a shade or two darker than the main diffuse color of the material.

With a little variation in color, let's move on to shininess, which is varied with specular intensity. Enable the **Intensity** option in the Specular section of controls. The main Specular value for this material is set around 0.15, and enabling this seems to blast it back out, which you can see in a sphere material preview. This is because texture influence adds to whatever the original value is in the material panel. So, an original Specular Intensity of 0.15 plus full (1.00) intensity from the texture panel generates a value over 100%. That's not what we want at all. Ideally, we'd like to just have the texture intensity completely substitute for the material value. Reducing the material's Specular Intensity to 0.0 does the trick. Now, whatever value we get from the texture is added to 0.0, which is just the same as pretending that the material value doesn't even exist.

So, the maximum Specular Intensity from the texture is 1.0 at the moment. We want to retain our original limit of 0.15, so simply reducing the slider to 0.15 gets us to where we need to be. When working with single values like this (Alpha, Mirror, etc.) in the future, the rule is: Reduce the material value to 0.0, and set the texture-based value to the maximum you would have used in the material.

Finally, let's look at the roughness of the wall. A gypsum wall, although often smooth, is not a mirror. It has some roughness to it that you can feel—sometimes more or less depending on the decor. This roughness can be simulated with the **Normal** value in the **Geometry** section. Applying a texture to a surface's normal value is a rendering trick that lets us pretend there is more complexity to the geometry than actually exists. The "normal" we're talking about just means "which way the surface is pointing." Figure 7.9 shows two renders of a simple quadrangle. The one on the top has normals all pointing in the same direction. The one on the bottom has a texture applied to its normal channel. The texture is used by the renderer to vary the actual normal, giving the illusion that there's a lot going on, when in fact it's just the same old quadrangle as the one in the first image. To actually model that kind of surface detail on a mesh would take a ridiculous amount of time, both to construct and to render.

The Normal value defaults to 1.0. This affects the apparent "depth" of the roughness introduced by the texture. It's usually more efficient to just test-render and adjust to get the value correct, rather than trying to do some kind of funky math involving texture space sizes, geometry, and texture values. Keep in mind the principle of subtlety, though. You may have spent an hour getting all the aspects of your texture just right, but that doesn't mean you need to beat your viewer over the head with your triumph. How much

depth should you add to your normal variation? Let observation of the real world be your guide. The real triumph will be an image that clicks inside your viewers' head.

For the example scene, I've settled on a low value (0.010) for the normal variation with the wall texture. You can just make it out in a high-resolution render, or where the camera is closer to a wall. It's not overpowering. It doesn't scream "Look at me! I'm a wall!" It just sits there and does what walls are supposed to do: feel like a wall.

How do you know when you have your material and texture properties just right? The only real way to tell is to render them, applied to your objects, with the lighting that you determined in Chapter 5. The lighting (hopefully) looked good without any additional surfacing, so we

Figure 7.9 *The effect of varying the surface's normal value.*

know it's correct. This means that the surface properties of our objects must look correct in that lighting. If you've observed your references carefully, then your texture will look right within the lighting scheme that you've chosen. And, since you've chosen your lighting based on careful observation as well, your materials should actually be semi-portable, meaning that they will look appropriate in a variety of reality-based lighting schemes.

## Adding a Second Material and Using Image Textures

The floor. It's a bit ugly, textured like the walls. Let's throw some carpet down there using an image texture. First though, we need some way to apply a separate material to the floor.

Back in the 3D view, make sure that the room is selected and enter Edit Mode with the Tab key. Choose Face select mode on the 3D header and make a selection that consists of only the faces of the floor. On

the Material properties window, click the + sign in the material selector pane in the topmost panel. This adds another material to the list. Press the **Assign** button below the material selector to set the selected faces to use the new material. Tab out of Edit Mode. One important thing to note at this point is that the new material is not completely new: It is an instance of the original material. You can tell because both the original and the new one have the same name ("walls"), and there is a small number **2** to the right of the material name. Just like the duplicates versus instances lesson from Chapter 3, the same rules apply here. Any number of objects or material slots can be linked to the same material. Changing the properties on one changes them for every other instance as well. As we want to create an entirely new material, this won't do.

There are two ways to proceed. If the new material is going to be close to the original, you can just hit the + sign to the right of the material name. This creates a completely independent copy of the original material for you to work on. As it is not an instance, the adjustments you make to it will not affect any other materials. However, if you want to start with a blank slate, click the "X" button to unlink the material instance. When you do so, the material name turns into the **New** button. Click it to add a material with default values. In order to tell if you've done it correctly, change the diffuse color of the new material. It should change the color of the floor in the 3D view (in Solid mode), but leave the walls alone. Figure 7.10 shows the room with the diffuse color of the floor material set to a dull red.

Starting from the top, let's look at the settings I derived from observing some real, relatively new carpet. The color of the reference isn't that important. In this case, we're more concerned about how the color fits with the rest of the scene. The incoming sunlight already gives a bit of a warm feel, so I've decided to augment that and use a warm color. Note that it's not highly saturated, though, much like real carpet. It has an RGB make up of (0.33, 0.13, 0.14), of which the saturation value happens to be under 60%. That's the diffuse color. There's nothing that remarkable about carpet when it comes to reflectivity one way or another, so I'll start it fairly low, around 0.55. For the shader, however, we're going to branch out a bit. Figure 7.11 shows the material settings.

In the earlier discussion of materials, we mentioned that the Minnaert shader worked nicely for lush fabrics. This shader has a special control called **Darkness**, which defaults to 1.0. Pushed above the default, it darkens faces that are pointing straight toward the viewer. Pushed below it, toward 0.0, it lightens faces that point perpendicular to the viewer. The net effect is to somewhat mimic the variable sheen that certain fabrics like velvet or silk exhibit. New carpet actually has a certain lush quality to it, so Minnaert is worth a try. I've turned Darkness down to 0.0 so as to lighten sideward-facing geometry. Of course, it's a flat floor, so the only "geometry" that is side facing is the fake roughness that will be generated by a texture applied to the normals.

I don't note any specularity worth mentioning on real carpet, so I've set Specular Intensity to 0.0. With Intensity at 0.0, I don't have to bother with the color, hardness, or shader for specularity. Remember that with specularity, it won't be missed if it's not fairly prominent in your references, and if you put it in where it's not needed it will mess with your ability to properly create the material.

**Figure 7.10** *The floor with a new material.*

### Adding an Image Texture

Over in the Texture properties, add a new texture and call it "carpet." Figure 7.12 shows the first layer of carpet texture settings.

In the type selector, choose **Image or Movie**. This brings up the Image controls, just like the other texture types bring up a panel with controls specific to their needs. At first, though, the Image panel only contains two buttons: New and Open. Click **Open** and browse your way to your carpet texture. The specific texture I've used in this example (*carpet3.jpg*) is from the public-domain *Blender Texture CD*, and is available in the Web Bucket for this chapter. When you load the image, informational widgets appear in the panel that tell you the full disk path to the image, as well as its size in pixels and its color space.

Now that you have a texture with color data, the RGB sliders in the Colors panel become active. As before, I caution your use of them, as they can lead to strange color blending problems later.

Another panel that springs to life with an image texture is **Image Sampling**. It holds controls for a number of specialty items. The most important for general use are the Alpha and Normal Map settings, both of which we'll deal with later. This panel also contains the **Flip** x/y **Axis** toggle, which rotates your texture onto its side.

Now we come to mapping. By our earlier criteria, a carpet is definitely a surface texture. If you cut a floor in half, the carpet texture does not go the whole way through. So, Generated mapping (while it may or may not work depending on the geometry) is not what we want. Welcome to the wonderful world of UV mapping.

First, UV mapping has nothing at all to do with UV light/radiation. The letters are chosen because this mapping style is a way of converting 3D coordinates (from your 3D geometry) to 2D coordinates (flattened on a 2D image). X, Y, and Z are already taken with keys and axes, and the next two letters down are U and V. So, when you read, write, or say "UV mapping," think of the U and V as the corresponding 2D coordinate system that is used for images.

Set the **Coordinates** menu on the **Mapping** panel to UV, but don't bother to render yet. We need to assign UV coordinates to all of the faces in the floor model.

### Extremely Basic UV Mapping

UV mapping is such an important and frequent procedure in 3D work that it has its own screen. Use either the Screens dropdown menu on the main header or the **Ctrl-Left/Ctrl-Right-Arrow** keys to get yourself to the screen called "UV Editing."

The right half of this screen is a 3D view and some properties. The left is a new window: the **UV/Image Editor**. This is actually the window type that pops up whenever you hit Render, and is Blender's workspace for dealing directly with images. In the 3D view, find the room and go into a top view (Numpad-7). It'll help to switch to Wireframe and Orthographic modes (Z key and Numpad-5) if you're not already using them.

Figure 7.11 *The carpet's material properties.*

With the room selected, go into Edit mode. Using the A key, select all of the vertices in the room. The term for transferring 3D geometry into 2D space is called **unwrapping**. Imagine the geometry as a paper shell around a solid object—to flatten the shell onto the floor, you unwrap it. Bring up the Unwrap

182

▼ Image

[icon] 07.04.jpg                    [+][icon][X]

File | Sequence | Movie | Generated

ender Foundations/chapter_07/07.04.jpg [icon][icon]

Image: size 914 x 802, RGB byte

◯ Fields            ◯ Anti-alias
[ Even | Odd ]      ◯ Premultiply

▼ Image Sampling

Alpha:              ◯ Normal Map
☑ Use               [ Camera ▲▼ ]
◯ Calculate         Filter:
◯ Invert            [ EWA ▲▼ ]
◯ Flip X/Y Axis     [ ◀ Filter Size: 1.00 ▶ ]
                    ◯ Minimum Filter Size
                    ☑ MIP Map
                    ◯ MIP Map Gaussian fi
                    ☑ Interpolation
                    [ ◀ Eccentricity: 8 ▶ ]

▼ Image Mapping

Extension:   [ Repeat ▲▼ ]

Repeat:              Mirror:
[ ◀ X: 1 ▶ ]        ◯ X
[ ◀ Y: 1 ▶ ]        ◯ Y

Crop Minimum:       Crop Maximum:
[ ◀ X: 0.000 ▶ ]    [ ◀ X: 1.000 ▶ ]
[ ◀ Y: 0.000 ▶ ]    [ ◀ Y: 1.000 ▶ ]

▶ Colors

▼ Mapping

Coordinates:  [ UV ▲▼ ]
Layer:        [ ⊛ ]
Projection:   [ Flat ▲▼ ]
◯ From Dupli      [ X ▲▼ ][ Y ▲▼ ][ Z ▲▼ ]

Offset:             Size:
[ ◀ X: 0.00 ▶ ]     [ ◀ X: 1.00 ▶ ]
[ ◀ Y: 0.00 ▶ ]     [ ◀ Y: 1.00 ▶ ]
[ ◀ Z: 0.00 ▶ ]     [ ◀ Z: 1.00 ▶ ]

▶ Influence

**Figure 7.12** *Carpet image texture settings.*

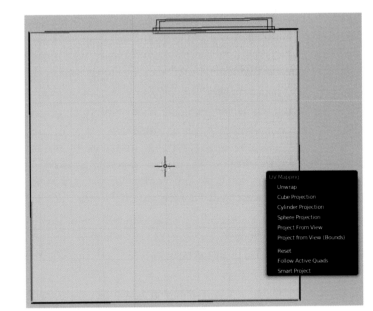

**Figure 7.13** *The Unwrap menu.*

menu in the 3D view with the **U** key. Figure 7.13 shows a cropped version of what you see, including the U-key menu. We'll work with some of those other options later in this chapter, but for now choose **Project from View**. When you do, the same mesh structure that you see in the top view is transferred to the image window on the left. It is an exact representation in 2D of the mesh structure from the 3D view, like someone just took a picture of the 3D view. To really see the effect, rotate the 3D view a bit so your room is off-axis, then try Project from View again.

> **Note**
>
> A quick reminder. All operations in Blender are not only accessible via their hotkeys (like U key for the Unwrap menu), but also from the context-sensitive header menus for each window, through the spacebar menu and search box, and the Add Tool section of the T-key toolbar.

Before we continue, though, return to a top view and redo the Project from View command so that your UV/Image Editor window looks somewhat like the one in Figure 7.13. Over in the UV Editor (as we'll call it for short), notice the control structure. It's basically the same as working with a mesh in the 3D view, with the exception that you're working in 2D. So, no 3D rotation. RMB select individual vertices. You can work in Vertex, Edge,

or Face select mode, with the switch on the header. You can make selections, then transform them with the standard shortcuts (G, S, and R keys). In fact, if your Project from View didn't nicely fill the available space (or perhaps went outside the boundaries of the workspace), select everything with the A key, then scale and translate the vertices until they fit closely within the outer edges, like the figure.

On the UV Editor's header is a selector for displaying an image, tagged with a "New" button. Click the image icon to the left of it, and select the texturing image *carpet3.jpg* that we'll be using for the floor. When you do, the image is shown in the UV Editor, with the projected mesh as an overlay. Sometimes choosing an image can alter the zoom of the window, so you may have to roll the mouse wheel and MMB drag a bit to get everything nicely centered and sized in the window. Now you can get a sense of how this works: Whatever portion of the image is contained within a mesh face in the UV Editor will be used for the texture of that same face in 3D.

If you're wondering about the ceiling and walls right now—don't. The material that uses UV mapping only applies to the floor. If we were UV mapping the walls as well, we would have to take some additional steps, but for now we're just getting familiar with the UV Editor and our simple overhead projection will work fine for the floor.

Get yourself back to the materials and texturing screen, where we'll deal with the scale of the texture. Looking at the carpet texture with the mesh overlayed in the UV Editor, it was pretty obvious that our carpet image is the wrong scale. Applied to the floor like that, it would look horrible. You already know two ways to adjust the scale of a texture: the Size control on the texture's specific style panel, and the XYZ size controls on the Mapping panel. However, we don't just want to decrease the size of the carpet image in the texture space. Unlike procedural textures that extend in every direction for infinity, image textures have a definite and obvious end point. If we reduce the image too much (or at all, depending on the mapping), there will be places in the mesh that don't receive any texture information. Blender handles this by repeating the image over and over in all directions. So, if you shrink it using the XYZ size controls on the Mapping panel, Blender will happily fill in the empty space with copies of the image.

That's the default behavior, but you are by no means stuck with it. The **Image Mapping** panel provides the controls for dealing with this. Figure 7.14 shows a close-up of the panel. The **Extension** menu decides whether to Repeat the image, Extend its edges to fill in empty space (useful for pictures with a solid color border), Clip it (leave the empty space empty), or to even use it as a checkerboard with another image texture. With Repeat chosen, you can easily specify how many times you want the image to repeat within the texture space. When working with UV mapping, the texture space is the entire UV space as shown in the UV Editor. So, how many times do we need to repeat the carpet image across the floor to achieve the correct scale? Trial and error with test renders indicated that the number was six. And, since the room was square, I chose six for both the *x* and *y* repetition. A rectangular room would have required different values.

Figure 7.14 *The Image Mapping panel.*

## The Danger of Repeating Textures

The great advantage of image textures is their shortcut to believability. Their disadvantage is that they have a start and end. While this isn't a problem when using them for objects of limited size, it presents a unique problem when trying to repeat them across a large surface like walls or floors. The human eye is excellent at perceiving patterns, and if there is even the slightest hint of repeatable variation within a repeated (sometimes called "tiled") texture, it will look phony. Figure 7.15 shows a stone floor texture with a repeating image. It's obvious that something is seriously wrong.

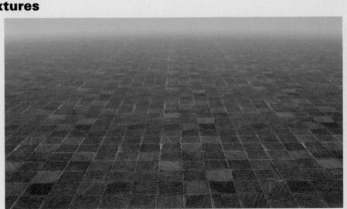

Figure 7.15 *A stone floor with repeating texture.*

Any kind of distinct mark or pattern in your image texture will show up like this. There are several ways to work around this problem. The first is to use the repeating texture only for normal and specular intensity maps, taking the diffuse color from another source. The viewer's eye won't perceive minor repetitions in normal nearly as easily as it will in color. A procedural texture can then be used to vary the color in a nonrepeating fashion, giving you the best of both worlds.

Figure 7.16 *The texture image fixed.*

Things to look for in your image textures that will stick out when repeated over a surface: gradations and uneven lighting and obvious visual elements that break up the main pattern. When such things are removed from the floor image, and a cell noise—based stucci texture is used for color, the resulting render is free from the bad effects of repetition, as you can see in Figure 7.16. This technique isn't suitable for every situation, but can save you if you're in a pinch or just feeling particularly lazy.

As the carpet image probably won't tile correctly (i.e., you'll notice a hard edge between the repetitions), I've enabled the **X-Axis Mirror and Y-Axis Mirror** options. I could have used a paint program to make sure that the image tiled seamlessly by making sure that the left–right and top–bottom edges of the picture matched perfectly. However, you don't always want to take the time to do that. Using the mirror option in this panel won't produce a good result every time, but it's worth a try.

At this point, we've selected a texture image, provided UV coordinates for the floor, and decided to tile it six times within the texture space. The only thing left to do is to tell the renderer which properties we want the carpet image to affect.

In the **Influence** panel, Diffuse Color is enabled by default and set to 100%. We'd like the carpet to use the diffuse color chosen in the Material properties, but perhaps to use some of the colorization from the image to enhance it. You could just turn the effect percentage down until you achieved a mix that you liked, but there is another way. At the bottom of the Influence panel is a pop-up menu labeled **Blend**. This menu determines how the colors and values found in this texture channel blend with those from other channels, and with the base values in the Material properties. Here is a rundown of the most useful ones:

- **Mix:** The default. Simply blends values based on percentages. At 100%, you get the texture's color. At 0%, you get the original color, unaffected by the texture.
- **Multiply:** The texture darkens the original color. Pure white in the texture has no effect on the original. Use this when you want your texture to only darken, and never lighten the original values.
- **Screen:** The opposite of Multiply. The texture lightens everything that it touches. Black in the texture does nothing. Use this when you want your texture to only lighten the original.
- **Value:** Uses the gray values of the texture to replace the gray values of the original. This is a good choice for applying a colored texture to an already colored base when you only want the patterning of the texture.
- **Soft Light:** For colorization. Use the colors of the texture to tint the colors of the original. Useful for color casting, or when you want to tint the original without completely replacing it.
- **Overlay:** The texture attempts to darken areas where the texture is dark, and lighten areas where the texture is light. Kind of like a combined "Multiply/Screen" operation.

So, if we want to get the patterning of the image without completely replacing the color, there are a number of options that will work. Clearly, Value would do it, as it would use the base color from the material, but the gray values from the texture, giving a dull red result with black and white details like those of the texture. Overlay would also work, as the texture image doesn't have much color (it's very close to black and white), but Overlay's result can be slightly unpredictable. It is better to find something else if possible. Multiply looks like a good choice, as it guarantees that the base color we've chosen in the material properties will be the lightest the result will ever be (because multiply only darkens). A test render using Multiply blending and Value blending shows that the result with Value is unusually bright. So, Multiply it is.

With diffuse color taken care of, the next item on the list is specular intensity. Of course, we're not using specularity for this material, so we can skip it.

Let's deal with the roughness. Disable Diffuse Color in the Influence panel. We'll turn it back on after we get the Normal value sorted out, but it's best to work on each setting in isolation at first. Enable Normal influence at the default value of 0.5 and try a test render. Eh. It's pretty lame, and while subtlety is good, the result doesn't look anything like carpet. I had to raise the Normal value over 4.0 to get an acceptable result.

One thing you might note in your renders is that some ugly patterning is showing up in the carpet texture. When we talked about texture scaling earlier, this was one of the potential problems. When the carpet is scaled to an appropriate size for believability, its render turns ugly. The solutions are to either increase the apparent size of the texture, which is unacceptable with something very familiar like carpet, or to enable **Full Oversampling** in the **Options** panel of the Material properties. And indeed, that is what I had to do when working on the carpet. It takes longer to render, but the results are nice. Figure 7.17 shows the difference. You don't have to suffer with the slower rendering speeds for the rest of your work, though. Once you have finalized the surfacing of the floor, simply turn Full Oversampling off. The floor will look nasty while you work on other aspects of the scene, but it won't slow you down. Whenever you do your final renders, turn it back on.

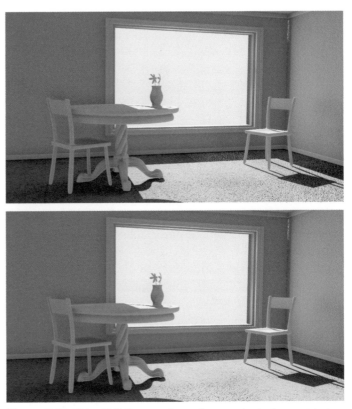

**Figure 7.17** *Using Full Oversampling to fix patterning in the carpet texture.*

With that done, we re-enable Color Diffuse influence and render. The result is nice. It looks like carpet.

Let's do one last thing with the carpet before we call it finished. In the "The Danger of Repeating Textures" sidebar, we mentioned that one way to hide repetition is to apply a procedural texture to the diffuse color channel on top of the main texture.

Back in the top texture panel, LMB click on the empty texture channel below the one labeled "carpet." Then, click the **New** button to add a new texture in that channel. We're going to create a procedural texture that blends with the original, to add some larger scale variation to the diffuse color of the carpet. Call this texture something like "carpet variation" or "floor dirt."

Figure 7.18 shows the Texture properties for the result. It didn't really matter which texturing type was chosen, as it was going to be barely visible. The **clouds** texture provides a general, nontrending noise (wood and marble trend toward stripes), which is what we want. The actual settings are likewise fairly unimportant. The real trick is in achieving the proper scale and the correct blend between this texture and the ones before it.

Set mapping to UV. It will use the same coordinates you generated earlier. And yes, procedural textures will work quite happily with UV mapping. The renderer will "paint" the procedural onto the surface just like an image, instead of calculating 3D coordinates for it.

When working with several textures, it is useful to set their scale in isolation from each other. In other words, it can be hard to see what you're doing with a complex texture setup. To work with only this texture for the moment, disable the carpet texture by unchecking the box beside the texture's name in the top panel's texture selector. You'll notice that the carpet texture disappears from the material preview. In the floor dirt texture's Influence panel, make sure that only Diffuse Color is enabled, and that it is set to 1.0. In the color swatch at the bottom of the panel, choose something that really sticks out: completely black, bright blue, etc. The goal is to do a test render and have the texture stand out quite obviously. This makes it easy to evaluate the scale. Adjust the texture size and re-render until it gives a nice variation across the floor, like the one in Figure 7.19.

Once the scale is correct, a simple adjustment to the texture color (back to black in this case), the blend mode (the standard mix worked pretty well), and the amount of Diffuse Color influence (0.4) establishes a subtle variation in color around the carpet, as though it has been walked or sat on, and generally enjoyed the presence of people. Don't forget to re-enable Full Oversampling in the Material properties and the main "carpet" texture before doing your final render.

Step back now and take a breath. You've slogged through Blender's main material and texturing system, which is no easy feat. Almost everything else we do in this chapter will be an extension of this foundation.

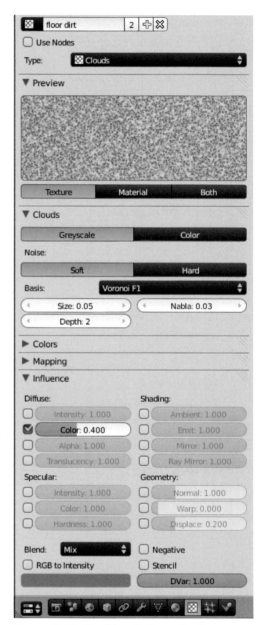

Figure 7.18 The "floor dirt" procedural texture.

## The Table: Cheap, Fast Unwrapping and Real Reflection

The table has some wild stuff going on geometrically, especially in the twisted central column. We're going to make the table a nice wood. Before we get into texturing, though, let's find a reference and create our

basic material. Figure 7.20 shows such a reference picture.

Following is a rundown of the relevant settings in the Material properties:

- **Diffuse Color:** We'll be using an image map, so it makes no actual difference. It doesn't hurt to make it a light brown, though, so it looks that way in the 3D view.

- **Diffuse Intensity:** Regular wood comes in pretty low on the chart, anywhere from 10–50%. The wood itself will be on the darker side, but we're going to pretend it's varnished as well, so that will bump up the amount of light that gets thrown back. Let's set it at 0.4.

- **Diffuse Shader:** Lambert, as the surface will have a varnish (polyurethane) coating, which is essentially clear plastic.

- **Specular Intensity:** A gloss varnish will make a fairly intense specular highlight. However, we don't want to go over the total light limit for the surface, and we already have a maximum possible of 40% coming from the diffuse shading. Let's go with 0.5.

- **Specular Shader:** Once again, the gloss coating dictates either Cook-Torr or Phong.

- **Specular Hardness:** The highlights on the reference don't appear to be too tight. Judging by the highlight size in the preview, I've set it down to 21.

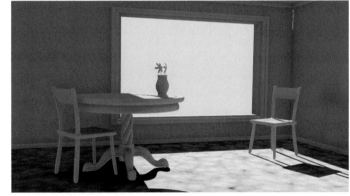

**Figure 7.19** *Using whacked out colors to visualize your subtle texture.*

**Figure 7.20** *A real table. (Creative Commons 2.0 Commercial Housing Works Auction.)*

As always, **Cubic Interpolation** has been enabled on the Shading panel for smoother shading transitions.

The real work for this material will be accomplished in the textures. Figure 7.21 shows the texturing setup for the color texture channel. The wood image is called *walnut.jpg*, another useful entry from the *Blender*

*Texture CD.* To achieve the proper scale, *x* and *y* repeat have been set to 6 and 4, respectively, as determined by test rendering the table and comparing it to the reference. We're replacing the Diffuse Color entirely, so that factor in the Influence panel is enabled and set to 1.0 (100%). Even though the reference table is varnished, there is still some roughness to it that mostly follows the wood image. So, Normal is enabled as well, and test rendering determines that a value of 0.30 is appropriate.

The Mapping coordinates are set to UV. We're going to hold off on the true guts of UV unwrapping just one more time, and teach a shortcut first (Wow! How often does that happen? Certainly not in math class.) You already know that UV unwrapping lets you control how a 2D image is mapped onto the surface of 3D geometry. In Section 7.4, we'll really get into the nuts and bolts of creating high-quality unwraps for use with things like characters. However, for environmental items like this table, there is a shortcut that often is more than good enough.

**Smart Project** is a feature that examines your model, tries to guess how it's constructed, then performs a UV unwrap for you based on that analysis. If the result is good enough, your work unwrapping the object is done. To generate UV coordinates for the table, then, select it and go into Edit mode. Use the A key to select all vertices. Bring up the Unwrap menu with the U key and choose **Smart Project**. If your table has as many vertices as mine, Blender might actually stall for a few seconds as it looks at the geometry. For a look into the mind of Smart Project, you can bring up a UV Editor window to see the raw result. It slices your object into what it considers distinct surfaces. While you're in the UV Editor, use the A key to make sure that everything is selected there and choose the **Pack Islands** operation from the **UV** menu on the header. It takes all of the tiny little islands of UV mesh and packs them into the available UV space. The finished result is shown in Figure 7.22. When you're finished, Tab out of Edit mode.

Smart Project is so easy to use and hits the mark so often that it is always worth a try. Even with Blender's superior unwrapping tools, unwrapping by hand can still be a bit of a pain. Any of the objects in your scene that Smart Project can take care of for you represents probably about an hour of time that you can devote to something else.

The table now has main material properties, UV mapping coordinates, and a texture applied that varies both the color and roughness. The only thing we still need is a variation of shininess. We could use the same wood texture, but let's try a new trick: generic dirt maps. If the table were brand new and sitting in some overpriced furniture store, it would shine like a

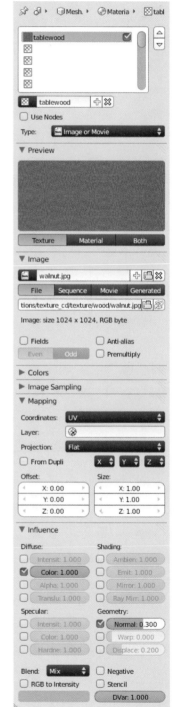

**Figure 7.21** *Texture channel for wood.*

mirror. But it's not. It sat in a room for several years, and people set drinks and books and papers on it, and kids scratched it, and no one has even *thought* of dusting it for weeks. In fact, it's a real table, and real stuff happens to it, so the gloss finish isn't going to be perfect.

LMB click on the second texture channel, and click **New** to add another texture. This will be another image texture, using UV coordinates. For this one, though, we're going to use a file called *spottywall.jpg*. It's mostly black and white and contains ugly dirt stripes and grain. Apply it to the table's Specular Intensity on the Influence panel. When you do it, nothing happens. This is because something like Specular Intensity represents a single value from 0.0 to 1.0, while the texture image is in RGB.

**Figure 7.22** *The Smart Project result from the sample table.*

In order to make an RGB texture affect one of the single-value influence fields, enable **RGB to Intensity** at the bottom of the panel. Also, if you recall from the previous example, to replace a material property like Intensity, you have to set the material's baseline to 0.0. So, "steal" the influence value of 0.4 for the texture's Specular Intensity influence from the Material window, setting the main material property to 0.0.

Figure 7.23 shows the table as it is on the bottom, and with an enhancement on the top. It's pretty obvious that the one on the top looks significantly better. This is one of those times that ray tracing, which we tried to avoid when working with lighting, makes a huge difference. Blender can create real reflections, and, due to a recent coding project, is much faster at it now than it used to be. In a case like this table, we're going to just have to bite down on something leather and use it. The fact is that there's no way around achieving the look of a glossy, reflective table without mirroring.

Back in the Material window, find and enable the **Mirror** panel. **Reflectivity** is the percentage value of light that is reflected. A perfect mirror is 100% (1.0) reflective. Observing the reference image, it's clear that this is not the case. Trial and error indicates that the correct value for reflection sits around 0.48. Unfortunately, that was the easy part. One of the aspects of reflective materials is that their levels of reflectivity can differ based on the viewing angle. For example, looking across a pond with your head at ground level will show a near-perfect reflection. However, looking straight down into the water will show almost no reflection. This effect is measured and reproduced by the **Fresnel** control on the Mirror panel.

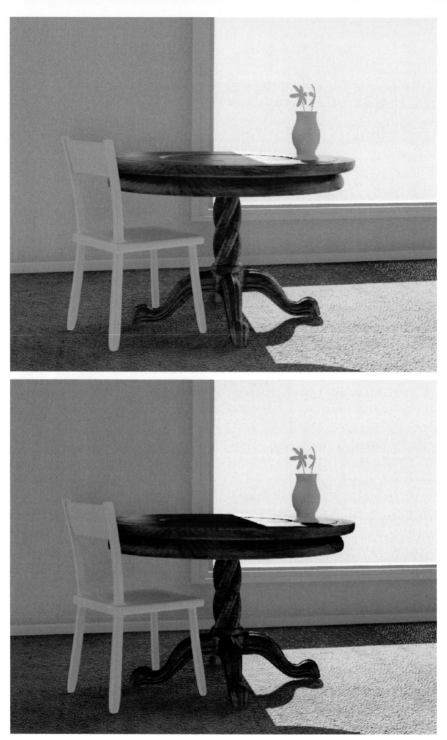

**Figure 7.23** *The table with and without reflection.*

> **Note: Using Trial and Error with Settings**
> It's actually not as unmethodological as it sounds. When experimenting with settings, a good way to proceed is with the "rule of halves." Instead of starting with a high (or low) value and changing it incrementally, begin in the middle. If you need more of the effect, go halfway from there toward the maximum. Simply repeat. This lets you narrow in on the right value quickly.

A Fresnel value of 0.0 means that reflection works identically from all viewing angles. At 5.0, only faces that are almost perpendicular to the viewer show reflection. Going with the rule of halves method, I try 2.5, and it looks like that's just where it needs to be. Yeah, rule of halves!

The last thing we need to do is to adjust the **Gloss Amount**. Gloss Amount in the Mirror panel controls the sharpness of the reflection. The default, 1.0, creates a perfect reflection. Reducing the value causes the reflection to blur. This reflection blur costs a little bit of time, so it's worth it to try the material both with and without it to see if you can get away with perfect reflection. Often you can. Generally, you'll want to leave the Gloss Amount value at 1.0, but sometimes it just makes things look nonbelievable. Reducing Gloss Amount to 0.5 (halfway!) was too far, so I bumped it back up to 0.75, which worked nicely.

And finally, remember how we used the dirt texture to vary the specular intensity? That same dirt should probably affect the reflectivity, no? It's easily accomplished. In the dirt texture's Influence panel, enable the **Ray Mirror** channel under Shading and set it to 0.48, the value from the material. Set the material's base Reflectivity to 0.0 so the values don't interfere with each other.

## The Vase: Transparency and the Faked Reflection

The vase will be blue glass. Diffuse properties of the glass will be: a light blue, the Lambert shader, and an Intensity of 0.6. As this is going to be transparent, it's a little hard to pick an intensity this soon. The specular properties should compliment the diffuse, so, the WardIso shader, which makes a bright glasslike highlight, and Intensity at 0.4.

It wouldn't hurt to add the same dirt texture we used on the table to the glass to vary the specular intensity a little. Add a texture channel and in the selector at the top where you would normally name the texture, use the browser button to find the dirt texture (which you named appropriately to make it easy to find, right? Right?). Use Smart Project to add a rapid UV map to the geometry, and set the Mapping coordinates to UV. Disable Diffuse Color on the Influence panel. Turn on Specular Intensity influence, and while we're there, enable Normal as well. Keep it subtle, though. The glass isn't window glass—adding a tiny bit of normal roughness will give it an artisan appearance. In this case, we want the glass to always have some amount of specularity, say, half the maximum value, and use the texture to allow it to go the max.

To do this, set the Intensity in the Material properties to 0.2 (half of the original), and the Intensity in the Influence panel to 0.2 as well.

None of this should be news to you at this point.

Take a look at the Transparency panel of the Material properties, shown in Figure 7.24. The two methods of rendering transparency are ray tracing and a technique called **Z Transparency**. Ray tracing is slower, but produces more realistic results. Z Transparency (Ztransp) is very fast but cannot generate refraction, which is the way that light changes direction when passing between two transparent substances such as glass and air. In many cases, Ztransp is sufficient (regular windows, small unimportant objects). For rounded objects that will be the focus of attention though, ray tracing is hard to do without.

As we're already using ray tracing on a couple of lamps and the reflective surface of the table, let's skip it on the vase. Having ray tracing interacting with ray tracing can drastically raise your render times. So, enable Transparency and make sure that the **Z Transparency** button is selected. For uniform transparency across an object, use the **Alpha** control. 1.0 equals 100% opacity; 0.0 is 0% opaque, or completely transparent. Glass, however, also exhibits the Fresnel effect we mentioned with reflection. Start to adjust

**Figure 7.24** *The Transparency panel and Fresnel preview.*

the **Fresnel** control, which is found to the right of the Alpha slider. The material preview, when set to either the Sphere or Monkey, shows the effect, like Figure 7.24. The rule of halves makes the first attempt set to 2.5, which seems to work pretty well.

One thing conspicuously missing from the material is reflection. Glass reflects, and without it the vase looks horribly unconvincing. A trick that will often suffice is to use a fake reflection map.

Add a new texture channel, setting the Mapping coordinates to **Reflection.** Reflection mapping pretends that the texture is in a ball all around the object, and the texture is mapped to the object as though it were perfectly reflected on its surface. Set the texture's style to **Blend**. Figure 7.25 shows the texture properties for this channel, including the color ramp.

Build the color ramp according to the sidebar instructions from earlier in the chapter. On the **Blend** control panel, set it to **Vertical** so the resulting texture runs up and down, as opposed to side to side. Notice how the colors in the ramp in the figure are configured to provide a kind of generic outdoor reflection. While this isn't realistic, the map is going to be fairly light, not the subject of close scrutiny, and *will* provide an appropriate look for the vase. Set the Diffuse Color influence of the texture to around 0.6. The effect is immediately apparent in the material preview. Once again, this is not realistic, and close examination will break the illusion. However, when you just need a suggestion of reflection, the fake reflection blend can save you hours of render time. Figure 7.26 shows the vase, rendered with these settings. Notice how believable everything is beginning to look—so much so that the nonsurfaced flowers stick out noticeably and horribly.

**▼ Preview**

| Texture | Material | Both |

**▼ Colors**

☑ Ramp

| Add | Delete | ◄ 3 ► | Linear ⬍ |

Color: [ A: 1.000 ]
◄ Pos: 0.713 ►

RGB Multiply:          Adjust:
◄ R: 1.000 ►    ◄ Brightness: 1.000 ►
◄ G: 1.000 ►    ◄ Contrast: 1.000 ►
◄ B: 1.000 ►

**▼ Blend**

Progression: Linear ⬍
| Horizontal | Vertical |

**▼ Mapping**

Coordinates: Reflection ⬍
Projection: Flat ⬍
[ X ⬍ ] [ Y ⬍ ] [ Z ⬍ ]

Offset:              Size:
◄ X: 0.00 ►    ◄ X: 1.00 ►
◄ Y: 0.00 ►    ◄ Y: 1.00 ►
◄ Z: 0.00 ►    ◄ Z: 1.00 ►

**▼ Influence**

Diffuse:                Shading:
☐ Intensit: 1.000    ☐ Ambien: 1.000
☑ Color: 0.600       ☐ Emit: 1.000
☐ Alpha: 1.000       ☐ Mirror: 1.000
☐ Translu: 1.000     ☐ Ray Mirr: 1.000

Specular:               Geometry:
☐ Intensit: 1.000    ☐ Normal: 1.000
☐ Color: 1.000       ☐ Warp: 0.000
☐ Hardne: 1.000      ☐ Displace: 0.200

Blend: Mix ⬍          ☐ Negative
☐ RGB to Intensity    ☐ Stencil
                      DVar: 1.000

**Figure 7.25** *The fake reflection color ramp.*

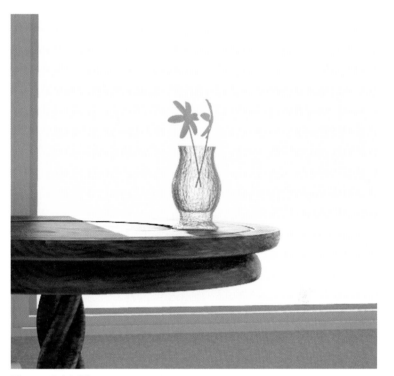

**Figure 7.26** *The vase.*

## The Character: High-Quality UV Unwrapping, Subsurface Scattering, and Projection Painting

You've already done two simple UV mapping methods: Project from View and Smart Project. Something more complex that will be the center of attention (like a character) requires a high-quality UV unwrap. The problem with Smart Project is that it cuts an object up into separate islands of UV space. This results in seams in the texturing on the final render. For things like furniture or background objects, this is acceptable, but for a main character's face it obviously won't cut it.

Within Blender's Edge Specials menu in Edit mode are the **Mark Seam** and **Clear Seam** tools, which allow you to specify where you would like such seams to be, instead of letting Smart Project decide. Figure 7.27 shows our character's head in Edit mode, with selection set to **Edges**. Notice the red, thicker line of edges that runs from the top of the forehead, over and down to the back of the neck. This was created by selecting these edges individually with the RMB, pressing **Ctrl-E** to bring up the **Edge Specials** menu, then choosing **Mark Seam** from it.

195

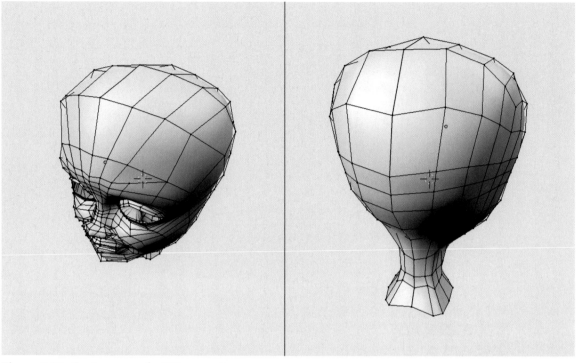

**Figure 7.27** *Creating a seam for UV unwrapping.*

When preparing to unwrap something like a head, it pays to know your goal ahead of time. Those goals are simple, but sometimes mutually exclusive: Preserve the relative angles and areas of the mesh faces, and make sure that no seams are in obvious places (i.e., down the middle of the face, across a cheek). The reason that we try to keep angles and areas of mesh faces the same as they are in 3D is so the scale of our eventual texture image can remain relatively uniform. For example, if a face has an area of two square units in the 3D mesh and two square units in the unwrap, but another takes up two square units in 3D but only a half of a square unit in the unwrap, think about what that means for the texture image. If we were creating an image of freckles, the freckles in the 2:2 portion would have to be a different size in the texture image than the ones in the 0.5:2 portion so that they all looked the same scale when rendered onto the 3D surface. The reason to relegate seams to hidden or unobtrusive locations is obvious—you don't want to see any texturing seams in your final render.

When working on a head, pretend that you are doing reconstructive surgery, taking the skin off a head (yuck), fixing it up, then putting it back on again. Where can you cut and stitch so that no one will notice when the person goes out for dinner? If you're working on a whole body, like an animal, pretend that you are a taxidermist and someone wants a whole pelt, removed from the animal and flattened. Where to place your cuts? The most likely places will be along the belly up to the chin, and on the insides of the

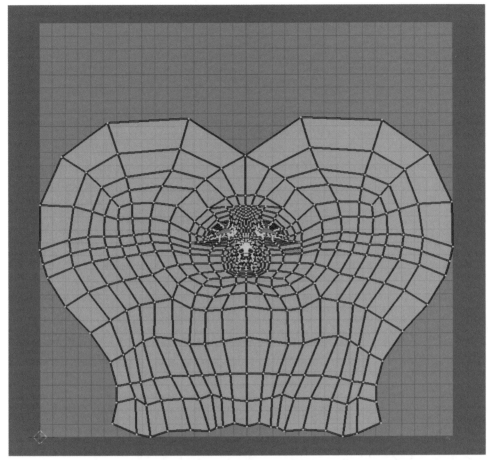

**Figure 7.28** *The initial unwrap of the example head.*

legs—that is, however you would take the thing apart in real life to best preserve the flattened appearance is what you should do here.

With that single seam in place on our character model, select everything (A key) and press the **U** key for the Unwrap menu. This time, choose **Unwrap**. The unwrapped mesh appears in the UV/Image Editor. Figure 7.28 shows the initial result if you are using the sample file. Your own work may differ slightly.

Notice how the actual area the face occupies is small compared to the rest of the head. While this may or may not be realistic, it won't do us any favors artistically. When making trade-offs between seaming and maintaining surface area, special attention needs to be given to the areas of greatest focus, like the eye/nose/ mouth triangle of the face. The sides and back of the head, which will be covered with hair, aren't really that important when it comes to texturing. So, it would be great if we could get the face to occupy a greater

amount of area, while deemphasizing the rest of the head. Also, it would be good to use as much of the available UV space as possible, so we're not wasting image space when we eventually create our texture.

There are two ways to fix this. The first requires a little work on your part, and the results are good. The second is so almost magical that it seems like cheating. It's good to know both, so if the ridiculously easy method doesn't deliver good-enough results, you can always fall back on the fairly easy way.

### The Easy Way: Pinning and Live Unwrap

We'd like the eyes and mouth to have almost the same shape in 2D as in 3D, as they are points of intense focus on a character. Using the regular selection and editing tools (RMB, Proportional Editing Falloff, G-key translation), reshape the eyes in the UV Editor to more closely resemble their shape in the 3D view. On the example head, not a lot needs to be done, but a little tweaking doesn't hurt. With the eyes and mouth shaped appropriately, use Alt-RMB to select the entire ring of vertices that make up the eye and mouth holes in the UV Editor. **Pin** those vertices by pressing the **P** key.

"Pinning" tells the unwrap algorithm: "I like these just the way they are. Don't mess with them unless I specifically tell you to." Anything that is pinned will stay put. However, when you move a pinned vertex on your own, all of the unpinned vertices in the unwrap adjust themselves to follow. It's a cool enough thing to see that there is a video in the Web Bucket called *live_unwrap.mpeg* that demonstrates the effect.

So, with the eyes and mouth pinned, select everything in the UV Editor (yes, it's the A key here as well) and scale it up until the face takes up the central quarter of the space. Figure 7.29 shows this. Notice that much of the rest of the unwrap has been scaled to fall outside of the UV space. Let's get it back inside. Select two vertices at the extreme left and right of the unwrap and pin them (Figure 7.29). Enable **Live Unwrap** on the **UV** menu of the editor's header. With those four pinned vertices selected (two left and two right) press the S key, followed by the X key to scale them along the horizontal (*x*) axis. The rest of the unwrap (excluding the pinned eye and mouth vertices) adjusts to follow the motion. What Blender is doing is actually re-unwrapping the model as you move these pinned vertices, using them as a guide.

If you're following along yourself (or watching the video), you'll notice that the unpinned portions of the face are distorting pretty badly, causing some bad overlapping into the eye regions. That's bad, so undo the movement of those outer vertices. To keep things in the face in place better, use Alt-R to select an entire ring of vertices surrounding the face (careful edge loop construction in the initial model makes this possible—yeah, edge loops!) and pin them. Now, bringing the four outer vertices inward leaves the face alone.

And so you proceed with the outer vertices: select one or two, pin them, and move them within the bounds of the UV space. Do this until the whole unwrap is in bounds. Remembering our goals of minimizing distortion in shape and area of the faces, let's see how we're doing. Press the **N** key to bring up the Properties panel in the UV Editor. In the **Display** section of the panel, enable the **Stretch** option and make sure that **Area** is selected below it. This applies a colorization scheme to the UV display. Faces that have minimal distortion appear in blue; high distortion, in red. Figure 7.30 shows the unwrapped mesh before trying to deal with stretch.

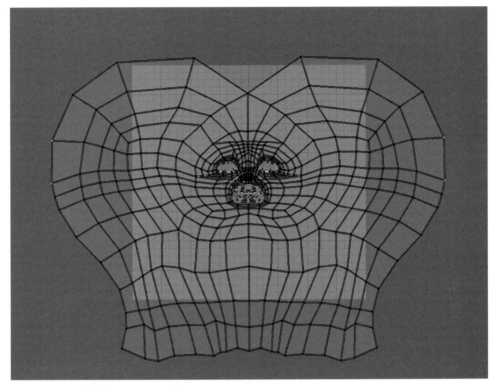

**Figure 7.29** *The face unwrap scaled up.*

For an example of how to minimize distortion, let's focus on the chin. The mesh under the chin shows some green, which when found beside the nice blues will probably produce some visual distortion during the render. To fix it, choose a vertex amid the green, pin it, and move it. You'll find as you move it that the stretch color changes on all affected faces, giving you immediate feedback on whether your movement is helping or hurting. The odds are that your whole model is never going to be blue in stretch view. What you are really trying to avoid are hard jumps between levels of distortion, which show up as different texture scales across the surface of your model. Figure 7.31 shows the chin area once I've pinned and pulled some vertices. The major benefit came from moving the original row of pinned vertices downward to provide the entire chin area with some room to expand.

That's the hard way to do this. Sometimes, you'll need to adjust a UV unwrap *just so*, and in those cases, Live Unwrap, Pin, and move will be the tools you use. Now, let's go back and do it the easy way.

Use the A key to select all of the vertices in the UV Editor and press **Alt-P** to unpin them. Press the **E** key to re-unwrap the model. You could have focused on the 3D view and called Live Unwrap from the U key menu, but the same command is provided in the UV Editor as a convenience. The model re-unwraps to the original state. Enable Area Stretch display, if it isn't already.

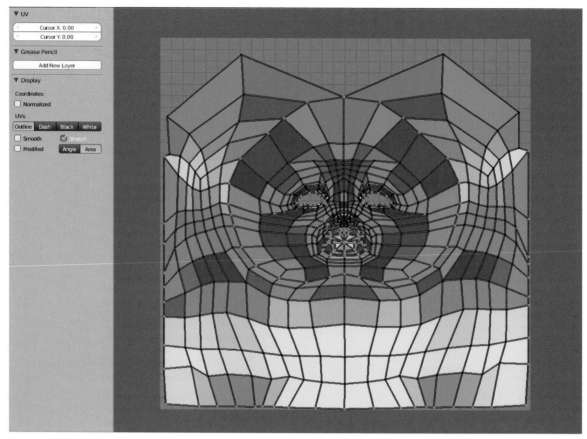

**Figure 7.30** *The unwrapped mesh showing area stretch.*

Make sure that the entire unwrap is selected and choose **Minimize Stretch** from the **UV** menu on the header (Ctrl-V is the keyboard command, but I don't consider this one a "must memorize"). Watch as Blender magically begins to minimize stretch over the entire model. It does it in steps, like an animation. You can stop the process at any time, accepting the result by clicking the LMB. RMB cancels, as usual. The result of letting the process run on the basic unwrap is seen in Figure 7.32. This is actually a pretty good result, showing stretch distortion transitions issues around the eyebrow line and between the mouth and nose. If you're in a hurry, it is certainly usable. If you use the Minimize Stretch feature, be aware that it is fairly difficult to adjust afterward using the Pin and Live Unwrap method. In fact, trying to do so will almost instantly ruin the result. To adjust an auto-unstretched unwrap, you're better off using the standard selection tools along with O-key PEF and avoiding pinning altogether.

Whichever way you choose to go, you'll end up with a decently unwrapped head.

The next step in texturing the head is very cool, and will work for texturing any unwrapped object for which you have real-life texture references. You will need both a front view and a profile shot of a real

**Figure 7.31** *The chin, destretched a bit.*

person. We're going to be stealing the skin textures from these shots, so while the front and side views don't necessarily have to be from the same person, they should at least have the same lighting conditions and skin tones. What we're about to do is to define several different simple UV unwraps in addition to the one we have, attach images to them, then use something called **projection painting** to easily and intuitively merge them into a single texture that fits our original high-quality unwrap.

### Defining the Material

Since we're already in the UV Editor with our nice unwrap, let's start there. From the **Image** menu on the header, choose **New**. This brings up a little operator panel for defining a new image that will be created and painted directly within Blender. Figure 7.33 shows the pop-up. Give it a name like "skincolor," and set it for 2048 × 2048 pixels, colored black (default), with Alpha 1.0 (default). Blender should fill the UV space with the new black image. From that same **Image** menu, choose **Save** and enter a file name into the file browser. Simply creating and naming the image in Blender *does not* save it to disk.

**Figure 7.32** *Minimize Stretch process.*

Back in your material and texturing screen, add a new material to the head object, if it doesn't already have one. For now, turn off any Specular Intensity and set the Diffuse Intensity to around 0.65. Enable both Cubic Interpolation and **Shadeless** on the Shading panel. Shadeless causes all surfaces of the object to be fully illuminated, regardless of actual light or shadow conditions. While this is bad for rendering, it's great for the kind of on-screen activity we're about to do, which requires being able to see the texture at all times and from all angles.

**Figure 7.33** *The New Image pop-up.*

Add an image-based texture to the material, choosing the "skincolor" image you just created in the UV Editor, and choosing UV for the coordinate space. Influence will default to Diffuse Color only, at 100%, which is fine. Next, bring up the **Object Data Properties** (the triangle icon on the properties header) in one of your properties windows. You can safely replace the material properties as we're done with them for a while. Figure 7.34 shows the UV Texture section of the window, which is very similar to the Vertex Groups control set you already used.

### Adding UV Channels

The UV Texture channel that was added when you created your head's unwrap is called "UV Tex" by default. We're going to be adding a few more, so rename it to something like "final face unwrap" by clicking on the UV channel and changing the name in the **Name:** field below the selector. Use the + button to the right of the selector to create two new UV Texture channels, naming them "front" and "side," respectively. Back in the actual Texturing panel, set the **Layer** control to use the "final face unwrap" channel under the **Coordinates** control on the **Mapping** panel. This tells the renderer (and display) to use the original face unwrap regardless of what we might be doing elsewhere in Blender with UV textures.

**Figure 7.34** *The UV Texture panel of the Object Data properties.*

In the 3D view, change to the **Textured** view style (Alt-Z, as opposed to Solid or Wireframe). If you've done everything correctly, the head should turn completely black. It's displaying the head using the UV mapped texture, which is flat black at the moment. If you don't see this, bring up the 3D view's N-key properties and make sure that Shading is set to **GLSL** in the **Display** section. Blender has several methods for drawing textures in the 3D view, and GLSL is the best for what we're about to do.

### Creating UV Unwraps for Different Views

For this step, you'll need to have a screen with three views: 3D, UV Editor, and the Object Data properties. For convenience, you can just turn the Texture properties window into a UV Editor.

LMB click the "front" UV Texture channel in the Object Data window. This sets the "Front" UV channel as **active**, which means that it will be the one displayed in the UV Editor. Go into Edit mode on the head, and in a front orthographic view use the **U** key to unwrap the head in **Project from View** mode. This should transfer the mesh as you see it directly from the 3D view into the UV Editor, just like projecting the floor of the room in the very first section of this chapter. With this new unwrap in the UV Editor, choose **Open** from the **File** menu on the UV Editor's header, and find the file called *kid_head_front*.

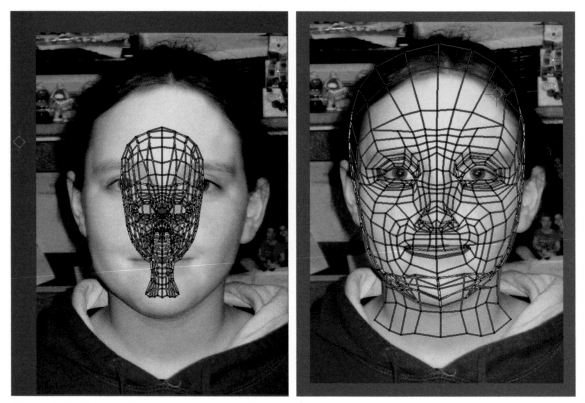

**Figure 7.35** *Fitting the front view projection to the front view image.*

*jpg*. Now, using the regular selection tools and PEF, make the front view unwrap fit the image as closely as possible. Figure 7.35 shows a before and after: immediately upon unwrap, and once the unwrap has been edited to fit the image. Pay special attention to the fit around the eye and mouth holes. Of course, this is easier said than done. You'll feel more like a modeler than a materials and texturing artist when doing something like. You can watch the Web Bucket video *matching_uv_to_image.mpeg* to see me do it in real time for a better idea.

When you have that done, LMB click the "side" texture channel in the Object Data window, **Project from View** unwrap in a side view, and repeat the matching process with the image called *kid_head_side .jpg*. Once again, it's a bit of a slog matching this stuff up, but this is much better than it was in the old days, so, like, get off my lawn if it's too much for you. In the end, you will have three different UV channels. The first will be "final face unwrap," which currently uses a blank image. The second is called "front" and uses the front view reference. The last is called "side" and uses the side view reference. Both reference unwraps should conform pretty closely to their reference images in the UV Editor.

## Projection Painting

Now comes the brilliantly fun part. In the Object Data window, LMB click the "final face unwrap" channel to make it active. A quick check in the UV Editor should show the nicely unwrapped face and the blank, black image.

Hit the **T** key to bring up the 3D view tool shelf. On the object mode selector on the 3D view header, change from Object (or Edit) mode into **Texture Paint** mode. Check your tool shelf to make sure that it matches the settings in Figure 7.36. **Tool** should be set to **Clone**. **Project Paint** should be enabled, along with **Occlude**, **Cull**, **Normal**, and **Clone** below it. Beside the Clone checkbox you will see a little bit of text, which could possibly be a portion of "final face unwrap." The UI here isn't the hottest, so you're going to have to be brave. In Figure 7.36, it shows as just the plain words "front face unwrap" with little other indication that it's a button or control. This text is actually a selector that when LMB clicked shows all of the mesh's UV channels. Choosing a channel here will use its unwrap and attached image as a painting source.

Use this selector to choose the "front" UV channel you just created. With your LMB, drag across the eye region of the black head in the 3D view. You should be magically painting with the front view texture image directly onto the model! You can't see it at the moment, but you're actually cloning the image from the source UV space into the final image in the nicely unwrapped UV space. Depending on how well you got the front projection to match the reference image, you should be able to just paint around most of the head and get a decent result. Use the MMB in the 3D view to rotate the head and make sure that you've not missed any nooks and crannies with your brush. You might want to drop into Local view with **Numpad-\** to work with the head alone and maximize the painting workspace with Shift-spacebar. Figure 7.37 shows the result of this first round of painting. Notice how faces on the sides and top of the head have extremely stretched texturing. This is because there isn't a lot of image data for these faces, which appear very thin from the front projection.

Now, switch your clone source to the side projection by LMB clicking the **Clone Source** control on the tool shelf and choosing the "side" UV channel. This time, don't paint the parts of the front of the face that look nice. Front

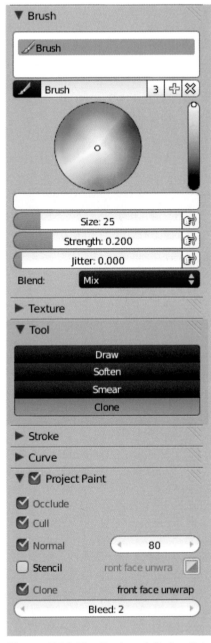

**Figure 7.36** *The Brush and Project Paint tool panels.*

project did a good job with them, and we don't want to mess it up. Instead, focus on painting the sides of the head that are easily displayed in the side projection. Certain portions of the front of the face, like the sides of the nose, are better seen in the side projection, so zoom in on them and carefully paint them now.

In this way, you can proceed by switching back and forth between the front and side projections as your source, refining the paint job on the model in 3D. If you are going to have a bald character (or are painting an animal), you can also include a top view with a different reference image and projection. Figure 7.38 shows the finished head in the 3D view.

If you reselect the "final face unwrap" channel as your active one and examine the image in the UV Editor, you'll see something much like the creepy thing in Figure 7.38. *Make sure you save this image from the controls in the Image Editor.* Blender will not save such things automatically when you save the BLEND file itself, meaning that quitting without specially saving the image will void your work.

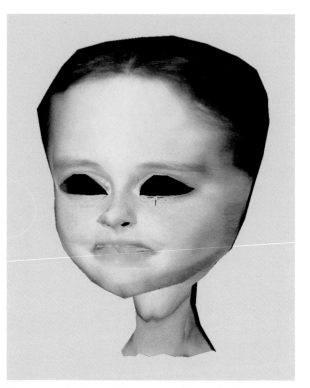

**Figure 7.37** *After painting with the front projection.*

In Figure 7.38, you can see several places where the originals combined from only two points of view created less-than-ideal results. The lighting and saturation was off a bit between the two, leading to the fairly "hot" color on the sides of the head. A good shot of the neck and underjaw areas was lacking. There remain two vertical portions of darkened skin rising from the outside edges of the eyebrows. Also, a few glitches are showing due to a lack of precision in the Project Paint feature itself. All of these problems are easily fixed within your favorite painting program.

### Completing the Head Texturing

Creating a decent skin material isn't easy, but having a good starting texture map goes a long way toward the goal. Remember that a good material will show variation in color, specularity, and roughness. If you are familiar with image editing software (GIMP, Photoshop, or similar packages), you will be fine. If not … the operations we're going to perform are relatively simple and any tutorial that covers the basics of painting and filtering in any package will get you up to speed quickly. For this brief demonstration I'll be using something that almost everyone will have access to: GIMP, a free, open-source image manipulation program.

To make a roughness map for use with the Normal influence channel, load the color face image that we created with projection painting into your image editor and change it from RGB to grayscale (GIMP: Image

> Mode > Grayscale). Sharpen it to bring out the detail in the skin; this will create the roughness (GIMP: Filters > Enhance > Sharpen: 85). The goal with a bump map like this is to provide contrast—the more the better. You can always choose to reduce the amount of Normal influence in the texturing panel. Remember though that we are looking for contrast on a small level, pores and such, so just opening the Contrast control and cranking it up will not work. Oversharpening is usually a good solution. A grayscale, oversharpened version of the face map is shown in Figure 7.39. Save this as a new file called something like "face bump .png."

Creating an image for specular intensity is a little more involved, but still fairly simple. Reopen the original color texture image, and convert it to grayscale again. This time, reduce the contrast by about 50% (GIMP: Colors > Brightness-

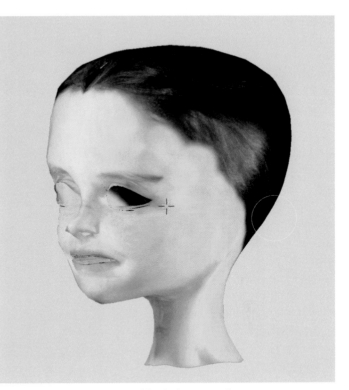

**Figure 7.38** *A nicely textured head, from two references.*

Contrast > Contrast: −75). The image really flattens out, resulting in a mostly middle-of-the-road gray. Using a smoothly feathered brush in Dodge mode (or just using the Dodge tool in Photoshop) set to about 10% opacity, paint over the areas of the face that are considered "shiny": the nose, cheekbones, and chin. You can also paint a little above the eyebrows and on the forehead. The goal is to lighten these areas so that they give more specular intensity when mapped onto your model. Of course, you control the overall levels within Blender's Influence panel. A final image for specularity should look something like Figure 7.40.

Heading back to Blender then, disable the Shadeless option on the head's material. Create two new texture channels, setting each to use an Image type texture, and to use UV coordinates and the "final face unwrap" UV channel on the Mapping panel. Title the textures appropriately ("head bump" and "head specular"). For the bump texture channel, load the bump image you created in your paint program. Disable the Color influence and enable Geometry Normal. Some rule of halves experimentation after the first render leads me to a very low number for this: 0.025. On the specular texture channel, load the image you created for shininess. Disable Color influence and enable Specular Intensity. Make sure that Specular Intensity within the main material is set to 0.0. The Diffuse Intensity is around 0.65, so the Specular shouldn't go above 0.35. Set the Specular Intensity influence value to 0.35, then, so that the absolute brightest spot in the image map receives that much specularity, while everything else gets reduced accordingly.

At this point you should have a decent skin material with three texture channels, one each for color, specular intensity, and normal variation. Try a test-render to see how we're faring. Figure 7.41 shows the result.

Human skin, as well as a host of other substances (marble; jade; lots of foods like milk, apple, and chicken) exhibit an effect called **subsurface scattering** (SSS). It is most obvious when holding a flashlight against your fingers or putting one in your mouth and puffing your cheeks! The red glow that you see is caused by the light passing through your skin and other tissues, which are semi-translucent, bouncing around a bit, then coming back out. Without this important effect, rendered materials for these types of substances will not look believable.

In the Material properties for the head, enable the **Subsurface Scattering** panel. From the **Presets** menu, select **Skin 2**. The provided presets are good starting points, and skin usually only requires a tweak or two to get it looking right. Figure 7.42 shows the SSS panel with the final settings for the example skin. The three main values that you will need to adjust are:

**Scale:** This is the most important (math warning!). This refers to the scale of your object, as opposed to any kind of scaling factor or tool. Calculating the correct value involves some serious mathematical voodoo, so we'll just resort to the rule of halves. Try 0.5 first. If there is too much of the SSS effect, reduce by half (0.25). Too little, increase by half (0.75).

**Figure 7.39** *A face map prepared for the Normal channel.*

**Figure 7.40** *A specular map for the head.*

Repeat until you hit an amount that looks good. Figure 7.43 shows the character with too much SSS. The light source, which is on the left of the shot like the previous figure, is diffuse and scattered throughout the entire model, essentially destroying any shading. The right amount will be when it looks better than rendering with no SSS, but isn't obvious. For the sample character, the scale value is very small: 0.003.

**Figure 7.41** *Not too bad, but something is clearly lacking.*

**Color:** The color field determines how heavily the color portion of the SSS result affects the final render. If you find that the color of the render with SSS is wildly different than what you are expecting, reduce this value. Thinking about the way that skin works, though, a lot of the color we perceive comes from the natural SSS. Skin that is removed from its form (yuck) is yellowish and pale. For a better effect, you can edit your color texture map, reducing its saturation and pushing toward a pale yellow. Then, you let the Color value add the live flesh look back to it during the SSS process.

**Texture:** SSS in real life tends to soften any spotting and texturing on a surface. This controls the amount of blurring that is applied to any textures. If I use this feature at all, I keep it to a minimum (0.100) as I prefer to control the influence of textures directly within the Influence panel.

**Figure 7.42** *The Subsurface Scattering material properties.*

Finally, Figure 7.44 shows the head with all three image maps, subsurface scattering, and a couple of handy eyeballs. Obviously, we're going to have to do something about that hair.

## Hair Materials

Blender's hair and fur system uses a special set of material properties called **Strand**. You still need to set both Diffuse and Specular properties. In my own tests, I've found that the Lambert shader works well for

diffuse, while WardIso is good for specular. The Strand properties, shown in Figure 7.45, describe the sizes of the strands themselves. We'll set the colors entirely with texturing.

The key to using the Strand properties is to enable the **Blender Units** control. Without it, the **Root** and **Tip** fields stand for an absolute size in pixels at which all strands are rendered. A very distant strand, like a far-off blade of grass, and a strand that is part of the mustache of a character in extreme close-up would all get the same rendered size: 1 pixel. With **Blender Units** enabled, though, the strands on your particle system are given a real size. When making hair and fur, this means that you have to determine an actual size to enter into these fields. The **Root** control describes the size of the hair strand where it grows from the mesh. The **Tip** is the end of the strand. Notice in Figure 7.45 that they are set to the same value, even though real hair tapers. We'll get the taper effect using texturing.

**Tangent Shading** is also enabled, which should be used for glossy round strands like hair or fur, but turned off for flat strand uses like grass. The **Surface Diffuse** option is good for strand systems that closely follow the topology of the underlying mesh, like fur or grass. It causes the shading of the strands to more closely follow the base shading of the mesh. In those instances, the mesh shape (i.e., the animal's body or rolling grassy hills) is more important to the shading than the vagaries of the strands. With

**Figure 7.43** *Too much SSS effect, from a too-large scale value.*

**Figure 7.44** *The finished head material.*

something more styled like hair though, it is the shape of the strands themselves that are important.

**Transparency** is enabled and set to **Ztransp**, with **Alpha** down to 0.0. We'll be using Alpha in the texture, so we remove it from the main material setting. Finally, reduce the **Specular** control on the Transparency panel to 0.0. Transparent objects like glass can still show a full specular highlight, and this field determines whether or not that happens. We're going to make the tips of the strands fade to Alpha 0.0 (no opacity), and we don't want a crazy highlight showing up there, so it goes to 0.0.

Figure 7.46 shows the texture that will do all the work. It is a simple Blend style texture with four control points on its color ramp. It begins on the left as a very dark brown with an Alpha of 0.350, making it almost two-thirds transparent. Next, it changes to a similar brown, with much higher Alpha: 0.856. Then, just before the end, it begins to lighten a bit, though the Alpha stays the same. Finally, the color brightens to a light tan, and Alpha drops to 0.0, completely transparent.

The real key is the **Coordinates** setting in the **Mapping** panel: **Strand**. This maps the Blend texture along the length of the strand, meaning that all hair strands begin as semi-transparent dark brown at their root, becoming less transparent along their length, ending with complete transparency as they lighten. To make use of this transparency, be sure to enable the **Alpha** influence slider in the texture properties. When rendered, it looks like Figure 7.47.

We're not going to do it with our example, but here's a neat property of strands: Their base diffuse color is taken from the base color of the mesh at the location of their emission. You could use the strand-mapped blend texture

**Figure 7.45** *The Strand properties, and a suggested starting point for shaders.*

to simply vary the Alpha and let the strands take their color from the underlying material. This is how you would generate the spots in a leopard's fur, or the salt-and-pepper beard of a middle-aged man.

### Materials for Clothes

Creating materials for clothes (and other elements) will follow the procedure we've used so far: observe, estimate, and test. Putting our sample character into a red cotton shirt and blue jeans shouldn't seem like such a daunting task now. We'll do the shirt here and leave the jeans up to you.

First, set your overall material properties. Your default shader is Oren-Nayer for Diffuse and Blinn for Specular, and a cotton shirt gives no compelling reason to deviate from that. Diffuse Intensity starts at

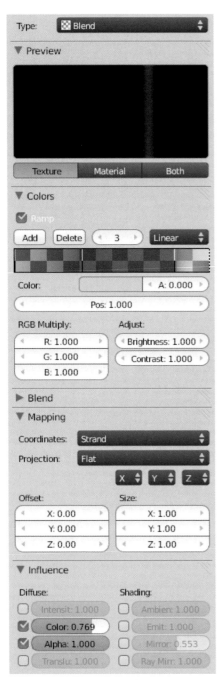

**Figure 7.46** *The texture for hair.*

around 0.6, with no specularity at all. The Diffuse Color should be a fairly bright red, but be sure not to make it pure (RGB, 1,0,0), as nothing in reality short of a neon light looks like that. Cubic Interpolation is enabled.

Unwrapping clothes is one of the easiest things you will be asked to do. "Where to put the seams?" is generally the toughest part of a good unwrap. With clothing, that question is already answered. Put the seams where they really are. Select the edges that correspond to the seaming and stitching in your reference, then use Mark Seam from the E-key Edge Specials menu. U-key Unwrap, and bingo, you have a nicely unwrapped UV map. You can apply a generic dirt map like the one we used before to the Diffuse Color channel to give some variation across the red. A nice texture map like *denimgrey.jpg* from the *Blender Texture CD* can provide a good Normal influence channel, when repeated appropriately for the scale of the piece. This same map can be used in Multiply blend mode as an additional color channel, with

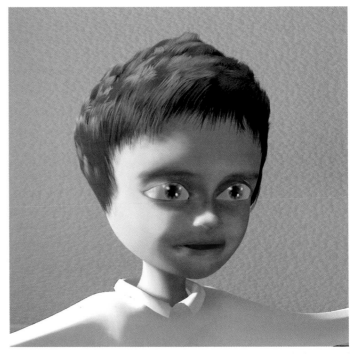

**Figure 7.47** *Rendered hair, using an Alpha blend texture mapped to Strand coordinates.*

a low Color influence to give the fabric some additional definition. Of course, as there is no specularity on the shirt, no Specular Intensity map is needed. Figure 7.48 shows the result of these quick-and-dirty settings. Verdict? Not bad.

If you're feeling ambitious, you can get front, side, and rear views of some jeans and projection paint them onto the 3D pants. In fact, that's what I've done to produce the texture map in Figure 7.48.

## Painting Custom Textures

Besides using UV coordinates for surface mapping procedural and imported textures and projection painting, you can also use the UV map itself as a guide for custom painting. Figure 7.49 shows the flower from the vase, with the upper portion unwrapped and flattened in the UV Editor. The stem will just be a nice green with subsurface scattering applied, so we won't bother unwrapping it. Of course, one could just find a real straight-on image of a similar flower, import it, and adjust the UV map to fit. However, as a demonstration—and to complete the texturing for our models—we will set up the flower petals for painting.

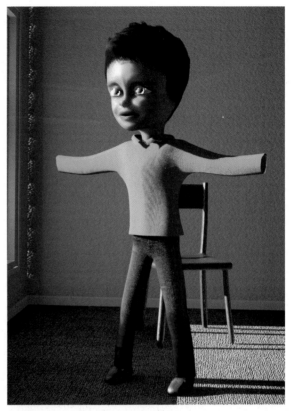

**Figure 7.48** *The red shirt.*

> **Note**
> This is not a painting tutorial. That's an entirely different book. It's just an example of using a UV unwrap as a painting template.

Like many things in Blender, there is more than one way to proceed. If you are happy with your current paint program, the best course of action is to export the UV layout as an image file. From there, you open it in the paint program of your choice. Create a new layer, set your layer blend settings so you can see the exported UV layout, and you're off to the races. Remove the image of the UV layout before saving the painted image map. Then, it's back to Blender where you use your newly painted image as an Image texture. The UV unwrap should line up exactly with your painted image.

With only meager painting needs, you can do the work directly within Blender's UV/Image Editor. The beginning of the process is the same as preparing for projection painting: unwrap your model and add a **New** image in the UV Editor. The little button on the header that's highlighted in Figure 7.49 toggles **Image Paint** mode, allowing you to paint directly within the editor. The **N** key brings up the Properties panel with all of the paint tools and settings, shown in Figure 7.50.

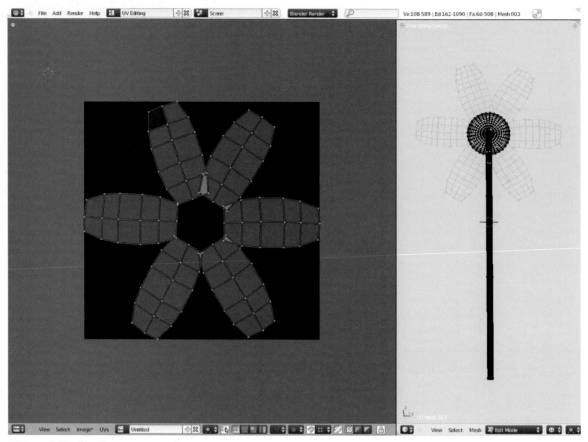

**Figure 7.49** *The flower, unwrapped.*

Blender's painting tools are largely similar to the paint tools in just about every other paint program out there. You pick a color to paint with; set your brush's size, strength, and mix mode; and paint away. Airbrushing (continuous paint flow as long as you hold down the mouse button) is toggled in the Paint Stroke section. Only a couple of settings differ from paint application norms, and so are worth a mention.

**Jitter** provides some random placement to your brush strokes. This is useful when creating organic textures, as a brush set to Jitter with a low strength in Multiply blending mode creates a decent dirt layer. Reducing Jitter to 0.0 removes the effect completely, painting only and exactly where you specify. Jitter at 1.0 allows the actual paint drop to appear anywhere within the brush area.

**Paint Curve.** Instead of having a single selector for brush softness (Does it paint with a hard edge or soft?), Blender has a user-definable curve. The Presets button below the graph is there for the basic brush styles: **Soft** for a brush with a nice feathered edge, and **Hard** for general painting and drawing.

The curves are editable, though, so you can create any brush profile that you choose. Figure 7.51 shows several curves paired with the brush that they create.

Of the four different painting modes, **Draw** is self-evident. **Soften** blurs existing artwork. **Smear** allows you to LMB drag in the image and smear it as though it were finger paint. **Clone** works differently than other paint systems. When the clone brush is chosen, the **Clone Source** controller is enabled, letting you choose another image. That image is superimposed in the center of the painting space. When you LMB click in the image space, whatever portion of the source image is under your mouse at the time is cloned into the active image. To align different parts of the source image with portions of your active image, you move the active image in the space with the normal methods (i.e., MMB drag and the mouse wheel) while the close source image remains in place.

These same tools all work in the 3D view as well. You've already done it, actually. Instead of painting directly, though, you were projection painting by cloning from other UV texture layers. Switching to **Texture Paint** mode in the 3D view and using a Draw brush works just as well, as long as you have unwrapped the model and given it an image in the UV Editor. Don't forget to give the mesh a shadeless material that uses the image as a UV mapped texture so you can see what you're doing. Figure 7.52 shows Blender set up for 3D texture painting.

Before you begin painting, here's one more trick. As the flowers petals will all look similar, you can use the UV editing tools to individually select, rotate, and stack the different petal islands. This way, you only paint one petal, and because all of the petals share the same space on the UV Editor, they all receive the texture at the same time!

**Figure 7.50** *The paint controls.*

To finish the flower, use the multiple materials method detailed for the walls and floor to add and assign a green material to the stem (try using subsurface scattering), and a dull brown material to the center of the flower.

> **Warning**
>
> It's been mentioned before, but is important to note again: Blender does not save your painting work when you save your BLEND file. You must specifically choose **Save** from the **Image** menu in the UV/Image Editor header. You could lose hours of work if you save your work session and quit without saving your painted image.

**Figure 7.51** *Curves and brush falloff.*

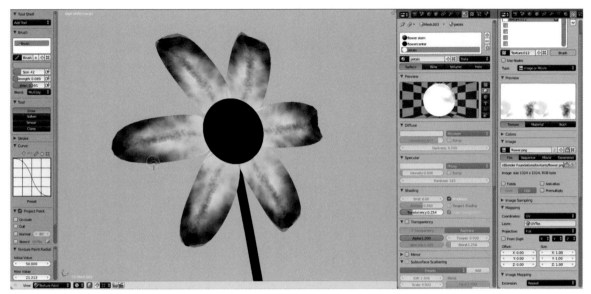

**Figure 7.52** *Painting the flower texture directly in the 3D view.*

## Combining Painted Textures with Procedurals

Painted texture maps can be combined with other textures in creative ways to lessen your work load. For example, the walls in our scene use procedural texturing with generated coordinates. There is no reason that you cannot also unwrap the walls of the room, create a second texture channel, and use the paint tools to add dirt and scuffing to the walls. To do something like this, you begin with a completely white image instead of black, then paint dirt into places it would normally occur: around window sills where people rest their hands, near baseboards, in corners. Then, apply that image map to the existing color scheme using Multiply mode and UV coordinates. Anything that is white in the image will leave the underlying colors unaffected, while any dirt that you paint will darken it.

## Live Mattes: Camera Projection

In film and television production, backgrounds are often generated or enhanced through the use of matte images. Mattes are photographs, illustrations, or paintings that are used as backgrounds for live action. Great mattes are indistinguishable from the real thing, although they restrict camera movement. If you have a simple 2D image as your background and you move your camera, it will be obvious that things aren't what they seem when the elements in the image fail to move in a realistic fashion. When working in 3D, there is a simple way to map a matte onto corresponding 3D objects so that limited camera motion produces the correct effect. This technique is called **camera mapping**.

217

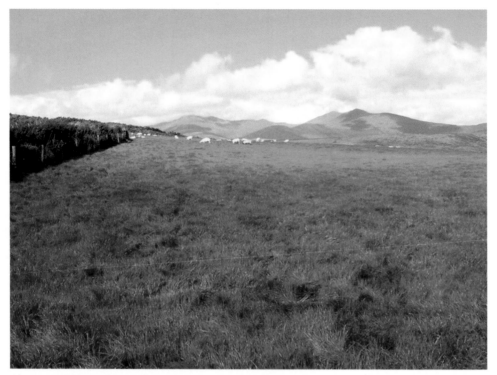

**Figure 7.53** *An image to be used as a matte. (Creative Commons Attribution 2.0 Generic, Francois Schnell.)*

There are several ways to accomplish this in Blender, but the simplest is to project UV coordinates from the camera. Figure 7.53 shows the background image I've chosen for the scene: a plain with green hills, leading up to a mountain, a cloudy sky in the background.

What we are going to do is to create some geometry that roughly matches the elements in the picture, from the Camera view. The biggest trick is getting things in the right perspective. Usually I begin with a large mesh plane for the ground. Looking at the matte image, I try to estimate how high the camera that took the shot is off the ground, then place my Blender camera that same height above the ground plane.

Using the **Background Image** section of the N-key 3D view properties bar, enable the background image and set it to show your matte. Temporarily alter the pixel dimensions in the Render properties to match the dimensions of the image you are using. The sample image is 1024 × 768 pixels.

Enter Camera view (Numpad-0) and see how things are lining up. Ideally, you want your 3D horizon to match the horizon in the image. If your guess about the height of the camera off the ground is good (or even close), you should be able to match horizons by selecting the camera itself (the outline of the camera is selectable even in Camera view) and rotating it on its local *x* axis (R key, then the X key twice).

Remember that many landscape pictures have hills or other features that will obscure the actual horizon, so make your best guess as to where it lies in the image. The good news is that camera projection is a fairly forgiving process—a little miss here or there isn't going to be the end of the world.

With a suitable ground plane created and the camera positioned, you can begin to add (or modify) geometry to match the image. Keep in mind that we are trying to match the image from the camera's point of view, so any modeling and tweaking that is done should take place in Camera view. For the example matte's rolling hills, I've subdivided the ground plane a number of times and pulled it into shape using selections and PEF modeling. Figure 7.54 shows both a camera and off-axis view of the modified ground plane. Notice how the hills in the Camera view follow the contours of those in the background image. These same hills could have been created by adding new objects and modeling them to match the image directly.

The large mountains in the distance begin their life as a cube, roughly positioned "behind" the ground plane in a top view. Back in the Camera view, the shape is refined through some subdivision, loop cutting,

**Figure 7.54** *Low hills.*

**Figure 7.54, cont'd**

and PEF modeling until its shape matches the outline in the image. As you work on these forms, try to keep them 3D from the camera's perspective. In other words, don't just create a flat surface for the mountains of which the outline fits the image. Make sure that it is a fully 3D object, and that any prominent features or protrusions in the image receive a corresponding element in the 3D model. The more you do this, the better the final effect will be. Figure 7.55 shows the mountains added to the view.

Finally, a large UV Sphere mesh can be added for the sky. It's usually best to scale the resulting sphere down along the *z* axis, creating a squashed ball. You can delete any faces that will be below the ground plane or always outside of the camera's field of view.

When you have your matte objects created, go into Edit mode on each of them, press the **U** key for the Unwrap menu, and choose **Project from View**. This takes the mesh's appearance in Camera view and translates it directly into the UV Editor.

**Figure 7.55** *The mountains.*

Create a new material for these objects (called "matte painting" perhaps), turn off specularity, and set it to **Shadeless**. Also, turn off the **Traceable** option and all of the options in the **Shadow** panel. These matte elements should never render with shading, or interact or interfere with any lighting schemes. Then, add an Image texture, choosing the matte image, with UV coordinates. Influence should only be Diffuse Color, 1.0. This uses the camera-projected UV coordinates to lay the matte image onto the surface. Rendering from the Camera view at this point should produce something that looks just like the background image. However, the cool part happens when you move the camera.

Without rendering an animation, you can just jump into Textured view mode from Camera view, which should show the UV-mapped models. Select the camera and move it (within Camera view). It should appear as though you are moving the camera within a live, 3D environment. Figure 7.56 shows a long shot of this setup. You can see that the field of view is limited, and that the backs of the geometry receive the same

221

texturing as the fronts. This means that your ability to move the camera around is limited—go too far and the illusion breaks. But it is certainly better than dealing with a 2D image for your background.

> **Note**
> For a little bit of additional camera freedom, you can make several duplicates of your matte image, and have each layer of objects use a different one. For example, for the image that is mapped to the sky, you can open it in your paint program and attempt to clone out the mountain. This way, even if you move the camera enough to see "behind" the mountain, all you see is sky, as you should. Using the original unaltered image, you would see another copy of the mountain, mapped to the sky sphere.

**Figure 7.56** *A long-distance, nonperspective view of the textured set.*

**Figure 7.56, cont'd**

Often, you will get distortions on the mesh closest to the bounds of the camera, like in Figure 7.57. When this happens, use the Loop Cut tool to add additional geometry in the distorted area. Then, select all of your vertices and redo the Project from View unwrap command.

The last step once you have this working is to select all of the mapped objects, selecting the ground plane last, and using the Ctrl-P command to make them all children of the ground. This way, you can just grab the ground object and rotate and position the entire matte set according to the needs of your scene.

When it comes time to actually render this along with your set, realize that the technique is not perfect. You cannot just render it from any angle and expect that it will look spectacular. The closer your final camera angle matches the original Camera view, the better your results will be.

**Figure 7.57** *Distortion near the camera bounds is cured with additional geometry.*

**Figure 7.57, cont'd**

## Finishing Up

The chair is much like the table, and the process for applying materials and texturing is identical. Drop the chair into Edit mode, and use Smart Project from the U-key unwrap menu. In the material properties, click the icon to the left of the material's name and browse for the table material. Do a test render. Remember that if you want to make adjustments to the material on the chair and not have it affect the table, they are both linked to the same data block at the moment. You need to click the little number to the right of the name to make the material local to the chair.

The shoes, hands, and room trim are left to you, with a few hints. The trim could be a dull white, as it is in the provided sample scene, or you could make it a nice rich wood. The shoes can be given a brown material with a bit of gloss, and a crackling texture to look like leather. The soles could be given a second, separate material for black rubber. The hands can be textured or not, depending on what kind of time you want to put into it. If you texture them, use the projection painting process like you did with the head. For a general material, something that matches the overall tone of the face when SSS is enabled is your target. Use the same SSS scale as the head material for consistency.

## What We Missed

Not a whole lot, really. Admittedly, we skimped a bit on procedural textures, but there's a good reason for that. I've seen people invest countless hours into learning procedural texturing systems, and they still need to fight with them to get good results. Your time is better spent with a digital camera or a good paint package. The one area we completely skipped is the nodes interface. Nodes are a completely different way of looking at both the material and texturing pipelines, granting enormous control and flexibility. Blender's implementation of nodes for materials is complex and can be quite confusing, but it is worth looking up once you have these basic skills under your command.

## Next Up ...

In Chapter 8, we look at rendering and compositing. You've been hitting the Render button already throughout the book, but we get into the different portions of the renderer, optimizing your render times, and using the integrated compositor to enhance the renderer's raw output.

# Chapter 8
## Sculpting

## An Alternative to Traditional Modeling

In addition to modeling in Edit mode, Blender has integrated sculpting tools. The sculpting workflow allows you to work with a mesh as though it were clay—carving details, pushing and pulling the surface, imprinting it with textures—all with an intuitive, brush-based interface. The two main uses for sculpting lie in detailing and adjusting existing models, and creating new forms from scratch.

## Basic Sculpting Tools

Figure 8.1 shows our character's head mesh from Chapter 6, with Subdivision modifier level 1 applied to it, raising the density of the mesh. On the 3D view header, you'll see a new mode: **Sculpt**. In the tool shelf are the sculpting tools. As sculpting uses the same brushlike interface as weight and projection painting, several of the tool shelf panels directly related to brushing should already be familiar.

While sculpting, the standard paint tool shortcuts apply in the 3D view. The **F** key interactively changes brush size. **Ctrl-F** changes brush strength. LMB drag executes whichever sculpting tool is selected (i.e., you "paint" with these tools just like a regular brush). Holding down the **Shift** key while painting reverses the effect of the tools, as we'll see in a bit. Let's run down the different sculpting tools, with gratuitous examples on the head.

- **Draw:** "Draws" a raised path on the mesh, as shown in Figure 8.2. Holding down the Shift key cuts into the mesh.
- **Smooth:** Evens out local geometry.
- **Pinch:** Gathers any geometry within the brush area toward the center of the brush. Holding down the Shift key pushes geometry away from the brush center.
- **Inflate:** Kind of like Draw, but this brush blows everything up like a balloon, as shown in Figure 8.3.
- **Grab:** Like an interactive G-key grab tool. Use it to LMB drag portions of the mesh around.

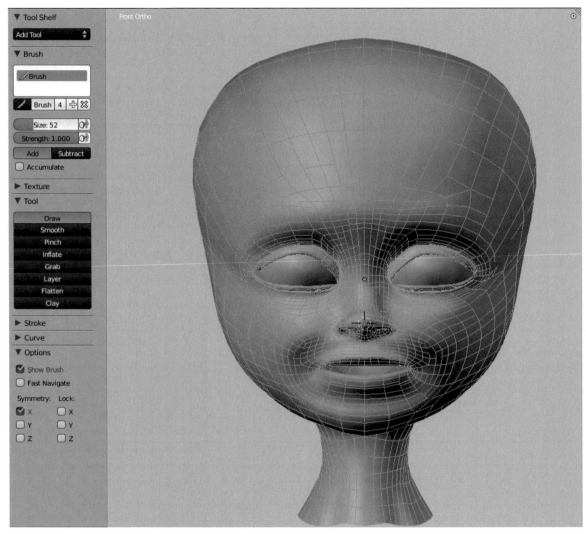

**Figure 8.1** *The basic head, with sculpting tools shown.*

- **Flatten:** "Squashes" geometry toward the center of the model.
- **Clay:** Builds the mesh up as though with layers of clay.

## Shaping Existing Models

Back when we discussed character modeling (Chapter 5), one of the techniques for generating a head was to start with a default head structure and push it around to match reference images. While you can do this in Edit mode using the O-key Proportional Edit Falloff (PEF) technique, a more intuitive way to work is with the sculpting Grab brush.

To use this technique, select the model and enter Sculpt mode using the mode selector on the 3D view header. While in Sculpt mode, the standard view transformation tools are available (MMB rotate, Shift-MMB pan, and mouse wheel to zoom). Make sure the **Grab** tool is selected in the tool shelf. Now, just LMB grab a portion of the mesh and drag it around. Since sculpting doesn't work in Wireframe display mode, you can't see the reference image through the mesh like you can while hand editing. For that reason, it isn't the best choice if you're trying to exactly match a reference. However, there usually comes a time when modeling from a reference when you have to "let go." You've hit the reference as closely as you can from a technical standpoint, but when you go into Camera view and hit Render, it lacks life.

That's when you pull out the sculpting tools. Put the reference out of your mind, and try to think of the current 3D version as the original. I've found the sculpting Grab tool to be a much more intuitive way of doing the final tweaks on a model than working in Edit mode.

While you're doing this, here are some hints. First, the Grab tool moves geometry in the plane of the view. Figure 8.4 shows this. The Camera view that is seen in the left is represented by a plane on the right. Grab sculpting from the view on the left will move geometry only within the plane. It will not go "into" or "out of" the display plane. So, if you want to pull a cheek away from the face to make it a bit rounder, you will have

Figure 8.2 *Drawing on the face.*

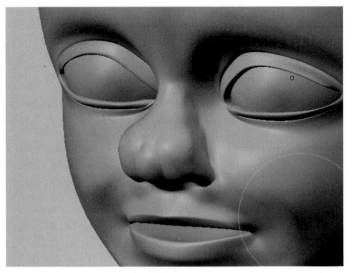

Figure 8.3 *Using Inflate on the nose.*

229

to find a view like the one in Figure 8.5 in order to so. This is one of those things that sounds complicated, but is fairly intuitive once you start actually doing it.

Second, the size of the brush on screen is important. A brush will affect whatever falls inside its boundaries. So, the same "size" brush will affect a different amount of geometry when zoomed in as it does when zoomed out. With the entire head within your view, you can easily change the whole shape at once with a large brush.

Third, the controls in the **Options** section of the tool shelf can save you a lot of time. When working on something like a face, enable **X Symmetry** so that changes made to one side of the head show up on the other side as well. Of course, you might want to sculpt asymmetrically as a final pass on your model to make it more lifelike. No one is perfectly symmetrical.

Using the Grab tool to alter your existing models can add a nice organic touch to an otherwise rigid structure. In fact, when we deal with adding different morphable shapes to our face in Chapter 10, we'll use Grab sculpting to do it.

## Detailing and Normal Maps

The sculpting tools can also be used to add realistic detail to your meshes. The **Multiresolution** modifier allows you to add high levels of real geometry to your models that are ideal for sculpting things like wrinkles and pores, while maintaining a relatively responsive system. Sculpted details can be "baked" into a

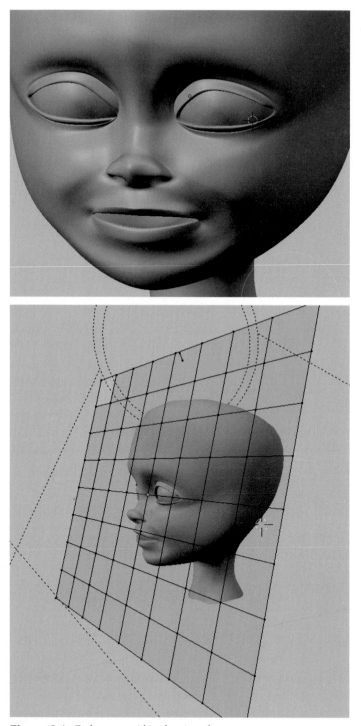

**Figure 8.4** *Grab moves within the view plane.*

**normal map** image, which is like a bump map's older, tougher brother.

### Using the Multiresolution Modifier

The Multiresolution modifier (Multires) allows you to add subsurfacing, and make each level of that subsurfacing editable. Figure 8.6 shows the sample head with several levels of Multires. The thing that makes this different than a standard Subdivision Surfacing modifier (Subsurf) is that the mesh is completely editable at each of these levels of resolution. Want to add fine detail? Make changes at the highest Multires level. Want to adjust the proportions of the head? Make changes at the lower levels and see them reflected throughout the different levels. With a regular Subsurf modifier, you always have to work on the lowest-level cage and don't have any say in what happens to all those little polygons that the modifier adds.

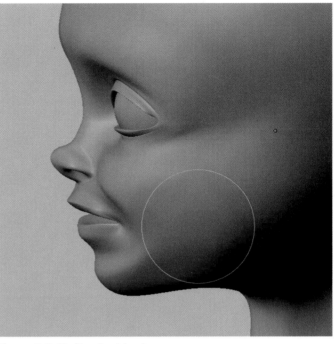

**Figure 8.5** *Finding the right view to move your geometry.*

Blender does some neat tricks in the background to keep your system running smoothly even with very high polygon counts, when coupled with the Multires modifier. It doesn't work very well in Edit mode, but that's okay. The original intent of Multires was as a brother to the sculpting tools. With sculpt, it works beautifully. Figure 8.7 shows the project head, set to Multires level 6, which has over 2.6 million faces! On a dual-core laptop with on-board graphics and a measly 2 GB of RAM, the sculpting tools are still quite usable. Desktop systems with better specs will get appreciably better results.

To begin adding detail to something like the head of your character, start a new Blender scene with Ctrl-N. Bring in a copy of the head from your scene by pressing **Shift-F1** or choosing **Append** from the **File** menu. Navigate to your scene file in the browser and dig into the "Object" folder that is presented. Find your head object, make sure that **Link** is disabled on the left side of the browser, and press the **Link/Append from Library** button. This brings a copy of the head model into your Blender session. We're going to be doing heavy-duty stuff to this model, and there's no need to clutter the main scene file with it.

In the Modifier context of the head's properties, add a **Multiresolution** modifier. The Multires panel is shown in Figure 8.8. In addition to the normal modifier controls, we have several banks of tools. The Catmull-Clark/Simple selector determines whether the subdivision smoothes the mesh (Catmull-Clark) or just adds extra geometry (Simple). Since our target for this extra detail is going to be a mesh that uses subsurface smoothing, leave it on Catmull-Clark. The stack of number buttons controls which Multires layer is

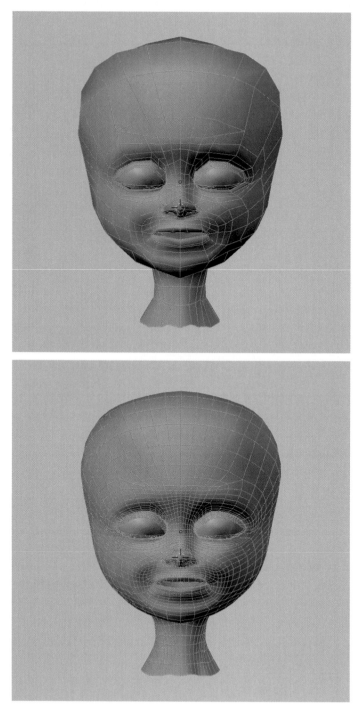

**Figure 8.6** *Different Multires levels on the head.*

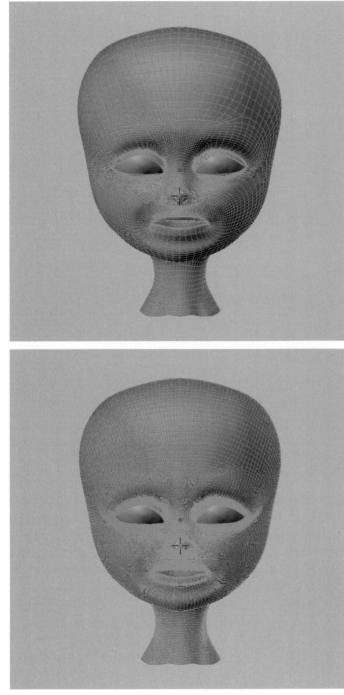

Ve:2733969 | Fa:2732362 | Ob

**Figure 8.7** *Not bad for a laptop!*

**Figure 8.6, cont'd**

currently used for nonsculpting display modes like Object or Weight Paint (Preview), during sculpting (Sculpt), and at render time (Render). To add Multires levels, LMB click the **Subdivide** button. The first few times you do it, the response will be almost instant. It should appear as though your applied a Subsurf modifier.

You can watch the vertex and polygon count climb in the informational header at the top of the screen. How many polygons do you need? Only testing will tell. If you're following along with the included model, you should probably stop at level 6. If you add too many levels though, removing them is simple. Set the **Sculpt** control to the highest level you want to retain and press the **Delete Higher** button.

**Figure 8.8** *The Multiresolution modifier panel.*

When you've reached level 6 on the example model, set the **Preview** control down to 0. This takes the pressure off of nonsculpting modes and prevents you from doing something silly like entering Edit mode on a 2.6 million polygon model. Blender *might* be able to handle it, but you're going to wait a while to even find out.

Anyway, once you're at Multires level 5 for sculpting (preview at 0!), enter Sculpt mode on the 3D view header and bring up the tool shelf. Select the **Draw** tool and use the F key to size the brush down to something like Figure 8.9. Zoom in around one of the eyes, like in the figure. Check to be sure that **X Symmetry** is enabled on the tool shelf.

**Figure 8.9** *Ready to add some eye lines.*

Recall that the sculpt tools are inverted with the Shift key. We're going to draw some age lines under the eyes, and the best way to begin that is by carving a line. Holding down Shift, LMB drag under the eye.

Obviously, the character is a kid, and he's not going to have age lines. Skin details are kind of limited though: wrinkles, general texturing, and bumps. You'll need to know how to do all three, so the kid gets wrinkles for now. Dragging under the eye carves a line into the highly subdivided mesh like the one in Figure 8.10. If yours is too deep or fat, undo with Ctrl-Z and try reducing the brush strength or size until the scale of the line is better. Once you have it, make the brush a little larger and reduce the strength some more. Without holding down the Shift key this time, brush along both sides of the carved line you just made, creating something like the second half of Figure 8.10.

To make it more creaselike, change from the Draw brush to the **Pinch** brush. Pinch pulls everything within the brush radius toward its center. Holding the brush over the crease, resize it with the F key until the brush reaches from the apex of one ridge to the apex of the other. Now, drag the brush along the length of the crease. It should pull the ridges together, gathering them over the line you carved. You may have to "paint" a bit to get it to happen properly, moving the brush back and forth over the area as you go along.

When you've used the Pinch brush to tighten the crease, you should have something that looks like Figure 8.11. The outer edges of the ridges need to be blended into the original topology, as do the end points of the crease. For this, use the **Smooth** brush. When working with the Smooth tool (or any sculpting

**Figure 8.10** *Carving a line, then girding it with soft ridges.*

**Figure 8.11** *The wrinkles tightened with the Pinch brush, and smoothed on the right.*

tool, for that matter), start with a low brush strength, around 0.1. You can always use multiple strokes of the brush to build up an effect, and it usually looks more organic to do so instead of hitting everything with a single pass of a high-strength brush.

That's how you make wrinkles, and scars too for that matter.

---

**Warning**

When detail sculpting, avoid the Grab brush. We're going to be baking our high-resolution sculpted details into a normal map, which describes the difference between Normals of the high-resolution surface and the low-resolution one. If you actually move the base geometry around, the results from the normal map will be less than ideal. Try to have your basic structure "locked" by the time you get to detail sculpting.

---

Let's add some minor blemishes and bumps. For this procedure, disable X Symmetry. Bumps are much easier than wrinkles. Choose the **Inflate** brush and set the brush size to match the size of the bump you want to create. Take a look in the tool shelf at the **Curve** panel. We haven't messed with it before, but it's useful to take a look now. Figure 8.12 shows the panel. Unlike RGB curves that affect color, the curve in this graph defines brush falloff. Figure 8.13 shows the three preset brush curves, and what they actually translate to as a painting brush. The effect is most obvious during sculpting when using the Draw tool, but it affects the way that all tools lay down their influence.

When creating little bumps on skin, it's probably best to ignore the presets and create your very own curve. The Curve tool itself is identical to ones elsewhere in Blender (see Section 12.3 on compositing in Chapter 12). Click and drag anywhere on the curve line to add a control point. Dragging control points allows you to alter the shape of the curve. To remove a control point, LMB click to select it (it turns white) and click the "X" above the curve workspace. To create a curve for skin bumps, choose **Sharp** by clicking on the word "Preset" below the workspace. Grab the central control point of the curve and drag it up and to the right, until it looks like Figure 8.14. If you closely observe the little bumps on your own skin, you'll notice that most of them are plateaulike, or mostly flat on top. The curve that we've created reflects that.

Before adding bumps, check to be sure that the **Space** option in the **Stroke** panel is disabled, and that you've disabled any symmetry settings in the **Options** panel. While you might be able to get away with fine wrinkles being symmetrical, any kind of little skin bumps will look bad if they are mirrored from side to side. The **Space** option causes your brush to "dab" as you paint, with each dab a certain distance apart. When enabled and set to a low value, it is pretty indistinguishable from just turning it off, but when set to higher values, it allows you to easily "draw" evenly spaced instances of your brush. Figure 8.15 shows a surface that has received skin bumps at regular intervals by using the Space option. The reason we turn it off now though is because we want to just be able to LMB click on the skin and have a bump appear. You cannot do this when Space is enabled.

Don't go overboard with the bumping. Remember that the sample character is a kid. The older we get and the longer our skin is subject to the environment the worse it becomes. As for varying the size of the bumps, there are two methods. You can simply use the F key to change the size of the brush, or

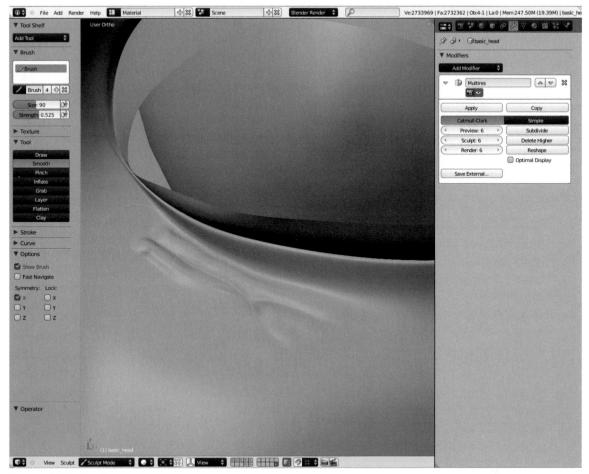

**Figure 8.12** *The Curve panel.*

you can leave the brush alone and zoom in and away from the model itself. Either way changes the relative size of the brush to the surface. For a more pronounced bump like a giant mole, hold down the LMB until the inflation creates the size you are looking for. If you make a larger feature like this, you will probably have to blend its base into the rest of the surface with the Smooth brush to get it to look natural. Remember that it's better to use a weaker brush (lower strength value) in multiple passes than to try to find a single higher strength that does what you want in one click. The results will be more organic.

While sculpting details, use references, including close-ups if they're available, and carefully observe the direction and depth of wrinkles and creases, how spots that you might think are only colorations also have a little bit of dimension to them, and how the orientation of the skin texture itself changes on different parts of the body. Also, remember to maintain a proper scale. How are the features you are sculpting related in size to the overall piece? Remember that when we look at a person (or other commonly

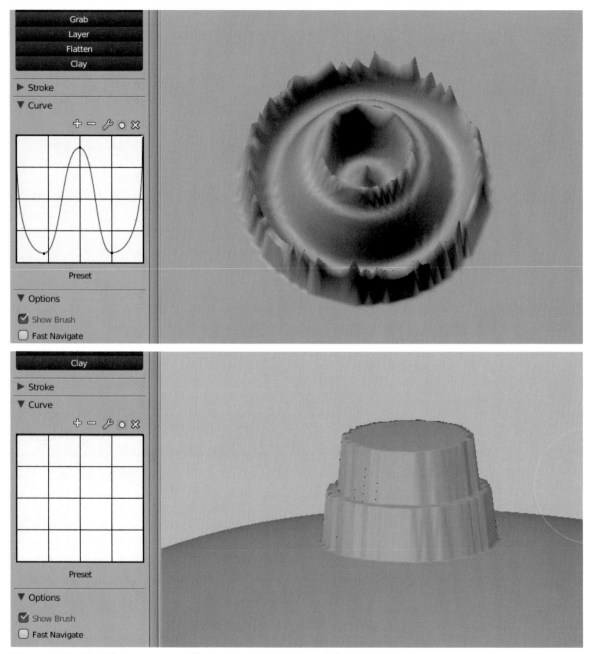

**Figure 8.13** *The default curves, accessible from the Presets menu, and their brush equivalents.*

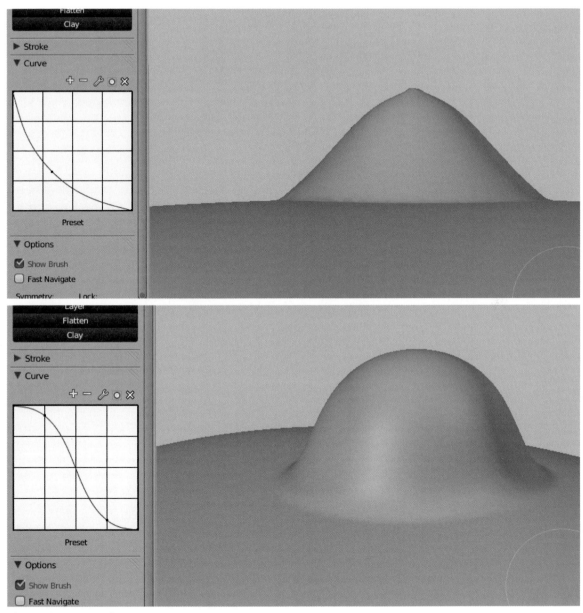

**Figure 8.13, cont'd**

**Figure 8.14** *The Curve panel for creating single-click bumps.*

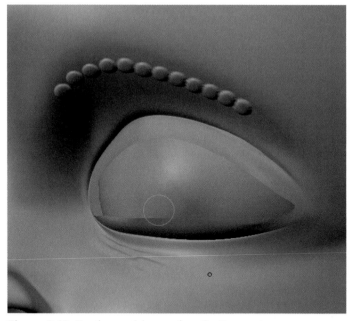

**Figure 8.15** *Evenly spaced bumps, from the Space option.*

encountered thing), most of the details get a quick once-over from our brains and, as long as they match what we're used to seeing, are discarded from our perception. When we shoot for believability, this is what we are trying to achieve. Enough accurate detail to tell the viewer's brain, "Hey, we're okay. You can stop paying attention so closely." Don't overdo it with the sculpted details.

We're not going to add any further nastiness to the kid's face, but you should note that any smaller-scale features of your models can be created in this way: veins, muscle striations, scarring, even scales.

We do, however, need to add the skin texturing. It will be fine (as opposed to coarse) and probably not noticeable in anything but a close-up, but while we're here, let's do it.

The best way to give skin a realistic texture is by using an actual texture on the sculpting brush. If you recall from Chapter 7, you can get a texture through Blender's procedural system or from an image. You already know which one will give you better results in a shorter amount of time. For this exercise, you can use the included skin image from the Web Bucket called *skin_alpha.png*, which is shown in Figure 8.16. This image will form our skin brush. Notice how the texture itself in the image is black and white, fading out to pure black at the edges. Only areas in white will "draw" when used with the brush, so we will in effect be etching this image into the surface of the face.

With this kind of texturing, especially on "regular" people, you want to keep it subtle. For beings with more pronounced skin texturing like monsters or Edward James Olmos, you can let it show a bit more.

To add a texture to the Draw brush, expand the **Texture** panel in the tool shelf and click the **New** button. If you have an available Properties window, use it to show the Texture properties, which should now have this newly added texture. If it isn't showing, you may have to enable the **Brush** button, as shown in Figure 8.17. You get many of the familiar texturing controls in the properties, but panels like **Influence** are gone and **Mapping** has changed completely. You really don't need to do anything here other than changing the texture type to **Image or Movie** and selecting the *skin_alpha.png* file as the image.

Before you begin sculpting with this brush, look under the **Stroke** panel in the tool shelf and enable **Anchored**. Anchored invokes a different painting mode than you are used to. Instead of

**Figure 8.16** *A skin brush image.*

simply applying the brush as you LMB drag across the surface of the model, Anchored mode considers the spot where you press down on the LMB as the "anchor" for a single stroke. As you hold down the LMB and drag, whatever the current brush is grows outward with it. Figure 8.18 shows the effect. Moving the mouse in a circle around the original click point rotates the brush texture along with it. With the skin image attached to the brush, this means that using Anchored mode lets you interactively "stamp" the skin texture onto the mesh at different sizes and rotations. By covering the whole surface with these stamps, and paying attention to the scale and direction of such texturing on a reference, you can achieve a very good approximation of skin.

In my own work with this technique, I've found that the higher resolution of the brush image, the better the final results. Low-resolution images will give you blocky sculpting, even if your mesh resolution is high enough that it shouldn't be a problem. Once again, start at a low brush strength and work your way up until you have acceptable results.

---

**Note**

While this technique is nice, you may not need to use it at all. If your source and final projection painting images are high resolution enough, the bump map you originally created might be more than good enough. You can still use the rest of the techniques to add wrinkles and bumps, but skin texturing to this degree might be overkill.

---

Brush ▸ skin texture

skin texture 🞤 🞨 Brush

Use Nodes

Type: 🎞 Image or Movie

▼ Preview

▼ Image

🖼 skin_alpha.png 🞤 🖫 🞨

| File | Sequence | Movie | Generated |

nder/Blender Foundations/textures/skin_alpha.png 🖫 🗘

Image: size 399 x 399, RGB byte

⬜ Fields          ⬜ Anti-alias
Even | Odd       ⬜ Premultiply

▶ Image    Convert RGB from key alpha to premultiplied alph
▶ Colors              Python: Image.premultiply
▼ Mapping

| Fixed | Tiled | 3D |

◀ Angle: 0.000 ▶

Size:
◀ X: 1.00 ▶
◀ Y: 1.00 ▶
◀ Z: 1.00 ▶

▶ Image Mapping
▶ Custom Properties

**Figure 8.17** *Adding an image brush for sculpting.*

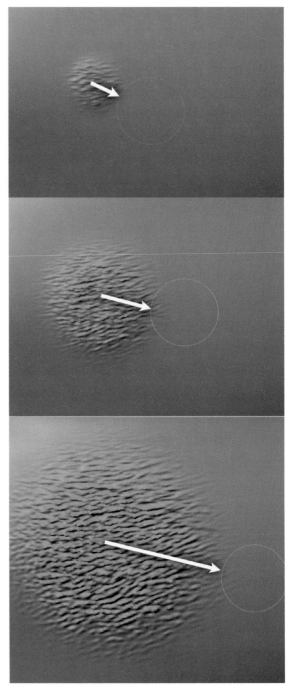

**Figure 8.18** *Using a brush in Anchored mode (strength raised drastically to show the effect).*

## Baking to a Normal Map

Once you have sculpted your details, you have to get them back onto the original model. Just using the sculpted form is possible, but if you're over the 2 million polygon range, your renders are going to be unnecessarily lengthy. You can tell Blender to store the high-resolution detail in a kind of bump image called a **normal map**. When you use a black-and-white image as a bump map in Blender's texturing system, the renderer simply says, "If the image is white here, I'll pretend that the surface is this much further along its normal value." Bump mapping only encodes for "in" and "out" normal variation. An actual normal map, though, uses all three image channels (RGB) to encode an actual direction and distance, generating a much more realistic effect.

To create this type of normal map, save your sculpting work and reopen the original scene file. Use the **Append** command (F1) to find the head model in the separate file that was created for sculpting. The goal is to get the high-resolution head to sit in the exact position as the low-resolution one. To do this, bring up the N-key properties panel, select the high-resolution head, then Shift select the regular head so it is active. RMB over the transform controls in the panel for both Translation and Rotation. From the RMB menu, choose **Copy to Selected**. This copies the transformation of the regular head to the sculpted head, putting them in identical locations and orientation.

If you find that things are too slow in the main scene with the high-resolution head brought in, make sure that the **Preview** value on the Multires modifier is set to 0. If things are still too slow, change the display type on the 3D view header to **Bounding Box**. You'll only see a bunch of boxes that represent your objects, but the display speed and interface responsiveness will be back to normal.

For the baking process, we need a blank image attached to the low-resolution object and a UV unwrap. We already have a nice unwrap for our head (the "final" channel that we projection painted into). Select the low-resolution head, make sure that the "final" UV channel is selected for Render in the Mesh properties, and add a new image in the UV/Image Editor. It won't hurt to use a 2048 × 2048 pixel image, as it would be nice to capture all of that detail that has been put into the sculpt.

That's the setup. To actually bake, we do the standard multiple-selection dance that we've done elsewhere when there is a source and target to be defined. RMB select the high-resolution head (the source), then Shift-RMB select the low-resolution one (the target), making it active. On the **Bake** panel in the Render properties, shown in Figure 8.19, choose **Normals** from the **Bake Mode** pop-up menu. The standard method of normal baking is in **Tangent** space, which is selectable on the **Normal** space control. Finally, enable **Selected to Active**, which does the normal comparison between the two objects. Hit the **Bake** button, and take a break. It won't take too long, but it is a render process.

As soon as it's done, use the **Save As ...** command in the UV/Image Editor to save the baked image.

**Figure 8.19** *The Bake panel.*

It acts just like a still render. If you quit without specifically saving the image, it's gone and will have to be rebaked.

Back in the Material panel for the head, applying the newly baked normal map requires only a few adjustments. Find the texture channel for bump mapping that you (cleverly, wisely) labeled and change from the original painted bump map to the just-created normal map in the Image selector. The differences, which are shown in Figure 8.20, are as follows. Enable **Normal Map** in the Image Sampling panel of the Texture properties, and be sure to choose **Tangent** from the space types selector below it. This has to match the space in which the map was baked in order for the effect to work. That's it! Really, it's the only difference. You might find that you need to adjust the value of the Normal slider on the Influence panel. Figure 8.21 shows the baked normal map, and the regular-resolution head rendered with this new map in place. Note the wrinkles around the eyes. Of course, this kind of detail looks strange on a stylized kid's face, so we're probably better off pretending we didn't see it.

**Figure 8.20** *The baked normal map and a render of the effect.*

## Sculpting from Scratch

Sculpting from scratch can be a fun exercise in form over function. Without worrying about topology or matching a predetermined outcome, you can quickly sculpt heads or other shapes. The Web Bucket contains a video called *rapid_sculpting.mpeg* that demonstrates just how quickly you can create a finished form with the sculpting tools.

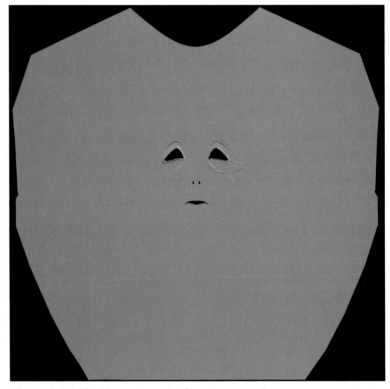

**Figure 8.21** *The Texture properties for using a normal map.*

## Sculpting and Performance

While Blender can handle a large number of polygons during sculpting, there are some settings you can toggle and steps you can take to try to boost performance.

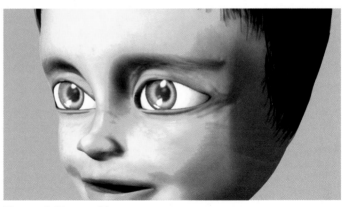

**Fast Navigate**, on the **Options** panel of the tool shelf in Sculpt mode (Figure 8.22), displays the lowest sculpting resolution whenever you transform the viewport. At high levels of Multires detail, this can dramatically speed up viewport rotation.

**Figure 8.21, cont'd**

**VBOs**, found in the **System: OpenGL** section of the User Preferences, stands for Vertex Buffer Objects. When enabled, it can drastically speed up all areas of 3D viewport and mesh manipulation. Turn it on and see what happens. Using VBOs can lead to some display and selection glitches, so it is disabled by default. One such glitch that I experienced on one of my production systems is the inability to select edge loops in Edge select mode when mesh editing. If you turn on VBOs, don't forget that you've done so. Things may start acting strangely in the 3D view, and if they do, you'll know why.

**Figure 8.22** *Fast Navigate.*

**Smooth Shading.** You might be in the habit now of using Smooth Shading on all of your models. This can hurt performance during sculpting. Set your object back to Flat shading with the Object mode button on the tool shelf. At very high polygon counts, you'll hardly notice the visual difference anyway.

## Next Up ...

In Chapter 9, we rig the character model for animation.

# Chapter 9

## Rigging: Digital Orthopedia

Before you can animate your character (or anything else that changes shape as it moves), you need to rig it. Rigging is the process of creating and binding a control structure for your model. In Blender, rigs are usually created as an object called an **Armature**, which consists of **Bones**.

I'm not going to lie. I despise rigging, and need to get this off my chest. When I'm knee deep in building a hand rig, selecting *this* bone from the maze of existing ones and making sure it lines up with that one *just so* only to find that the constraint is preventing the whole thing from working for the tenth time, well, it's enough to make me want throw my computer through the window and run screaming into the forest to spend the rest of my mortal years with the raccoons and groundhogs.

But that's not going to happen to you. Honest.

Some people are into it. The process is kind of like a puzzle, and the fact is that rigging (creating the control structure) and skinning (binding that structure to your model) is probably the singlemost difficult thing you'll have to do in 3D. Before we get into actually creating a rig for our character, let's think for a moment about what we want in an animation control structure.

An animated character is really a poseable digital puppet. Controls should be obvious, fairly simple, and able to quickly produce poses that mimic (but often exceed) real-world positions. Controls should provide useful shortcuts to the animator (e.g., finger curling), but allow freedom to deviate when necessary.

## Preparing to Rig

Not every model is in a suitable state for rigging and skinning. The process works most reliably when the different objects that make up the model have neither scaling nor rotation transforms. Most likely, you haven't been paying attention to this sort of thing up until now. Use the N-key panel in the 3D view to see if any of these transforms are present on your model. Figure 9.1 shows the Properties panel with both

a scale and rotation. In order to remove these without retransforming your model, use the **Ctrl-A** hotkey to bring up the **Apply** menu (also found in the **Object** menu on the 3D header) and first choose **Rotation** then **Scale**. These commands "clear" those transforms without otherwise changing your model. *Do not* choose **Location**—this will move your object's center point.

Note that you can begin to create your rig before your model is finished. Nothing that you do during the rigging

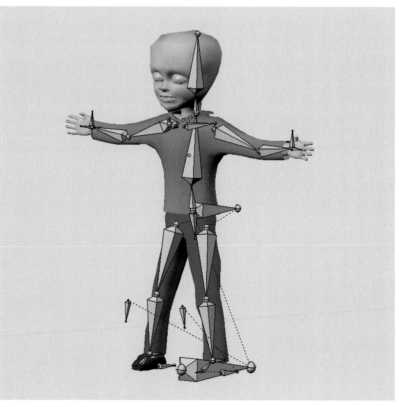

**Figure 9.1** *The Properties panel with a scale and rotation.*

process will be broken if you update, refine, or otherwise change your model. In fact, a "stand-in" model with detached parts is often used during the rigging process so that the rigger can focus on building the controls without worrying about skinning and deformation.

When you have rotation and scaling removed from your objects, select each of the objects that make up your character and make sure that their **object center's** are truly in the center of the mesh by pressing **Shift-Ctrl-Alt-C** and choosing **Origin to Geometry** from the menu that pops up. This command moves the object's center (origin) to the center of the object data (the mesh itself). Remember that you can always use the Spacebar search tool or the header menus to find little-used commands like this one. Select the mesh that represents the main body, and use the **Shift-S Snap** command to snap the 3D cursor to the selected object. This positions the cursor properly for armature creation.

## Creating the Initial Skeleton

Figure 9.2 shows our sample character overlaid with a skeleton. This skeleton is the **armature**. You can start your own by using the **Shift-A** menu and choosing **Armature** then **Single Bone**. The armature begins its life as a

**Figure 9.2** *Our character, with his skeleton showing.*

bone, with its **head** on the 3D cursor. The bone tapers toward its upper end, which is called the **tail**. Just like working with mesh objects, armatures have both an **Object mode** and **Edit mode**. We would like to work with the structure of the armature itself as opposed to manipulating it as a whole, so use the **Tab** key to enter Edit mode.

RMB selecting either the head or tail of the bone then transforming it with the G key will cause the entire bone to stretch or shrink accordingly, like a rubberband. To transform a bone in a more normal fashion, RMB select the long middle portion then use the G, S, and R keys. Bones are deleted by selecting them and pressing the X key.

New bones are added to an armature either with the Shift-A key, which immediately adds a bone at the 3D cursor, by selecting and Shift-D duplicating existing bones, or by selecting the head or tail of an existing bone and using the E-key extrude command. Note that all of these methods map directly to the same skills and commands used in mesh editing. What works there generally works here.

Once the first bone is added, the goal is to get something that looks like Figure 9.2. Notice in the figure how the armature bones don't necessarily represent every bone in a real body. What they really represent are bridges between joints, or points of articulation. When designing your own rigs, keep that in mind so you don't overcomplicate things.

We'll start with the spine, neck, and head. Go into a side view. We want to keep the spine bones directly down the center of the character (from left to right), and working in side view assures us that we won't accidentally move them off the left-right axis. In the **Object** context of the Properties window, find the **Display** panel and enable **X-Ray**. This option lets you see the armature, regardless of whether or not it is behind or inside another object. You can do armature construction in Wireframe or Solid view, but I prefer to work in Solid. It gives me a better feeling for what is what (all those wires can get confusing!) and works quite well with X-Ray enabled.

Making sure that you're in Edit mode (check the 3D header if you're not sure), grab the bone and try to position its head near the top of where the pelvis would be and its tail at the bottom of the crotch (or "inseam" for the squeamish), angled slightly backward like Figure 9.3. You can do this either by grabbing the entire bone, and using the G, S, and R keys to transform it into place, or by first grabbing the head and moving it appropriately, then doing the same with the tail.

Use the RMB to select only the head of the bone (the fat end). To create our next bone, press the **E** key to extrude a new bone. After you extrude, the new bone is automatically selected and in Transform mode, following your mouse. Move it straight up to meet what would be the bottom of the character's rib cage, and click the LMB

**Figure 9.3** *Placing your first bone.*

to accept the new bone and location. Figure 9.4 shows this second bone.

Hit the E key again, and drag the tail of this even newer bone up to the base of the neck. Do it twice more, pulling those bones to the top of the neck and the top of the head. Figure 9.5 shows the entire spine chain. Yours probably won't look exactly like that, but in rigging, positioning is crucial. The joints between the bones will be the actual pivot points for your character. Having them at the wrong place will produce unrealistic deformations, and you will find yourself fighting with your rig just to get things to look right. So, using RMB selection and the G key, try to get your rig in side view to look just like the one in Figure 9.5, paying special attention to both vertical and horizontal positioning relative to the neck and head, and the front and back of the rib cage.

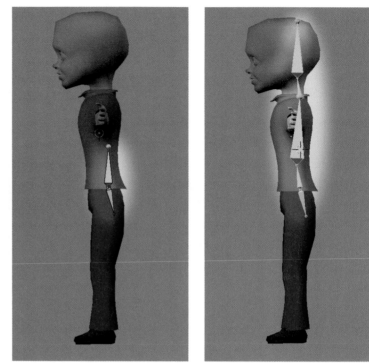

**Figure 9.4** *A second bone.*    **Figure 9.5** *The entire spine chain.*

Notice that when you select a single joint with the RMB and move it, both of the attached bones on either side move to follow. This is because these joints are a single bone element that consists of the head of one and the tail of another. Additionally, if you grab an entire bone that is a part of this chain and move it, then both of the bones on either side of it will adjust their size and orientation to keep everything connected. Each of these bones that you extruded from a previous bone's tail are called **connected children** of the bone from which they "grew"—their parent bone. The parent–child relationships of bones within an armature are the basic way that bones relate to and affect each other. In the same way that moving your own arm at the shoulder makes the lower portion of your arm come along for the ride, so too do parent–child bones work.

However, when dealing with bones, there are two kinds of parenting: **connected** and **disconnected**. The bones you have just created for the spine, neck, and head are all connected—the tails and heads are combined into a single unit. When you're animating, you'll find that connected children can rotate on their own, but their head cannot translate away from the tail of their parent bone.

The other type of parenting is disconnected. The child bone comes along for the ride with any transformation that the parent has, but it is free to translate wherever it likes. Figure 9.6 shows both kinds of parenting, as well as two unrelated bones.

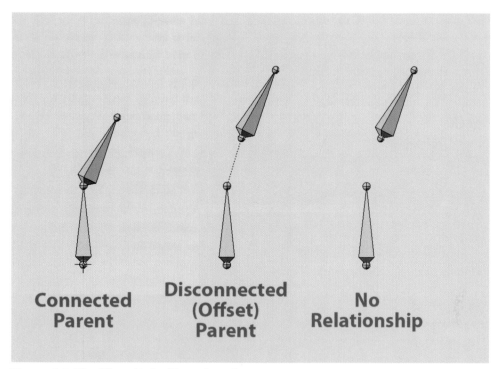

**Figure 9.6** *The different kinds of bone relationships.*

You can also create parent–child relationships between bones after they are created, in the same way that you do at the object level. RMB select the bone that is to be the child, Shift–RMB select the parent-to-be, and press **Ctrl-P**. When you do this with bones, you are presented with a choice of **Connected** and **Keep Offset**. Obviously, the first option moves your bone and attaches it to the parent, forming a connected relationship. The second option creates a disconnected relationship. Also similar to Object mode, the relationship can be broken with **Alt-P**, which gives you the option of removing it altogether, or just "downgrading" a connected parenting relationship to a disconnected one.

As we construct this armature, we'll note which kind of parenting we're using and why. Before we proceed, RMB select the very first bone we created, which now sits facing downward inside the pelvis. Use the G key to move it. Be sure to cancel the move with the RMB. Notice that none of the other bones follow it or are affected by it in any way. It is not a child of any other bone in the armature at the moment.

> **Note**
> The rig that we are building here is relatively simple. It has few shortcuts or automatic controls. Neither its spine nor its neck are particularly flexible. This is because all of those "features" a rig might have really raise the complexity of the process. What this chapter will do is prepare you to create simple but effective rigs of your own, and perhaps more importantly, to examine and understand the complex rigs that have been created by some extremely talented artists and technicians.

Finally, select each of these bones in turn and assign them useful names in either the **Bone** panel of the Properties window, or the **Item** panel of the N-key shelf in the 3D view. Figure 9.7 shows both. Naming your bones is important, especially later when you might have dozens of bones in your armature. Descriptive names will make the task much less frustrating than it can be. In the example files, the bones are named *pelvis, spine_lower, spine_upper, neck,* and *head.*

With the bones for the trunk in place, let's move into a front view and add the arms. RMB select only the joint between the upper spine and neck bone. Press the **T** key to bring up the tool shelf and enable the **X-Axis Mirror** setting in the **Armature Options** section. This property allows you to create only one side of the armature and have the actions automatically duplicated and mirrored on the other side. Even with a simple armature like this one, it is a great timesaver.

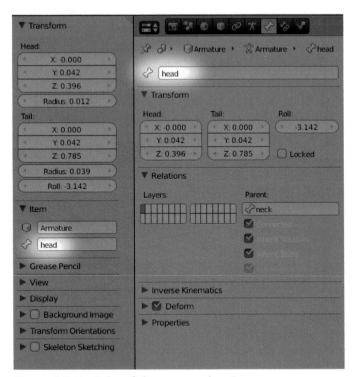

**Figure 9.7** *Don't be a fool—name your bones!*

Make sure again that you're in a front view (Numpad-1), and press **Shift-E**. This is a modification of the extrude command. When used with **Shift** and **X-Axis Mirror** enabled, this extrudes two new bones in opposing directions. Pull one of the new bone's tail the whole way over to the character's elbow. The second bone should proceed to the opposite elbow on its own. RMB select one of the new bones—it doesn't matter which, but I tend to keep all of my direct work on the right side of the armature—and use **Alt-P** to break its parent–child relationship to the spine ("Clear Parent"). Now, you should be able to grab the entire bone, move it away from the spine, and adjust its size and position to properly create an upper arm. Figure 9.8 shows the result.

RMB select the tail of the upper arm bone and use Shift-E to extrude another bone along the lower arm, ending at the base of the hand. Because you used Shift-E to extrude instead of just the E key, the opposite arm has also grown a new bone. Shift-E again on the lower arm, and pull the new bone to cover the length of the hand (not the fingers). Switch to a top view (Numpad-7) and RMB select and move the various joints and end points of these new bones so that they fall inside the character's body.

The important thing to keep in mind when placing joints is that these will be the pivot points of your mesh during animation. For example, the head of the upper arm bone should be located exactly where the real bony ball of the character's humerus would fit into the socket of the shoulder muscles, if he had

such a thing. And even if your character is stylized or cartoonish, you need to attempt to visualize them as real, physical things if you are going to get anyone to believe in their animation.

With these arm bones, we'll be able to somewhat mimic the motion of natural arms. We'll add one last bit before moving onto the legs: collarbones. Humans (and every anthropomorphic character based on them) generate a lot of expression and body language through the set of their shoulders. The actual placement of the shoulders themselves can signify determination, defeat, and curiosity, among other things. These shoulder positions pivot from the collarbones.

To make them, RMB select one of the upper arm bones and use **Shift-D** to duplicate it. A mirrored duplicate should also spring to life on the other side. Using both front and top views, manipulate this new bone until it appears like the one in Figure 9.9. Feel where your own clavicle begins and ends and place your character's appropriately.

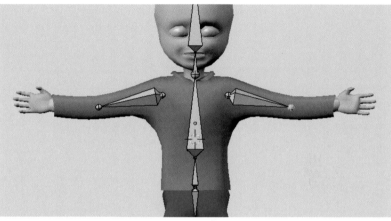

**Figure 9.8** *The upper arm bones.*

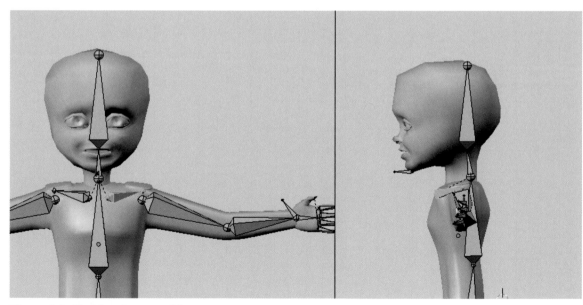

**Figure 9.9** *Clavicle and upper and lower arms.*

253

Before things get too messy, select and name each of these new bones. As we're working on two sides at once now, it is the usual practice to tag your bones with designators. So, your upper arm bones might be called "upper_arm_L" and "upper_arm_R." The exact names aren't important, so long as you'll be able to look at a long list of bone names and know what they mean. Designate left and right side bones with either, respectively, "_L" or ".L" and "_R" or ".R".

Head back to a front view and select the head of the pelvis bone. Use Shift-E to mirror extrude a new set of bones down to the knees. Select one of them, and use Alt-P to break any parent–child relationships it might have. Then, adjust the bone to fit the upper portion of the leg. Just like the shoulder joint, the head of this bone should be in the actual location of the hip pivot in a real body: halfway from front to back in side view, and inside the flesh of the hip. Figure 9.10 shows the leg bones for reference.

Select the tail of the bone at the knee and Shift-E extrude it downward to where the leg meets the foot. Put the tail of this shin bone near the front of the leg, as the bone in a real leg rides very close to the front as well.

Select each of these four new bones and name them appropriately, using left and right designators.

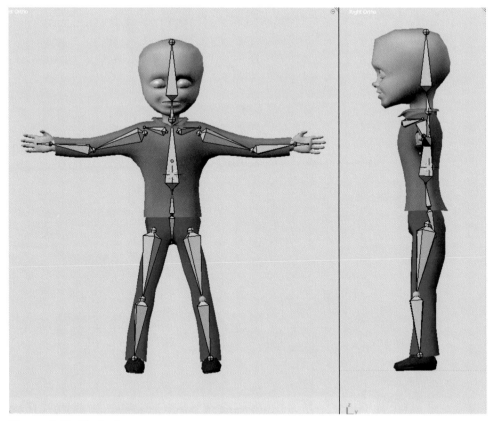

**Figure 9.10** *The leg bones.*

## Rig Testing and Adjustment

Let's test things out. You animate and manipulate rigs in **Pose** mode, a mode unique to armatures. You can always get to Pose mode by using the mode's pop-up on the 3D header, or by using the **Ctrl-Tab** hotkey. This one is worth memorizing.

Using Ctrl-Tab turns all of the bones blue, which is the best indicator that you are in Pose mode. The armature as presented in Pose mode begins its life just like the one in Edit mode. However, regardless of how you transform the armature in Pose mode for animation or testing purposes, the Edit mode armature remains exactly how you left it. It is the baseline for Pose mode. To get a feel for how things work, RMB select one of the upper arm bones. Use the G key to move it, and the R key to rotate it. It moves freely, and however you transform it, the lower arm and hand bones follow. Select the lower arm bone, though, and you'll see that due to its status as a connected child, it can only rotate.

Now, select either the upper or lower back bone and rotate it. While the spine bones up the chain move along, the arms and shoulders do not. We need to fix that. Out of Pose mode and back into Edit mode, then. Remember that Pose mode is only for animation, not for tweaking an armature that was designed in Edit mode. Any structural changes should always be done in Edit mode. To return to Edit mode, hit the Tab key.

In Edit mode, RMB select the upper arm bone, then Shift-RMB select the corresponding collarbone. Use **Ctrl-P** to create a parent–child relationship, choosing **Keep Offset** from the menu that pops up. This makes the upper arm bone a disconnected child of the collarbone. To have made it a connected child would both change the location of the head of the upper arm bone to merge with the tail of the collarbone, and removed our ability to independently move the bone itself when animating. Repeat this process, this time making the collarbone the disconnected child of the upper spine bone. As you do this on one side, the **X-Axis Mirror** feature keeps pace with you on the other side of the rig.

Go back into Pose mode (Ctrl-Tab) and try rotating either the lower or upper spine again. This time, the arms should follow along.

As you proceed through your own rigging tasks, remember to frequently drop into Pose mode to make sure that your bones are working the way that you intended. It's not uncommon to make a minor adjustment in Edit mode, jump to Pose mode to test, then back again for another tweak, a number of times to get things just right.

## Adding Basic Controls with Parenting

When we eventually get to animating, some shortcuts will make your life easier. In particular, it will be nice to have a way to move the entire upper body and the tops of the legs at once. It will also be useful to move the entire rig within Pose mode (i.e., not as an object in Object mode). Right now, you would have to move the upper leg bones, the pelvis, and the lower spine bone simultaneously every time you wanted to move the whole character in space. An extra bone and some parenting can fix that.

Back in Edit mode, simply hit Shift-A to add a new bone at the 3D cursor. We don't need this one to be mirrored, so no need to extrude from an existing bone. It doesn't really matter where this bone goes,

as long as it is somewhere down the center line of the armature and is easily accessible, away from others. In Figure 9.11, you can see where I've placed mine: the tail of the bone behind the character at waist level with the head meeting the base of the spine. Select the lower spine bone, the pelvis, and both upper leg bones, then Shift-RMB select this new control bone. Use Ctrl-P (with Keep Offset) to make all of these selected bones the disconnected children of the control bone. Name the bone something like "body_control."

Jump into Pose mode (Ctrl-Tab), select the bone, and transform it. The entire armature should happily follow along.

## Rigging with Constraints

While you're in Pose mode, bring up the tool shelf and enable **Auto IK** in the **Pose Options** section. Select one of the lower arm bones and use the G key to move it. Because the lower arm is the connected child of the upper arm, it shouldn't be able to translate—only rotate. However, using IK (which stands

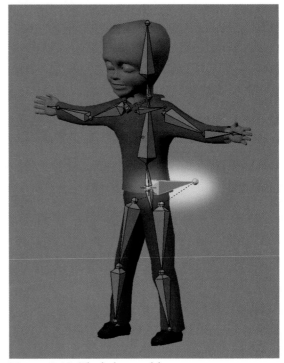

**Figure 9.11** *The body control bone.*

for inverse kinematics) allows you to manipulate a target and have other bones automatically adjust themselves to follow that target. If you spent any time playing with our rudimentary armature in Pose mode (which you should have done, because playing around is a huge part of learning), you'll see that this is a significantly different approach to armature manipulation.

Without IK involved, you are using what is called forward kinematics, FK. With FK, a pose is built from the base of the chain upward, the user defining the rotation of each bone by hand along the way. IK works in reverse. The *last* bone in the chain tries to reach the IK target, which can be another bone or some object outside of the armature, and that motion propagates *down* the chain, eventually reaching the head of the base bone.

When animating, certain types of motion are more easily and realistically achieved with IK, and some are better suited to FK. Here's the rule: Limbs that bear weight or support the rest of the armature use IK; everything else uses FK. For a human, the solution appears simple: IK for the legs and feet (they support the body), and FK for everything else. True enough. But what if our character leans on a table, or puts his or her hand against a wall? In those cases, the hand would also be bearing weight, so you would want to use IK. So, we'll work toward constructing a rig that uses IK for the legs and feet and FK for the main body and arms, but gives us the option of using IK on the arms and hands if we need to.

Disable **Auto IK** and head back to Edit mode. We're going to make some feet.

> **Note**
> From now on, we're not going to give you step-by-step instructions when it comes to adding and placing bones. Remember the different methods:
> - Shift-A adds a bone at the 3D cursor.
> - E key extrudes a connected child if extruding from a bone's tail, but just a standard bone when extruding from a head.
> - Shift-E extrudes while mirroring across the armature, if X-Axis Mirror is enabled in the tool shelf.

## The Reverse Foot

The "reverse foot" is a tried-and-true foot rig that is fairly easy to build, yet provides a nice set of controls for animators. Figure 9.12 shows the foot bones. To build it, add a bone (A) that runs from the center of the pad of the bottom of the foot (where the toes begin) to the bottom of the lower leg bone, then extrude a connected child (B) bone back and away. To get the joint between the two bones to line up exactly with the tail of the lower leg bone, RMB select the bottom of the leg bone, then press Shift-S for the Snap menu and choose **Cursor to Selected**. Select the joint, press Shift-S again, and choose **Selected to Cursor**. This moves the joint to the exact location of the head of the leg bone.

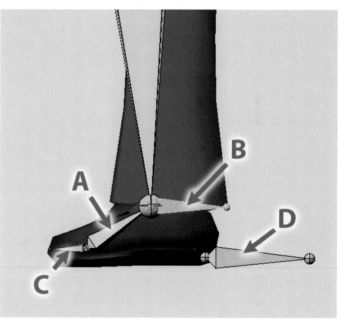

**Figure 9.12** *The reverse foot.*

Extrude a bone (C) from the ball of the foot to the tip of the toe. Finally, add a bone (D) that begins at the base of the heel and extends backwards, away from the foot. That's all the bones we need. To link it up, make the foot bone (A) and the toe bone (C) the disconnected children of the heel bone (D).

Now for the fun. Go into Pose mode and first RMB select the connected child (B), then Shift-RMB select the lower leg bone. Press **Shift-I** and choose **To Active Bone** from the menu that pops up. This shortcut adds an **IK constraint** to the lower leg bone, targeting bone B. Switch two of your Properties windows to show the **Bone** and **Bone Constraint** contexts, seen in Figure 9.13. Notice on the Bone Constraint context that a panel exists called **IK**. Constraints on bones operate a lot like modifiers do with meshes. You only need to make one adjustment to the default settings in order to start playing around:

set **Chain Length** to 2, as it appears in the figure. Chain Length tells the constraint how many bones to include in the effect. In this case, we only want the lower and upper leg bones included. If we had left this setting at 0, the IK constraint could possibly have affected the entire armature, which, while it can lead to some wild animation, will not usually give you a controllable, natural result.

Constraints can be added to a bone through the **Add Constraint** control on the panel, and rearranged for different results. Like modifiers, each has its own unique effect on the bone and its own battery of settings.

Constraints can also be added to bones by using the **Shift-Ctrl-C** hotkey in the 3D view, which provides a pop-up menu of the large variety of constraint types. Adding an IK constraint is so common that it gets its own hotkey: **Shift-I**. Notice in Figure 9.13 how the **Target** and **Bone** fields are already

**Figure 9.13** *The Bone and Bone Constraint panels.*

filled in. When adding a constraint directly from the panel controls, you have to populate these fields by hand. However, the fact that we first selected bone B when creating the constraint with the hotkey told Blender to use that as the target bone.

You'll find that you can now manipulate the entire leg by grabbing the bone that extends backward from the heel (D) and moving it around. Begin by doing this in a side view. Translating the heel gives some fairly nice knee-bending motion. Rotating the heel bone gives a good result too. If you move the heel bone too far away from the leg, the foot detaches. While there are some nice rigging solutions to prevent this from happening, there's an even simpler solution: Don't move the heel too far when you animate. This highlights one of the "personal preference" aspects of rigging and animation. Some animators prefer to have everything automated. Others prefer a rig that is simpler and assumes that you're going to pay attention when you're animating. My preference is for the second, but yours may differ.

Switch to a front view and translate the heel bone again. The leg moves from side to side, but the motion is clearly wrong. The knee shouldn't twist like that. A real knee only rotates along a single axis. We'll look at how to lock that down in a moment.

Return the heel bone to its rest position (Alt-G to clear translation and Alt-R to clear rotation) and switch to a top view. With the heel still selected, rotate it. The foot structure rotates as you would expect, but the leg doesn't follow. We'll fix that first.

### Adding a Pole Target

Head back to a side view and enter Edit mode. Select the lower leg bone—the one with the IK constraint—and use Shift-D to duplicate it. Move the duplicate in front of the leg bone, then scale it downward until it looks something like Figure 9.14. We're going to use this bone to influence the rotation of the lower leg. An IK constraint can use something called a **Pole Target**. This is a secondary target bone that the constrained bone will always adjust its roll to face. To use this new bone as a pole target for the lower leg, switch to Pose mode and use the "X" control on the Bone

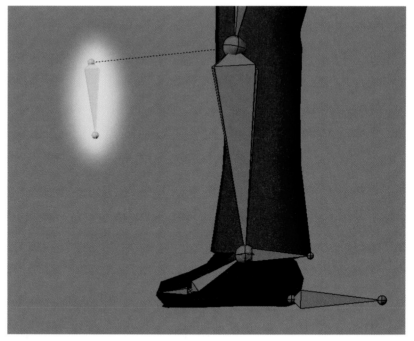

**Figure 9.14** *The creation of the pole target bone.*

Constraint properties to delete the IK constraint from the new bone. This bone had a constraint because we duplicated it from a bone that already had a constraint.

In Edit mode again, select this pole target bone, then Shift-RMB select the heel bone. Use Ctrl-P to make the heel bone its disconnected parent. Name the bone something like "pole_target_L." What this will do is cause the pole target bone to swing in space as the heel bone is rotated. The IK-constrained lower leg will rotate to face it, meaning that the whole leg will rotate along with the heel and foot.

One last step. In Pose mode, select the lower leg bone and check out the **Pole Target** field on the IK constraint on the Bone panel. Use the pop-up control to find the armature object itself. When you do, another control appears below it for locating the bone. Since you named the target bone, its easy to find and select it now.

Here's the subjective part. Depending on how everything lines up—even a few degrees can make a difference—this might mess up the starting rotation of your lower leg bone. The **Pole Angle** control on the IK constraint panel allows you to adjust this. There's no way for me to tell ahead of time what your adjustment will need to be on your own rig. The pole angle on the left leg in my own armature was −84 degrees. To find the right value for your rig, just slide the control and watch what happens in the 3D view. When the leg is oriented correctly to the front, you've found the proper value. The odds are that the value on the opposite side of the rig will be close to the same.

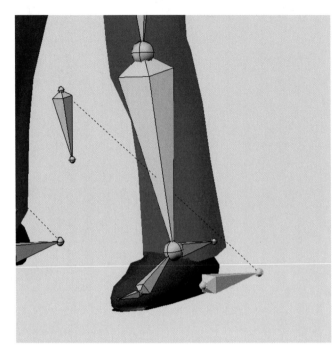

**Figure 9.16** *The Inverse Kinematics panel in the Bone context.*

**Figure 9.15** *The reverse foot rig, complete.*

Now, when you move the heel control, both translation and rotation, the leg bones exhibit the proper behavior, following and twisting with the foot. Figure 9.15 shows the completed reverse foot rig.

Let's go back and tackle the problem of the knee bending along more than a single axis. At the bottom of the Bone context in Pose mode is a panel called **Inverse Kinematics**. Shown in Figure 9.16, it lets you set rules for each bone's rotations while under the influence of IK. The x, y, and z controls are enabled by default, meaning that the bone is free to rotate along all three axes. To disable rotation around any of them, just uncheck it. But which axis is which when it comes to bones? Here's how to tell.

The Transformation widget that we used for object manipulation back in Chapter 3 is very useful for working with bone rotations. Enable the Rotation widget in Pose mode with the **Ctrl-spacebar** hotkey, or by clicking the button on the 3D view header. The widget is visible in Figure 9.17, set to

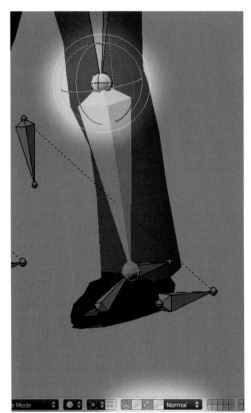

**Figure 9.17** *The Rotation widget in Normal space for bones.*

Rotation. **Normal** is selected for the alternate transformation space. When dealing with bones, using Normal space always aligns with the current pose of the bone, meaning that the rotation manipulator provides a convenient interface for rotating bones during animation. Note that the colors of the Rotation widget match the ones on the miniature 3D axis in the lower left corner of the 3D view. The mini-axis is labeled: red for $x$, green for $y$, and blue for $z$ (RGB = $xyz$).

So, to determine which rotation axes to disable in the Inverse Kinematics panel, enable the Rotation widget and set it to Normal. You can see in Figure 9.17 that the red orbit on the widget aligns with the type of rotation we want to allow for the knee, and red = $x$. We want to allow rotation around the $x$ axis, but not the others. Disable $y$ and $z$ in the panel and try moving the heel bone. This time, the motion of the leg bones is closer to real life, with the knee only capable of bending along a single axis.

In addition to being able to toggle Rotation on and off completely, you can also restrict it within a certain range. Figure 9.18 shows the collarbone, with restrictions set on both its $x$ and $z$ axes. The $y$ axis has been completely disabled. Notice the restriction values in the Inverse Kinematics panel, and the corresponding image in the 3D view. Restrictions are visualized on selected bones by showing the range around which the bone can rotate. With the collarbone set in this way, it will not move outside of this area when driven by Inverse Kinematics. Of course, if the collarbone isn't part of an IK chain, these restrictions mean

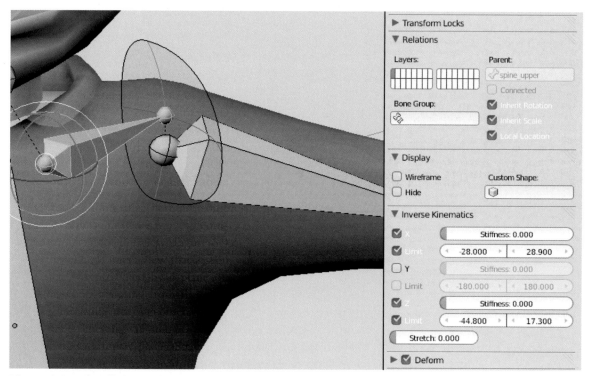

**Figure 9.18** *The collarbone with IK rotation restrictions.*

nothing—you can directly manipulate the bone and move it however you like with the standard controls.

Whenever you use IK in your rigs, be sure to pay careful attention to the actual range of motion of the joints in question. You can save yourself a lot of grief later on by accurately transcribing the real-world limits on joint rotation into IK restrictions.

Unlike work that is accomplished in Edit mode, the constraint work you've been doing in Pose mode is not mirrored and duplicated for you with the X-Axis Mirror option. You're going to have to add and configure the IK constraint and restrictions for the other leg by hand.

## Finishing the Foot Rig

We've introduced a new wrinkle while creating the reverse foot: bones that should never deform the mesh. Up until now, all of the bones we've created will be used to directly change the shape of the mesh when they move. With the reverse foot though, we've added three bones per side—pole target, heel, and ankle— that are only there for purposes of rigging or control. They should never directly affect the mesh. They just help to drive other bones that affect the mesh.

On the **Bone** properties is a simple toggle for **Deform**, shown in Figure 9.19. It should be disabled for these types of bones. Since you've already added and used these bones, you can use a shortcut to toggle this property on all of them at once. First, select them all in Pose mode, then press **Shift-W** in the 3D view. This brings up the "toggle properties" menu. Select **Deform** from the pop-up, and Deform will be turned off for all selected bones.

**Figure 9.19** *The Deform option.*

### More High-Level Control

The addition of IK legs and feet to the rig has caused a neat and useful thing to happen. In Pose mode, grab the main control bone that protrudes backward from the base of the spine. Translate it. Recall that the upper legs, spine, and pelvis are all children of this bone. Before using IK on the legs, the lower leg bones took their commands from the upper leg bones. Since IK reverses the causal relationship, this is no longer the case. Now, moving the control bone, which in turn moves the upper legs, has no effect on the heads of the lower leg bones. They stay glued to the feet. So, this control bone has become a control bone only for the upper half of the body.

This is cool, and is your primary method for having your character do things like sit, squat, and even walk. It is now the center of your character's gravity.

But what if you still want to move the entire rig at once in Pose mode? Add another bone in Edit mode. This overall bone is usually called the "base" or "root" bone, and is often located at floor level. Figure 9.20 shows the character's armature with just such a bone in place. To make it an effective base bone, select both the previous central control bone and each of the heel bones, and make them the disconnected children of this new bone. Jump into Pose mode to move it, to make sure that all the bones in the rig come along with it.

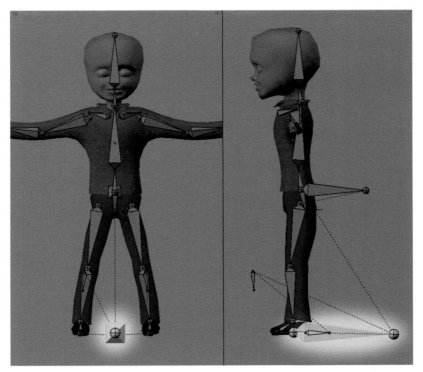

**Figure 9.20** *A root bone.*

---

**Note**

You've no doubt seen in this section the frequent movement between Edit and Pose modes. This is quite typical when rigging, although less so when animating. If the Ctrl-Tab hotkey for Pose mode isn't burned into your brain already, make it happen.

---

## Hands

Hands are complex. Any decent hand rig is going to be a bit nasty behind the scenes. The hand rig we're going to do is based on a "scaling curl" control, which is shown in Figure 9.21. In this mini-rig, the arcs of smaller bones are used to deform the mesh but are hidden during animation. The long bone below them is the actual control. Scaling it causes the bone arc to curl toward its tip, as shown in the figure. This is accomplished by extruding a small bone from the end of the control, and pointing an IK constraint at it from the last bone in the arc. As the main control bone is scaled or rotated, the end bone follows it, which is followed in turn by the IK-constrained arc.

This mini-rig is used on each of the fingers, and laterally across the hand to simulate the way that a hand can curl between the index and little fingers. Let's create one of the fingers, which can be duplicated and tweaked to fit the others.

Put the 3D cursor in the center of the first knuckle (where the finger joins the hand) of the index finger. Add a bone and place its tail at the second knuckle. Extrude twice and adjust to finish the finger arc, like in Figure 9.22. Notice how the arc of the bones is actually a little more acute than the arc of the finger mesh. We do this on purpose. When you straighten your hand and fingers fully, the fingers actually curve a little bit past a flat plane. An IK chain can only be stretched until it straightens perfectly, meaning that it would be difficult to use IK on a system that needs to flex past straight. If the finger mesh's arc is less pronounced than the bone chain, though, the resulting deformation at the flat full IK extension will actually be a little backwards on the mesh.

With the 3D cursor in the same place, use the Add command to create a new bone there. Select the end point of the finger arc and use Shift-S to snap the cursor there. Select the tail of the new bone and snap it to the cursor. With that end still selected, extrude the small bone that will be our IK target. In Pose mode, select this new end bone, then Shift select the last bone in the finger arc. Add an IK constraint to the finger arc by pressing Shift-I. Remember to set Chain Length to 3 (the number of bones in the finger) in the Bone Constraint properties so the IK doesn't affect the entire body. Now, scaling and rotating the large bone in Pose mode causes the finger to curl.

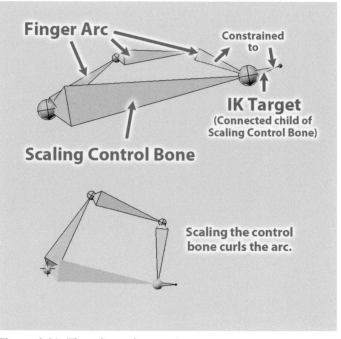

Figure 9.21 *The scaling curl construction.*

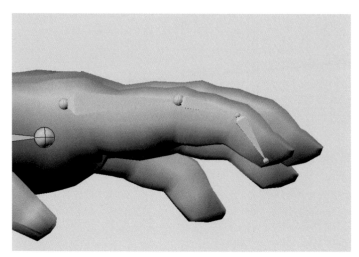

Figure 9.22 *The finger arc.*

Before we get too happy and start duplicating the finger, there is some housekeeping to do. Name all of the bones descriptively. Disable **Deform** for the control bone and its IK target end. On the **Inverse Kinematics** panel for each of the finger arc bones, disable all but one of the axes. Finger joints only bend

one way. Use the same tech-
nique described for knees
(Rotation Manipulator +
Normal) to determine which
axis should remain free. It'll
probably be *x*, but your
mileage may vary.

With that out of the way, feel
free to go back into Edit
mode and duplicate the finger
three times, making sure to
adjust it to fit the mesh.

The thumb is a special case,
and benefits from a slightly
different technique. It's the
same arc, but note in Figure
9.23 where the first bone
begins. Take a look at your
own thumb and how it actu-

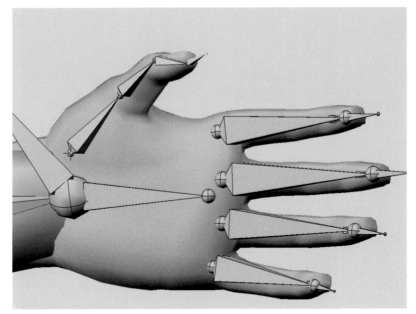

**Figure 9.23** *The thumb, with IK target bone.*

ally moves. It pulls a decent amount of the hand along with it. Add a new bone onto the end of the thumb
arc, but make sure that it is not a child of any other bone. If you extruded it from the tail of the last thumb
bone, you'll need to use Alt-P to disconnect it. In Pose mode, IK constrain the end of the thumb to this
bone. Disable Deform for the IK target, and lock the rotation axes in the Inverse Kinematics panel so the
joints only bend along the proper axis. If you move the IK target bone, it pulls the whole thumb along with
it, including the larger base bone. This is fine, but the overall motion is a little too much.

Select the base of the thumb and on the Inverse Kinematics panel of the Bone properties, raise the **Stiffness**
values for all three axes to around 0.85. Disable the *y* axis entirely, as these bones never roll. Now when you
operate the IK target the whole chain moves, but the base bone that has had its stiffness raised doesn't follow
along quite as well. Its motion has been damped, and this produces something very close to a good result.

So far, we have fingers and a working thumb. Take a look at your own hand again. Bring all of your fingertips
together and note how this forces your hand to curl, primarily due to the little fingertip touching the end of
the thumb. To create a control for this type of structure, the same scaling curl construct can be used, as in
Figure 9.24. The hand arc begins at the first knuckle of the index finger and bridges the gaps between the
same knuckles of the other fingers. You can use the "Cursor to Selected/Selected to Cursor" dance to make
sure all of the bones line up correctly. Run the main control bone from the first to the little finger, extruding
the IK target bone at the end. IK constrain the last hand arc bone to the IK target and set the IK Chain Length.

Finally, we link it all together with parenting in Edit mode. Select the base and large control bone of each
finger, and make them the disconnected child of the hand curl arc bone the tail of which they rest on.

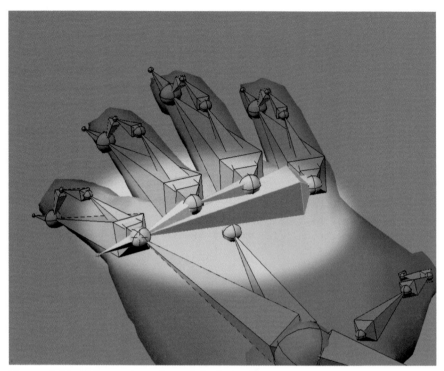

**Figure 9.24** *Adding another scaling curl for the hand.*

This means that the bones of the little finger follow the end of the hand arc, on up the line. Figure 9.24 shows which bones go with which ones in the hard arc. The index finger and its base simply become disconnected children of the main hand bone. Also, the base and control of the hand arc, the base of the thumb, and its IK controller all become disconnected children of the main hand bone. This way, when you move the hand bone itself in Pose mode, the entire hand and finger structure follows along as it should. This part of the armature and how we built it gives you a good idea of the complexity that can be involved when rigging. If you really liked building this hand, then congratulations. You might have what it takes to be a good rigger. If not, don't feel bad. There are lots of great pre-built rigs available, and there is absolutely no shame in using them.

## Toggle IK and Other Constraints

The arms of the character are currently only rigged for forward kinematics, for the reasons we've already discussed. Many times though, you might want to anchor a hand temporarily, whether it be placing it on a tabletop or having your character lean against a wall. The hand becomes locked in place, with the arm getting its motion from the anchor point instead of the shoulder. In those cases, you'll want to use IK. This is perhaps the trickiest thing we'll set up in this very basic rigging tutorial, but you should be able to handle it by now.

What we're going to do is create a second set of arm bones that operate with an IK controller. Then, we will add constraints that cause the original arm bones to follow these IK arms' transformations exactly. Finally, we'll turn off the influence of these transformation constraints so that the arms are free to move with forward kinematics again. A controller will be created that toggles the influence of the constraints, letting you switch between FK and IK as needed during the animation process.

The first step is to duplicate the arm bones. You already know how to do that: Select them in Edit mode and press Shift-D, then Enter. Pressing the Enter key after the duplication ensures that the bones are in the exact spot as the originals. If you try to use the LMB to accept the duplicates, it can be easy to accidentally move them. Note that you should only duplicate the upper and lower arm bones. Don't include anything from the hand or shoulder.

With these two new bones still selected, use the M key to send them to another layer. Bones within an armature have their own layering system, just like objects do with scenes. Rigs can become complicated, and you don't always want to see every bone. In fact, you'll usually want to organize your rigs so that only control bones are visible. So far, every bone we've worked with has appeared on bone layer 1. It doesn't really matter to which layer you send these two bones, as long as you decide on a consistent scheme. I would suggest:

- Layer 1: Main control bones
- Layer 2: Facial controls (see Chapter 10)
- Layer 3: Hand and other "detail" controls
- Layer 4: Deform bones
- Layer 5: Other helper bones

Anyway, those bones are gone for now. In the scheme we've just laid out, let's say they're sent to bone layer 5. Select the tail of the original lower arm bone (the wrist joint), and snap the 3D cursor to it with the **Snap Cursor to Selected** operation (Shift-S). Use Shift-A to add a new bone. Name it something like "arm_control_ik." This will be the bone that we use when we want to animate the arm using Inverse Kinematics. With this new bone selected, use the M key again, and this time hold down Shift key and click bone layer 5. Both bone layers 1 and 5 should be selected (that's what holding down the Shift key did), meaning that this controller bone will appear on both layers.

Figure 9.25 shows both the Armature and Bone contexts at this point. Notice that the panels displaying the bone layer buttons are similar. It is sometimes easy to get confused as to which panel you are working with. Remember that the layer controls in the Bone context affect the layers on which the selected bone resides, while the ones in the Armature context control which bone layers are currently shown in the 3D view. Up until now, we've only been displaying bones on layer 1. LMB click bone layer 5 (or wherever you sent those other bones) in the armature property layer controls.

**Figure 9.25** *The different sets of layer controls for armatures.*

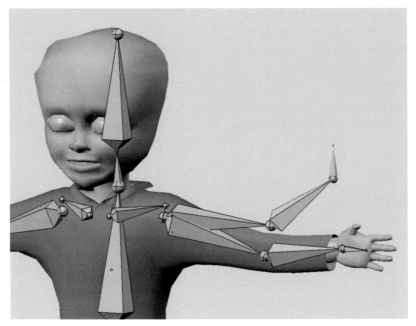

**Figure 9.26** *The secondary arm, IK constrained, with the primary FK arm in place.*

This should make all of the bones in the armature disappear except the two new arm bones and the arm's IK controller. Change to Pose mode, select the IK controller followed by the lower arm bone, and use Shift-I to add an IK constraint. Immediately set the **Chain Length** property of the lower arm's IK constraint to 2 in the Bone Constraint properties. This constrains the lower arm bone to follow the IK controller. Moving the controller causes the arm to move, just like the legs. While you're showing only this bone layer, name the new arm bones. I would suggest "arm_upper_ik_L" and "arm_lower_ik_L."

Staying in Pose mode, Shift select bone layer 1 in the Armature context so that both bone layers 1 and 5 are shown. Grab the IK controller for the arm and move it a bit. If you don't, the bones of both sets of arms will overlap exactly and it will be hard to tell what is what. Figure 9.26 shows this structure. What we're going to do now is apply constraints to each bone of the primary (FK) arm: **Copy Location** and **Copy Rotation**. The lower arm is always attached to the upper, so we only need a Copy Rotation constraint on it.

To do this, RMB select the secondary (IK) lower arm, then Shift-RMB select the primary lower arm. Add a Copy Rotation constraint by pressing Shift-Ctrl-C (or doing it by hand in the Bone Constraints context) and choosing **Copy Rotation**. The bone will probably change its orientation. Over in the Bone Constraint context, examine the new Copy Rotation constraint, shown in Figure 9.27. It holds a lot of imposing options, but the constraint's main function is to make one bone orient itself exactly like its target bone. The control that we're concerned with is called **Influence**, at the bottom of the panel. Reduce it from 1.0 (the default) to 0.0. Notice when you do that the bone in the 3D view reverts to its original

orientation. The Influence control does exactly what you would expect—it determines how much influence the constraint actually has on the bone.

Now, select the secondary arm's upper bone and Shift-RMB select the primary upper bone. Use Shift-Ctrl-C twice to add both a Copy Location and Copy Rotation constraint. The order doesn't matter. Over in the Bone Constraints context, reduce the Influence of each of these constraints to 0.0. LMB select bone layer 1 in the Armature context, so that only it is shown. With the two bones of the secondary IK arm hidden, all you are left with is the original arm and an IK arm controller. When the Influence of each Copy Location and Copy Rotation constraint is at 0.0, the arm moves and is animated in FK mode. However, if you need to switch an arm to IK for a moment, changing the Influence controls on the constraints causes the arm bones to match their positions and orientations to the hidden IK arm bones.

Of course, animating all three influence sliders is a pain. There is an easier way. Well, it's not easier to set up. In fact, it's actually a bit intimidating. But once it's done, your job as an animator becomes much easier. Any control in Blender (like influence, color, transformation) can be tied to another control through a system called **Drivers**. A single Driver, which can be a bone, an object, a UI element, or whatever, can influence a host of other controls.

**Figure 9.27** *The Copy Rotation and Copy Location constraints.*

## Drivers

Drivers can become extremely complex. We're only going to take the barest peak under the hood, but what you'll see might fascinate you.

The first thing we'll do is add a custom property to our armature, which will become the switch that controls whether the arm is IK or FK. At the bottom of the Object context is an innocuous panel called **Properties**. Expand it and click the **Add** button. Figure 9.28 shows the result. Clicking the **Edit** button reveals a pop-up panel for editing the property's parameters. Change the name to something like "IK Switch Left Arm." The minimum and maximum can remain at 0.0 and 1.0, which simply means that the control can have a value anywhere between the

**Figure 9.28** *Creating a custom property that will drive our constraint influences.*

269

two. At this point, it doesn't matter what the property value itself is, so just leave it at 1.0.

Select one of the primary arm bones in Pose mode so that its Copy Rotation or Copy Location constraints show in a Bone Constraint context. RMB over the Influence slider and choose **Create Driver** from the menu that pops up. Most of the options in this pop-up menu (shown in Figure 9.29) deal with keyframing, which we'll address in Chapter 11. When you create a driver for a control or property, it turns purple. Any changes you make directly to that control's value while an active driver is attached will be ignored.

Now we're going to venture into the Graph Editor. There's a lot here, so don't freak out. We're pretty far into the guts of rigging now, and it's not the time to faint. Most of the stuff in the Graph Editor can be happily ignored for the time being. This is a targeted mission: Get in. Tweak a setting or two. Get out.

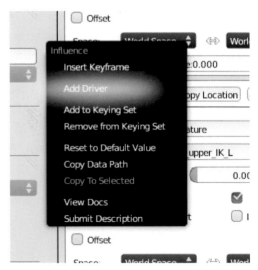

**Figure 9.29** *Adding a driver to the constraint's Influence control.*

Temporarily switch your 3D view to show a Graph Editor instead. You could create a whole new screen for working with Drivers if you'll be doing a lot of it, but for our purposes, reusing our existing screen is fine. On the Graph Editor header, change the visualization from **F-curve Editor** to **Drivers.** When you do, you'll see something like the mini-nightmare in Figure 9.30. Press the N key to bring up the Graph Editor properties on the right. In the upper left of the window you'll see your armature listed, with the driver you just created underneath it. LMB click on the driver name, which will be called something like "Influence (arm_lower: Copy Location)," to make sure it is activated.

What we're really concerned with here is the **Drivers** panel on the right. Change the **Type** control to **Averaged Value**. The type control tells the driver how to deal with incoming information, which is called **targets**. You can actually have a driver that is influenced by several targets at once, using the Averaged or Sum types. You could also just enter certain mathematical expressions with the Scripted Expression type. However, we're just going to point the driver at the object property we created a few minutes ago, so either Averaged or Sum will work fine.

Below the Averaged value selector, LMB click the **Add Variable** button. This is where we define the actual target. Figure 9.31 shows the new panel that is created. In the **Value** field, select the armature object from the pop-up menu. When you do, a weird field called **Path** appears with what looks like a strand of DNA in it. This is where the magic happens. Make sure that you have the Object properties context showing, along with the custom property we already created, the one called "IK Switch Left Arm". Hover the mouse over the property value itself, click with the RMB, and choose **Copy Data Path** from the pop-up menu. You've just copied to the clipboard Blender's internal reference for that particular property. LMB in the **Path** field over in the Driver panel in the Graph Editor and press **Ctrl-V** to paste that data path. Press **Enter** to confirm it.

**Figure 9.30** *The Graph Editor, set to Drivers mode and showing the N-key properties.*

Your driver is built. Change the Graph Editor back to a 3D view. Don't try it just yet—we need to create drivers on the two other constraints. Not to worry though. RMB on the Influence slider on the constraint that already has the completed driver and choose **Copy Driver**. Now, RMB over the two other Influence sliders and choose **Paste Driver**. You should now have two constraints on the upper arm and one on the lower arm, the Influences of which are driven by the Object property.

To test it, grab the IK arm controller and move it away from the arm. In the Object context, slide the value of the created property between 0.0 and 1.0. The arm should slide between its FK position and the IK position that meets the controller. When it's time to animate, we can animate the value of this Object-level property just like it's any other controller, or even give it its own driver for complex, cascading controls.

Of course, you're going to have to go back and repeat these instructions for the other arm. Isn't rigging a blast? Before moving on to skinning, give your rig the once-over. Make sure that everything moves in Pose mode as you expect. Break the bones out into layers, perhaps using something like the scheme men-

tioned earlier in the chapter. The goal is that when you begin to animate, you only see bones that you directly manipulate.

## Skinning

The process of binding your mesh objects to your control armature is called **skinning**. Before you bind them, though, there is an armature and object preflight you should perform:

- Make sure that your mesh objects and armature are unrotated and unscaled. If necessary, apply any scaling and rotation with the Apply Transformation operation (Ctrl-A).
- In Edit mode in the armature, make sure that bone roll has been controlled. In most cases, this is accomplished by selecting all bones and using the **Recalculate Roll: Axis Up** operation (Ctrl-N). You may have to readjust certain things like the IK pole target after performing this step.

**Figure 9.31** *Setting a data target for a driver.*

- Review each bone by selecting it in Pose or Edit mode to make sure that the Deform option in the Bone panel is set correctly. Only structural bones should be set to Deform.
- If your meshes use array, mirror, or other geometry-generating modifiers, you should consider applying them. While many of the skinning operations will work with these modifiers in place, fine-tuning the deformation can be difficult or impossible. If you're worried about applying these modifiers, make duplicates of your objects and place them on an unused layer in case you need them later.

**Figure 9.32** *The armature parenting menu, and the Armature modifier.*

When you have these conditions satisfied, it's time to do your initial binding. Select one of your mesh objects, then Shift-select the armature. Press **Ctrl-P** to parent. A new set of options appears! Figure 9.32 shows the pop-up menu. Choose **Armature Deform: With Automatic Weights**. This operation does a number of things. First, it adds an Armature modifier to your mesh object, also shown in Figure 9.32. Along with the default settings, enable **Quaternion**, which gives cleaner deformations. Second, it creates a number of vertex groups within the mesh, one for each of the deforming bones. Third, it estimates the relative influences of each of the bones on the mesh, storing those values in the vertex groups.

Repeat this parenting process with each of the objects that make up your character. In the case of the sample character, this means one object for the main body form, one for legs/pants/shoes, one for each hand, and one for the head. What do you do now? Grab a bone in Pose mode and see what happens. The automatic weighting isn't horrible, but a number of problems can occur. Let's look at several cases and learn how to fix them.

## Too Much Influence

Figure 9.33 shows the arm in rest position, raised, and lowered. In the raised position, it clearly pulls too much of the ribs and side along with it. In the lowered position, it pushes the same geometry into the body. This is one of the easiest problems to fix, and a good demonstration of the Weight Painting workflow.

Raise the arm so the bad deformation in the ribs is obvious. Then, Shift-RMB select the mesh and press Ctrl-Tab. This puts you into Weight Painting mode on the mesh, but leaves the upper arm bone highlighted in Pose mode. In this special mode (weight paint + active armature) the transformation controls affect the selected bone, not the mesh. Use the T key to bring up the tool shelf, which includes the Weight Painting controls. You can refer back to Chapter 7 on surfacing for a refresher on the brush

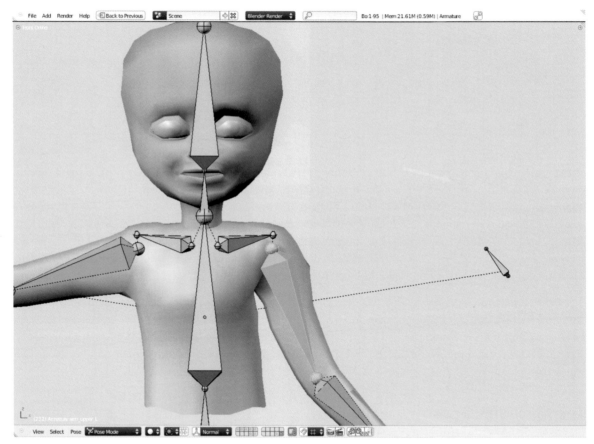

**Figure 9.33** *Bad deformation with the upper arm bone.*

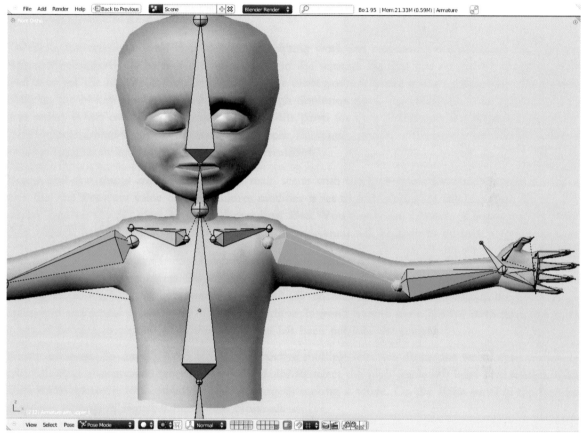

**Figure 9.33, cont'd**

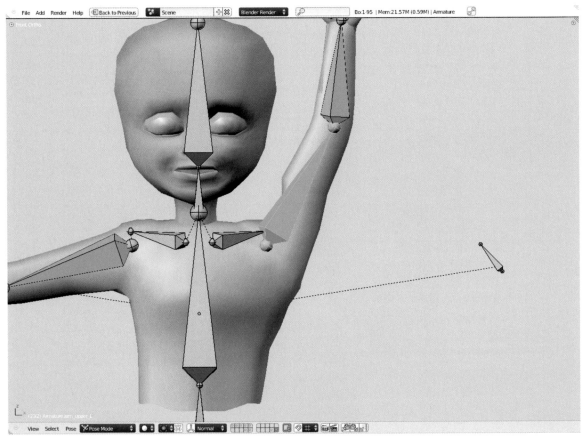

**Figure 9.33, cont'd**

controls. Set the **Weight** property to 0.0 and use the LMB to paint the 0.0 weight onto the mesh. Paint onto the areas that are deforming too much. As you paint, the mesh will redeform in real time, allowing you to check your work.

The one important difference to the brush controls for weight painting is the **Auto Normalize** option. It is possible to have several bones with 100% influence over the same part of your mesh. While this can work if you're expecting it, it can lead to surprising results. Enabling Auto Normalize, which I recommend, will automatically reduce other bones' influence on a mesh when you paint influence for the selected bone.

> **Note**
> Take a look at the bottom of the tool shelf for the X-Axis Mirror option. It works with weight paints too! You might have to do some tweaking after the fact, but for the most part, enabling this option will allow the custom work you do on one side of your rig to automatically be ported to the other. Of course, if you're character isn't symmetrical, you shouldn't be using this. But you already knew that, didn't you?

Figure 9.34 shows the result of painting away some of the influence so that the ribs don't bulge out when the arm is lifted. Don't worry if you paint too much influence away, or if you accidentally paint onto the arm and things go crazy. You can either Ctrl-Z to undo or adjust the weight property up to 1.0 and paint it back in. To test the deformation, use the R key and rotate the upper arm bone. One other item to note in the figure: The bones are now represented by sticks. The **Display** panel of the Armature properties allows you to change the visualization of the bones. Thus far, we've been using the bones in **Octahedral**, which is perfect during rig creation when the orientation of bones can be crucial. When working with weight painting and animating though, it's best to see as much of the mesh as possible. Choosing **Stick** mode cuts bone display to the absolute minimum.

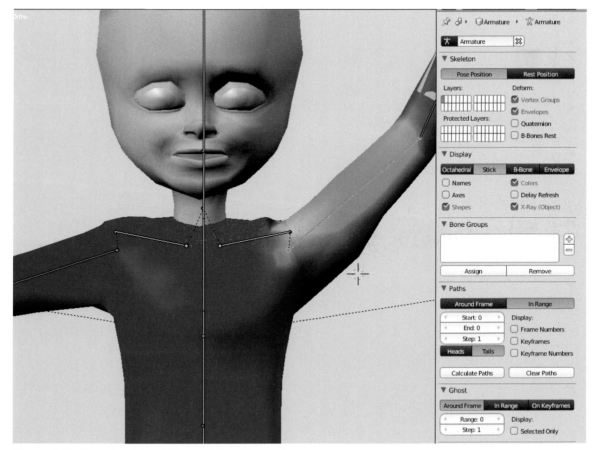

**Figure 9.34** *Removing deform influence with weight painting.*

## Spikes, or No Influence

Proceed through your whole armature, testing the motion of each bone to look for deformation problems. When you find them, figure out which bone is causing the problem, select it, and adjust its influence on the mesh with Weight Painting mode. Every so often during the process, grab one of the master control bones and move it around. During the original binding and throughout the skinning process, it's possible to end up with portions of your mesh that aren't influenced by any bones at all. These will show up as "spikes" in the mesh when you move the overall control bones, or as overall areas that remain in place when their bones are moved. Figure 9.35 shows what happens to the character's head when the whole rig is moved.

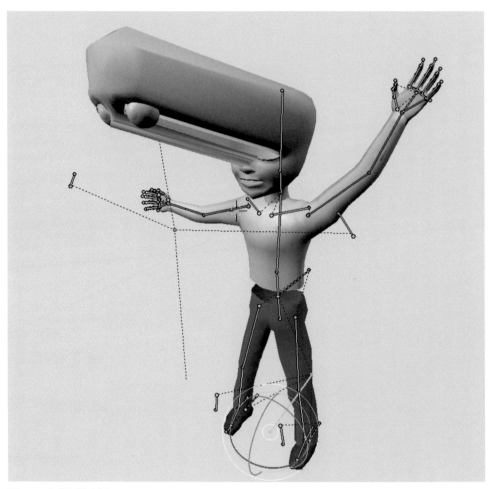

**Figure 9.35** *Shriek!*

Fixing this problem is also easy. Leave the figure in the badly deformed state, with the control bone away from rest position and the "left behind" mesh showing. Follow any spikes or bad mesh back to its origin, so you can determine to which bone (or bones) they should be bound. Then, RMB select that bone and hit the points of the spikes with the Weight Painting brush set to 1.0. They should pop into their proper place. In the case of Figure 9.35, it's obvious: The top front of the face should follow the head bone. Figure 9.36 shows the problem mostly fixed, having selected the head bone and painted with a **Weight** of 1.0 on the badly deformed portion of the head. All that remains to do is to hit the last few "spikes" to force them into place.

After the problem is fixed, I kept painting the head with a full-strength brush until it was red inside and out. With **Auto Normalize** enabled, this forces the head to follow the head bone and only the head bone.

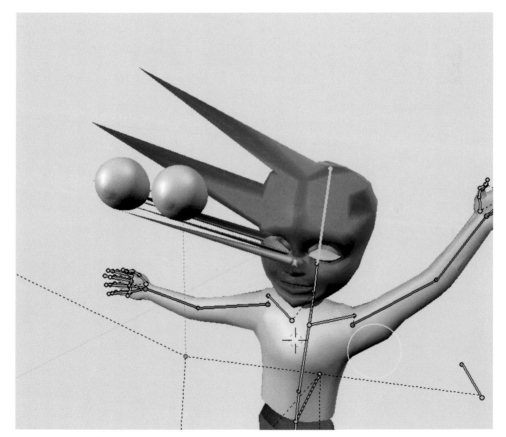

**Figure 9.36** *Whew.*

## A Hard Break

Another problem that occurs is the hard break. Figure 9.37 shows the character bending to the side. Notice the sharp line that occurs on the inside of the bend, near the waist. It would be better if the mesh kind of compressed here, as opposed to the top half entirely following the upper spine bone and lower half staying completely put. When working on this situation, it is best to return the bones to their rest positions. While it's easy to paint on an expanded surface, painting on a pinched surface is a lot tougher. The best way to paint a graded weighting is to set the **Weight** control to full power (either 1.0 or 0.0, depending on whether you want to add or subtract weight), but to drop the brush strength way down to around 0.1.

**Figure 9.37** *The transition at the midriff is too abrupt.*

This allows you to build up the weighting with multiple strokes, giving you a more natural result. Figure 9.38 shows a before and after for the weight of the mesh around the midriff for the upper spine bone.

**Figure 9.38** *Midriff weight before and after painting.*

## Helping Deformation with Extra Bones

Some situations present special challenges. For example, the areas on the inside of both the elbow and knee bends are difficult to deal with. You might find that no matter how much time you spend weight painting, the deformations on a tightly pinching spot are just ugly. A bone with a **Stretch To** constraint can help.

Figure 9.39 shows the difference in deformation with nothing but weight paint, and an additional deforming stretch bone. Adding a bone like this to your structure only requires a few steps, and can really help ease the pain.

The goal of using an additional bone is to bridge the gap between the two contracting bones, giving the mesh a little more information to work with as it deforms. You'll have to get out of Weight Painting mode on the mesh itself first (use the mode menu on the 3D header or Ctrl-Tab), then select the armature and find your way into Edit mode. Use the LMB to position the 3D cursor on the upper arm bone, a little way up from the elbow. Make sure to set the 3D cursor

**Figure 9.39** *A stretched bone helping with the inside elbow deformation.*

in both a front and side view so the new bone will appear in the right place. Use Ctrl-A to add a new bone.

Grab the tail of the bone, and pull it so that the bone approximates the span that you see in Figure 9.39. Make this new bone the disconnected child of the upper arm bone, so that its head always moves along with the upper arm. Mark the spot where the helper bone meets the lower arm bone with the 3D cursor.

Return to Pose mode. RMB select the lower arm bone, then Shift-RMB select the new helper bone. Trigger the **Add Constraint** operation with **Shift-Ctrl-C** and choose **Stretch To** under the Tracking column, or add a Stretch To constraint with the Add Constraint button in the Bone Constraints properties context.

**Stretch To** causes the tail of the constrained bone to stretch (grow or shrink, doesn't matter!) to meet the head of the target bone. Of course, we don't want it to meet the head of the target bone; we want it to hit the spot on the target bone that we specified in Edit mode (which we *very cleverly* marked with the 3D cursor so we know where it is). Over on the Stretch To panel in the Bone Constraints context is a control called **Head/Tail**. This specifies the actual target along the length of the bone. The default is 0.0 for the head, and 1.0 for the tail. Adjust this value until the helper bone crosses the lower arm at the location marked by the 3D cursor. Now, hit the **Reset** button located below the Head/Tail control. This resets the bone to its original (Edit mode) length. Rotating the lower arm bone causes the helper bone to shrink and grow as the joint compacts.

Select the mesh again, enter Weight Painting mode, and RMB select the new helper bone. It won't have any weighting assigned to it. Paint in some weighting on the inner side of the elbow and try bending the lower arm. The mesh holds together better with the stretch bone in place.

You can use this technique anywhere that you have a fairly strong pinch in your armature: behind the knees, under the arms, even in the stomach. If you look at the sample character's rig, you'll see a stretch bone that extends from the middle of the upper spine bone to the top of the pelvis. Figure 9.40 shows stomach deformation with and without it. Notice how using this construction gives your character's deformations more volume. Another place this technique is used is in the hands. A stretch bone is added that runs from the base of the wrist to the first knuckles of the little finger. It follows the scaling curl of the hand, giving a better deformation in extreme hand poses.

**Figure 9.40** *The stomach with and without a stretch bone.*

## Conclusion

So that's an introduction to the basics of rigging and skinning. It's probably the most technically difficult thing you'll have to do when working in 3D. If you don't get it, try again, but don't beat yourself up about it. It's not for everyone. Chapter 11 on character animation includes the character file with the exact rig described in this chapter.

Blender also includes a fairly automated rigging solution at the moment. It is found in the **Add** menu under the **Armature** heading. The **Human** and **Quadruped** rigs are armature systems that have been designed with complex, high-level controls. Their setup and use is shown in the video *automatic_rigging .mpeg* in the Web Bucket.

## What We Missed

Rigging is a huge topic, and it should be no surprise to you that we've only flirted with it here. The amount of advanced material you can learn with rigging and skinning, just in Blender alone, is staggering. On the rigging side, topics you might want to look up are "spline IK," which let's you use a Bezier curve to guide curving spinelike chains of bone; "py Constraints," which use Python scripts to generate new constraint effects on-the-fly; and of course the long list of normal constraint types that we didn't even touch. With skinning, take a look at the Mesh Deformer, which uses a simple mesh cage for smooth deformations of complex geometry, as well as Curve and Lattice deformation.

## Next Up ...

In Chapter 10, we give our character some facial expressions using the Shape Keys system, and learn how to add their controls to our rig.

# Chapter 10

## Shapes and Morphing

Before we begin animating the character using the rig in Chapter 9, there is one more bit of work that needs to be done. The armature and bone system is perfect for making deformations that in real life would be driven by a skeleton or other kind of rigid structure. While the human face is partially driven by this method (the jaw), for the most part its great expressiveness is created by muscles that are attached to the skull, pulling and bunching the skin of the face. You could set up a bone structure to try to do this (it's been done!), but there is a more intuitive method for achieving this kind of animation.

Our goal as animators is to achieve specific shapes and configurations of the face (expressions, like a smile), and the easiest way to do this is to simply edit our model to have the correct look. Blender's system for saving different shapes within the same model is called **Shape Keys**. Other 3D packages call this *morph targets*, *blend shapes*, or some combination of those terms.

In our example file, we will use Shape Keys exclusively to create facial expressions, but the system is by no means limited to that functionality. The ability to have your meshes change their shape over the course of an animation in such a detailed and finely controllable way can be useful for fixing stubborn deformation issues with armatures, changing one object into another, and enhancing character animation. The point is to keep Shape Keys in mind when you are approaching animation problems. It might hold the solution.

## Creating a Shape Key

Figure 10.1 shows the example character (in pretty GLSL textured viewport mode) and the Mesh properties. The Vertex Groups panel contains all of the groups automatically created during the rigging and skinning process. The UV Texture panel contains the three UV projections we used to projection paint the face's textures. Between those is the **Shape Keys** panel. Note that there are a number of shape keys already created. Figure 10.2 shows several of these keys selected, and their various effects on the mesh.

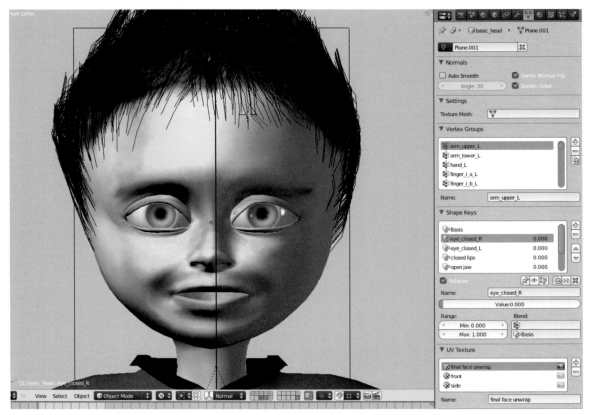

**Figure 10.1** *The Shape Keys panel.*

To create shape keys for a mesh, you begin with the Shape Keys panel completely empty. With the mesh selected in Object mode, LMB click the + symbol to the right of the Shape Keys panel. This adds a shape key called **Basis**, which is the foundational shape of your mesh—its default state. If you edit your mesh while the Basis key is selected in this panel, it will change the basic shape of your object.

The fun begins when you add the second shape key by again pressing the + button. It is called "Key 1" by default, but you can and should change it immediately in the Name field below. Figure 10.3 shows the panel ready to work on a new key. Before we examine the controls and buttons involved, let's just change the mesh to create our first shape key.

With the new key active in the panel—it is selected in the key list and its information appears below it—go into Edit mode on the mesh. Any changes you make to the mesh at this point will *not* affect the Basis shape. It will be stored in this new key. Let's try a smile. In the tool shelf, make sure that **X-Axis Mirror** is selected at the bottom and select one of the vertices near the corner of the mouth. Enable Proportional Falloff Editing (O key) if it isn't already. In a front view, rotate the vertex and move it up a bit, using PEF to pull its nearest neighbors along.

Leave Edit mode. The changes seem to disappear. Fear not. Jump back into Edit mode and you'll find that they are still there. This is the basic workflow for Shape Keys: Although visible in Edit mode when the key is active in the Shape Keys panel, they are not shown in Object mode unless you take specific action. So this solidifies in your head, select the Basis key and Tab into Edit mode. Nothing. Just the basic mesh. Staying in Edit mode, LMB click the second shape key in the panel. The mesh jumps into the new configuration. Now, hop back to Object mode, and let's take a look at the panel controls from Figure 10.3.

There are two ways to get your shape key to show outside of Edit mode: the "pin" icon and the Value slider. The pin icon forces the currently active shape to be displayed regardless of any other settings. It is useful when you want to do other work, perhaps on another object, and just want to quickly make your model hold that shape. The other way to show the shape in Object mode is to adjust the Value slider. Set to 0.0, the shape is not displayed. Set to 1.0, it is displayed exactly how you created it. By moving the slider from 0.0 to 1.0 and back, you can update the mesh in real time. As you might guess, you don't have to use Shape Keys at 100% strength. You might edit a shape key into a very intense, exaggerated smile. Used at 1.0 (100%), it looks just like you made it. However, lesser values could produce less-intense expressions.

You can adjust Value sliders of several keys to combine them into a single

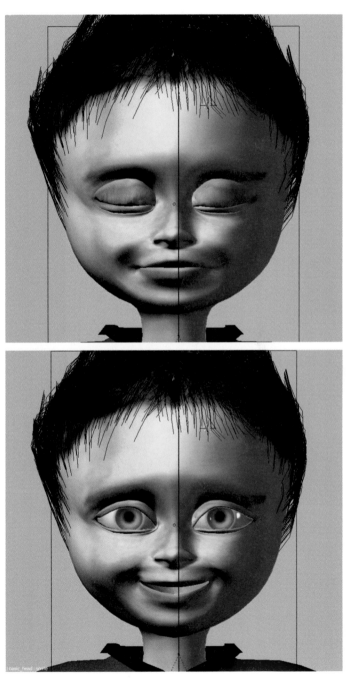

**Figure 10.2** *Several shape keys and their results.*

expression. One way to work is to create, for example, an entire smile that encompasses all areas of the face. However, you could just as well create a smile for the mouth only, which when combined with separate shape keys for bunched cheeks, squinting eyes, and a drawn chin, would produce a full face smile. While obviously more labor intensive, this approach is more flexible, allowing you to create subtle expressions by reducing or increasing the Value sliders of different sections of the face.

Shape Keys can also be applied over a greater range of values than just 0–1.0. The allowable range is controlled by the **Min** and **Max** range sliders. Setting these to −1.0 and 2.0 for the smile shape shown in Figure 10.2 lets you push the shapes past how you modeled them, in both directions. Figure 10.4 shows the smile pushed to 200% (2.0), which is clearly a bit maniacal, and pulled down to −1.0. It's not exactly a frown, but you can see that the Shape Keys system is capable of usefully going beyond the bounds of your original work.

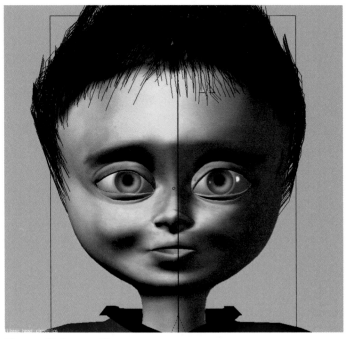

**Figure 10.2, cont'd**

The **Blend** field allows you to specify a masking vertex group. The smile used in the example has more going for it than just a rotation at the corners of the mouth. The entire geometry of the face has been adjusted: checks, chin, eye shape, and brows. We'll get into that in the next section, but for now let's say that you liked your smile shape, but wanted to create an additional shape key for a "dead" smile—one that worked for the mouth only but left the eyes alone.

**Figure 10.3** *The Shape Keys panel, ready to work.*

First, you would create a vertex group for the area around and including the mouth. The easiest way to do this is to click the + button on the Vertex Groups panel, name the new group "mouth," then drop in to Weight Paint mode with Ctrl-Tab. Paint the area around the mouth, then return to Object mode. Down in the **Blend** field for the smile shape key, select the new "mouth" vertex group. The shape key is displayed only for the areas that fall within the vertex group. To make a new key using only this masked

shape, click the + button. A new key is created, reflecting the visual state of the masked smile shape key, but without the use of the vertex group.

This is an important point. Using the + button creates a new key, based on the visual state of the mesh. You can set the Value sliders for several shape keys at once, and their effects accumulate on the object, allowing you to test different combinations. When creating a series of keys for facial expressions, you should always make sure that you create new keys with the + button only when all of the Value sliders for other keys are set to 0.0. Fortunately, there is a shortcut that resets them: the "X" control located on the far right, just above the name field.

The ability to create a new shape from the current appearance also lets you experiment with different combinations of your existing shapes. As you change the Value slider for your different shapes, you might run into a look that you particularly like. Saving it is as simple as adding a new key and naming it.

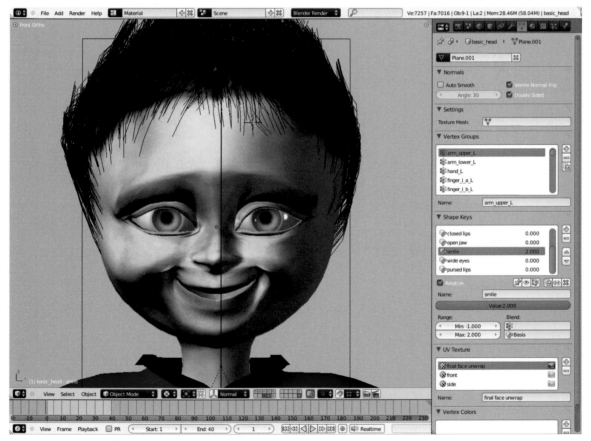

**Figure 10.4** *Too much smile, and a smile turned upside down.*

And so, this is how you create shapes for your character: Adding Shape Keys from the Basis shape and editing them to reflect different facial states. For the example character, I've only created a few: each eye closed, a smile, wide eyes, open jaw, and closed and pursed lips. If your character will be talking and you'll be lip syncing, you'll need shapes that correspond to the different forms your mouth makes during speech.

## Creating Effective Shape Keys

Once you're familiar with the mechanics of adding and setting shape keys, you can turn your attention to the artistic aspects. The best thing to do when creating shapes is to get a small mirror that you can keep by your computer. Let's focus for a moment on the smile shape. It's not enough to simply obtain a reference image of someone smiling and push your mesh to mimic it. What is really important for shape keys is the change in state from the base shape.

Here's how to proceed. Look in the mirror. Make the expression you're trying to create. Don't only note the end state. Try to notice what changes, and in what directions. Most likely, a smile will include the following facial motion:

- An upward turn at the corners of the mouth.
- A stretching and tightening of the skin between the mouth corners and the chin.
- The chin consequently narrows a bit.

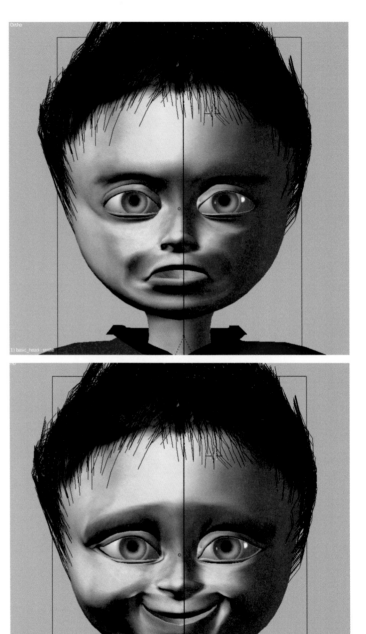

**Figure 10.4, cont'd**

290

- Cheeks are pulled up, bulging out.
- Large crease between mouth area and cheeks becomes sharper.
- Wrinkles under the eyes become more pronounced as the cheeks bunch up into them.
- Laugh lines at the outside edges of the eyes show.
- Eyelids may pull back slightly.
- Nostrils may flare.

As you craft your mesh to show a smile then, you will have to make all of these changes. It might seem like a lot to observe and do, but if you just make the mouth curl and change nothing else, your character will look like a robot. Keeping all of these things in mind, work on your shape. Every now and then, run the Value slider up and down repeatedly and watch the transition in the 3D view.

Another thing to think about when creating shapes for faces is the underlying bone and muscle structure. You can't just randomly start pushing vertices around and think that the result is going to look natural. For example, when pushing the cheeks upward, remember that in real life there would be muscle and bone beneath that skin and the cheeks would slide along it, not just move straight up. As you play with the Value slider, watching the face change in real time, see if it gives you the feeling that the skin is moving *over* an underlying structure and that that structure remains intact. If you get that sense, then you're doing it right. If not … keep working.

You've already seen one of the two methods for altering the shape of a shape key: Edit mode. When working in Edit mode to create effective shapes, PEF is your best friend. Remember to frequently check the state of your work by adjusting the Value slider in Object mode.

A more intuitive way of creating shapes is through the sculpt tools, in particular the Grab brush. In Chapter 8 on sculpting, much is made of the Multiresolution modifier and using the sculpt tools for adding fine detail to existing models. However, you will find that switching to Sculpt mode and using the Grab brush provides a great workflow with shape keys.

The only restriction when sculpting into shapes is that the target shape key must be selected and pinned in the Shape Key panel. If you want to see this in action, the Web Bucket video *sculpting_shape_keys.mpeg* provides a good example.

## Preparing Shapes for Animations

The Value slider for each shape key is animatable just like any other property. You set a frame, set the value, and either press the **I** key while hovering the mouse over the control or RMB clicking on it and choosing **Insert Keyframe**. When trying to key complex facial animation though, the process of selecting a shape key, setting a keyframe, selecting a different shape, etc., is tedious and unintuitive. Therefore, most users use Blender's animation Drivers system to link sets of shape keys together under Custom Properties or to bone controllers.

For full instructions on using Custom Properties, you can refer back to Chapter 8, in the section on building a switch for the arm's IK/FK controls. The short version is: Add a custom property to the armature

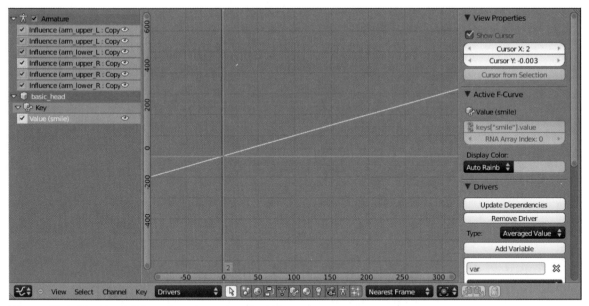

**Figure 10.5** *The Graph Editor, for setting a shape key driver.*

object (use the Object properties panel), and name it appropriately ("smile control"). Select the head, RMB on the Value slider of the shape you're working with, and choose **Add Driver**. Here's where things deviate a bit from the previous instructions. We will be adding the control property to the armature object, even though the shape we're driving is on the head mesh. Figure 10.5 shows the Graph Editor set to display Drivers. Note that it shows not only the mesh smile one we just created, but the other ones we attached to the armature during rigging too. The Mouse Cursor button immediately to the right of the Drivers/F-curve selector on the header toggles this behavior. When enabled, the Graph Editor only displays curves for the selected object. Otherwise, it shows everything as in the figure.

Making sure that the smile value driver channel is selected in the Graph Editor, show the N-key properties panel and click **Add Variable** in the **Drivers** section. Set **Type** to **Averaged Value**. Set the **Value** object below to your armature by clicking the field beside it and using the Object browser. If you remember from Chapter 8, the last step is to copy the data path of the custom property and paste it into the **Path** field. To do this, you first need to select the armature object in the 3D view. With the armature object selected, its Custom Properties are displayed once again, and you can RMB on the smile property and copy its data path. Then, you reselect the mesh, make sure that the smile value driver is selected, and paste the data path into the Variable section.

That might seem like a long way to go just to control one Value slider (the shape key smile value) with another (the custom property smile slider). You are not wrong. However, the first advantage is that when you add custom properties and drivers for each shape key, you get access to all of them in one convenient

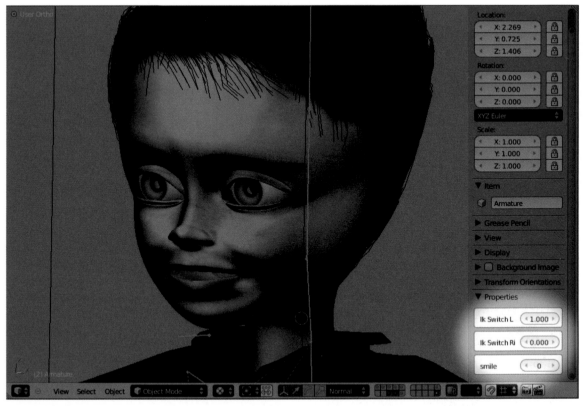

**Figure 10.6** *The 3D view with Custom Properties showing.*

panel. By showing the Custom Properties panel of the armature object, you don't have to click on individual shape keys just to get their Value slider to display. All of the different drivers' properties you create are there for you to play with, shown at once. This suggests another advantage, and explains why we chose to add the custom control properties to the armature object, as opposed to any particular bone or the armature data itself. When you're animating, you will often show only the 3D view and the timeline. This would make it difficult to access the controls without a Properties window showing, which would take up valuable screen space. Figure 10.6 shows the 3D view maximized to fill the screen. The armature is selected in the same way it would be during animation. Note the bottom panel of the N-key properties panel: Custom Properties. With the armature selected, your controls are right there in the N-key panel, ready to be shown or hidden with a single keystroke.

The last big advantage of using drivers and properties for control is the ability to drive several shape keys with a single custom control. In the example file, the left and right eyes each have their own shape key for closing. Adding a Driver/Custom Properties combination to one of them, then using Copy/Paste Driver on the other, allows both eyes to be driven by a single controller.

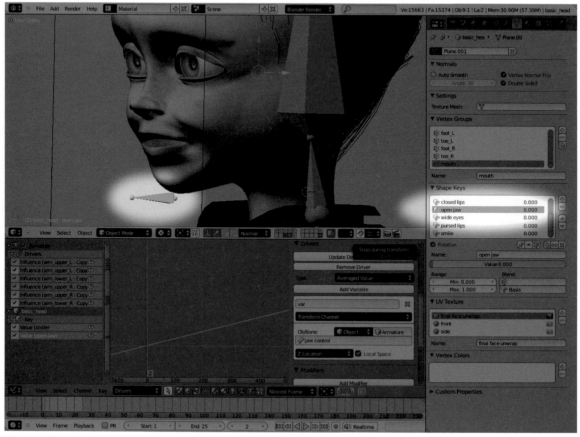

**Figure 10.7** *Ready to add a bone-based driver.*

Even more flexible than using Custom Properties as Driver controls is the use of bones in the armature. For an example, let's add a bone near the character's chin and name it "jaw control." When it is moved down, it will drive the "jaw open" shape key. Moved up, it will drive "lips closed." We'll start with the jaw. As these will be some complex and specific instructions, I'm going to recommend that you follow this part of the chapter with the example file from the Web Bucket, even if you've been creating your own up to this point. You can go back to your own file afterward and apply the skills you've learned.

Figure 10.7 shows the screen with a new bone added at the chin and the "open jaw" shape key selected in the Mesh properties. RMB click on the shape key's Value slider and choose **Add Driver**. The new driver, called "Value (open jaw)," is added to the list of drivers under the head object in the Graph Editor. As we did when binding the previous driver to a custom property, use the **Add Variable** command on the **Drivers** panel of the N-key properties space. Once again, use **Averaged Value** for the mapping type. This time, though, choose **Transform Channel** instead of Single Property, as we will be using the motion of "jaw control" to drive the value. Instead of using the value of a property to control the shape key, we'll be using the transformation of a bone.

A number of things have to happen in the lower portion of this variable section for everything to work. First, you have to select the armature object in the **Ob/Bone** field, then set the correct bone below it. In this case, it is the "jaw control" bone, shown in Figure 10.8. Second, you have to determine which transform channel you will use as the actual driver. This will be determined by exactly how you placed the bone and how you want the control to feel. In the example, the bone faces forward, and we would like the jaw to open and close as the bone moves up and down.

As we did when determining the correct axis to use as a pole target, enable the transform manipulator on the 3D header and set it to **Normal** mode. Select the "jaw control" bone, and its local axis will display. In the example, the blue (*z*) axis is pointing up, so we know that we should choose **Z Location** in the variable panel. Enable **Local Space** beside the channel selector, and we're somewhat ready to go. Thus, moving the bone along its local *z* axis in Pose mode will drive the smile value, changing the shape of the mesh.

If you actually try to move the bone now, you'll find a problem. It would be great if moving the bone down applied the shape key in just such a way that the chin seemed to follow the bone. With a "plain vanilla" driver like we've created though, this isn't the case. By default, drivers map their values on a 1:1 basis. This means that as the bone's Z Location moves from 0 to 1, so does the value of the property it drives, which in this case is the "jaw open" shape key. So, to get the jaw to open to the full extent specified in the shape key (a Value slider of 1.0), we have to move the chin bone 1.0 units along the local *z* axis, placing it way above the character's head.

Although it's a little more work, it's possible to create a custom mapping for the channel and driver values. This mapping is created with the curve in the Graph Editor. Something you may have wondered about when fooling around with creating the driver variables previously was the **Modifiers** panel below it, shown in Figure 10.9. Like Mesh modifiers, F–curve modifiers can either change or completely replace the values found in a standard animation curve.

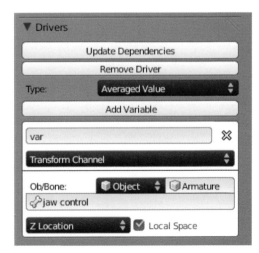

**Figure 10.8** *Setting up the variable.*

**Figure 10.9** *The Modifiers panel of the Drivers view in the Graph Editor.*

In the case of Drivers, a modifier called **Expanded Polynomial** is added by default. We're not going to go into it in detail, but its effect is to replace any curve in the Graph Editor with a perfectly diagonal line that provides the original driver 1:1 relationship. We want to send that relationship packing, so click the "X" to kill the modifier. While we're removing stuff, let's completely isolate the "open jaw" curve in the Graph Editor. On the left panel where the different objects and animation channels are listed, uncheck all of the boxes beside them, with the exception of the "Value (open jaw)" one. You can uncheck all of the armature-related ones with a single click, by removing the check from beside the Armature channel itself. When you're done, only the "Value (open jaw)" channel should be checked. There will be no curve in the editor's workspace, because you already removed the Modifier that was responsible for generating it in the first place.

Ctrl-LMB click twice in the Graph Editor's workspace. This will create a two-point curve, possibly like the one in Figure 10.10.

Now comes the math. When the bone is at 0.0 along its $z$ axis, we want the shape key to also have a 0 value. Unfortunately, there's no way to directly enter $x$ and $y$ axes values for curve points in the Graph

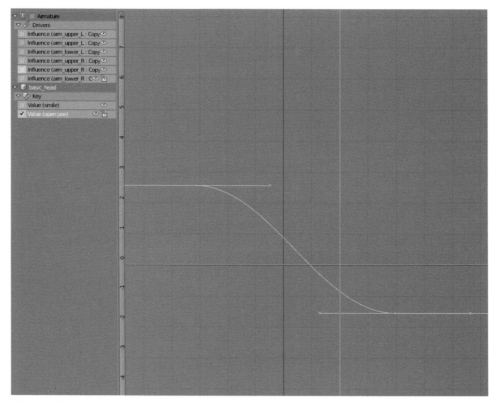

**Figure 10.10** *Any two points will do.*

Editor. To make it happen, you'll have to LMB click at the 0,0 point, setting the green crosshairs there that function as the Graph Editor's 2D version of the 3D cursor. Now, select the first curve point with the RMB, and use the Shift-S to snap the point to both the cursor's value and frame. This is a massively annoying workflow, but you don't have to do it that often.

Here's the math. Well, it's not technically math, its measurement, but using that in conjunction with coordinates seems mathish enough to have warned you. Bring up a 3D view and move the chin control bone downward as far as you think you would prefer to pull it for the control. Note the transform $z$ value on the header as you do it. This will be the $y$ value for the second curve point. The $y$ axis for a driver represents the driven value, in this case the "Value (open jaw)" property. When the bone hits the specified value, we want the $y$ axis to be at 1.0. So, the second curve point should be set at 1.0 $y$ (up) and whatever the noted value from playing with the bone turned out to be for the $x$ (across) axis.

There's one problem with that: The $x$ axis normally represents time, so you can't select a fraction or decimal frame. Whole numbers only. Unfortunately, that means real math. The simplest solution is to just multiply both the $x$ and $y$ values by 100, then set them. So, if the $y$ value was supposed to be 1.0, it's now 100. If the $x$ value is supposed to be −0.034 (which it is in the sample file), it becomes −3 after rounding. Your actual $x,y$ pair for the second point in the curve becomes (−3, 100). That's as rough as it gets. Use the shenanigans with the 2D cursor again to set the second curve point to $x = −3$ and $y = 100$. Now, when you pull the bone down, the jaw moves fairly closely with it.

Once again, why would you possibly want to jump through those kinds of hoops just for something you did much more easily with the Custom Properties controllers? The first reason is that you can attach as many custom-mapped drivers to that bone as you like. You could add a driver for the "lips closed" shape and map it to execute as the bone moves between 0.0 and 0.015. That would mean that moving the bone down opened the jaw, while moving it upward fully closed the mouth. It's a gigantic pain to set up, but from the animator's standpoint it's an intuitive, effective control.

To really finalize such a control, you can lock the bone's transform on the $x$ and $y$ axes by LMB clicking the lock icon in the 3D view N-key properties panel for the bone. Shown in Figure 10.11, this will prevent the bone from moving along anything but the $z$ axis during transform, meaning that when you grab and move it, it will move only the axis that's bound to the drivers.

The other advantage is that you can use bone parenting to achieve additional levels of control that are not capable with Custom Properties sliders. Figure 10.12 shows the character with an "eye closed" control bone placed beside each eye.

**Figure 10.11** *Locking transform.*

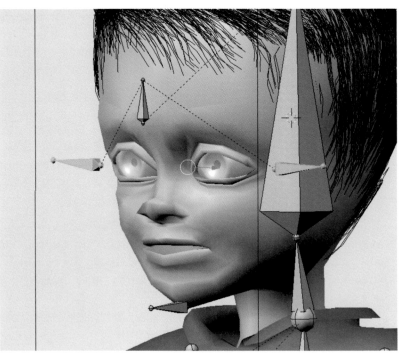

**Figure 10.12** *Two eyelids controllers become the children of the overall eyelid control in front of the brows.*

The controls can be operated one at a time, allowing your character to wink. If an additional bone is added and both of these eye controls are made its children, you get an additional action for free: a blink. Moving the parent control moves both the children along with it, creating a symmetrical blink action. This kind of behavior and structure is simply not available with the custom properties.

Is this tedious, somewhat brain-bending work? Indeed it is. In fact, thinking about all of the different shapes and combinations of shapes you have even on a simple character like this, it might seem like the facial rig is almost as complex as the rig for the entire rest of the body. And you wouldn't be wrong. The face of a character is just as expressive as the body, and it needs appropriate care if you're going to do anything useful with it.

If you don't relish the thought of rigging the rest of your face, you're not alone. It wasn't exactly a party for me either. Fortunately for you, you can start Chapter 11 with a fully rigged sample file.

## Next Up ...

The fun stuff: character animation. We make the kid walk across the room, grab the chair and throw a toy. It's not How to Train Your Dragon, but it's a start.

# Chapter 11

## Character Animation: The Fun Part

## What We Missed

I'm going to put this section at the beginning of the chapter because for more than any other topic we've discussed, what we're *not* doing here is almost as important as what we *are* doing. We won't be doing a walk cycle, which is a repeating walk animation in which the character appears to walk on a treadmill. While it's a great way to learn motion basics and to work on the character of your actor's motion, there are hundreds of walk cycle tutorials on the Internet, and for most animation situations, it won't help you all that much. You *will* be learning how make your characters walk around and do what they need to do, which is much more helpful in general.

We won't be doing an in-depth study of the principles of animation. Entire lifetimes have been devoted to both learning and teaching them, and we certainly can't do them justice in the few pages we have here. We will explain them as we craft a few seconds of animation for our character though, pointing out where they fit into the process.

Finally, we're not going to deal with blending animation from different sources. Blender has a major tool called the Nonlinear Animation Editor that lets you mix and build animation in different passes. It's pretty useless though, unless you have a solid grounding in using the animation tools to begin with. Instead of rushing through just to get to that, we're going to focus on the basic character animation tools to make our character wave, walk across the room, grab the chair, and throw his cube toy onto the table. Believe me—there's plenty to do.

## Pose Mode and the Dope Sheet

Character animation in Blender follows the same method as the object-level animation that you learned way back in Chapter 3. You set the current frame, move things, and create keys to store their transformation at that point in time. However, when animating a character, you are working with a different kind

of structure (the armature) that is composed of a number of smaller pieces, the bones. Each bone receives its own full set of keys and F-curves, for translation, rotation, and scale. The fairly simple character rig that we've created has almost a hundred bones. If you were to keyframe each of these and try to determine what was going on in the F-curve editor, it would look like a bowl of spaghetti. There would be so much information that the visualization of it would be next to useless.

So, when working with character animation and dealing with keyframes from dozens of bones at once, we use the Dope Sheet, shown in Figure 11.1. The Dope Sheet shows all of the keyframes for every object and property in your scene, accumulated on a single screen. The white diamonds in the figure each represent a keyframe for their particular channel.

If you look at the expanded section of the editor shown in Figure 11.2, you'll see that each white key diamond actually stands in for any number of actual keys that are contained by its component parts. In Figure 11.2, the channel for the **Body Control** bone has been expanded to show all of its individual animation channels: X, Y, and Z Location; W, X, Y, and Z Rotation; and X, Y, and Z Scale. The main Body Control channel, which is all that usually shows, displays a keyframe dot anywhere that a key appears in any of its components. You can see this with the yellow keys, as the first stack of four represents a rotation key, with the ones four frames later representing both location and scale keys. The Body Control channel itself has yellow keys on both frames. Note also that the overall armature channel shows the same style of key accumulation for all of the bones in the armature.

So, each channel in the Dope Sheet is really showing a summary of the keys of all of its component parts down to the F-curve level. And even those, say, Body Control's **X Location** channel, are a summary of the F-curve itself, showing only the locations of the keyframes in time and not the interpolation curve between them.

Those yellow keyframes are **selected**. Like all selected objects in Blender, they are eligible for transformation, duplication, and deletion. This is how the Dope Sheet editor helps you as you work

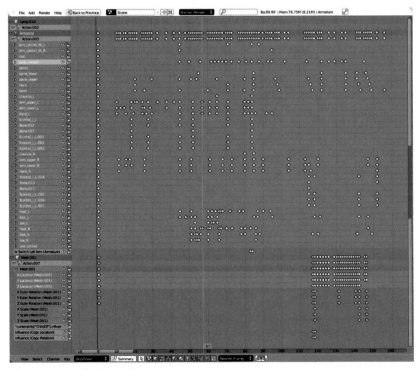

**Figure 11.1** *The Dope Sheet.*

**Figure 11.2** *The Body Control bone's animation channel expanded.*

with an armature to create animation. You set your character's poses in the 3D view and keyframe them. You change the current frame, create a new pose, and keyframe it. Then, you can begin working in the Dope Sheet, adjusting timing by selecting and moving keyframe markers, duplicating and moving others to create holds, and even deleting entire sections of keys when your mad animation skills have failed to live up to your expectations.

Keys can be selected in the Dope Sheet in several of the normal methods you've come to expect: the RMB, the A key for deselect/select all, and the B key for border selection.

With a little bit of familiarity with the Dope Sheet, our main tool for working with the character animation, let's set it aside and start fooling around with our character in the 3D view.

First, you might want to switch to the preconfigured Animation screen that ships with Blender. Shown in Figure 11.3, it features a main 3D view, a timeline, both a Dope Sheet and Graph Editor, as well as very small Properties, Outliner, and Camera views. When working, I usually let the Dope Sheet take over the Graph Editor to give it more space, and let the Properties window eat the Outliner.

For animation, you want to only show the essentials. For us, that means we need our character, the armature, and the objects with which the character will directly interact. Our goal is to have him take a few steps, hold onto the chair, turn, and toss his cube toy. So, we'll also need the toy, the chair, and the floor. The best way to do this is to choose a layer that isn't in use for anything else, and enable each

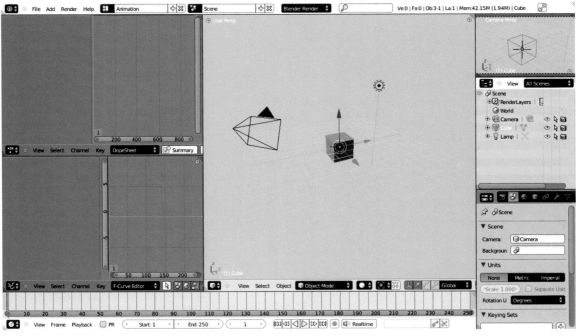

**Figure 11.3** *The default Animation screen.*

of these objects for use on that layer in addition to their existing layer sets. In the case of the example scene, I've enabled all of the relevant objects for display on layer 20. For good animation feedback, and to simplify things even further, I've disabled (not removed) all of the Subsurface and Particle modifiers. Things look a bit rougher, but the animation speed and display response is so much faster, it's worth it. Having something near real-time playback is important for judging the effectiveness of your animation's speed and timing. In addition, I've added a simple plane mesh to stand in for the floor. We don't want to have to deal with seeing through the walls of the room, and the easiest workaround is to create a temporary object.

Turning to the actual control structure, the armature, there is a bit of preparation left. If you haven't already done so, set your armature's display type to **Stick** in the armature properties. Also, make sure that only the bone layer with your control bones is showing. At first, you are going to be keyframing all available bones, and you don't want to be adding keys to helper bones or any kind of control that you don't directly manipulate. Your rig is hopefully constructed according to the suggestions in Chapter 9, which means that you should only be keyframing the controls. Select one of the control bones in Pose mode (Ctrl-Tab) and enable the rotation transformation widget, setting it to Normal mode as shown in Figure 11.4. This aligns the widget with the selected bone, creating a simple, graphical rotation tool. While some of our animation will involve translating bones, a great deal will be accomplished through bone rotation, and the widget is superb for this type of interaction.

Now, set the current frame counter to frame 1 in the timeline and maximize the 3D view with **Shift-spacebar**. When you're posing, there's almost no need to waste screen space on anything else.

Let's start the character slightly in front of the window, facing toward the camera. To change the overall location of the character, remember to grab the root bone in Pose mode, as opposed to moving the armature object itself in Object mode. Figure 11.5 shows the character's default location in an overhead view, followed by where we put it by transforming and rotating the root bone.

And now, we create our first pose. To make it easier, show the tool shelf (T key) and enable **Auto IK** at the very bottom. **Auto IK** is a posing tool that, as discussed in Chapter 9 on rigging, allows us some more freedom while posing and gives a more intuitive feel. Figure 11.6 shows a before and after of the character's initial pose. It's obviously a big difference, and for this first one, let's analyze how we use the armature controls to actually build the pose.

Use the Numpad-0 key to set the display to the Camera view, as we always want our animation to "play to the camera." This doesn't mean that your characters should look at or interact with the camera, but that the only thing that really matters about your posing and animation is *how it looks from the camera*.

**Figure 11.4** *Enabling the rotation widget and setting it to Normal space.*

Many times, your character might end up with some kind of funky arm motion going from one extreme pose to another. An elbow might pass through a stomach. Fingers might rotate backwards for a couple of frames. Whatever. The point is that as long as you can't see it from the camera, it doesn't matter, and you shouldn't waste one second worrying about it.

In the tool shelf just above the Auto IK control is the **X-Axis Mirror** control. Make sure it is disabled. One of the battles you'll fight constantly when animating is to change the set of fairly mechanical controls at your disposal into something that appears to be alive. Symmetry of motion and posing is not something that any living thing exhibits. At first, you might have to strive to break up any accidental symmetry that creeps into your work.

So with Auto IK enabled and X-Axis Mirror disabled, RMB select one of the main hand bones and press the G key. Due to the Auto IK setting, moving the hand pulls the whole arm along with it. As you move

**Figure 11.5** *Moving the character into the starting location with the root bone.*

**Figure 11.6** *Rest position versus a good starting point for the animation.*

it about, it will generate both good and bad poses for the arm. The point, though, is to get the hands down near the sides and into a fairly natural (asymmetrical!) pose. Pulling them down with Auto IK is just the first step. As you work the arm by moving the hand bone with AutoIK, it's okay to accept a bad or suboptimal pose with the LMB, change your point of view, and continue moving it. For example, you might want to adjust the hand's position back-to-front in a side view, while fixing its left-to-right distance from the hip in a front view.

It doesn't matter if the hand or other parts of the arm are oriented incorrectly. We'll fix them in a moment. Our goal was to get the arms out of their airplane wing position. Figure 11.7 shows the pose from Camera view with the arms moved using only Auto IK and the hand bones. To do it, I grabbed each hand bone individually and alternated between working in front and side views.

Let's get him to face the camera a bit. RMB select the upper spine bone (called *spine_upper* in the example file). The rotation widget appears on it, and since we set the widget to use Normal mode, it is perfectly aligned with the bone. LMB dragging on the green orbit of the widget rotates the bone along its *y* axis, which is to say it causes the bone to roll in place. Now, we

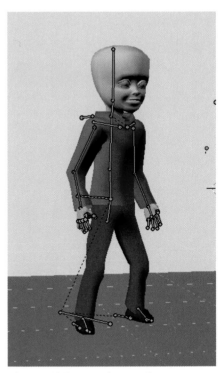

**Figure 11.7** *Bring the arms down.*

could simply make the character face directly at the camera by using this bone alone, but that's not natural. Let's say that our goal is to have the face looking directly into the camera to start the shot, so our little guy can deliver a salute to the viewer before he starts walking. A pose that involves the spine, head, and neck should actually make use of all of their articulations. So, using the upper spine bone, rotate it a small distance toward camera-facing. Then, select the neck bone and turn it a little further. Finally, select the head bone and go the rest of the way. Figure 11.8 shows the result. To add a little character to the pose, I've also tilted the head a bit to the left (from our view) and tipped the chin up slightly.

Grab the heel bones that control the location and rotation of the feet and give him a bit of a forward stance: right foot forward, left foot a little back. You can do this most easily from a top view so that the feet never move along the *z* axis. However, you might want to consider doing it from the Camera view as well, so you can better see the final effect. When moving the feet in Camera view, constrain the motion using Shift-Z. It allows the bone to move freely along the *x* and *y* axes, but not up and down. We're not shooting for a widespread karate-punch stance, so don't overdo it. A little bit of spread, plus the forward and back to remove the symmetry of the default pose. Once you have the feet moved, grab the **body_control** bone that protrudes from the base of the spine and move it down just a touch. As the feet are governed by IK, they stay in place, causing the knees to flex slightly and the upper body to drop. Figure 11.9 shows the pose thus far.

305

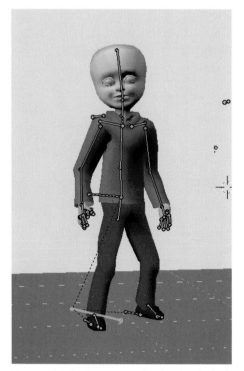

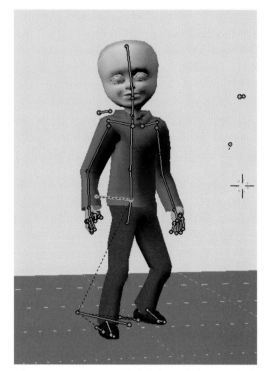

**Figure 11.8** *Create poses that involve the body trunk, neck, and head by building the rotations throughout the bone chain.*

**Figure 11.9** *Feet moved slightly, and the upper body dropped to flex the knees.*

Anytime you adjust the placement of the feet, jump into a top view for a quick inspection. From the positioning of the feet, and by your own knowledge of what the character is doing on that particular frame, try to determine where the character's center of gravity should be. Is it balanced between the feet? Is the character depending on one foot more than the other? Using the **body_control** bone, make sure that the character's body mass is resting over that spot. In this example, the character is just standing there, so the body should be spaced evenly between the two feet. A character who is acting aggressively or feeling hostile might cheat his or her body mass toward the front foot, while the opposite would hold true for one feeling reticent.

To finish the pose, we'll add some life to the hands. If you haven't fooled around with the hand rig yet, now's the time. Fingers are curled by scaling the bone that runs from the base of each finger to its tip. The same bone rotates the fingers. Zoom in on the hand holding the cube. Using the four finger bone controls and the IK controller for the thumb, curl and rotate the fingers so that they appear to be gripping the cube, like in Figure 11.10. I found that I had to use Perspective view (Numpad-5) and rotate the view quite a bit to make sure that everything lined up properly and that the fingertips just touched the surface of the cube. I've also rotated the entire hand a bit so that you can see the cube better from the camera.

The left hand is given a simple, natural resting formation. Figure 11.11 shows a close-up of both hands from the camera's perspective.

## Recording the Starting Pose

That's how you build a pose. Consider the camera location and what it can see. Position hands, feet, and the body's trunk, making sure that you utilize each bone chain's full articulation. If you're using Auto IK to help with posing, make sure that the rotations for the affected bones make sense, and adjust their rotations by hand if necessary. Examine the pose for symmetry and kill it. Make sure that the body's weight is distributed over the feet in accordance with the situation. Pose the fingers.

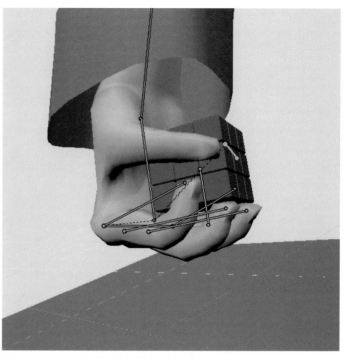

**Figure 11.10** *The hand grabbing the cube.*

Now, select all of the visible bones in the armature, press the I key, and choose **LocRotScale** from the keying menu that pops up. This sets your initial keyframe for the animation, and also indicates to the automatic keying system which bones will require keys later on. If you have non-control bones (i.e., helpers or deformers) showing along with the control bones, you'll get keyframes added to them too, which might cause problems later. Obeying the advice in Chapter 9 on rigging, though, will keep you in the clear.

**Figure 11.11** *Both hands posed.*

After setting these keyframes, the Dope Sheet editor will look like Figure 11.12. Note that there are more bone channels than there is available space on the screen. You can scroll the Dope Sheet editor up and

down by MMB dragging anywhere within the workspace, or using the mouse wheel over the channel names on the left side of the screen.

## Creating a New Pose, or Animation

Let's make the kid give a wavy salute type of thing before he starts to walk. To begin this process, we'll need two additional poses. The first will have his hand in the anticipatory phase of the wave, perhaps almost touching his forehead. The second will be the extreme pose of the wave where the arm and hand are at their furthest extension. The poses themselves will be built in the same fashion as the original.

At this stage of animation, where you're just building a series of poses, some people prefer to set them at equal intervals in time and adjust the timing later. Personally, I prefer to start to work in timing from the ground up. To do this, just stand up and give a wave. If you've watched the finished animation, you know the kind that I ended up using. As you perform this action several times,

**Figure 11.12** *The Dope Sheet holding your first keys.*

count to yourself. See how long it actually takes. Not long, really. For the sake of argument, let's say that we'll allow about a second and half between the standing pose and the wave anticipation, then execute the actual wave itself in a half second. In frame terms, that means that we need to build the first new pose around frame 36 and the next one 12 frames later.

On the timeline, or even directly within the Dope Sheet, set the current frame indicator to frame 36. Also on the timeline, and this is very important, enable the red recording button in the header. Figure 11.13 shows the control. This enables automatic keyframing. Now, any bones that you move that have been keyed before will automatically receive a keyframe for their current transformation.

**Figure 11.13** *The automatic keyframing "record" button.*

Figure 11.14 shows the next pose, which should be created on frame 36. Not a whole lot has changed, compared to the amount of setup we had to do on the initial pose. The big difference is obviously the left hand. Auto IK and a few different view orientations make it fairly easy to position it near the head, like the figure. For a bit of additional life, I've also rotated the left collarbone a bit so that the shoulder hunches upwards. You probably won't be able to see it in the figure, but remember our old rule: subtlety. Yes, we want to communicate a good pose and action, but that is best done through an accumulation of small, good choices as opposed to a single, glaring one.

A couple of other things have been changed too. The head is inclined toward the hand, incorporating a bit of a nod into the motion. The torso is slightly twisted away from the camera. The hand holding the cube has come forward a bit to balance the backward motion of the other hand. As a final consequence of the motion, the character's center of gravity has changed a fraction, so we move the **body_control** bone subtly to reflect this shift. It's a lot to think about, but after you've worked through a couple of animation sessions, this stuff should become second nature to you.

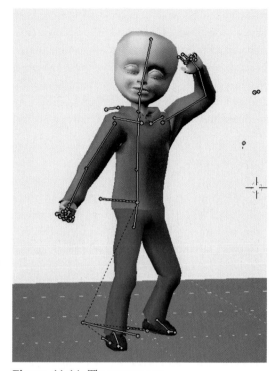

**Figure 11.14** *The prewave pose.*

Try to remember this: The mechanics of character animation are all about balance. A character's primary action, like bringing an arm up to wave, must be balanced by other motion and action in the body. Sometimes that balance might be achieved by an almost equally obvious large motion in the other arm, if appropriate. More often though, it will be balanced by an accumulation of smaller motions from the entirety of the rest of the body. Animators refer to this type of motion as *secondary* action.

With that pose built, skip ahead 12 more frames, to somewhere around frame 48. On that frame, build the pose shown in Figure 11.15.

Once again, notice how body parts other than the left hand change position to attempt to balance the major waving motion. It's important enough to repeat that these kinds of compensatory motion and posing shouldn't be gigantic. That will make your character look like they're dancing, or at least like they have some kind of neurological disorder.

A glance at the Dope Sheet upon completing this pose should show something like Figure 11.16. Notice that bones that were moved either directly by you or through Auto IK have received keyframes automatically. Later on, when the animation has become complex, this is fine. At this early stage though, it's going

to be helpful to have keys set even for the bones that haven't changed. This is because right now, we're only **blocking** our animation—creating the extreme poses that will eventually become our finished product. We're going to be playing with timing in a moment, and we want the entire pose captured and movable in time.

To do this, set the current frame indicator back to frame 36, where the wave-anticipation pose was created. Use the A key to select all available bones in the 3D view, then press the I key with the mouse over the Dope Sheet. An **Insert Keyframes** menu pops up, from which you should choose the **Only Selected Channels** option. This inserts keyframes at the location of the current frame indicator, for all selected animation channels. Note that when you select the bones in the 3D view, the corresponding channels in the Dope Sheet are selected. What you've done is add keyframes for the current transformation of all control bones at frame 36. Repeat this process on frame 48 to fully capture the extended wave pose.

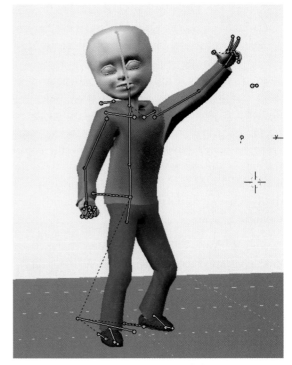

**Figure 11.15** *The extreme position of the wave.*

So now we have 48 frames of awesome animation right? Right? Hit Alt-A to play it.

Yeah, it's not so good. If you're too embarrassed of your effort up to this point, you can just watch the video called *bad_first_animation.mpeg* in the Web Bucket While the poses themselves looked fine, the interpolation between them looks horrible. In fact, let's just eliminate the interpolation altogether and work on the timing. In the Dope Sheet, use the A key to select everything. To remove the smooth interpolation between keyframes, head down to the **Key** menu on the header, and select **Interpolation Modes > Constant**. You can also access this operation from the Ctrl-T hotkey, but it's not one you'll use frequently enough to need to memorize. Pressing the A key now shows each of the three poses you've created so far, snapping into existence right on their keyframes. No interpolation. This might seem odd, but it's actually a good way to set your poses and check your timing before you start to deal with interpolation.

By setting the frame range to something like 1–75 on the timeline header, pressing Alt-A lets you watch the animation over and over. Let it fill your eyeballs and try to determine how it would look better. When I do this, it strikes me that perhaps the wait period between the first two poses is too long. To change it, we need to select all of the keys on frame 36. RMB select one of them, then press the **K** key. This command looks at the current key selection and selects all other keys on the same frame as the currently selected ones. In this case, it just selects all keys on frame 36.

**Figure 11.16** *The Dope Sheet with a few new keyframes.*

Using the G key, move that entire column of keys to the left something like eight frames, to frame 28. Press Alt-A again and analyze the timing. It's better, but now the gap between the second and third poses is a little long. RMB select one of the keys in the third pose on frame 48, use the K key to select all of the other keys on that frame, then move them to the left three frames or so. Pressing Alt-A again seems more natural. The trick here is that if you get the timing close to correct on these static poses, your eye and brain will fill in the motion for you, and it will click. Later, once all of the poses for your animation are done, you come back and "release" it from Constant Interpolation mode and actually start to work on the in-between motion.

With that in mind, let's block in the rest of the sequence: a walk to the chair, grabbing the chair, followed by the kid pitching the block. Before we do though, let's take a brief detour to discuss the philosophy of walking.

What is walking? Putting one foot in front of the other, in a way. But if you walk around for a while and really pay attention to what you're doing, it's actually rather fascinating. When we walk, we don't usually think about our feet. They seem to have a mind of their own. We just decide where we want to go. The main part of our body heads in that direction and our feet manage to keep themselves under us, maintaining our balance as we go. In fact, it's even a little better than that, as our leading foot during a stride seems to also know which direction we'll be heading in next, with the toe pointing in the appropriate direction to manage the arc.

To translate this into animation terms, it would be ideal if we could just pull our character around and have the feet do the automatic balance and ESP act that our own feet seem to be capable of. Unfortunately, Blender does not have such a system. It does, however, give us some insight into how to proceed. Since the feet are really a secondary consideration, positioning themselves to maintain balance and optimize launch force, what should be considered first is the motion of the main body.

The technique that I use, as well some other animators, is to temporarily ignore the feet and just move the body around. Later, during the interpolation phase, you key the feet to keep up with the body. In the case of our sample project, this is easily accomplished by removing the leg/foot portion of the model from the active layer. The result is that we will continue our posing adventure with half a person. Figure 11.17 shows our poor kid, *sans* legs.

From a top view then, you can advance to something like 20 frames past our last set of keys, move the **body_control** bone, then rinse and repeat several times until he stands beside the chair. The automatic keying takes care of saving the positions each time. Figure 11.18 shows the character at 20-frame intervals, which is where keys were made. Notice how he starts to rotate before he gets to the chair. Do a similar walk for yourself and see how your body pulls itself into position, anticipating where you're going to end up.

The fact that we're advancing 20 frames is just for convenience. If you actually set up a chair near yourself and walk this off, you'll find that the amount of time it takes really depends on how fast you're moving. There is a pretty wide latitude here, and the final determination will be made by the specifics of your character and the needs of the scene. Here, we don't really have a lot of "char-

**Figure 11.17** *What hath our method wrought?*

**Figure 11.18** *Twenty-frame intervals.*

acter" or "scene" to deal with. It's just a study, so we've arbitrarily placed 20 frames between keys. And, when you play it back with Alt-A in constant interpolation mode, it looks okay. His body is perhaps moving a bit slowly, but that's okay. It's easier to keyframe the feet during a slow walk than a particularly fast one.

The next task is to go back to each of these keyframes and adjust the arms, head, and spine to something more reasonable. You don't have to bother with arm swing (we'll add that when we actually do the feet), but you need to pay attention to where the character is looking at how their upper body is oriented.

The video *walking_with_no_feet.mpeg* in the Web Bucket shows the poses that I've created. Note how the kid looks down at his feet near the end of the action. Judging by the body motion, he'll be doing a little shuffle move with his feet near the chair, and people often glance downward to position themselves in a situation like that. For each pose that you create on the upper body to correspond with the **body_control** locations, make sure to select all of the upper body bones (possibly with B-key border select) and set a LocRotScale key for them as well, even if they haven't been moved. Here's why.

Figure 11.19 shows the last pose of this sequence, with the hand resting on the chair. To create this pose, Auto IK was used to get the hand in the general vicinity of its target location, but I had to adjust the rota-

313

tions of the upper and lower arms and the hand bone itself to get it to line up with the chair correctly. Additionally, I hunched the left collarbone, and even translated it a tiny bit. Since we haven't actually keyed any translations on the collarbone so far, with the exception of the end of the wave where we keyed everything available, that bone will interpolate to the hunched position all along with the length of the walk. That's clearly not what we want. It should only happen sometime between the previous full key and this one.

Making sure to key everything in the upper body for each of these preliminary walk frames solves the problems. Whatever you do though,

**Figure 11.19** *The hand resting on the chair.*

don't add keys to the foot bones! We'll do that later, and keying them along with the body ruins the system.

Let's add the last few poses, in which the character throws the cube. The first pose should be anticipatory—the hand drawn back. We'll do an underhand throw so the toy can arc upward and have a reasonable chance of ending up staying on the table and a bounce or two. Figure 11.20 shows both this pose and the next one, which is the extreme position of the throw. Finally, we bring his hand down in a little fist pump.

As for initial timing, I've placed the throw anticipation frame almost 34 frames after the last key set. The actual throw extreme comes 10 frames (less than half a second) later, which looks close to correct in constant interpolation playback. Finally, the fist pump happens on frame 187, about a second later. It looks good enough in playback, but we'll certainly be fixing it later when we release the whole thing to smooth interpolation. Remember to select the whole upper body on each of these new poses and key everything so we don't end up with unintentionally long interpolations later on.

We're about to release everything back to the default Bezier interpolation method. To see the difference, check out the two videos called *last_of_the_constant.mpeg* and *first_of_the_bezier.mpeg* in the Web Bucket.

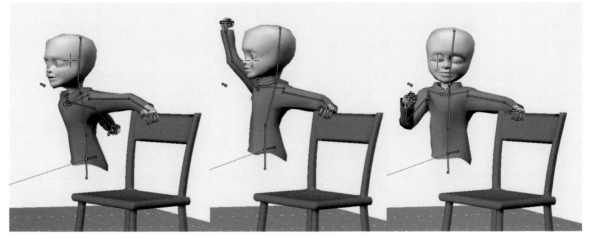

**Figure 11.20** *The last three poses.*

They use the same set of keyframes. The only difference is the interpolation method. If you're following along with your own animation, go ahead and switch everything back to Bezier interpolation by selecting all the keyframes in the Dope Sheet with the A key, then choosing **Key > Interpolation Mode > Bezier** from the Dope Sheet header. If you watch that video or your own playback after the conversion to Bezier, you'll see the terrible default state. The kind of motion you're seeing is referred to as "swim," "float," or as being "soft," and it is a bad thing. To get good animation, we're going to need to remove all traces of that default style of interpolation.

More than any other step, this is where your artistry and critical eye are going to come into play. Can you look at poor timing and tell that it isn't right? Once you've determined that, can you decide where to go? If so, you'll probably do well. If not … your prospects as an animator might be limited.

Let's give it a shot on the first motion: the wave. Focusing on the waving arm for a moment, what we want to have happen is for the actual transitions between the different poses to happen more quickly, but we don't want to mess with the overall timing of the poses themselves. The easiest way to begin to do this is through keyframe duplication in the Dope Sheet. RMB select the hand and two arm bones

of the waving arm. In the Dope Sheet, those channels are highlighted. Using B-key border select, select the key dots on frame 1 for only those channels. This is shown in Figure 11.21. Use the Shift-D key to duplicate them, and move them to the right until

**Figure 11.21** *Select and duplicate the starting pose keyframes for the left arm.*

they are around frame 18. This makes the arm hold its position for the first 18 frames, then execute the move to the wave anticipation pose in only 10 frames. Pushing Alt-A to watch shows that it's not bad. It might be better just a touch faster, so slide those same three keys one more frame to the right.

That second set of keys that produce the hold are not natural though. No one can hold their limbs perfectly still. To break it up, set the current frame to the location of the "hold" keys (frame 19 in this case). Grab the hand bone and move it just the tiniest amount. It shouldn't even be noticeable as a move without close analysis. We're just looking to give a little bit of life to it. In animation terms, this is called a **moving hold**.

Even though the semi-saluting pose is the one anticipatory to the wave, we can build some anticipation into the movement up to that pose. Just before the arm pulls up into that pose, it would be nice to give it a few frames of backward motion. Place the current frame midway between frame 1 and the new keyframes you just created, around frame 10. Grab the hand bone in a side view and pull it backwards an "inch" or two. Because of Auto IK, this should create new keys for each of the arm bones. The result is that the arm pulls back slightly before moving into the actual pose.

Now, we proceed through the rest of the wave, adding holds between the original keyed columns. I duplicated the salute pose and moved it to within three frames of the wave's extreme on frame 45. This executes the actual wave in just three frames, making it very snappy. The end of the wave is duplicated and held until the middle point of the next two columns, around frame 55. On each of these duplicated hold frames, we've also pulled the arm the smallest bit out of position to give it some life. Playing this back with Alt-A shows that there are some other obvious problems. Namely, the rest of the animation during this time period still floats like crazy because we haven't touched it. That's right. We need to do this same breakdown to the left arm, the spine, the head, and the fingers. It's a lot of work, but it's the way it needs to be. You can watch a brief video of this first section before adding holds to the rest of the limbs, in the Web Bucket file *holds_for_the_wave.mpeg*. Also, Figure 11.22 shows the Dope Sheet after adding the holds.

We're not going to go step-by-step for adding the moving holds for the rest of the body during the wave. You know what to do, so go ahead and do it. You can compare your result to the next video: *holds_for_everything.mpeg*.

**Figure 11.22** *Moving holds added to adjust transition times between poses.*

As you go about adding holds for the other parts of the character here, keep in mind a corollary to our principle of asymmetry. When a person moves, nothing syncs up perfectly. For example, if you reach out to grab something with both hands at once, your hands will not move in perfect concert. It might be close, but only a robot is able to coordinate their movements with absolute precision. This means that one hand

will find its goal a fraction of a second before the other. In fact, the motions of each of your arms probably won't even begin at the same instant. You need to reflect this in your animation as well.

In the example file, the hand that holds the cube toy moves in opposition to the waving hand to provide some balance. However, it shouldn't move exactly in sync with it. Which should move first? Well, the cube hand is moving in reaction to the waving hand, so its motions should probably lag by a few frames. So, when creating the moving hold for the opposite hand, the hold should last until two frames (give or take) after the main arm's hold ends. Also, the actual keys after the hold should be moved a few frames to the right so the opposing arm hits its pose after the main arm. Figure 11.23 shows this construction.

With moving holds added to fix the velocity of each transition, you might think you're done with this section. But you're not. The next step is to add something called **overlap**. If you've ever seen a martial artist throw a punch in slow motion, you've seen this before. All within the fraction of a second that it takes to throw that punch, the following happens in sequence: the weight shifts on the feet, the

**Figure 11.23** *Make sure your character does not move perfectly in sync.*

hips rotate to square with the target, the upper arm starts to move, followed by the lower arm, and finally the fist, all snapping into place at the end. These motions all overlap in time, but do not begin at once. In fact, you can follow the generation of the eventual force of the punch through the body.

When adding overlap to your animation, this is what you're trying to do: demonstrate the origins of the forces acting on your character's body. So, the waving arm will actually begin with the motion of the upper arm, followed by the motion of the lower arm, and followed by the motion of the hand. The easiest way to do this is to simply slide the keys for the relevant body parts forward and backward in time. In truth, that's all we're going to have time to do here. Professional animators all have their own way of building overlap into their animation, and it can become quite complex.

The larger the motion, the more pronounced the overlap will be. In our example though, we're not going to move anything more than a frame or two. Figure 11.24 shows the keys of the left arm for the actual wave adjusted for a bit of overlap. Remember what you're doing though: demonstrating the progression of force. You can't just randomly start moving keys in

**Figure 11.24** *Overlap has been built into the keys for the left arm.*

time. For example, when adding overlap to the motion of the head, neck, and spine, where does the force or motion begin? If your character gets kicked in the chest, throwing him or her backward, the spine will move first, followed by the head, then the neck. However, if your character is turning his or her head to look at something, the head will move, followed closely by the neck, then the rest of the spine. The two situations show different motive forces, and will look very different depending on how you build the overlap.

The Web Bucket video *holds_plus_overlap.mpeg* shows the same section as the previous video, but includes overlap. The difference is subtle but noticeable. I've compiled both videos into a side-by-side demonstration for direct comparison, called *effect_of_overlap.mpeg*.

Let's recap before tackling the walking animation. To create character animation, we begin by creating a series of poses in constant interpolation mode, with attention being paid to such things as balance, weight, and symmetry. Keys are inserted for all bones in the armature on each of these keys. Basic timing is estimated. If the character will be walking, the legs and feet are temporarily ignored. After the initial posing is complete, the animation is released to Bezier interpolation. Then, moving holds are added to correct the velocity of the pose transitions. Motions are also adjusted so that different parts of the body act together, but not perfectly in sync. Finally, overlap is added to hint at the origins of force.

## Walking

It's interesting that such a mechanical process as the one we've just worked through can lead to things that appear to be alive, if we're doing our job. That notion goes double for walking. As we discussed before, walking is the process of making your feet land underneath you in such a way that you maintain your balance as you hurl your body through space. It's probably one of the most mechanical things that people do. So too is the process of animating it. This isn't to say that you can't add character to a walk. You certainly can. But the actual motions of the feet—the way they contact the ground and position themselves—is pretty much dictated by physics.

To get started, find the lower body mesh and re-enable it for the layer with the rest of our animation objects. If you want some amusement, press Alt-A and watch the legs stre-e-e-e-tch as the character's upper body moves. In accordance with our theory about walking, we're going to find the first frame on which the body begins to move, then step to the end frame by frame, keying the feet in order to keep everything in balance.

You're going to need a large 3D workspace and a timeline view for this, and not much else. I created a special screen for working on a walk that contains only those two types, shown in Figure 11.25. LMB drag in the timeline to scrub the animation back and forth until you find where the body begins to move. This is your starting point.

By scrubbing in the timeline back and forth over the point where the body begins to move, it's pretty obvious that the right foot needs to go first. Here's the procedure for walking:

1. Determine the frame on which the back foot needs to leave the ground. In the case of the example file, this is frame 50. How do you tell? Usually, it's when the leg can no longer withstand the motion

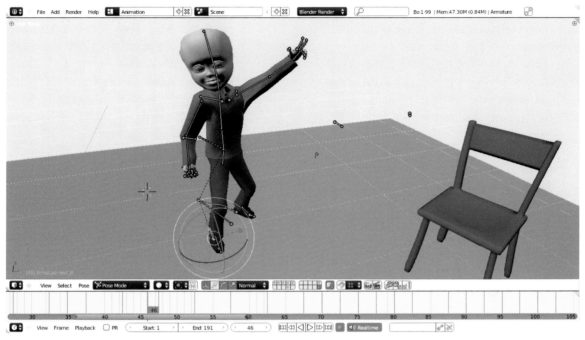

**Figure 11.25** *A screen appropriate for walking.*

of the body without stretching. A real leg doesn't stretch out at this point—it gets pulled off the ground by the body's motion.

2. Back up two frames by tapping the Left Arrow key twice.

3. RMB select the foot bone and set a LocRot key on it, without transforming it (Figure 11.26).

4. Advance two frames.

5. Rotate the foot bone upward so the foot is arched, but the toe is still on the ground. Automatic keying creates a key for this (Figure 11.27).

6. Select the heel bone, and set a LocRot key on it, without any transformation (Figure 11.28).

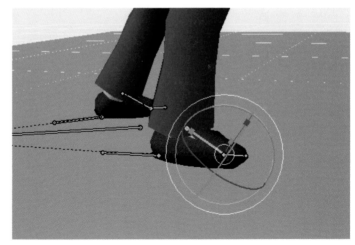

**Figure 11.26**

7. Scrub the frame counter ahead until the other leg just hits its own stretching point. In the example file, this comes only ten frames later. This is the frame on which the first foot needs

to reconnect with the ground. I know we haven't made it leave the ground yet, but that's the way it works.

8. On this advanced frame, move the foot along the ground until the body's center of gravity is once again between the two feet. In other words, center the body control between the feet by moving only the original foot (Figure 11.29).

9. Select the foot bone, clear its rotation, and set a LocRot key (Figure 11.30).

10. Reselect the heel bone, advance one frame, and set a LocRot key (Figure 11.31).

11. Go back one frame and rotate the heel bone so that the foot rises slightly off the ground, but the heel stays in place (Figure 11.32).

12. Scrub the timeline backward until the moving foot is just below the center line of the body, about five frames in the example.

13. Move the heel bone vertically (G key, Z key) (Figure 11.33).

That's footstep number one. You can see it in all its glory in *babys_first_step.mpeg* in the Web Bucket. The entire process now repeats for the other leg.

To summarize, what you're doing is finding the extreme position of the leg that is trailing the body's motion, and

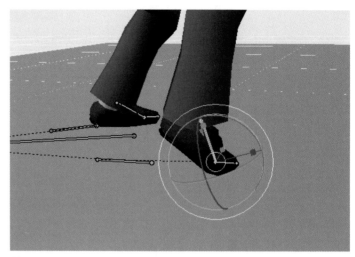

**Figure 11.27**

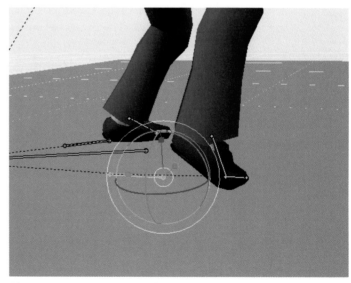

**Figure 11.28**

setting some keys to mark the foot's position there and to make it start to flex. Then, you identify where and when the foot must land to maintain the body's balance. Once there, you set a few keys to mark the new spot. After that, you find the middle and pull the foot off the ground. A lot of refinement can go into it now, but those are the basics. It's actually best at this point to not even bother with the Dope Sheet, as the key placement can get a bit confusing. Better to just follow this method and examine it after the fact.

**Figure 11.29**

**Figure 11.30**

**Figure 11.31**

**Figure 11.32**

One of the great things about this method is that it doesn't just work for walking. Any kind of complex body motion can be dealt with body first, feet later. Not everyone chooses to deal with it that way, but if you can make the upper body look like it's moving naturally with no legs present, you are almost guaranteed to be able to fit the legs and feet in afterward.

Before we continue, let's take a look back at step 8 in the walk process. When the foot strikes the ground at the end of a stride in real life, it is usually oriented in the direction that the person is intending to go next. It's like a little arrow of intent. You should do the same thing when placing the foot in 3D. Figure out where the character is headed with their next step, and make the foot point in that direction if possible.

**Figure 11.33**

I've followed this process through until the character's body stops moving beside the chair. You can see the result in the Web Bucket video *walked_a_hundred_miles.mpeg*. The Dope Sheet is shown in Figure 11.34.

It doesn't look very good, but it's only the feet. There are obviously some additional things that need to go on to make it look right. If you watched that video carefully, you might have noticed that while the first half of the footsteps followed the procedure we just detailed, the latter half, where he's walking sideways and backwards, doesn't follow the toe-down lift/heel-down placement. That's because people don't

**Figure 11.34** *The Dope Sheet with foot and heel keys for walking.*

move their feet that way when they walk sideways or backwards. In those cases, people generally place their toe first, then plant the heel. This requires only a slight alteration of the procedure outlined above.

When walking backward, instead of clearing the foot bone's rotation (step 9), you leave it alone. Instead, you key the heel bone right on that frame. This pose looks like the toe is striking the ground first. Then, you advance two frames (or just one if things are moving quickly) and clear the foot bone's rotation, effectively planting the heel.

With the feet done though, it's time to refine the rest of the body. First up is the body_control bone. The body rises and falls as you walk. The highest point is when one foot is at its own highest point off the ground, and the body's weight is borne completely by the other foot. When the weight is evenly distributed on both feet, the body is at its lowest point. Scrub through the timeline, stopping at each high and low point. Move the body_control bone up or down at those points. A lot of vertical travel will make your walk look silly. That might be what you want, depending on your animation goals. However, we're going to try to keep it at least semi-realistic.

The Web Bucket video *body_control_adjustment.mpeg* shows the difference. Not only has the vertical positioning of the upper body been adjusted, but some of the later motion too. There were a few places where the placement of the feet seemed a little off in comparison to where the body was, and also where the body perhaps moved too quickly. So, a simple adjustment and new key here and there helped to fix it.

While working on fixing the overall body motion, it's important to keep an eye on the legs. What you're looking for is called "IK pop." It happens when an IK limb like a leg is pushed to its fullest extension. At that point, the chain of bones "pops" completely straight. It is obvious in an animation when this happens, and should be avoided. So, as you adjust the upper body of your character, make sure that you are not moving it so far that either of the legs pops.

When you're satisfied with the interaction between the feet placement and the upper body, turn your attention to the arms and hands. Arms move in opposition to feet. When the left foot is back, the left hand is generally forward, and vice versa. With Auto IK enabled, this is simply done by finding the keyframes on which both of the feet are on the ground and pulling the hands appropriately. This is another area like body control where more motion will give a cartoonish feel, while less will tend toward realism. Depending on how much time you have, you can carefully craft these arm poses, based on your own observations of walking. How are the hands rotated at the forward and backward extremes? On the frame midway between the extremes, how close is the hand to the hip? You might need to insert an additional keyframe there to make sure it doesn't pass through the body in certain cases.

As a last pass through, you can also rotate the spine. Once again, how "loose" do you want your walk to be? How much jive? The upper spine should rotate in opposition to the feet, just like the hands. The right should rotate forward when the left foot proceeds.

Watch the Web Bucket video *not_horrible.mpeg*, which is where we're at right now. It's not horrible. It's not really good, though. Unfortunately, this is where the artistry kicks in. Sure, you can go in and add overlap to the arms. You can maybe even add a hold here or there if the walk is slow and things begin

to float, like they do near the end of this example. In the end though, you have to be able to look at the Alt-A playback and be able to honestly tell yourself, "What's wrong with this motion?"

The Web Bucket video *workshopped.mpeg* represents the same idea, but approached a little differently. I rebuilt the animation from scratch for this video. I've often found that, like projects in the real world, you're only really ready to animate a shot or scene once you've … actually animated that shot or scene. I tried to give the character some more life in this attempt, by making his movements a little fast, making holds last a little long so the resulting velocity of motion is higher, and making him lighter on his feet. While I didn't give it the full studio-quality treatment, I think that in this iteration, the animation has gone from "not horrible" to "not bad." I've seen worse on TV, which isn't saying much.

We haven't talked a lot about "art" in general, but one piece of advice I'll give you is this: Don't be afraid to throw it away and start again. It's entirely possible that what you learn about a particular project while working on it the first (or second, or third) time will enable you to do it much better the next time around, even if your first attempt isn't salvageable. Be merciless to your digital creations. They'll thank you for it.

## Grabbing the Chair

If you watched the "workshopped" video, you'll notice that the character's hand locks nicely onto the chair when he grabs it. Remember the IK/FK slider we constructed back in Chapter 9? When the character "grabs" the chair, the arm becomes a weight-bearing limb and should use IK.

To make use of the IK controls for the arm, we need to put the controller itself in place and properly keyframe the custom property we created for the IK/ FK switch. First, we need to identify the frame on which the "grab" is going to happen. Scrubbing through the timeline on the sample file, frame 123, shown in Figure 11.35, looks like a good spot. Also, find the left arm's IK controller, which is probably still hanging out near its initial location at the beginning of the animation.

With the IK controller selected (called *arm_control_IK_L* in the example files), move it near the wrist of the left arm. Leave Pose mode for a moment, going back to Object mode, and use the N key to show the 3D view properties panel.

**Figure 11.35** *Where we'll activate IK for the hand and arm.*

Down at the bottom, in the **Properties** section, you'll find the property you created during rigging. Figure 11.36 shows the panel from the example file. Set the *IK Switch L* property to 1.0 to turn it on.

When you switch to IK, the arm will change its pose more or less, depending on how closely you placed the IK controller bone. Adjust the location of the bone until the hand seems to rest just on the back of the chair. Automatic keyframes saves the new location of this bone, but not the IK/FK switch property value. This is because automatic keyframing by default only works on properties that have already been keyed once. So, RMB over the property value and choose **Insert Keyframe** from the menu that pops up.

If you scrub back through your previous frames now, you'll notice something bad. The IK controller appears to have control of the arm through the entire animation. This is because there were never any other keys set for the switch property. All it knows is the 1.0 value we just gave it. The

**Figure 11.36** *The N-key panel and the Properties section for the armature in Object mode.*

solution is simple: Step one frame backwards from the one where we began the grab, and dial the IK/FK property back to 0.0. Now, there is a 0.0 key on frame 122, and a 1.0 key on frame 123.

It's also possible that the IK controller bone itself has some additional keys that we don't want. If you recall, we placed keyframes on everything but the feet back when we blocked in our poses. This included the arm IK controllers. Once again, the solution is simple. In the Dope Sheet, use the B key to select all of the left arm IK controller's keys, with the exception of the one in frame 123, and delete them. Figure 11.37 shows the Dope Sheet, with the keys from the *arm_control_IK_L* channel selected.

The only thing left to do with the hand is to step through the rest of the animation and add some corrective keys to the hand bone. As the body moves, the IK controller becomes a kind of pivot point for the arm and hand. The hand itself just follows the rotation of the lower arm, so its orientation may need

**Figure 11.37** *Ready to delete some superfluous keys.*

to be adjusted so that it looks like the character is actually holding on. This brings up one of the necessary deficiencies of our rig. If we had really wanted to be accurate, we would have put IK controllers at the ends of the fingers too, as they are technically bearing some of the weight of the hand when they press against the chair back. Such a construction would have locked the hand perfectly in place. Why did I call this a "necessary" deficiency? Well, it would just be too complicated to execute, especially in a supposed beginner's book. And if the only problem that not having it causes is that we have to add a few keys to fix hand orientation, I'd say it's a worthy omission.

**Figure 11.38** *What happens when you constrain the cube directly to the hand. The pain!*

## Throwing the Cube

In order to have our character carry and eventually throw the cube, we have to go the whole way back to frame 1. The cube needs to become a temporary part of the rig itself. The easiest way to do this is to give the cube both a Copy Location and Copy Rotation constraint and bind it to the hand. Of course,

we can't bind it to the hand itself because the constraints would cause the cube to appear in the middle of the hand, like Figure 11.38. The solution, shown in Figure 11.39, is to go back into Edit mode on the armature and duplicate the hand bone, moving it to float above the palm. Make this new bone the disconnected child of the hand bone so that it always moves with the hand.

The result is that when the cube is constrained to this new bone, the bone becomes a full controller for the cube. You can use it to translate and rotate the cube into a nice location among the fingers of the hand. The cube, positioned by the new bone, and its two constraints are shown in Figure 11.40.

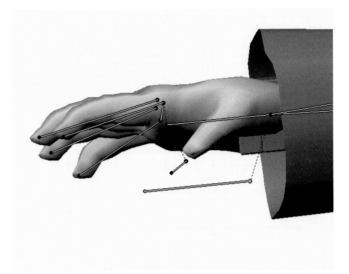

**Figure 11.39** *Adding a new bone is the solution.*

And now everything's cool until we get to the end, where he actually has to throw the cube. Can you figure out how to release to cube from his hand? We've not done this exactly, but we've accomplished something much like it already. First, find the frame on which you want the cube to come free. Select the cube itself and press the I key to bring up the keyframing menu. Notice the three keying options at the bottom that all begin with **Visual**? Ordinarily, objects that are under constraints don't actually "know" where they are. They display correctly, but if you were to add a location keyframe to them, it would key from the unconstrained position. Choosing one of the **Visual** keying options tells the object to actually take a look around and figure out where it *really* is. So on this frame, set a **Visual-LocRot** key, which will record the actual location and rotation of the cube in its constrained state.

Step back one frame and use the RMB > Insert Keyframe method to insert keys on the Influence property of each of the cube's constraints. Step forward again, set both Influence values to 0.0, and make sure to key them.

What you've done is record the constrained transformation of an object, but turn the constraints off. On that frame, it will appear exactly as though it is still constrained, although it no longer is. And from that point, you're free to animate it any way you like. You can see from the finished product that I chose to have the cube tumble through the air, then bounce to a stop on the tabletop.

**Figure 11.40** *Add both Copy Location and Copy Rotation constraints to the cube, targeting the new bone in the armature.*

## Checking Your Arcs

As a final step in refining your animation, you should check your arcs. Being creatures whose limbs generally rotate around pivots of one kind or another, our natural motion tends to create arcs. For our animation to look believable, it should too. Figure 11.41 shows the complete paths taken by both of the character's hand bones throughout the animation.

A path for any bone can be calculated and displayed by selecting the bone and choosing **Motion Paths > Calculate** from the **Pose** menu on the header. They can be removed by choosing **Clear** from the same submenu. The purpose of displaying these paths is to make sure that your character's limbs aren't moving in a jerky, robotlike fashion. It appears for the example file that things aren't too bad. The straight lines you see represent the very fast motion of both the wave and the throw. If there were more frames between those key points, the curve would look smoother.

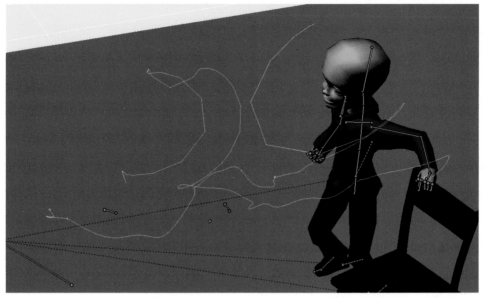

**Figure 11.41** *Hand paths—the background has been made darker to highlight the paths.*

If you were preparing this animation for production, you would probably move the frame counter to a couple of the more pointed spots in the path and see if you could adjust a key or two to smooth it out. For our purposes in this first animation though, it's fine.

## Next Up ...

In Chapter 12, we learn how to optimize render times for previews, and how to make use of the integrated node compositor to add additional believability to our final renders.

# Chapter 12

## Rendering Basics

The eternal conflict in rendering is between time and quality. Generally, enabling rendering options that can lead to greater believability costs you time. We've already seen this, particularly in Chapter 7 on surfacing and Chapter 5 on lighting. Recall how certain material options like ray-traced transparency with index of refraction, blurry reflections, and subsurface scattering, or lighting techniques like ambient occlusion can drastically increase rendering times.

For a final render of a still image, render times aren't really a factor. Who cares if your image takes two hours to render? The problem though, is when you get into animation. A mere 30 seconds of animation requires 900 frames. At two hours a piece, that's a long time. The other situation where long renders hurt you is during the fine-tuning process. While there are some tricks you can use while tweaking your settings, very long render times degrade the final quality of your image by the simple fact that you can do fewer tests in the amount of time you have available. Let's say you're doing a project for work, and you have two days to finish it. At an hour per render, you can only tweak your scene and settings 16 times before you have to give up. Cut that render time in half, though, and you double the number of times you can change something, test it, and change it again.

The good news is that the modeling, lighting, and shading processes we've discussed earlier in the book should have already gone a long way to getting things in the right place for your final render, as well as to optimize the time/quality ratio before we even start to mess with render settings.

Let's take a look at the available rendering options, and see how each of these can be used to optimize efficiency during test renders and your final render.

## Render Options

Although you can render from any screen or view, there is a default screen available for tweaking render settings, called **compositor**. You can always access the render properties from anywhere by setting a

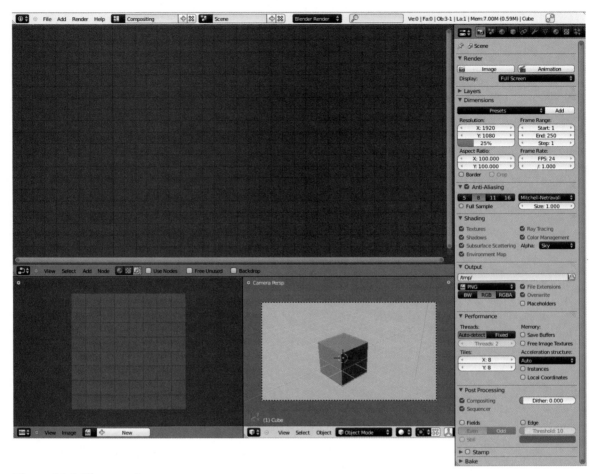

**Figure 12.1** *The compositor screen.*

Properties window to the Render context, but it is so much faster to just hit Ctrl-Left or Ctrl-Right arrow a few times to jump to the compositor screen. Shown in Figure 12.1, it features a 3D camera view, an Image Editor, a Properties window set to the Render context, and a large window at the top for the compositor, which we'll learn about later in this chapter.

From top to bottom, the panels are:

**Render:** Push the **Image** button to render a still. Push the **Animation** button to begin rendering the frame range that's designated on the timeline, and in the Dimensions panel below. The **Display** menu lets you decide where the render will be shown: in a new window, in full screen, or in an Image Editor. I always use the Image Editor option, and have it set as my default.

**Layer:** Contains controls for breaking your render into sections and layers for compositing work. We'll deal with this later.

**Dimensions: X** and **Y** resolution set the pixel size of your final render. The percentage slider below them causes Blender to render at a percentage of the noted size. So, if your X and Y are set to 1920 × 1080 (HD 1080p), and you set the percentage at 45, the actual render will be 864 × 486 pixels.

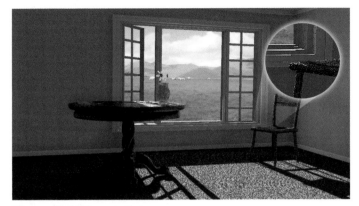

**Figure 12.2** *No anti-aliasing.*

**Frame Range** is a duplicate of the same control that you learned on the Timeline window. **Frame Rate** was already discussed in Chapter 11, but it's always worth it to double check before your final render. The **Presets** menu at the top of the panel holds common settings for modern production work. Just choose your target media from the Presets list and don't touch a thing.

**Anti-Aliasing:** Since this is better illustrated than explained, Figure 12.2 shows the example scene without anti-aliasing. The smoothness you normally see but that is missing here is generated when the renderer subsamples the edges of objects. Instead of just saying, "I have either this object or the background" and showing one color or the other, it looks more closely and says, "I actually have 15% of the object in this pixel, 80% of the background, and 5% of another object peeking out from behind," which it then uses to make a much better decision about the final color of the pixel. The different anti-aliasing levels (5, 8, 11, 16) refer to how "closely" the render looks "into" that pixel. The more closely it looks, the better the result, but the longer it takes. Of course, this comes at the additional cost of "sharpness," as a highly anti-aliased render will appear soft around object edges.

**Shading:** These settings directly affect which portions of the renderer's shader pipeline are available. Disabling any of them (Textures, Shadows, Subsurface Scattering, Ray Tracing) will cause those sections of the renderer to be skipped entirely. You already know what each of these features brings to your image, so you can figure out what disabling them will do. The **Alpha** control is crucial for compositing, so we'll address it in the second half of this chapter.

**Output:** Decides where rendered animation frames will be stored. Blender *does not store still renders by default*. If you want to save a rendered still, you have to specifically save it by pressing the **F3** key with the mouse over the rendered image, or choosing **Save As** from the **Image** menu on the UV/Image Editor header. The pop-up menu on this panel allows you to choose the image file format for saved renders. The default is PNG, which is a fine choice. When dealing with final animation renders, the OpenEXR format is great. I do not recommend rendering animation directly to any of the animation formats (Quicktime, MPEG, Windows Media). If a single frame goes bad, all of the rendering time for the whole animation is wasted. It's better to render to a series of still images, then put them back together later as we'll see in Chapter 14.

**Performance:** Blender automatically makes use of your multicore processor with the **Autodetect** option in **Threads**. **Tiles** refers to how many sections the renderer divides the image into while working.

You'll notice the effect when rendering the example scene, as it seems to work in chunks. These chunks are the tiles.

**Postprocessing:** By default, Blender sends all renders through both the compositor and the sequencer. We haven't messed with either of them yet, but we will. **Dither** adds noise to the final image, and is useful if you see banding in image backgrounds or on surfaces.

**Stamp:** We looked at the Stamp options when working with character animation.

## Speeding Up Test Renders

While you're working on surfacing and lighting, you need to constantly render your scene to see how you're coming along. The faster you can get meaningful feedback on your tests, the better able you are to refine your work. The two ways to speed up renders for test purposes are by reducing the render dimensions and reducing quality. Figure 12.3 shows a full-size, full-quality render of the example scene. You can refer back to that as we go through the different ways of increasing speed for comparison. This render took 9 minutes and 25 seconds (9:25) on a system running Ubuntu Linux 64-bit, Intel Core2Duo, 4GB RAM.

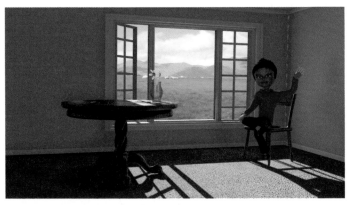

**Figure 12.3** *The full-size, full-quality render.*

If you are just going for overall impressions, as you might be when working with lamp settings, reducing the resolution by using the percentage slider on the Dimensions tab is ideal. How small should you go? The answer is another question: How small can you stand to look at? Figure 12.4 shows the scene rendered at 15% size.

Another way to reduce the size of the render without reducing the resolution is to set a Render Border. For example, when working on a shirt material, you need to see a high quality of a portion of the shirt, at full resolution. However, you don't need to see anything else in the scene. You could create a new camera, zoom it in so that nothing shows but the shirt, and render from there. A better solution though, is to enter a Camera view (Numpad-0) and use the Border operation, which is triggered

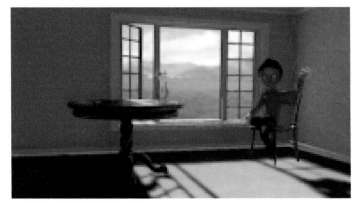

**Figure 12.4** *15% size; time: 1:08.*

with **Shift-B**. A crosshairs appears, just like with Border Select, and you LMB drag to define a region. Rendering now will only render the portion of the image within that border. To clear the border and render the entire image, you can either Shift-B Border Select outside of the Camera view, or disable the **Border** option on the Dimensions panel of the Render properties.

When it comes to reducing quality, you have many more options. Once again, you'll take a different approach depend-

**Figure 12.5** *No anti-aliasing; time: 0:09.*

ing on if you're performing overall "look and feel" adjustments or doing detail work.

For overall work, the most effective thing to do is disable anti-aliasing. This will severely compromise image quality, but you'll gain a lot of speed. All of the other features still work—shadows, textures, ray tracing, subsurface scattering (SSS)—so you get a view of what things will actually look like. They'll just have ragged edges. Figure 12.2 shows a full-resolution render with anti-aliasing disabled. If you really want a speed boost for doing "overall" work, disable anti-aliasing *and* reduce the size percentage, as shown in Figure 12.5.

To take quality and feature reduction farther you have to consider your scene. Do you use ray tracing (refraction, reflection, shadows)? If so, how integral is it to the aspects of the scene you are working on? In the example scene, the shadows from the main window and wall bounce are provided by ray tracing on area lamps. Disabling ray tracing kills that and the wood reflections. Figure 12.6 shows the result. Consider what you're working on, and if you can get along without ray tracing, disable it in the Shading panel. Likewise with shadows and subsurface scattering.

In fact, unless you're actively tweaking a material that uses SSS like skin, it's a good idea to disable it for speed. SSS adds a whole separate rendering pass to the process, and can take up a significant amount of time under certain conditions. Get your skin and other SSS-based materials as you like them, then disable SSS until final rendering.

Disabling shadows is a little harder to justify for stills. However, when working with animation and correct motion under

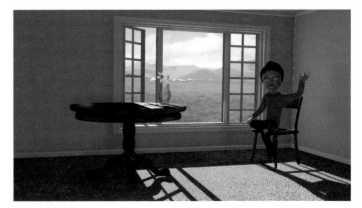

**Figure 12.6** *No ray tracing or subsurface scattering; time: 2:03.*

the microscope, killing off ray tracing, SSS, and shadows can give you immense speed ups.

There is one last bag of tricks that doesn't involve the render settings. Because of this, they are a little more of a pain to implement, but can be worth it, especially when working with animation testing. The Subsurface and Particle modifiers can both significantly increase the complexity of a scene's geometry. Unfortunately, there is no global setting to disable these features. By selecting each object in question and disabling the Render button in the appropriate modifier like Figure 12.7, you can eliminate these from the pipeline and gain some speed.

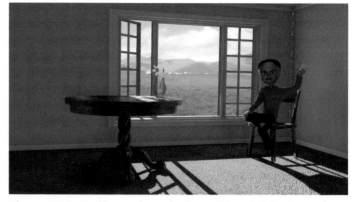

**Figure 12.7** *Disabling rendering on the Particle and Subsurface modifiers, everything else turned back on; time: 3:57.*

Finally, Figure 12.8 shows what happens when you use all of these strategies together, rendering at 100% of original size. At 25% size with the same quality optimizations, the render time drops to 0:05! Re-enabling anti-aliasing and adding back the particle hair bumps the time up to 0:23, and the result is much more useful. Granted, it's not useful for much, but it's a good demonstration of how far you can strip things down if you

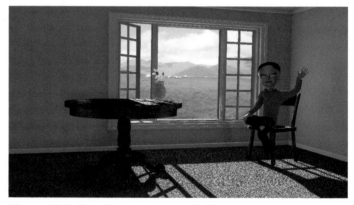

**Figure 12.8** *Everything at once; time: 1:09.*

need to. When things are this far away from how the final render will really look, you might be better off using the 3D view in Textured mode with GLSL enabled. It only supports buffered shadows and a subset of the texturing options, but it might look better.

## Finding the Sweet Spot for Final Renders

When it comes to final renders, you need what you need. If you've used subsurface scattering with someone's skin, you can't very well turn it off and expect your results to be any good. Beyond that, there is not a whole lot you can do. The techniques shown earlier in this book for modeling, lighting, and surfacing should already have your scene optimized to a large degree.

For actual render settings, do a few tests. Render with anti-aliasing set to both 5 and 16. Compare the results. Can you notice a difference? Is the difference you see worth the difference in render times, multiplied by

the number of frames in your animation? Try raising the number of tiles in the Performance panel. The default is 8 × 8, but try 12 × 12. Under certain circumstances, smaller tiles can give faster results while increasing memory usage a bit. Most likely, though, the difference in times will be negligible.

In the end, it won't hurt to review the surfacing and lighting in your scene. Ask yourself: Do I really need that ray-traced shadow, or would a buffered shadow do just as well? Does the subtle blurred reflection on the table need to be an actual reflection, or can I get away with a phony blend texture mapped to the reflection coordinates? There's only one way to find out, and you're the judge because it's your image. This goes the whole way back to Chapter 1 of this book. The entire exercise of working in 3D is fakery—what you can get away with. If you maintain that attitude, it will help you make the decisions about what looks good enough, and what doesn't.

## The Compositor

Blender's renderer isn't just for evaluating and drawing geometry. Integrated right into it is something called a **compositor**. A compositor is like an image processor with an awareness of what's going on in 3D. If you're used to image processors like Photoshop (or GIMP, etc.), you know that in order to, say, blur the background of a picture, you have to create a mask for it, painstakingly painting around the foreground elements so the blur effect is applied to the right portion of the image. This is because standard image processing programs have no idea *what* is in that image. It's just a bunch of colored pixels.

An integrated compositor, though, is much better. Since it's part of Blender's renderer, you can tell it to blur the background of your render, and it can do it without jumping through a lot of hoops, because it knows what parts of the image are near to the camera and which are far away. It can tell if something is moving, to generate motion blur. It can differentiate individual objects from each other. It knows what light comes from diffuse shaders, specular shaders, ambient occlusion, reflection, and refraction. It even knows if you've been bad or good.

All of this gives you immense power when completing your renders. That's right: The compositing process is really a part of rendering. Your images are almost certainly not everything they could be before passing through the compositor. Figure 12.9(a) shows a very simple image that consists of three crinkled orange balls on a flat plane. It's rather unrealistic. Figure 12.9(b) shows that same image after it comes out the other side of the compositor. It is significantly better. And, while it is far from realistic, it has achieved a degree of believability that would have been impossible from the raw render.

### Getting Familiar with the Compositor

The screen that we're already using to adjust render settings (Figure 12.1) has a Compositor window for its upper half. Blender uses a **node** compositor, which means that the compositing workflow is created by adding little panels to the screen and connecting them in various ways. Figure 12.10 shows the compositing workflow (sometimes called a *node tree* or *noodle*) to create a simple glare effect on our sample scene.

Before you begin to duplicate this, you'll have to enable the compositor. If you look at the actual window type, though, you'll notice that it is called a **Node Editor**. That is because the node interface that we'll be

using here is fairly generic and can be used to create advanced and flexible materials and textures, too. On the Node Editor's header, LMB click the rightmost button on the cluster indicated in Figure 12.10. This sets the Node Editor to compositing, as opposed to materials or texturing. When you select this, another series of options appears on the header. Enable **Use Nodes** to start the fun. You might think it's silly to have a separate Use Nodes control—*I'm here*, you think, *so I obviously want to use nodes!* The control should probably be called "Evaluate Nodes," because that is really what it toggles. Some nodes that you might add can take a long time to evaluate, and having to wait for them each time you make a small change can become tedious. Turning off Use Nodes causes Blender to skip node processing, allowing you to work more quickly and to re-enable it once you've adjusted all of your settings.

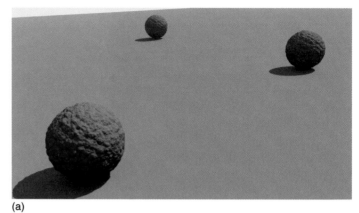

(a)

(b)

When you enable **Use Nodes** for the first time, the simplest of node trees is created. Shown in Figure 12.11, it consists of an **Input** node and an **Output**

**Figure 12.9** *(a) The image before the compositor, and (b) after the compositor.*

node. As you can see, the Input node is called Render Layers and represents the sample scene. The Render Layers node is how you get your rendered scene into the compositor. The Output node is called Composite. The Composite node is the end point of most node trees. It receives the final result of all the shenanigans that go on before, passing that result back to the renderer to present to you as an image. Notice also the curved line connecting the image sockets on both nodes.

Node trees are read from left to right. The labeled sockets on the left of the panels are called Inputs, because they receive information. The labeled sockets on the right side of a node are called Outputs, because they send out information. The node tree in Figure 12.11 is actually pretty useless, as you might guess. The Render Layers node receives the rendered image of the scene. That image is sent out through the Image output socket, which is connected to the Composite node's Image input socket. The image itself passes to the Composite node, which returns it to the renderer. In between, nothing happens. That's useless.

Contrast it with the Glare node tree in Figure 12.10. To learn the basics of dealing with nodes, let's turn the default tree into the Glare node tree. The Node Editor workspace functions just like Blender's other

**Figure 12.10** *A glare effect.*

2D windows: Use the mouse wheel to zoom in and out; MMB dragging pans; and use Ctrl-spacebar to fill the screen.

First, disconnect the two nodes by LMB dragging on the input socket of the Composite node. That end of the connector follows the mouse. Drop it anywhere in the workspace, and the entire connector disappears. Connectors need to touch sockets on both ends, or they cease to exist. LMB drag on the little

339

headers of the nodes to move them toward the edges of the screen, making space for a new node between them.

Use the universal key for adding elements in Blender (**Shift-A**) to bring up the complex Add Node tool. I say complex, because there are currently over 60 different node types, grouped into 8 categories. Figure 12.12 shows the menu, choosing **Add > Filter > Glare**. The Glare node springs to life in the workspace. LMB drag it to the center of the screen.

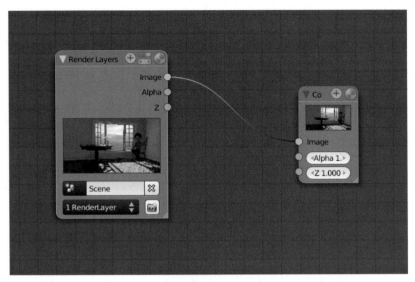

**Figure 12.11** *The most basic valid node tree.*

To create the node tree, LMB drag, starting on the Image output socket of the Render Layers node, ending on the Image input socket of the Glare node. That feeds the rendered image to the Glare node. Now, LMB drag from the Glare node's Image output socket on the right to the Composite node's Image input socket. All done! The node network might process for a second as it applies the glare effect to the image.

But what did it do? An easy way to get feedback on what's going on in a node tree is to add a Preview node. Use Shift-A again, this time choosing **Output > Viewer**. A new node called Viewer is added to the workspace. LMB drag it to rest just below the Composite node. Go back to the Glare node, and connect its Image output socket to the

**Figure 12.12** *The Add Node menu.*

Viewer node's Image input socket (LMB drag). A node's output sockets can feed their information to any number of input sockets on other nodes. Input sockets, however, can only receive information from a single source.

With the Viewer node hooked up, enable the **Backdrop** option on the Node Editor header. The composited image shows up in the Node Editor's background! A Viewer node pumps whatever image it receives in its input socket to the Node Editor's background, giving you a convenient way to maximize your workspace, while retaining a full-resolution preview of what your node tree is doing. We'll fiddle with

the actual settings of the Glare node later. Those are the operational basics of working with nodes.

Let's take a closer look at the anatomy of a single node: Render Layers. Figure 12.13 shows a close-up of the Render Layers node, the basic channel of communications between the renderer proper and the compositor. It contains a small preview of the image, as well as several selection controls. The first selector below the preview image allows you to choose from any scenes within the current BLEND file. The Layer control below that, which displays **1 RenderLayer**, allows you to select from any number of rendering groups that you'll learn how to create later.

On the right are three output sockets. One for the RGB image itself; one for

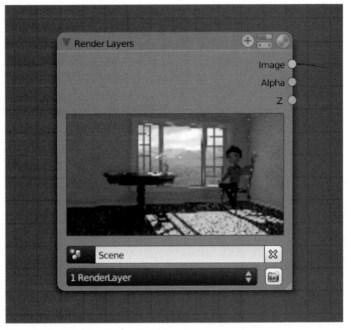

**Figure 12.13** *The Render Layers node.*

Alpha, in case your image uses transparency or shows the sky; and one for Z, which tells the compositor how far away the surface represented by that pixel is from the camera. Notice the little hashed area in the lower right corner of the node. LMB dragging the corner resizes the node, within certain limits. On the header of the node are several display controls. The + symbol hides and shows unused sockets. Node trees can become visually complex, and if you know you're not going to be using certain sockets, hiding them can help to avoid clutter. The two-tiered control to the right of the + hides and shows all nonsocket controls on the node. This can save a lot of space, especially when nodes have a large number of controls, like Glare. Finally, the ball icon that looks like the one from the Material properties context hides and shows the thumbnail image.

Pressing the N key in the Node Editor opens the familiar panel on the right of the workspace. The panel displays the nonsocket controls of the active node (the one to last receive an LMB or any kind of action). This is particularly helpful with large node trees when you might have to zoom out to fit everything onto your screen. The controls can be difficult to work at those sizes, so a simple LMB click on the node in question lets you work the controls at full size in the N-key panel. The node's name, displayed on its header, can also be changed here.

## Overall Effects
Let's look at some of the simple and useful effects you can generate.

### Depth of Field

Figure 12.14 shows the Defocus node. Defocus analyzes the depth information from the render via the Z-channel, then applies a selective blur. The final effect is very much like the defocusing that occurs when shooting a scene through a real lens.

To test this node, you can either create your own simple scene or use *defocus_testing.blend* from the Web Bucket. If you're making your own, create an array of objects (cubes, spheres, whatever) spread across a plane, and put a camera looking down on it at an angle. Select your camera and bring up its properties in a Properties window. At the bottom of the Camera properties **Lens** panel is a control for **Depth of Field > Distance**. Enable **Limits** below it in the **Display** panel. This shows the camera's clipping distance within the 3D view as an orange line. Now, start raising the value of the **Distance** control. A yellow target moves away from the camera, shown in Figure 12.15. This will be the node's focal point. Objects that are further from this target point will receive more blurring.

Set the target to fall nicely in the middle of your array of objects. This has already been done on the sample file. Back in the Node Editor in the Composite window hook the Render Layers Image output to the Defocus node's Image input, and pipe the Defocus output to the final Composite node. You can add a Viewer node and enable Use Background if you like. Depth information comes along with a render in the Z-channel.

**Figure 12.14** *The Defocus node.*

To let the Defocus node access it, connect the Z output socket of the Render Layers node to the Z input socket of the Defocus node. See how that works?

Going back to the node parameters themselves, the real ones to be concerned about here are f-Stop, Preview, and Use Z-Buffer. Enable **Use Z-Buffer** if it isn't automatically set when you connected the Z-channel to the node. Enable **Preview**. This gives a grainy result, but is very fast. Leave Preview turned on while you are adjusting settings, but turn it off when you're done to get a fully smoothed final image. You probably won't see any defocusing going on until you adjust **f-Stop**. This is akin to the f-stop setting on a camera. The lower you set this number, the more blurring will occur. F-Stop follows a "rule of halves" of it's own—cutting the number in half doubles the amount of blur. In the example scene, you can't really see any defocusing until it gets down to around 30 or so. A nice value seems be to around 24. You can see the result in Figure 12.16. It's subtle, and most noticeable on the hills in the background.

As a small suggestion when using Defocus, I'm going to take us back to the beginning of the book. Keep it subtle. I *know* that you're probably excited about how easy it is to use a feature like this, but restrain yourself. In addition to giving depth information to the viewer, the amount of focal blur in an image also gives hints about scale. Wade through Google image search or Flickr for close-ups of insects and such. Notice

the high levels of focal blurring away from the subject. Now check out some pictures of landscapes and natural vistas. Almost everything in those shots is in sharp focus. Remember as you apply this effect that high amounts of Defocus indicate a smaller scale.

## Motion Blur

Another kind of processing that is essential to a believable scene is motion blur. We experience the effects of motion blur in the real world, not just in movies and television, but even with our own eyes. When things move faster than our ability to process them or faster than a camera's ability to capture them, they are perceived and recorded as a blur.

Blender simulates this effect with the **Vector Blur** node, shown in Figure 12.17. Note that there is a new input socket: Speed. In order to decide how things are moving, the node needs speed information from the renderer. To get it, head over to the Render properties context. Remember the **Layers** panel that we skipped in the previous section? Expand it. There's a lot there, but for now, ignore most of it. At the bottom of the panel, though, are a number of checkboxes with names like Combined, Z, Normal, UV, etc. Enable **Vector**. When

**Figure 12.15** *The camera with Distance target.*

**Figure 12.16** *The Defocus node applied to the sample file.*

you do, an output socket named **Speed** is magically added to your Render Layers node in the compositor. Each of these checkboxes, if enabled, adds another output channel to the node, allowing you to deal with these channels (called "passes") individually if you like. For now, though, let's be happy with Vector. You'll need to re-render the scene at this point to generate the Vector (Speed) pass. Any time you enable another pass in the Render Layers panel, you will have to re-render before it is really available. With that in mind, it's probably a good idea to consider what passes you will need *before* you even hit the Render button for the first time, and enable them.

To add motion blur to the little example scene, use Shift-A to add a **Filter > Vector Blur** node. Now we have to decide where to put it: before or after the Defocus node. If we put it before Defocus, things might go awry. The Z-channel that Defocus uses to make its depth decisions comes straight from the render, while the image would come from the Vector Blur node. Defocus might accidentally apply blurring to a part of the image that has already been blurred by the Vector node. On the other hand, the same thing could happen if the order is reversed. If you defocus first, a portion of the image might be motion blurred because of the Speed pass that has already been blurred.

**Figure 12.17** *The Vector Blur node.*

In the end, this is going to be a judgment call, and it highlights one of the weaknesses of the compositor: Nothing is perfect. Although the compositor has depth and other data made available to it from the renderer, it still is only working with a flat image and there is only so much you can do. Trade-offs will have to be made. Tests will have to be done.

In this case, just try hooking up the node tree both ways and see which way looks most believable to you. You might not even be able to tell a difference, which is great. In the example, I've hooked up Vector Blur before Defocus. To do so, connect the Render Layer node's Image, Z, and Speed outputs to the Vector Blur inputs of the same name. Connect Vector Blur's Image output to Defocus' Image input. The node tree will look like the one in the second part of Figure 12.18. Notice how the basic information connections like Z and Speed always go back to the Render Layers node, but the image itself gets "threaded" throughout the tree, the result of each node passing on to the input of the next. This is the basic method of working in the compositor.

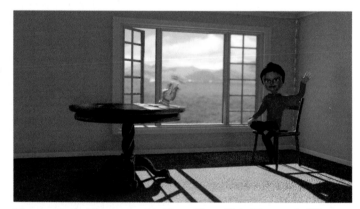

**Figure 12.18** *The image with Vector Blur added. The vase is falling.*

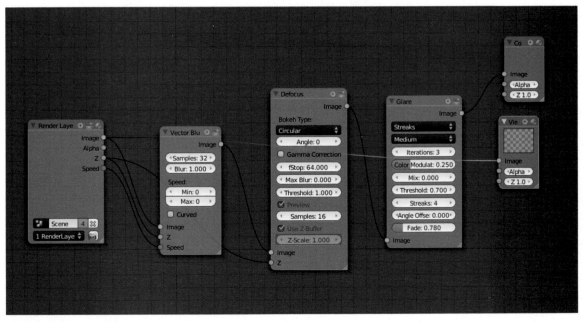

**Figure 12.18, cont'd**

Referring back to Figure 12.17, the relevant Vector Blur controls for most cases are Samples, Blur, and Curved. **Samples** controls the quality of the result; 32 is the default, and might work for you. The effects at very low values (like 5) are obvious. Once you hit a certain level of smoothness, though, raising the number any further only wastes time. **Blur** controls how far back and forward in time the object's motion is projected in order to generate the path of the blur. The default is 1.0, which means that the entire blur will take place over one frame in time. If you're rendering frame 324, it will use the Speed vector to determine where the object was at frame 323.5 and where it will be at frame 324.5. It splits the difference around the current frame. So, if you want a longer or more pronounced blur, you raise the value. For a shorter blur, drop it. Finally, the **Curved** option is slower, but provides a more accurate blur. If you think about the way the node works—it finds two points, then creates a streak between them—you'll realize that it won't work very well for objects that are rotating or traveling in an arc. The Curved option takes those types of motions into account.

### Glow and Glare

Glare is another one-shot node effect. The Glare node is found under **Add > Filter > Glare**. Its purpose is to identify bright areas of the image and spread them out in various ways, hopefully achieving the kind of bloom seen in photography.

Figure 12.19 shows the Glare node. By now, you should be able to put it into the growing node tree without step-by-step instructions. Put it after the Defocus node, right before the Composite node. The

way to adjust the Glare node is to set the **Mix** control to 1.0. The Mix control defaults to 0.0, which is an equal blend between the original image and the glare effect. Setting it to 1.0 shows only the glare effect, which makes it easy to see what you're doing. The **Threshold** control determines what the node considers "bright." At 1.0, it only affects very bright pixels, called "super brights" by compositors. Depending on what is in your image, you may have to lower Threshold in increments of 0.1 until you see you anything at all affected. This also allows you to experiment with the different glare effects: Ghosts, Streaks, Fog Glow, and Simple Star. **Iterations** affects the quality of the final effect.

Once you have your bearings with Mix set to 1.0, change it back to 0.0. Now you can fine-tune your settings and see what it actually looks like. Figure 12.20 shows the main sample scene rendered with the Glare node applied. Once again, subtlety is called for. A little bit of bloom and glare will add believability to your image, while overdoing it will just make things tacky.

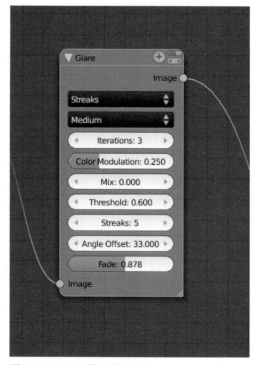

**Figure 12.19** *The Glare node.*

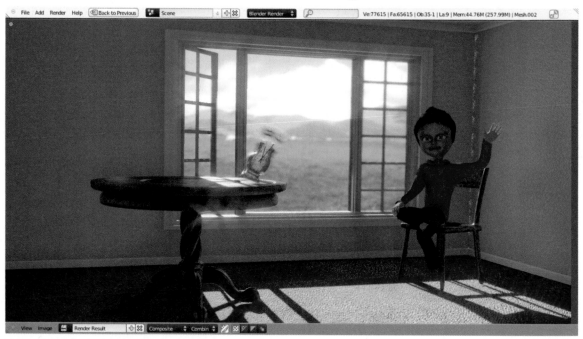

**Figure 12.20** *The sample scene with Glare node applied.*

## Color Changes

Beyond special effects, the compositor can be used to enhance images with color correction. Color correction using RGB curves is a complex topic, and entire books have been written about it. I'm going to give it to you in a couple of hundred words.

The **RGB Curves** node, found in the **Color** category, is the primary method for adjusting color in the compositor. Figure 12.21 shows the node. It takes an image as input, and delivers one as output. The diagonal line in the middle of the node's workspace is the default "curve." LMB clicking on that line and dragging it adds a control point, which deforms the line into a curve. You can LMB click multiple times on the curve, adding more and more control points as you need them. Also, LMB clicking and dragging on existing points moves them, altering the shape of the curve.

Without going into a bunch of color theory, Figure 12.22 shows several common curve configurations, as well as their result.

**Figure 12.21** *The RGB Curves node.*

You can also adjust the curves for each of the three color channels (R, G, and B) individually. The CRGB button set at the top of the node controls which channel is displayed in the workspace, with the "C" standing for "Combined." Working with the individual color channels is one way to alter the colors in your image. For example, raising the center point of the green curve shades the image green.

If you're looking to give subtle (or even not-so-subtle) color casts to your images, though, there is a much better way.

## Color Grading

So far, the compositor has only been used as a straight-through tool to add effects to an image. There is a single input, which passes to several nodes in turn, and finally to an output. The great strength of the compositor, though, is its ability to combine different inputs.

Let's go back to the default compositor setup: a Render Layers node and a Composite node. You can keep working in the same workspace by LMB selecting the intermediate nodes and using the X key to delete them. To this basic workspace, add a **Mix** node from the **Color** section of the Add menu. The Mix node is shown in Figure 12.23. Notice that it has two Image input sockets. The Mix node's job is to accept two images and mix them according to the configuration of the node's controls.

Connect the Render Layers Image output to the upper Image input of the Mix node. Also, send the Mix node's output to both the Composite node and to a Viewer node so you can see what you're doing.

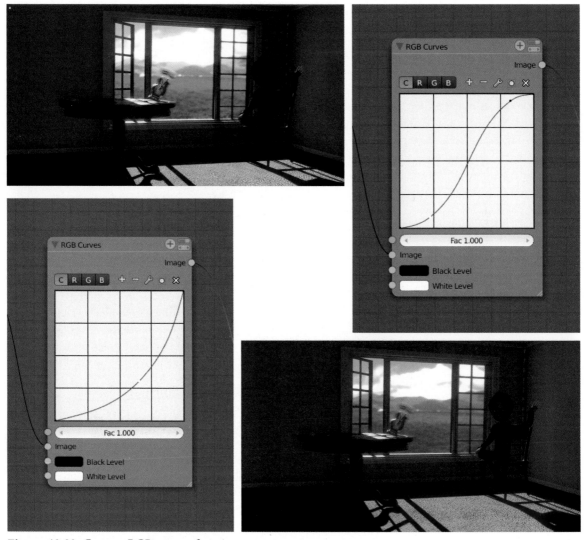

**Figure 12.22** *Common RGB curve configurations.*

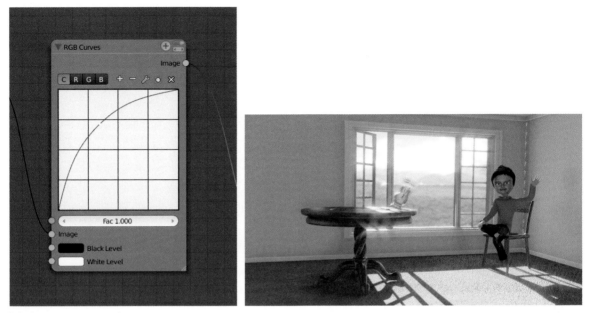

**Figure 12.22, cont'd**

Notice how the lower Image input socket has a white rectangle beside it. Unless you connect another actual image channel to that socket, the node will use the color in the rectangle as its input. LMB on the white swatch to bring up the color picker, and choose a bright orange. The preview in the compositor's background casts orange. This is because the node is blending the orange color from the secondary input with the image from the upper input, at 50% strength, in regular *mix* mode. The **Fac** (factor) control determines the mix percentage. The pop-up menu that defaults to Mix contains all of the blending modes that we went over in Chapter 7.

If you like, you can raise the Fac value to 1.0 to see orange take over the whole image, or drop it to 0.0 to see just the original render. Our goal, though, was to provide a nice colorization of the image. Simply mixing orange at 50% strength ruins the contrast of the original. Switch the mix type to **Soft Light**. This is the sort of work that Soft Light mixing was built for. You can turn the Fac control up to 1.0, and the effect is still very nice. In fact, pump it up to 5.0 (the max) and you get a nice, stylized look. Contrast is retained, and even some of the original color scheme. Figure 12.24 shows

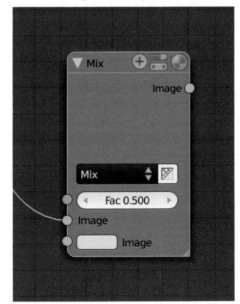

**Figure 12.23** *The Mix node.*

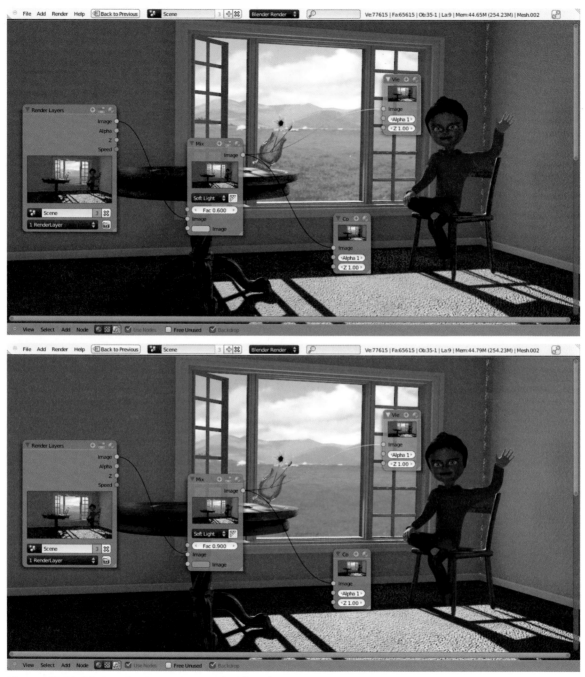

**Figure 12.24** *Mixing colors into an image with Soft Light.*

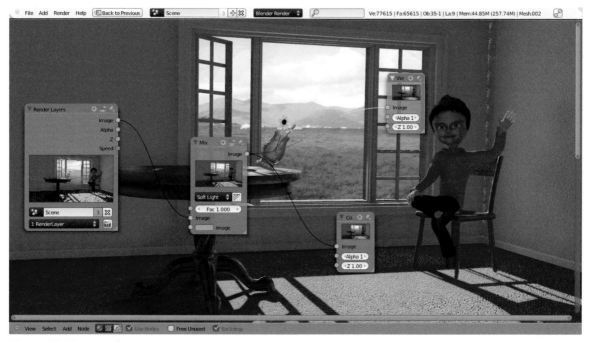

**Figure 12.24, cont'd**

a few combinations of color swatches and blend factors, demonstrating the flexibility of this colorization method.

But didn't we say we would be combining different inputs? Indeed. Add an additional node to the tree: **Converters > ColorRamp**. The ColorRamp is just a "nodification" of the color ramp that you learned to use for making blends in Chapter 7. Shown in Figure 12.25, it takes a **Fac** value (a single grayscale channel) as input, and generates a color image as output. Connect the RenderLayers Image output to the ColorRamp Fac input. Even though the image is RGB and the ColorRamp input is expecting grayscale, it works. The compositor automatically samples the RGB data to match the type of data expected by the input by completely desaturating the image. Connect the ColorRamp node's Image output to the Viewer node.

**Figure 12.25** *The ColorRamp node.*

Notice that the Viewer node doesn't have to be connected to the same node as the final composite output. You can connect it to the output of any node in the tree, if you want to see the image at that point. In this case, you'll see that the ColorRamp node is turning the image black and white. It takes the input,

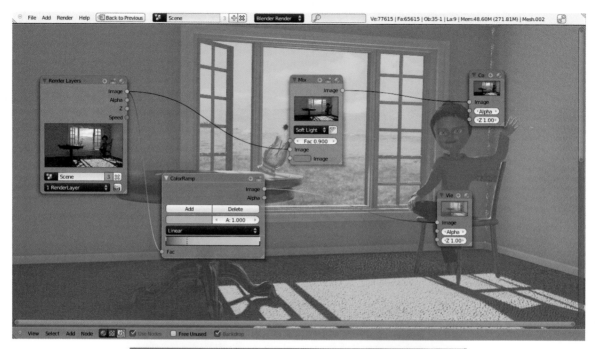

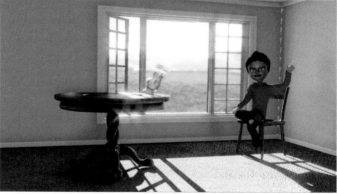

**Figure 12.26** *A colorized version of the render, and the original render with the Soft Light result mixed in.*

maps it to the colors on its ramp control, and sends the resulting image on its way. LMB click on the selectors in the ramp control, and change them from black and white. Remember that you can adjust the controls on the N-key side panel if you're more comfortable doing so. Whatever colors you choose, the new image is shown in the composer's background. In Figure 12.26, we've chosen a dark blue for the left side of the ramp, and a bright yellow for the right.

Now, send the ColorRamp's output to the bottom Image input of the Mix node. Instead of using a solid RGB color for our Soft Light mix, we're going to use the colorized image.

This is a simple but effective way to color grade your images and animations. Want to warm up the shadows and cool down the highlights? Soft Light blend a color-ramped image that uses deep reds for the darker tones and cyan for the brighter ones.

### Render Layers and the Compositor

The Render Layers system allows you to group the objects in your scene so that they are accessible as different inputs in the compositor. Figure 12.27 shows the chock-full-of-fun Render Layers panel in the Render properties context. At the top is the familiar control space for dealing with multiple groups of settings, like materials, vertex groups, and textures. In the figure, two Render Layers exist: "Sun" and "Earth." A different one is highlighted and visible in each half of the illustration. Each of these Render Layers will be available from a Render Layers node in the compositing workspace.

The **Name** control allows you to set the name of the currently selected Render Layer. Below that are two sets of layer buttons. The ones labeled **Scene** are just a convenient repeat of the layer buttons that you find on the 3D view header. Messing with them here will change the visibility of objects throughout your scene, so be careful. It's the layer buttons labeled **Layer** that are important. These ones control which

**Figure 12.27** *The Render Layers panel.*

scene layers will be included in this *render* layer. In Figure 12.27, layers 1 and 2 are enabled for the entire Scene, while only layer 1 is enabled for the "sun" Render Layer. Remember when I mentioned that the terminology when it comes to layers can get confusing? Well, here we are.

This stuff can get a bit complicated, so instead of working with the main example scene, we're going to simplify. Open the *monkey_orrery.blend* file from the Web Bucket for Chapter 3 (it's also included in this chapter's Web Bucket). In the scene, which is where the Render Layers panels came from, we have the sun, shining on layer 1, and the Earth chilling out on layer 6. If you hit Alt-A, you'll see that the sun rotates over 90 frames, and the Earth-monkey revolves around it. Due to the camera angle, at one point the Earth is completely obscured by the sun, and at another it passes directly in front of it.

Before we begin to fool with this in the compositor, hit F12 to do a basic render. When it's finished, you see that your render window only shows the sun. Down on the Image Editor's header, you'll see a control that you haven't dealt with before, to the right of the image's "Render Result" name. The control is a pop-up menu that reads "Sun" and is shown in Figure 12.28. LMB clicking shows that both the "Sun" and "Earth" layers are available as separate images within the render.

**Figure 12.28** *The Render Layers selector in the Image Editor.*

Further to the right on the header is a series of buttons that determine which image channels are displayed. We've worked with Alpha before when making objects transparent in Chapter 7, but didn't mention that each image you render has a full Alpha channel included with it. In addition to having an R, G, and B color, every pixel in your rendered image has an Alpha value, ranging from 0.0 to 1.0. If you remember to think of "Alpha" as "opacity" (instead of "transparency"), it will be obvious that pixels with an Alpha of 1.0 will be completely opaque—the normal state of things. Pixels with an Alpha of 0.0 will be completely transparent.

The buttons, which are highlighted in Figure 12.28, tell the Image Editor to show only RGB, RGB with Alpha, or just Alpha. In the combined image (RGB + Alpha), transparency is shown with a gray-and-white checkerboard pattern.

One of the reasons you may not have noticed this yet is because we have been rendering with a **Sky** for the background. The **Alpha** selector on the **Shading** panel of the Render properties controls what the renderer puts in the background when there are no objects. In the case of these space monkeys, a lot of the image is comprised of this kind of space. Set to **Sky**, empty space is filled with whatever colors or textures are designated in the World properties. This is what we have been doing so far. For simple renders with no compositing, it is an easy way to put something in the background.

Now we're all grown up, though, and it's time to leave our diapers behind.

The other settings of the **Alpha** selector are **Straight Alpha** and **Premultiplied**. Straight Alpha renders the full pixel color of an object's edge and assumes that you'll use the Alpha channel later to make it blend nicely with the background. Premultiplied shows up already nicely blended. If you're only going to be working within Blender, there's no reason to use Straight Alpha for now. The *monkey_orrery* scene in the Web Bucket has been set to use Premultiplied, which is often shortened to "Premul" in the interface.

All this talk about Alpha ought to be leading up to something, right? Let's dive back into the compositor to find out.

Do the standard dance of choosing **Compositing Nodes** from the Node Editor header, and enable both **Use Nodes** and **Backdrop**. Disconnect the initial Render Layers node from the final Composite node,

and move them apart to make some room to work. Notice that on the Render Layers node, the pop-up menu at the bottom allows you to select either the "Sun" or "Earth" layer. We want "Sun" for now.

Add an **Alpha Over** node from the **Color** section (Shift-A > Color > Alpha Over) and place it between the two other nodes. Alpha Over is the workhorse of the compositor. It takes two image inputs and combines them based on the Alpha values of the primary image. The socket stack order is counterintuitive, so be careful. The lower Image input socket is primary, meaning that if all of your images were printed on clear plastic and layered, it would be at the top of the stack. Personally, I think that's silly, but it's just the way it is.

Connect the Image output of the "Sun" Render Layer to the lower (primary) Image input of the Alpha Over node. Add a Viewer node and pipe the Alpha Over result to it so we can see what we're doing.

Add a new kind of input node: Image (Shift-A > Add > Input > Image). This lets you bring an image directly into the compositor. You can choose one that is already in use in Blender by clicking the image icon on the node—the control is the standard image selection set, shown in Figure 12.29. You can also click the **Open** button on the node, which sends you to the file browser to choose an image. In this case, open a new image and find *monkey_stars.jpg* from the Web Bucket. Connect the Image node's output to the upper (secondary) Image input socket of Alpha Over. Figure 12.30 shows the setup.

The compositing workspace is filled with beautiful stars! Notice that the Sun-monkey floats on top of the stars. Everywhere that had been designated as Alpha = 0.0 in the render lets the secondary image show through when pumped through the Alpha Over node. Alpha Over is the primary method for combining renders with imported images and renders with other renders.

Let's add the Earth-monkey into the mix. LMB select the original Render Layers node. Press **Shift-D** to duplicate it and move it away from the original. To get a new Render Layers node, you could also do Shift-A > Input > Render Layers, but this works just as well. Change the layer selector on this new node to the one marked "Earth."

Duplicate the Alpha Over node in the same fashion. For positioning of these new nodes, refer to Figure 12.31. The exact location of the nodes doesn't really matter, but it's nice to try to keep the workspace organized. Node trees can quickly become complicated, and having to follow a connection the whole way across the screen and under a dozen nodes just to find its source isn't something you want to have to do on a regular basis.

The nodes in Figure 12.31 have already been connected. The result of the original Alpha Over node, which contains both the star background and the sun, is piped to the secondary input of the new Alpha Over node. The Image output of the Render Layers > Earth node becomes the primary input. The Viewer node has been set to preview the output of this new node.

This is how you build up layers of inputs in the compositor: a series of Alpha Over nodes, bringing different inputs together.

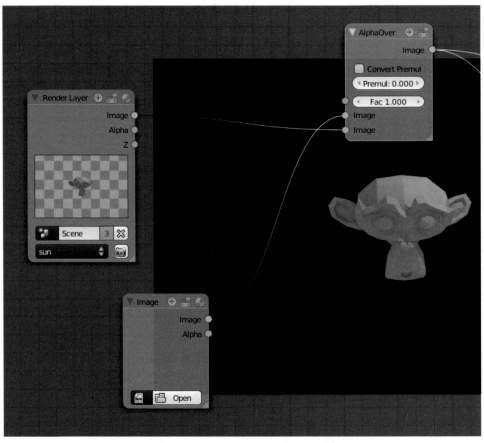

**Figure 12.29** *The Image input node, with the previous Alpha Over node.*

You might be wondering: What's the point of all of this? Why chop a perfectly good render up into different layers only to put them back together in the compositor? The answer: So you can process the objects differently. In this scene, we'll make the sun glow. Above the original "Sun" Render Layer, add two more nodes: Filter > Blur and RGB Curves. Send the sun's original rendered image to the Blur node's input. Set Blur's X and Y values to around 30—this determines the amount of blur in pixels that is performed on the image. Send the image result from Blur to the input of the RGB Curves node. Grab the center point of the curve line and pull it up and to the left, brightening the input image. You can attach the Viewer node to RGB Curves to see what's going on.

Finally, add a Mix node (Color > Mix). The output of the RGB Curves node becomes the primary input of this Mix node. For the secondary (upper) input, use the output of the very first Alpha Over node, the one that combines the sun with the image of space. Figure 12.32 shows the increasingly complex node tree. This mixes the blurred, brightened image of the sun into the pipeline. As we only want to brighten

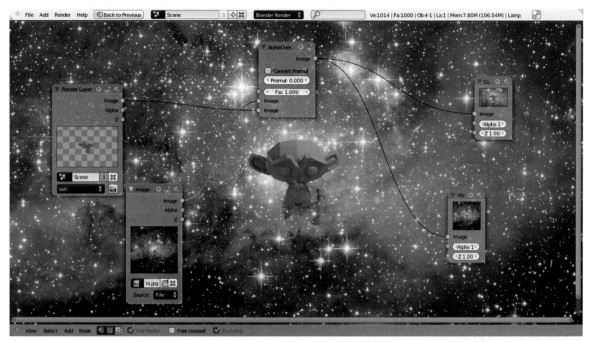

**Figure 12.30** *Monkeys in space!*

things, set the Mix type to Screen, and push the Factor on the node up to 1.0 at least. To connect this up with the rest of the tree, send the Mix node's output to the secondary input of the next Alpha Over node.

What we've done is create a miniature node tree with the Blur to RGB Curves section, and joined it into the rest of the node tree with the Mix node. The result is that the Sun-monkey now glows. If we had been rendering everything in a single layer, this glow effect would apply to every object in the scene. As it is, the effect is isolated to the sun. Chopping things into Render Layers isn't always necessary, and shouldn't be done without a reason. However, when you find that you need to apply different effects to portions of your scene in the compositor, this sort of compositing is exactly what you need to do.

Continuing, let's try to add vector blur to the composite. Think for a moment about what's going to happen, though. Vector blur uses the Z and Speed sockets of the Render Layers node to generate its effect. If we were to perform the blur on the entire finished image, which Z and Speed outputs would we use? Neither Render Layers node provides the entire picture, and neither one provides Z or Speed values for the other.

The best way to solve the problem is to use two Vector Blur nodes, and blur each portion of the image separately. Figure 12.33 shows the now-even-more-complex node tree that accomplishes this. Note that it isn't anything you haven't done before. It's just that different elements are being combined and spliced into the existing tree. Also, remember that to accomplish this on your own, you would have to enable

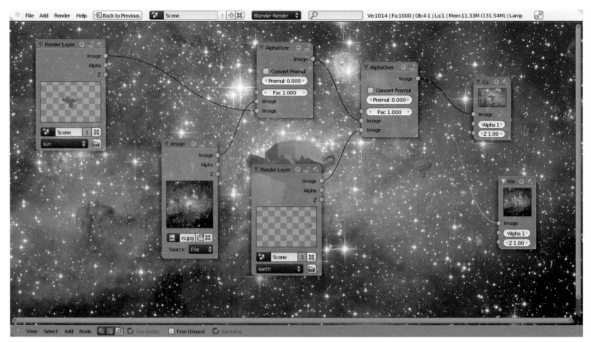

**Figure 12.31** *Adding the Earth. Well, the Earth-monkey.*

the **Vector** pass for each render layer in the Render properties to get **Speed** to show up as an output in the compositor. You will also have to re-render to get the Speed data to appear.

One final thing to note about this construction is that the Vector Blur is applied to the image *after* the Alpha Over procedure. Applying the blur to the raw render data before it is combined with the background is extremely difficult, due to the way Vector Blur deals with Alpha. You can try it if you like, but unfortunately it doesn't work like you'd expect. Combine your image with Alpha Over first, then Vector Blur.

If you were going to render out this entire 90-frame animation at this point, it wouldn't work. Everything would be fine until the Earth passed behind the sun. Figure 12.34 shows a render with our current composite settings on frame 44. The Earth is behind the sun from a 3D perspective, so it shouldn't show up in the final image. However, there it is.

The problem is that we're performing the Earth's Alpha Over operation after the sun is already composited into the background. To make it right, we would have to switch the order in which the whole image is composited: Earth first, followed by the sun. Of course, that setup would then fail when the Earth passed in front of the sun. As the sun would be composited last, it would still fall in front of the Earth.

The solution is to leave the node tree as it is, but to give it a little more information to work with. Back in the Render Layers panel of the Render properties, select the "Sun" Render Layer. In the Include section

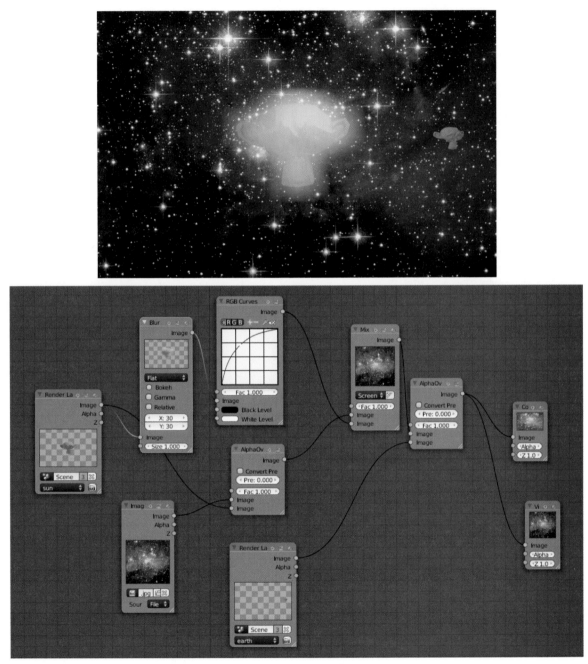

**Figure 12.32** *Adding a glow effect to the sun.*

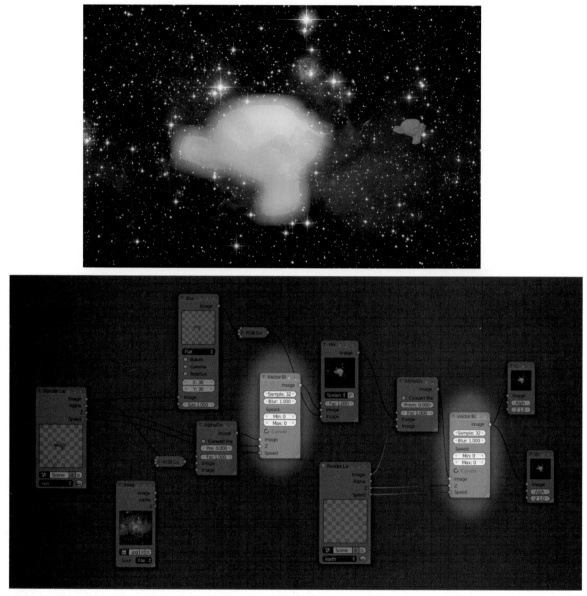

**Figure 12.33** *Adding Vector Blur to the image.*

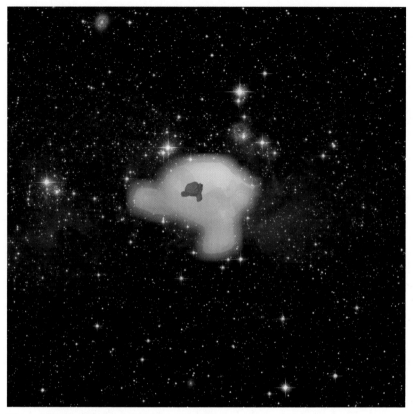

**Figure 12.34** *The Earth should not be here.*

of the Layers panel, enable **Zmask**. When you do, a whole new set of layer buttons appears, labeled "Zmask Layers." On this new panel, enable both the layer with the sun object and the layer with the Earth. Now, when you render and the Earth is behind the sun, the Earth no longer appears in the render, as anything behind the sun receives an Alpha of 0.0, effectively erasing it.

You don't always have to use this feature. In fact, the only time you do is when your composite is animated so that the layering of elements in the scene changes over the course of the animation. If nothing in an earlier composited render layer ever obscures something in a later composited portion, you don't need to bother.

## Conclusion

Figure 12.35 shows the node tree and result for a frame from the example scene. Breaking it up into separate Render Layers wasn't necessary, but I've used Glare, Defocus, and Vector Blur to enhance the image,

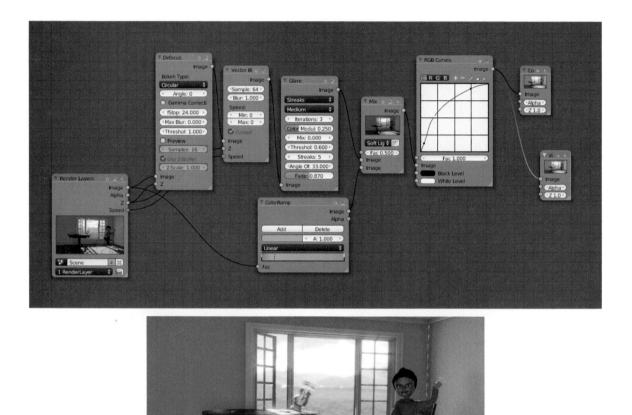

**Figure 12.35** *The final node tree and image for the example scene.*

and pushed the final color around a bit in an RGB Curves node. The final image is significantly better than the original, and it takes only 30 seconds for the node tree to process.

## What We Missed

Entire books are written on compositing and rendering, and what we missed could fill them. Mainly though, there are a pile of different node types for mixing, adjusting, and otherwise transforming your renders. You know the ones that will be most useful to you while you're getting started, but once you're familiar with them, start digging through the Add Node menus to see what other gems are buried therein.

All values in nodes, like the blending factor, are animatable just like any other property value. Blender also has a built-in network renderer that uses any computers in your network as rendering slaves with the proper setup.

## Next Up ...

In Chapter 13, we take a look at some of Blender's physics simulators to add windblown curtains and flowers to our scene, as well as magic particle system sparkles and smoke.

# Chapter 13

## Environmental Animation

## This Is Not a Physics Class

We've done some math, and now we're going to do some physics. For certain tricks in animation, there is no substitute for the real thing. A bunch of tumbling blocks. A flag blowing in the wind. A shirt draped across a moving body. You could hand-animate each of these, but they are so familiar to us that even a small deviation from real motion will ruin the illusion. In such cases, it can be helpful to use a physics simulation. Blender includes a number of simulators: rigid body (hard objects), soft body (squishy things), cloth, smoke, and fluid. Unfortunately, Blender's rigid body system was not available before the publication of this book. Lucky for you, you can find a whole section about the rigid body simulator in the Web Bucket for this chapter as soon as the developers have it hammered out.

## Cloth and Force Fields

While it would have been great to add a cloth simulation to our character's shirt, Blender's version of cloth just isn't up to the task yet. Flowing skirts, banners, and flags all work great, but the kind of pinching and friction-based wrinkling that occurs in a fitted item like a shirt makes using the simulator next to impossible for it. Let's take a look at what it *can* do though, by adding a simple set of curtains to our example scene's window, then lightly disturbing them with some wind.

Okay, for the home décor people, these aren't technically going to be curtains. They're shears. Curtains require massive amounts of wind to move and block way too much light. Shears can be disturbed by the slightest rustle and are mostly translucent. The model is simple: a **Grid** mesh primitive, subdivided once then scaled down along the $z$ axis. To make it fancy, I've selected every other column of vertices and moved them a bit backward, creating the zigzag base you see in Figure 13.1. The shears will be attached to some kind of curtain rod at the top, as they are in real life. This kind of fastening is indicated in the cloth simulator by an option called **Pinning**, which protects vertices from being affected by the simulation and causes them to act as anchors. I've selected the top two rows of vertices and made them into a vertex group called "pinned." The material settings aren't important to the simulation, but if you're curious, they use Translucency, the Minnaert shader, and Z-Transparency with Fresnel. If you're following along and adding this to

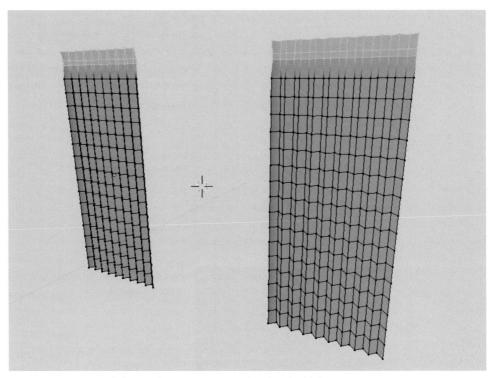

**Figure 13.1** *A set of shears. The top vertices are selected and added to a vertex group.*

your example scene, start by modeling the shears in the same object layer as the rest of the room so you can see where the window is. When you're finished, move the shears off to a layer by themselves so you can work undisturbed, or press Numpad-/ to drop it into Local mode. In the example scene, only the window on the left is open, so we're only going to simulate wind moving the shears on that side.

For a cloth simulation, enable **Cloth** in the Physics properties of the shear object. There are a number of helpful presets. The closest one to shear material is **Silk**, so choose that. Figure 13.2 shows the silk defaults. Although every attempt has been made by the developers to simplify the controls for cloth simulation, it really is some nasty voodoo to get it right. In this case, we want a material that's even lighter than silk, so we'll reduce **Mass** significantly, to 0.050. The key to this simulation, though, lies in the pinning. The vertex group that was created with the shears must be entered into the Pinning section of the Cloth controls by first enabling **Pinning**, then selecting the vertex group by name in the control below.

That's all you have to do to set up a cloth simulation. Press Alt-A in the 3D View to play any animation in the Scene, and you'll quite possibly see the shears droop and dangle a bit. Nothing dramatic, though.

In order to generate the motion of the shears, we'll add something we haven't used before: a force effector. While any object in Blender can be used as a force, it's traditional to use an Empty. So, add an Empty

to the scene behind the shears (technically "outside") and take a look at the **Force Fields** panel. In Figure 13.3, you see the pop-up selector with all of the choices for force fields. Most of these have very specialized uses, and you are free to play with them. The one we need though, and the one you will probably use most often, is **Wind**. When you set the Empty's Force Field panel to Wind, it gains a set of stacked rings in the 3D view. These rings represent the direction and intensity of the wind force. Rotate the Empty so that the rings point toward the shears.

Also in Figure 13.3 you can see the controls for the Wind style of force field, which is fairly typical of the control sets for the other force types. Set the **Strength** value up to around 20.0. Try the settings by pressing Alt-A in the 3D view. Depending on the scale of your shear model, you may have to increase or decrease the wind strength to get a decent reaction out of the mesh. Remember that like other aspects of the scene, we aren't going for a breakout wild effect. We're just trying to add some background interest with subtle motion.

Once you have a reasonable wind strength that moves the shears (but not too much!), animate that strength over the frame range of the entire sample animation. This is as simple

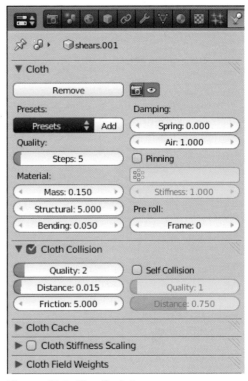

**Figure 13.2** *The silk cloth preset.*

as hovering the mouse over the Strength control and pressing the I key. Then, advance 20 or 30 frames, reduce Strength to 0.0, and insert another key. You've just created a mild wind gust that goes from your initial setting at frame 1 to nothing at frame 31. The best effect will probably be achieved with several "puffs" of wind from the Empty, generated in just this way. While we're messing with animating a single property (Strength), here's a neat trick.

Figure 13.4 shows the Graph Editor with a short bit of animation of the force field shown. To add additional wind gusts, you could continue advancing the frame, changing the Strength value and setting keyframes, but there is a faster way. With the F-curve for Strength showing, just start Ctrl-LMB clicking along the timeline to create something like Figure 13.5. This is much easier than setting keyframes by hand!

Now, hit the N key to bring up the Graph Editor properties panel, also shown in Figure 13.5. At the bottom of the panel, press the **Add Modifier** button and choose **Noise** from the pop-up selector. You can check out the other modifier types on your own, but the results are immediately apparent. The simple curve that you created to vary the Strength is now chock full of noise. Adjusting the Noise parameters shows the results on the curve in real time, which makes them fun to play with. In the end, I used a **Size** of 8.9 and a **Strength** of 3.3 on the Noise modifier. This gives the wind some random, gusty variation at a lower level than the actual curve points. Press Alt-A in the 3D view at any time to preview the effects of the new wind settings.

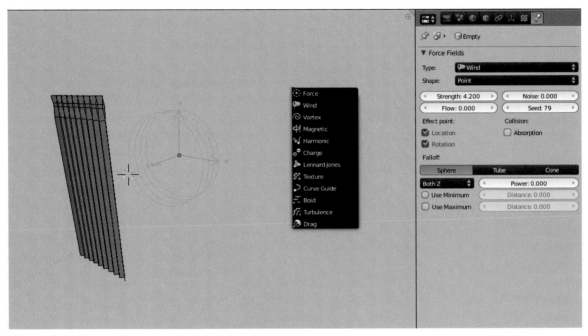

**Figure 13.3** *The force field types, Wind controls, and Wind Empty.*

The **Cloth Cache** panel is where you activate and store the simulation. You'll see some familiar controls here: Start and End frame. When the **Bake** button is pressed, the simulation runs across the frame range, and the solution is stored in the **cache**. The cache is a holding tank for all kinds of simulation data. While you might get decent results in real time for simple cloth simulations with Alt-A, anything more complex (as well as other kinds of simulations like fluid) might take quite a while to calculate. The Bake and Cloth Cache systems provide a convenient way to store the results. Figure 13.6 shows the **Cloth Cache** panel, which is common to all simulation types.

You can try pressing the **Bake** button now. Blender counts the frame range

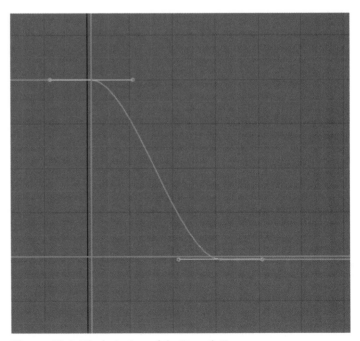

**Figure 13.4** *The beginnings of the Strength F-curve.*

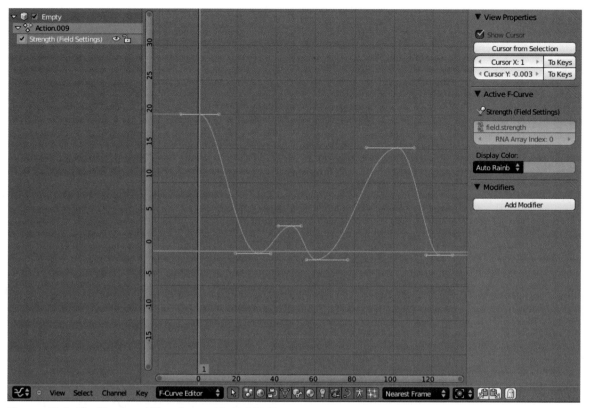

**Figure 13.5** *The F-curve quickly redrawn with Ctrl-LMB.*

indicated in the panel, the cursor turning into a frame number as though you played back an animation. When it is finished, all of the buttons in the cache panel go gray, and the **Bake** button turns into a **Free Bake** button. Using Alt-A for 3D view playback (or animation rendering) will show the baked simulation. Because it is baked, you can even quit Blender, then return to it later with the simulation result intact. Bake, then use Alt-A to see the result in the 3D view. There's your shear simulation, ready to go!

## Soft Bodies, or Bouncy, Squishy Things

The soft body simulator can work on entire objects, like a pile of gelatin struck with a spoon, or only on select parts to give nice secondary motion to things like flab, eye stalks, or, in our case, flowers.

**Figure 13.6** *The Cloth Cache panel for storing simulations.*

It would be cool if the petals of the flowers in the vase reacted to the same wind that affects the shears. To add a soft body simulation, we first have to define which portions of the flower mesh will be simulated by creating a goal vertex group. To the soft body simulator, the "goal" is the shape it tries to maintain. Within the vertex group we are about to create, a value of 1.0 (red in the Weight Painting interface) represents 100% of the goal, indicating that the soft body simulator should not even bother with that part of the mesh. It needs to remain 100% in its modeled state. Weight paint that down to 0.0, though, and the simulator takes over full responsibility for the mesh's motion.

With the flower selected, bring up the Mesh properties and go into Edit mode. Create a new vertex group called "goal," select all vertices in the mesh, and press the **Assign** button on the Vertex Groups panel. You've just added the entire flower to the "goal" group at 100%. Adding a soft body simulation at this point would do nothing, because the "goal" group would not let it handle any of the mesh. Switch from Edit mode to Weight Painting mode, either with the 3D view header menu or by pressing first the Tab key, then Ctrl-Tab. The entire flower should appear red. If it doesn't, go back to Edit mode and make sure that the **Weight** control on the Vertex Groups panel is set to 1.0, instead of 0.0. Set it to 1.0, and reassign the vertices to the group.

Using the standard Weight Painting interface you've used before, set the painting weight to 0.0 and paint the flower petals blue. The result is shown in Figure 13.7. Any area painted blue will be ruled by the soft body simulator. If you want your entire object to receive the soft body treatment, you just skip the entire vertex group creation process.

**Figure 13.7** *Weight painting a goal vertex group onto the flower.*

With your goal group created, bring up the Physics properties and find the **Soft Body** panel. Use the **Add** button to create a new soft body simulation for the flower. Figure 13.8 shows the option-laden soft body interface. Fortunately, you don't have to mess with everything here to get a decent result.

The first thing we'll do is assign the vertex group we just created. On the **Soft Body Goal** panel, which should already be enabled, choose the "goal" group from the **Vertex Group** selector at the bottom. Press Alt-A in the 3D view, and see what happens. The flower petals go crazy, blasted out by the wind. Select the wind Empty and put it on another, hidden layer. Force objects will not affect simulations on different layers. Now when you press Alt-A, the flower petals completely wilt and swing about. Not really acceptable, but at least it's doing something.

It would be great to have the petals at least try to maintain their original shape a little bit, while still being simulated. Without going back to the Weight Painting interface, you can accomplish this right from the Soft Body Goal panel. The **Maximum** and **Minimum** controls allow you to specify the range over which the goal vertex group is interpreted. In the actual vertex group, our painted values run from 0–1. As a default, the Maximum and Minimum controls in the Soft Body Goal panel do as well. However, if we change the Minimum control value to, say, 0.9, then

**Figure 13.8** *The Soft Body properties and controls.*

the entire 0–1 weight painting range is remapped to the new minumum and maximum values: 0.9–1. So, by making this simple adjustment, you provide the equivalent of 90% goal seeking to the flower petals.

Now, pressing Alt-A shows the petals sagging a little, then bouncing lightly in place. Still not great, but they aren't collapsing anymore. While the petals should have the ability to spring back from sagging or being pushed around by the wind (or other force field), that bouncing is too much.

While there are a number of ways to accomplish this, only one works really well in my opinion. You could raise the Goal Stiffness, which pulls the deformed parts of the mesh back into shape with more force; raise the values for Push and Pull Springs in the Soft Body Edges panel, which does the same thing through using the mesh edges as additional springs; or even try raising the Friction value in the main Soft Body panel. All of these solutions introduce other variables into the process though, and none of them make the little thing stop wiggling completely.

The problem is that there is just too much energy in the simulation. In the real world, the motion energy would generally be absorbed by the physical structure of the flower itself, bleeding off as an almost non-

**Figure 13.9** *The first attempt at soft body simulation, beside the current state.*

measurable amount of heat. Obviously, that's not going to happen here. To extract energy from the simulation, we need to use the **Damping** control. Default Damping is 0.0, and we already know what that looks like. So, crank it up to its maximum, 50.0, and see what happens with Alt-A. Figure 13.9 shows the difference between our first attempt after 200 frames, and a fully damped attempt. With damping turned up, the simulation forces the petals to sag a bit, then they stop and sit nicely like all good flower petals do. Doing a rule of halves test, damping set at 25 shows about one bounce, which still looks kind of silly. Let's keep it at 50.

Now, let's add the wind. Go find the wind force Empty and bring it back to the same layer as the shears and flower. If you press Alt-A and nothing different happens, try toggling one of the settings in the soft body properties back and forth, forcing the system to refresh itself with the wind taken into account. To further stiffen the flower petals, enable the **Stiff Quads** option in the Soft Body Edges panel. I usually use Stiff Quads, as it provides a little more shape retention.

We're not going to need it, but the other major setting you can use to good effect is **Mass** in the main Soft Body panel. Raising the Mass, which defaults to 1.0, causes affected parts of the mesh to be heavier. Thus, they are harder for something like the wind force to move. However, once they do get moving, they have more momentum, and everything that brings along with it—more energy, more bounce, more

squash and stretch, etc. Lowering the Mass has the opposite effect—the mesh is more immediately susceptible to forces, but has less momentum.

Finally, if you're looking at both the shear simulation and the flower petal simulation at the same time, you might notice that the wind seems to affect them disproportionately. For example, the amount of wind you need in order to sufficiently drive the cloth simulation might be overkill on the little soft body flower. The end result would be that the shears appear to be disturbed by a gentle breeze, while the flower is blasted by a hurricane.

**Figure 13.10** *The Soft Body Field Weights panel.*

One solution to this would be to create a second wind object with scaled-down force levels and place it only on the flower's layer, restricting the original wind Empty back to the shears' layer. Easier, though, is to check out the **Soft Body Field Weights** panel at the very bottom of the soft body controls, shown in Figure 13.10. It holds a slider for each of the possible force types, and allows you to dial back their influence on the simulation. Set the **Wind** control down to 0.5 (rule of halves!) and see how it goes. Adjust accordingly until the flower and shear motion appear to be driven by the same scale of force.

When you have the flower moving like you want, use the **Bake** control on the **Soft Body Cache** panel so that the simulation is renderable. Without baking, you'll get somewhat random results when trying to render.

## Particles

You've already used Blender's particle system to create hair for our character. It can also be used for more traditional particle effects, like "magic." It won't find its way into the "final" version of the scene, but just for fun let's give the thrown cube toy a sparkling trail as it briefly arcs through the air.

Select the cube toy and note the frames on which it leaves the boy's hand (117) and hits the table (145). These will be the start and end points for our particle system. With the cube selected, bring up the particle system properties, which are shown in Figure 13.11. If you'll recall from generating hair, particle systems have dozens of potential properties, and you could probably fill an entire book with a breakdown of all the options. We're going to show you how to enable a system, set its basic motion properties, and get it to render.

Particles are emitted from the surface of their parent object, which in this case is the cube. The top panel, **Emission**, holds the controls for the total number of particles, the start and end frames for their emission, and how long each particle lives. Set the start and end frames to the frames noted just a moment ago, so they begin when the cube is thrown, and end when it hits the table. The **Lifetime** property controls how long particles remain visible. How long should the particles in our little simulation live? That depends on the effect you are shooting for. As we're trying to make a quickly-dying trail, set it to 24, which represents

one second of time. The number specified in the **Amount** field is the total number of particles that will be emitted over the lifetime (start to end frame) of the system. The particle engine distributes this number evenly across the frame range. The default is 1000, which is probably plenty for our purposes. It's trivial to adjust the number up or down though.

The **Emit From** controls are set to a decent default, and don't require adjustment for basic usage. They control how the system determines where on the mesh each particle is born. In most cases, you want your particles randomly emitted over the entire surface, but by using the **Verts** or **Volumes** options, you can force them to be emitted only from vertices or from the space inside the mesh.

The **Velocity** panel is the next most important, as it controls the actual motion of the particles. Particle motion is calculated with two factors: initial velocity and environmental forces. The initial velocities are assigned in this panel. The **Normal** control in the **Emitter Geometry** section causes particles to shoot directly away from the surface of the mesh, following the mesh's normal at the point of emission. This is appropriate for explosions or any object that will need to "radiate" particles. The **X**, **Y**, and **Z** controls in the **Emitter Object** section shoot the particles in the direction of the object's local axes. For example, setting the Y value to 1.0 would give all particles a starting velocity of 1 along the object's $y$ axis. If the object were to rotate during the emission period, the direction of the emitting axis would change like a rotating sprinkler shooting water from its nozzle.

The **Object** control gives the particles a portion of the object's actual motion. If the object is animated (like ours!) setting this value to 1.0 will make particles come to life with the same velocity as the object at the time of emission. In practical terms, this means that a particle will seem to obtain some momentum from the object, following after it a bit. Setting the value below 0.0 will cause the particles to appear to shoot away from the object's motion vector, appearing like rocket thrust. The **Random** field adds randomness to whatever the total result is from all the other controls. In fact, Random will assign random velocities even when there is no other velocity set. We want our particles to seem to follow the cube a bit, but also to have a bit of randomness, so **Object** is set to **0.4**

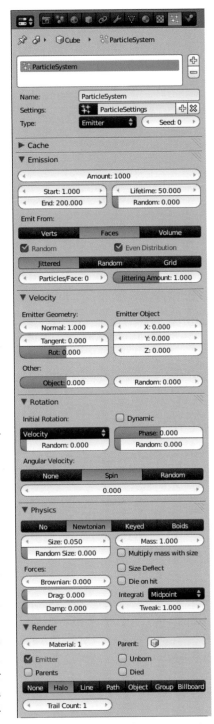

**Figure 13.11** *The particle system properties.*

**Figure 13.12** *The particle system in flight.*

and **Random** is set to **0.25**. Default particles don't have a noticeable orientation, making the **Rotation** panel irrelevant until you're using some of the more specialized visualizations later on.

Another basic decision that needs to be made when working with particle systems is whether or not the emitter object itself should render. For our cube, the answer is obvious: We want to see both the toy and its particles. For other uses, though, you may not want the emitter to show. The **Emitter** control on the **Render** panel determines whether it renders or not. Make sure that it is enabled.

On the **Field Weights** panel, we find the other factor that determines particle motion: environmental forces. Force field objects, like the wind Empty we added previously, affect particle systems that are found on the same layer. Like the other simulations, the Field Weights panel allows you to adjust how much each of the different kinds of forces actually affect the system. If there are no force fields in your

**Figure 13.13** *The collision panel of the Physics properties.*

scene, the panel is still useful, as it controls the effect of gravity. If your particles are going to represent something like sand or sparks, you will probably want to leave the **Gravity** control alone. In the case of "magical" sparkles, which fly and flit, you might want to significantly reduce the Gravity slider.

At this point you can hit Alt-A to see the particles spring to life in the 3D view. Try it once with gravity at full strength, then again with gravity reduced. I like the effect better with minimal gravity, but your opinion may vary. Figure 13.12 shows the particle system midway through the emission period.

As a final step for dealing with particle motion, select the table object and bring up the Physics properties. On the **Collision** panel, press the **Add** button to enable the table as a collision object. The Collision panel is shown in Figure 13.13. Running the simulation now shows any particles that are generated near the table bouncing off of it. Collision is easy to deal with. To reduce the amount of rebound, increase the particle damping **Factor**. Setting it up to 1.0 causes all particle motion to cease on collision. I've set the damping Factor to 0.8 so the bounce is significantly reduced.

The table is a fairly complex object, and it shouldn't be a surprise that it could slow down particle calculations to use something like this as a collision object. The system has to calculate the possible intersection of every particle with every face of the table. To speed things up, you could add a simple filled circle to the scene and position it to correspond with the tabletop. Enable collision for the filled circle, use the **Particle Cache** panel to bake the particle simulation, then move the circle to a nonrendering layer.

Once your particle system moves as you like in the 3D view, you need to assign materials properly for rendering.

## The Halo Material

The **Halo** material type was developed specifically for use with particle systems. Figure 13.14 shows the Material properties, set to Halo in the topmost panel. Also in the figure is a render of a cluster of points with the default Halo properties.

Shading panel properties are reduced to an Alpha slider. On the Halo panel, the following options are available:

- **Color:** The color of the halo
- **Size:** The apparent size of the halo. It isn't measured in Blender units, so you'll just have to execute a trial-and-error process to find an appropriate value.
- **Hardness:** This controls the concentration of the "core" of the halo. The maximum value, 127, creates a hard center with fuzz around it. The lowest, 0, spreads the core over the whole area of the halo, creating a blob of fairly uniform density.
- **Add:** Halos are self-illuminated. They will render even in a scene with no lamps. With **Add** at 0.0, the default, this self-illumination is the same no matter how many halos are in an area. When raised up to 1.0 though, the illumination of stacked halos is reinforcing. Figure 13.15 shows the difference. In general, particles that are supposed to create their own light (fire, magic, etc.) should use the Add property.
- **Rings/Lines/Stars:** These toggles add effects to the halo, letting you create sparkly magic for your unicorn and pony animations. Each has a different visualization, shown in Figure 13.15. They are independent, so you can enable them in any combination. The color swatches below Rings and Lines control the effect's colorization.
- **Soft:** Halos aren't rendered as real geometry. They are a postprocessing effect that is blended into the scene using the render's Z (depth) values. This can lead to halos ending abruptly when they intersect rendered meshes. To eliminate this effect, enable **Soft**. Personally, I always enable it.
- **Shaded:** The last option of note. Halos, as we mentioned, are self-illuminating unless you enable **Shaded**. This option causes halos to receive their shadow and lighting from the surrounding scene. Useful in the past for effects like smoke, it has mostly been supplanted by the smoke simulator and volume rendering.

The real trick with setting up halo materials lies in achieving the right balance between Alpha, halo size, and the total number of particles. All three of those values influence the visual density of the rendered

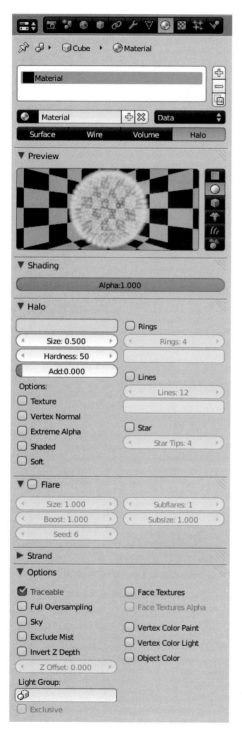

**Figure 13.14** *The Halo Material properties.*

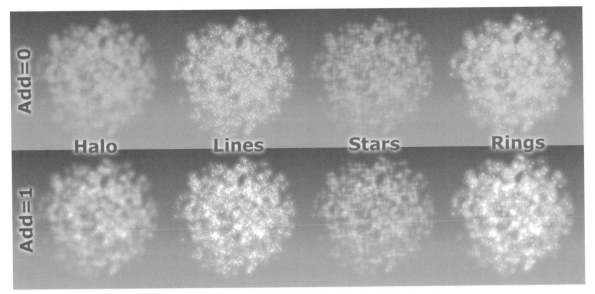

**Figure 13.15** *Halo Add, with Rings, Lines, and Star.*

particle system. With a large number of particles, or a large halo size, you will probably have to drastically reduce the Alpha value to get a good result. Conversely, small numbers of particles will probably require higher Alpha values and halo sizes to obtain any kind of decent density. Of course, it all depends on the final effect you're after, but just keep in mind that halo size, Alpha, and particle count all have a reinforcing relationship.

Since the particle animation isn't a part of the "official" example, we've added it in the Web Bucket as a standalone animation called *sparkle_time.mpeg.*

**Figure 13.16** *Choosing the halo material, and making sure the emitter object renders.*

The last bit of information you need in order to use the halo material effectively with particles is just a bit of administration. If you create a particle system on an object like we did with the cube toy and assign it a halo-based material, you'll find that the emitting object also receives the halo material. When this happens, each of the object's vertices will render with the halo properties, while faces will disappear. To prevent this, add a second material to your object to act as the halo properties. You use the same procedure as you did when adding a second material to the room's floor, except that this time you don't need to "assign" anything to that material. Figure 13.16 shows the Render panel of the Particle properties. Note the toggle for **Emitter** and the **Material** control. Make sure that Emitter is enabled, otherwise the mesh itself will not render. The Material field controls which material in the object's stack is used for the particles. In this case, with only a base cube material and the halo-based one, it should be set to **2**, indicating the second material.

## Smoking Is Good for You

Although it also won't appear in the "final" version of the scene, let's add some smoke to the room. Blender's smoke simulator is fairly easy to use, and produces cool results even at lower resolutions. It is based around particle systems, which you were just introduced to, and another material type: volume.

Smoke is emitted from particles, so to begin the process of creating smoke, we need a particle system. Smoke will continue to pour from any particle that is still alive, so it is important to decide what you would like your smoke to do. Should there be a burst of smoke that rolls into the sky, like an explosion? Make a particle system that emits all of its particles within a few frames, and of which the particle life is very short. Should it be a constant emission, like a smoldering fire? Create a particle system that emits over the length of your animation, or one that emits all at once with long particle lifetimes. So before you even add a smoke simulation, get your particle system squared away, which is a job in its own right.

So we don't have to create and tweak an all new particle system, let's use the one from the previous example. If we were to leave it just as it is, there would be a ton of smoke flying around, so reduce the total particle amount from 1000 to 100, and reduce the particle life to around 3 or 4. Bake the particle system so that you don't get any shenanigans involving particles not updating properly. Of course, you could leave these values as they are and use your original bake but we're going for speed since we're learning the ropes.

To enable the first part of the smoke simulation, make sure that the cube toy is still selected and LMB click the **Add** button in the **Smoke** panel of the Physics properties. This brings up a set of buttons with the labels: **None, Domain, Flow,** and **Collision**. The cube and particle system will be the **Flow** object, which means that the smoke system uses the particles to designate the flow of the smoke. Setting the cube to Flow brings up the Flow controls, shown in Figure 13.17.

Because your object might have more than one particle system, a selector is available at the bottom of the panel. Choose the particle system that we've just tweaked. **Temp Diff** affects the speed with which the smoke moves. At 1.0, the default, the smoke and surrounding "air" are balanced, so the smoke spreads, dissipates, and generally mixes with the air at a fixed rate. If you raise this difference (10.0 is the max) it puts more energy into the system, causing things to mix and spread faster. That's the flow control.

**Figure 13.17** *The Flow object's smoke controls.*

It would be nice if Blender could just determine a smoke simulation based on that information, but such calculations are labor and memory intensive. To make it work, we have to confine the smoke calculations to a finite area. This is done by adding a cube to your scene, and sizing it to fit the area in which the smoke will live. Particles that are emitted outside of this cube will generate no smoke. Smoke that rises (or sinks) outside of the cube vanishes. The cube can be scaled and rotated to best fit the scenario, but only a rectangular object will work. It you add a sphere, or some kind of strange extruded shape, Blender will simply use that shape's bounding box. To keep it simple, always use a cube. This cube within which the smoke simulation takes place is called the **Domain**.

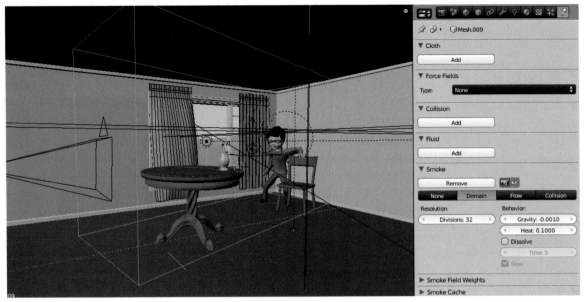

**Figure 13.18** *The Smoke panel and Domain controls.*

Add a cube to your scene and scale it so that it encompasses everywhere you would like smoke to appear. LMB click the **Add** button in the Smoke panel of its Physics properties, and set it to be the **Domain**. Figure 13.18 shows both the cube in the 3D view and the Smoke panel with Domain controls. Notice how the domain cube has been scaled horizontally.

The **Resolution: Divisions** field controls the overall resolution of the simulation. It defaults to 32, which is a decent choice. Pressing Alt-A in the 3D view shows immediate results. It's not quite real time, but the feedback is good. Figure 13.19 shows the smoke simulation at this stage. If things are intolerably slow, you can reduce the resolution, but you shouldn't need to make this value much higher. There is another option for generating high-resolution smoke.

The **Gravity** setting does exactly what you'd think. Higher gravity values tend to pull the smoke down instead of up. **Heat** affects the rate at which smoke rises.

Smoke is subject to the same force fields as the other Physics systems, and their influence on it can be adjusted in the **Smoke Field Weights** panel. In the example scene, I had to turn **Wind** influence down to almost 0 to prevent the smoke from being blown completely out of the domain object right away.

## Smoke Materials
The second half of getting results of the smoke simulator lies in using a **Volume** material. Finding the setup is the tricky part. After you have that, you can play around to achieve different results.

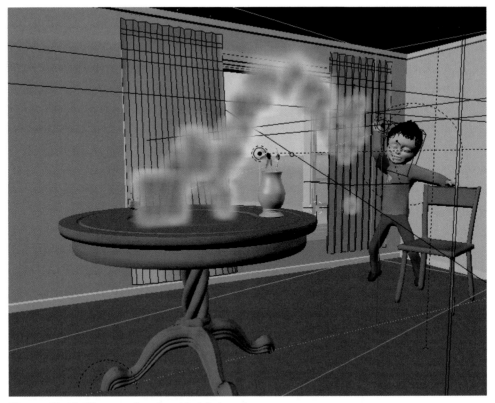

**Figure 13.19** *The state of smoke with default settings.*

Figure 13.20 shows a new material, added to the Domain object. The smoke itself is attached to the Domain, even though it appears to come from the Flow object, so it is the Domain that receives the material. The material types selector at the top of the window has been set to **Volume**. The only things to really mess with for basic effects in this panel are the **Density** and **Reflection** color. The Reflection color is what you would think of as the main color control for the smoke. Make it red, the smoke casts to red. The Density will be controlled by a texture, which in turn is controlled by the smoke simulation. When we want a material property to be controlled by a texture, what do we do? Set it to 0.0. So, change the Density material value to 0.0. The material preview goes blank.

Rendering now would produce a great gob of nothing. We need to hook up a texture to make use of the simulation data. Add a new texture to the material, and set it to the **Voxel Data** texture type. This type makes use of "volume pixel" data (a.k.a. "voxels"), which is what the smoke system generates. Figure 13.21 shows the Voxel Data texture properties. **File Format** defaults to Smoke, but you have to select the proper Domain object right below it. Note the name of your Domain object and set it here. Note once again that you do *not* use the Flow object.

Figure 13.20 *Smoke material properties.*

Figure 13.21 *The Voxel Data texture type.*

Down in the Influence panel, enable **Density** at 1.0. This is the final step that pipes the density values taken from the Smoke Voxel Data through the texturing system and into the material. Rendering now produces a nice smokey smoke, like Figure 13.22.

That's not bad for something in the 3D view, but real smoke has a little more detail than that. Rather than raise the simulation resolution, there are some tricks that can done with localized noise that greatly

increase the apparent detail of the result without sending the resolution (and calculation times) through the roof.

Making sure that the Domain object is selected, enable **Smoke High Resolution**, which is a heading in its own panel. Go with the default settings, and press the **Bake** button on the **Smoke High-Resolution Cache** panel. It'll take a little while. When it's done, you have a significantly better looking smoke simulation, at very little computational cost. Figure 13.23 shows the same simulation as the previous one, baked with the high-resolution option turned on.

## What We Missed

Blender's particle system has more options than perhaps any other section of Blender. You can visualize particles not just as sparkley points, but lines with trails, special cards that always face the camera, duplicates of objects, or even entire groups of objects. They can be given logic and goals with the "boids" settings, and can be made to swarm into different shapes with "keyed" targets. On

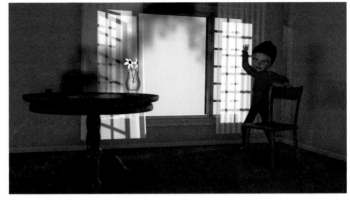

**Figure 13.22** *Regular-resolution smoke, rendered.*

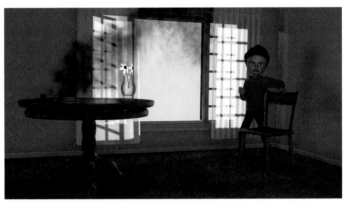

**Figure 13.23** *Smoke, in high resolution.*

the simulator side, we had to skip the rigid body system. Blender uses a powerful core for its rigid body system called Bullet, which is also used for some real-time content on the PS3. We also skipped the fluid simulator. It's fun to play with, and functions much like the smoke simulator (Domain and Flow objects), but its results are only useful in very limited circumstances.

## Next Up …

In Chapter 14, we pull together the whole thing in the Video Sequence Editor, and output animation files for our friends and loved ones to pretend that they watched.

# Chapter 14

## Video Compilation and Final Output

## Creating Animation Files

You have an animation that plays back with Alt-A. You know how to render. The last step in putting this whole thing together is rendering for animation. Blender lets you choose animation formats (Quicktime, AVI, MPEG) for direct output from the renderer, but that is usually not a good way to go. Rendering your animation directly to a single file can be fraught with peril. Well, as much peril as you're likely to face in 3D. Imagine hitting the button to render your 125-frame animation, each frame of which takes four minutes to render, and learning after eight and a half hours that your animation compression settings were lousy. That's depressing. Even if you get it right, what if you want to make a Web-resolution version, or a version that's small enough to email to your mom? Reset the Render properties and go through the whole thing again?

Instead, we recommend that you render animations into a series of still frames at full resolution and quality, then bring them back into Blender's Video Sequence Editor (the "VSE" or "Sequencer") for final animation output.

## Rendering to Still Frames

You learned the basics of rendering in Chapter 12, including the suggestion to render to still frames instead of to animation formats. Figure 14.1 shows the suggested basic configuration for rendering an animation out to stills.

The key settings in the **Dimensions** panel are the **Frame Range** controls. Make sure that they are set to render the correct spread of frames. During testing and the animation process, you may have altered the frame range for playback in the 3D view or for other reasons. Double check it before you render.

It's also a good idea to go over the **Shading** panel to make sure that all of the options you need are enabled. While constructing your scene and test rendering, it is sometimes useful to disable options like

Ray Tracing or Subsurface Scattering to increase speed. For your final render though, it should all be turned back on. Also, if you have any materials that require **Full Oversampling**, but for which you turned it off earlier, look them up and re-enable it. If you have a node network created in the compositor, and you want to use it, make sure that **Compositing** is enabled in the **Post Processing** panel.

Let's look at the **Output** panel. The main image formats to consider when rendering your animation out to stills are **PNG** and **OpenEXR**. If storage space is a concern, you'll probably want to stick with PNG. It provides a nice file size without compression artifacts. Also, most external imaging and video applications can easily deal with PNG files. You can even view them in your web browser. The OpenEXR format preserves more of the original color data from renders. Internally, Blender renders values as floating-point numbers, meaning that the red component of an RGB pixel is represented by decimal values between 0 and 1, capable of a high degree of precision. The PNG and most other RGB formats represent each color channel as an integer between 0 and 255, meaning that there are only 256 possible values for each channel on any given pixel. OpenEXR uses the decimal method, maintaining the actual render values. Under normal circumstances, you're not going to see the difference. When creating animation from still frames though, it's best to give the compression algorithms the most precise information possible, as long as you can afford the hard drive space.

A frame rendered in 720p resolution (1280 × 720 pixels) and saved as a PNG file is 0.25 MB, while it grows to 0.48 MB when saved as an OpenEXR with the **Half** option enabled. That's not a lot of hard drive space, but when multiplied by the number of frames you'll have in your animation, it's certainly something to consider.

Once you've made the decision about the rendering format and specified an output folder just like you do with still images, it's time to render. Press the **Animation** button on the **Render** panel to start the process. Depending on the single-frame render time and how long your actual animation is, it might take quite awhile to finish. This is another advantage to rendering a series of stills. Rendering seriously bogs down your

**Figure 14.1** *The Render properties for animation.*

computer, and if you need to do something crucial with it during the animation rendering process, you can cancel the render at any point and only lose the render time invested in the current frame. When you want to resume, just set the Start Frame to the frame that you canceled and press the Animation button again. All previously rendered frames are already saved. If you canceled a render to one of the animation container formats, you would have to start over from the very beginning.

## Creating an Animation from Stills

After a lot of time, Blender finishes rendering your frames. Save your BLEND file and start a new session with Ctrl-N. Switch to the default screen called **Video Editing**. This is the Sequencer we mentioned earlier. The Sequencer allows you to combine stills, 3D scenes, movie files, and sounds into a single output, cutting and mixing between them.

Figure 14.2 shows the Sequencer workspace, with several video strips imported. For the most part it looks like an expanded timeline view. The best way to learn the parts of the Sequencer is to actually use it. With

**Figure 14.2** *The video Sequencer.*

your mouse over the main workspace, press the universal key command to Add an element: **Shift-A**. It offers you the options of Scene, Movie, Image, and Sound. Selecting **Scene** would add a strip that pulled renders from the current scene. **Movie** lets you bring in movie files in any format that Blender supports (AVI, MPEG, and sometimes MOV). **Sound**

**Figure 14.3** *The imported image strip.*

brings in a sound. **Image** lets you import either a single image or an entire sequence at once. We want to bring in the whole batch of images that we just rendered.

The easiest way to do this is to navigate to the folder that contains the images and use the A key to select them all. LMB click the **Add Image Strip** button, and you are returned to the VSE. Figure 14.3 shows the imported image strip. The second VSE workspace in the upper right of the screen can be used to show a preview of the Sequencer's output. That upper window doesn't have a header at the moment, so show it by finding the + in its lower right corner and clicking it. With the header restored, you can change the visualization from **Sequencer** to **Preview** on the pop-up menu.

With this window set to a Sequencer preview, LMB click in the lower Sequencer's timeline somewhere inside the image strip. Whichever frame of your animation is at that location in time should display in the preview window. You should even be able to LMB drag within the bounds of the added strip and see the result immediately reflected in the preview, although high resolution OpenEXR images may take a moment or two to display. By adding them as a sequence strip, all of the individual images you rendered are treated like a single entity.

The imported image strip may or may not be in a useful position for you when it is first created. The timeline in the Sequencer is no different than any of the other timelines in Blender: You want the strip to start on frame 1. The easiest way to get the strip to frame 1 is to RMB select it and press the G key. Be careful when you select the strip though—the left and right sides of strips are individually selectable as well. In order to move the whole strip at once, you have to select it in the middle. Once it's selected and moving with the G key, you'll see that the start and end frame for the current position of the strip are displayed, and they change as you move it. Just move the strip until the beginning number is a 1, and LMB click to drop it.

If all that you want to do is bring in a sequence of images and publish it as an animation, you're almost done. A short trip to the Render properties finishes the job. Make sure that the pixel dimensions and frame rate match up with your original settings for the animation, as the Sequencer will happily resample your original work to the current settings if they are different. Choose one of the animation formats, depending on your target.

The **Output** panel provides a number of options under the **Movie** section: AVI Raw, AVI JPEG, H.264, Xvid, FFMpeg, and Frame Server. Ignore the two AVI formats. FFMpeg is the real workhorse of Blender's video export. In fact, the H.264 and Xvid options are just shortcuts to banks of FFMpeg settings. So,

choose **FFMpeg**, and expand the **Encoding** panel directly below it. I'm not even going to make a screenshot of the panel, because it contains a lot of things you shouldn't be touching at this point. In the **Format** control, you can choose from Flash, Xvid, H.264, DV, Quicktime, AVI, and three different flavors of MPEG. If you're distributing to people on Windows computers, choose AVI. Mac users would appreciate Quicktime. The truth is that most computers can play most video formats these days, regardless of how things were ten years ago. To be platform agnostic, I've used MPEG-2 for the videos that come along with this book. It's the compression standard used by DVD video. If you do choose AVI or Quicktime, you will also have to choose a codec from the control to its right. My recommendation would be to use either the H.264 or MPEG-2 codec. Both are widely supported, although H.264 is considered more "modern" and has better quality with smaller file sizes.

The only other setting you need to worry about is the **Bitrate**. This controls compression and overall quality. Higher bitrates give greater quality, but make larger files. In general, a bitrate of around 8000 kb/s will work out to about 1 MB/s. In the case of the sample file, the actual file is smaller than this, as there's really not that much going on in the animation. Most of the scene is static. Where to start with this value? Try the default: 6000. If things look nice, then you're fine. If you notice bad compression artifacts, you'll need to raise it. If your resulting animation file is too large, you'll need to lower it.

With a video format chosen, set your frame range to match the original and hit the **Animation** button in the **Render** panel. The frames will speed before your eyes, and before you know it you'll have an animation file. Find the file and play it with the animation player of your choice. Too much compression? No problem. Adjust your settings in Blender and re-render the animation. No need to go back to the actual Blender scene—you're just fooling around with the prerendered frames now. It is fast and easy to make adjustments to the animation settings.

Try this: Make sure that anti-aliasing is enabled in the Render properties and set the Resolution percentage down to 50%. Render out the animation. The Sequencer creates a half-size animation, sampling down the provided frames on-the-fly. You don't even have to stick with the same aspect ratio. You could go wacky, and render your 720p original frames out to a 128 × 300 pixel animation and the Sequencer would happily do it.

Let's do two things before we leave our little room and character forever. First, we'll add two sounds. One is a music track. The other is a clattering noise. Press Shift-A over the Sequencer's workspace and choose **Sound**. Browse to the file provided in the Web Bucket called *clatter.wav* (the sound was obtained from *www.freesound.org*, which provides Creative Commons licensed sounds). Figure 14.4 shows the new sound strip, with the original image strip in place. The goal is to move the sound strip so that it lines up with the cube toy hitting the table. It's simple enough to scrub the frame marker inside the image strip until you find the frame where the cube strikes the table. Once you've found it, use the G key to move

**Figure 14.4** *Adding a sound strip for the cube.*

the sound strip so that its starting point corresponds with that frame of the animation. Hit Alt-A to watch it and see how you did. You might have to adjust things by a frame or two to get it just right (*clatter.wav* is available under the Creative Commons Sampling Plus 1.0 License from *http://adcBicycle.com*).

The second piece of sound to add is a little bit of background music called *47617__hammerklavier___BRIGHTER_ INVENTIONS_FOUR_ON_SUB_D_1_.mp3* (available under the Creative Commons Sampling Plus 1.0 License from "hammerklavier" at *www.freesound.org*). It's only a few seconds long, but so is our animation, so it works out fine. Move the new sound strip until it begins on frame 1, along with the animation. Hit Alt-A to play, and you should hear both the music and the clatter sound mixed together. If you

**Figure 14.5** *The N-key panel lets you adjust strip properties.*

think the music is too loud, hit the N key to bring up the Sequencer's properties panel. With the music strip RMB selected, find the **Sound** panel, shown in Figure 14.5, and reduce the volume from 1.0 until you like the mix. If you wanted, you could also raise the volume of the clatter sound with the same method. The RMB context menu is available, so you can keyframe the volume. For example, if you wanted the music to fade out near the end of the animation, you could just set a key for the Volume at 1.0 20 frames before the end, then another key for Volume 0.0 on the final frame.

Finally, let's add a title card and a credit at the end. For my own title card, I've created a PNG file in Photoshop with the same dimensions as my rendered frames. It reads "Room Boy and the Cube of Eternal Peril." You can make your own, or use mine, which is included in the Web Bucket under the name *titlecard.png*. Bring your title card image into the Sequencer with Shift-A and place it so it begins on frame 1. As a single image, Blender assigns it a duration of 25 frames. To change that, zoom in and RMB select the right handle of the image strip, as shown in Figure 14.6. Use the G key to stretch the strip out as far to the right as you like. Want the title to show for three seconds? Pull it out to end on frame 72 (24 fps × 3 seconds). Playing the animation now shows something rather nonideal. The title card is displayed for three seconds, and we pick up the animation already in progress, not really leaving a lot due to its brevity.

Strips that are higher in the sequencer stack obscure the content of lower strips. What we need to do is to move the animation strip so that it begins at (or near) the end of the title card strip. This

**Figure 14.6** *Selecting a strip's handle.*

**Figure 14.7** *The MetaStrip.*

is easily done, but it would be nice to move the clatter sound along with it so that they stay in sync. Actually, it would be great if we could just bind the animation and clatter sound together so that we don't have to worry about messing up their relationship. By selecting both the animation and clatter sound strip and choosing the **Make Meta** operation, either from the **Strip** menu on the header or with the **M** key, you merge the two strips into a single one called a "MetaStrip." MetaStrips act like a single Sequencer strip and can contain any number of individual strips. They are intended to group strips of which the relationships in time have already been determined, like these two. If you change your mind, you can always break the MetaStrip back into its components with the **Alt-M** command, much like Alt-P breaks a parent–child relationship elsewhere in Blender. Figure 14.7 shows the Image Sequence of our animation and the clatter sound merged into a MetaStrip.

Move the MetaStrip that represents the animation and clatter sound to the right, but don't move it the whole way to the end of the title card strip. Try to leave about 12 frames (one-half a second) of overlap. While it's true that the upper strip (the title card) will obscure it because of its place in the stack, we can play with that. First, RMB select the title card strip, then Shift-RMB select the MetaStrip. With both selected, use Shift-A to Add an **Effects Strip**. The Effects Strip pop-up is shown in Figure 14.8. Choose **Cross**, which is short for "crossfade," a technique for smoothly blending from one shot to another. When you do, a new red strip appears that occupies the same slice of time as the overlap between the two strips. This represents the crossfade effect. Position the current frame marker just before the cross strip and use the → key to step through it a frame at a time. The preview shows the title card fading out over roughly 12 frames.

By adding strips that represent different shots of animation, video or still images, then arranging them in time, stacking them in the sequencer, and transitioning among them using effects like the crossfade, you create a finished piece of animation work. For the example scene, we've also added a little credits card at the end and crossfaded into it.

To export your final animation and include the sound, you need to enable the **Audio** section of the **Encoding** panel of the Render properties. Earlier in the chapter, we discussed some of the different

animation formats and which might work well for your target audience. When adding audio, it makes the choices even harder. Blender allows you to include audio with your video in the following formats: PCM, Vorbis, AAC, AC3, MP3, and MP2. PCM is uncompressed and can send your file size through the roof. Most people's systems will be able to decode MP3 and MP2 audio. The best way to do it is to do a short test with your target system. PCM will almost always work. AC3 is the format used by almost all commercial DVDs, as it supports both regular stereo and Dolby Digital surround channels. So, if your target is DVD, use AC3. If you'll be uploading to YouTube or Vimeo, it really doesn't matter. Their conversion tools are robust and will be able to handle just about anything you throw at them.

**Figure 14.8** *The Effects Strip menu.*

## What We Missed

The Sequencer can do a lot more than compile stills into animation and stick some audio on top of it. It can function as a full-fledged nonlinear video editor. By splitting and arranging different video tracks, you can edit an entire production in Blender, and in fact, people have done so! You can keyframe the opacity of different video tracks to have them fade in and out, dynamically adjust the color space of high-end video, and add more effects than the simple crossfade.

## Next Up ...

Nothing. That's the end. But obviously, it's not. You're familiar with Blender now. You should be able to go back to one of the sections of the example production and start poking around in the menus. Hopefully the knowledge and experience you've gained while working through these exercises will provide you with just the right set of fundamentals so that browsing the function menus will give you some ideas. Be adventurous. Choose a different option or pathway than the ones we've taken here. Don't worry. You won't break anything, and you just might create something amazing.

# Index

# Index

# Index

# Index

# Index

# Index

# Index